To the Grobaty Family,
Enjoy!
Claudine Burnett

Other books by Claudine Burnett:

*From Barley Fields to Oil Town: a Tour of
Huntington Beach, 1901-1922.*

Haunted Long Beach.

Haunted Long Beach 2.

Murderous intent? Long Beach, CA. 1880's-1920.

Soaring Skyward: A history of aviation in and around Long Beach, California.

Strange Sea Tales Along the Southern California Coast.

Jointly with other authors:

The Heritage of African Americans in Long Beach.
In association with the African American Heritage Society of Long Beach,
Aaron L. Day and Indira Hale Tucker.

Balboa Films: a history and filmography of the silent film studio.
With Jacques Jura and Rodney Barton.

Prohibition Madness

Life AND Death in and around Long Beach, California, 1920-1933

Claudine Burnett

authorHOUSE®

AuthorHouse™
1663 Liberty Drive
Bloomington, IN 47403
www.authorhouse.com
Phone: 1-800-839-8640

Photos used in book are from Long Beach Public Library, Long Beach Police Historical Society, Long Beach Heritage Museum, and the author.

Cataloging-in-Publication Data
Burnett, Claudine E.
Prohibition madness: Life and death in and around Long Beach, California, 1920-1933 / Claudine Burnett. p. cm.
Includes bibliographical references and index

1. Prohibition—California—History.
2. Long Beach, Calif.—History. Murder—California—Long Beach.
3. California, Southern—History—20th century. I. Title

979.495–dc23
F869.B94 2013

Published by AuthorHouse 01/25/2013

ISBN: 978-1-4772-9161-0 (sc)
ISBN: 978-1-4772-9162-7 (e)

Dedicated to my good friend and editing guru

Judi Cameron

Who has supported me in all my writing endeavors

LONG BEACH OFFICIALS DURING PROHIBITION

CHIEFS of POLICE
Ralph Amasa Newell—Sept. 18, 1919 to Mar. 1, 1920
James I. Butterfield—Mar. 4, 1920 to Nov. 22, 1920
Benjamin Ward "Ben" McLendon—Jan. 22, 1921 to Nov. 15, 1922
James Selwyn Yancy—Nov. 24, 1922 to Oct. 16, 1933
Joseph Henry McClelland—Oct. 16, 1933 to Oct. 6, 1939

CITY MANAGERS (position created by Charter amendment in 1921)
Charles E. Hewes—July 5, 1921 to Dec. 4, 1922 (recall election held Nov. 29, 1922)
Charles H. Windham—Dec. 9, 1922 to March 1, 1926
Charles S. Henderson—Mar. 1, 1926 to July 6, 1927
Henry S. Callahan—July 5, 1927 to December 28, 1928
George L. Buck—January 18, 1929 to July 7, 1930
Claude C. Lewis—July 7, 1930 to April 19, 1932
Edward S. Dobbin—April 19, 1932 to July 7, 1933
James H. Bonner—July 7, 1933 to Sept. 30, 1934

CITY MAYOR (position created by Charter amendment in 1921; selected from members of the City Council)
Charles A. Buffum—July 1921 to July 1924
Ray R. Clark—July 1924 to July 1926
Harry S. Callahan—July 1926 to July 1927
Oscar Hauge—July 1927 to July 1930
Asa E. Fickling—July 1930 to July 1933
Merritt E. Paddock—July 1933 to July 1934

CITY AUDITOR
Myrtelle Gunsul—July 7, 1919 to March 1, 1951

CITY COUNCIL
1920-1921—Thomas W. Williams; Harry B. Riley; Eugene E. Tincher; William T. Lisenby; William M. Peek; John D. Seerie

1921-1922—Fillmore Condit; Alexander Beck; Charles A. Buffum; George B. Workman; Galen H. Welch; Henry L. Pillsbury (resigned 6/19/1922; Charles H. Stanley appointed); Frank H. Downs

1922-1923—Fillmore Condit; Alexander Beck; Charles A. Buffum; George B. Workman; Charles A. Cover; William H. McCoy; Frank H. Downs

1923-1924—Fillmore Condit; Alexander Beck; Charles A. Buffum; George B. Workman; Charles A. Cover; William H. McCoy; Frank H. Downs; William L. Evans

1924-1925—Fillmore Condit; Alexander Beck; Ray R. Clark; Henry S. Callahan; Charles A. Cover; John T. Arnold; Charles H. Tucker; William L. Evans

1925-1926—Fillmore Condit; Alexander Beck; Ray R. Clark; Henry S. Callahan; Glen Thomas; John T. Arnold; Charles H. Tucker; William L. Evans

1926-1927—Fillmore Condit; Alexander Beck; Ray R. Clark; Henry S. Callahan (resigned, appointed City Manager); Glen Thomas; John T. Arnold; Charles H. Tucker; William L. Evans

1927-1928—Nicholas H. Alexander; Edward L. Taylor; Claude C. Lewis (resigned, replaced by Robert W. Jones); Alexander F. Bonzer (resigned, replaced by Robert M. Hicks); Oscar Hauge; Joseph Farnsworth (resigned, replaced by Benjamin B. Stakemiller); John J. Barton; William L. Evans

1928-1929—Nicholas H. Alexander; Edward L. Taylor; Robert W. Jones; Robert M. Hicks; Oscar Hauge; Benjamin B. Stakemiller; John J. Barton; William L. Evans; Ralph E. LoRentz

1929-1930—George A. Ward; J. Will Johnson; Robert W. Jones; Frank H. Church; Oscar Hauge; Benjamin B. Stakemiller; John J. Barton; Carlos B. Michener; Ralph E. LoRentz

1930-1931—Edward S. Dobbin; Oliver S. Peacock; Harry C. Waup; Frank H. Church; Asa E. Fickling; Benjamin B. Stakemiller; John J. Barton; Ralph C. Christie; Oscar H. Wolter

1931-1932—John W.V. Steele; Oliver S. Peacock; Harry C. Waup; Frank H. Church; Asa E. Fickling; Benjamin B. Stakemiller; John J. Barton; Ralph C. Christie; Oscar H. Wolter

1932-1933—John W.V. Steele; Oliver S. Peacock; Harry C. Waup; Frank H. Church; Asa E. Fickling; Benjamin B. Stakemiller; John J. Barton; Ralph C. Christie; Oscar H. Wolter

1933-1934 (Council in office July 1ˢᵗ 1933, recalled July 10, 1934)
John W.V. Steele (replaced by Frank W. Barnes); Walter D. Singleton (replaced by Clarence E. Wagner); Timothy A. Stevens (replaced by John Schinner); Frank H. Church (replaced by B.F. Kirkland); John J. Oswald (replaced by Thomas M. Eaton); Merritt E. Paddock (replaced by Carl C. Fletcher); John J. Barton (replaced by Melvin L. Campbell); Claude Winstead (replaced by Leroy H. Cederberg); Oscar H. Wolter (replaced by Virgil H. Spongberg)

Contents

Introduction

Throughout America cocktail parties sparkled defiantly during the dreaded first minutes of January 20, 1920. With morning would come the official start of Prohibition. It was easy, however, to keep the party going in Long Beach, California.

Though Long Beach had been "dry" throughout most of its history, illegal liquor distribution all over the city was already "perfected" by the time the 18th Amendment, banning the sale of most alcoholic beverages, became law. Already in place were underground booze operations, secretive speakeasies and bootlegging, the perfect staging ground for murder and crime.

Long Beach had a long history of illicit alcohol establishments. In 1904, O.H. Burbridge, who kept the "Surf House" under the Pine Avenue Pier, was arrested for selling "spirituous" liquor. Witnesses testified that when they asked if they could get a beer they were taken into a side room of the restaurant and served the real thing. A bottle of beer secured at the restaurant, and most of the contents, were preserved as evidence and introduced in court. Burbridge was found guilty and sentenced to 75 days in jail or a fine of $150. Burbridge paid the fine. He was but one of many to ignore the anti-alcohol sentiment of the city.

During the years of national Prohibition, at the underground clubs, many centered around Long Beach's amusement zone known as the Pike, inventive bartenders enjoyed new respect for disguising the taste of the day's alcohol. They created a new generation of cocktails heavy on fruit juices to mix with the bathtub gin. There was the Bennett Cocktail (gin, lime juice, bitters), the Bee's Knees (gin, honey, lemon juice), and the Gin Fizz (gin, lemon juice, sugar, seltzer water). At least those were the kind of drinks served at Long Beach's classier joints. Down at the harbor or around the oil wells of Signal Hill seedier establishments might be serving a cloudy cocktail called Smoke, made by mixing water and fuel alcohol. The drink was blessedly cheap, fifteen cents a glass, and just about pure methyl alcohol. Straight alcohol was simply awful to drink. There was no way to drink it straight and no way to disguise its dreadful taste. Green River, a lime soda, was a favorite mix as was ginger ale. But no matter how hard you tried to disguise it straight alcohol was hard to get down and even harder to keep down. Throwing

up was a way of life, Robert Gardner remembered in his book *Bawdy Balboa*. Gardner paid his way through college by cleaning up after those embarrassed by their mishap, charging fifty cents to scrape the solid stuff off the table and onto a plate, wiping up the liquid stuff and then using a rag soaked in ammonia to kill the smell. He'd pick up two or three dollars on a Saturday night at the Green Dragon in Balboa and no one ever complained about the fee.

Much of Southern California's "best" liquor during the Prohibition era was smuggled in from ships anchored off the California coast. Naples and the Long Beach harbor area were favorite sites to unload the illicit brew. This "prime" cargo was expensive and catered to the wealthy, the powerful, the artists, and the politicians, giving illegal alcohol a kind of high-life image, an alluring, seductive glamour. Most of the alcohol, however, was moonshine, made from either grain (ethyl) or cheap, poisonous, wood (methyl) alcohol. It was affordable to the "common" folk, the oil workers, shop clerks, and farmers. And, after the stock market crash of 1929, to all who saw the world they once knew end.

As filmmaker Ken Burns pointed out in his film series on Prohibition:

"Prohibition turned law-abiding citizens into criminals, made a mockery of the justice system, caused illicit drinking to seem glamorous and fun, encouraged neighborhood gangs to become national crime syndicates, permitted government officials to bend and sometimes even break the law, and fostered cynicism and hypocrisies that corroded the social contract all across the country. Thugs became celebrities, responsible authority was rendered impotent. Social mores in place for a century were obliterated. Especially among the young, and most especially among young women, liquor consumption skyrocketed, propelling the rest of the culture with it."

There was one component, however, that made Long Beach different from the rest of 1920's and '30's America. Almost eighteen months after Prohibition had become the law of the land Long Beach was hit by a revolutionary discovery that would change the life of the city in many unforeseen ways.

On Thursday, June 23, 1921, around 5 p.m., the Shell Oil Company struck oil at its well at Temple Avenue and Hill Street on Signal Hill. Oil fever quickly spread. The lure of black gold brought

countless newcomers to the Long Beach area, many eager for an illegal drink after a hard day working the oil fields. Amid all of this oil Signal Hill, which had been renowned for its scenic grandeur, productive soil and magnificent homes, was transformed. Building restrictions, paved streets and walks and curbs were supplanted by oil leases, oil stocks, derricks and drills. Palm trees and rose gardens were removed to make way for boilers and tool houses and speakeasies.

"Orgies of vice" catering to the oil industry, were said to fester around Signal Hill, the *Los Angeles Times* reported March 27, 1922. A recent raid of several so-called "hotels" had confiscated quantities of liquor, several pairs of loaded dice, decks of marked cards, a roulette wheel and other gambling paraphernalia "that made life in the old days of San Francisco's famous Barbary Coast look tame compared with the activities in the vice dens of Signal Hill," according to the same reporter. To make matters worse, at two of the places proprietors were armed with automatic revolvers, long-barreled rifles, as well as small-caliber pistols. Police Chief Ben McLendon vowed to keep the houses closed:

"Long Beach itself is clean and there is no excuse for permitting such places as these just outside the city limits. I shall raid them or bring about raids on such places whenever possible." [1]

McLendon and his successor James Yancy certainly had their work cut out for them through the years of Prohibition. As you'll soon find out there was much going on in Southern California and Long Beach during the era of the Eighteenth Amendment. 1920-1933 was an exciting time, indeed.

POLICING LONG BEACH

"Evidence . . . proves that prohibition only drives drunkenness behind doors and into dark places, and does not cure it or even diminish it."

Mark Twain. "Letter to San Francisco"
Alta California, 7/28/1867.

Gone But Not Forgotten

Change. That was the one word police chief James Selwyn Yancy used to describe his twenty-one years as a police officer in Long Beach, California. The former deputy sheriff of Arapahoe County, Colorado, and his family had moved to Long Beach in 1912. Back then there was not a legal place in the town of 18,000 to buy a bottle or a drink of liquor, though you could easily travel to nearby Alamitos Bay or Wilmington to do so. It was a time when cars were rare and drug addiction unheard of.

The Yancys had first considered moving to the new housing development of Los Cerritos. Three hundred acres of the Los Cerritos Rancho had been subdivided in May 1912 and placed on the market by Mayor Charles Windham's real estate company. Though Los Cerritos was close to the Pacific Electric line, only thirty minutes from Los Angeles and ten minutes from Long Beach, the family liked the more established Belmont Heights area of the city. That residential district had been one of many that popped up after the introduction of the Pacific Electric red car line to the city in 1902. It was also affordable to a new police officer who only earned $75 a month and was expected to buy his own uniforms, hats, guns, clubs and flashlights.

The department that the 30-year-old Yancy joined in July 1912 was still in turmoil over the murder of police officer Thomas Borden, killed in March of that year. Borden had been shot by a burglar outside his home that St. Patrick's Day evening and the whole city was in an uproar. Borden had been one of the original settlers of the community; now he would be remembered as the first police officer killed in the town he had grown up in.

This would not be the only policeman whose death Yancy would experience during his twenty-one year career with the Long Beach Police Department. He would see the city through the turbulent days of Prohibition, both as a regular police officer and later as chief of police. Along the way some good, honest men would give their lives trying to keep Long Beach safe. Wilkinson, Halstead, Walls, Bridgeman, Houske, Gibson and Morgan were officers Yancy would not forget.

Death is hard to deal with, even more so when memories about the individuals who died don't seem to go away. How could Yancy not remember James R. Wilkinson?

Wilkinson had served as a deputy marshal along the Mexican border before ending up in Long Beach. Affectionately called the "two-gun-man" by his fellow officers because he insisted on carrying two weapons, Wilkinson was always regaling rookies about the "old" days of law enforcement when he was a marshal on the frontier. The 58-year-old Missouri native was quite a character. He worked the night shift at Long Beach's amusement zone, the Pike. His friends used to joke that the Pike was the perfect assignment for Wilkinson because he was so entertaining. He certainly told a good story, especially about happenings he experienced patrolling the Pike.

Summer was an especially busy time for the Pike and Wilkinson. Every Memorial Day Long Beach launched its summer season with a two-day festival of merrymaking. The Pacific Electric red cars were crammed with arriving tourists, and the Walk of One Thousand Lights was a sea of white sailor hats. People flocked to the shore to listen to the music wafting from the band shell, to fish off Pine Avenue Pier and enjoy the Coney Island style amusement center known as the Pike. There was much to see at the Pike including the Majestic Dance hall, the ocean water bathhouse known as the Plunge, and the roller coaster. There were also lots of characters and illegal alcohol to entertain visitors.

Wilkinson was good friends with Reckless Ross, who rode his motorcycle around a 40-foot high motordrome at the Pike. Not only was Ross reckless, he was a wild man of ideas. If it was a slow day and Ross had trouble getting an audience, he would lie down and have his mechanic gently put the motorcycle on his chest. The mechanic would rush out of the motordrome, carefully leaving the door open so the people could see in. Someone would call the Fire Department (the department was in on the gag) and they would rush down the hill, sirens screaming. A crowd would gather and Ross would get up, hobbling and groaning and agree to do one more show before they took him to the hospital.

There was also Painless Parker, a dentist, who would do tooth extractions in his booth. He'd fill some person full of Novocain and do his work. Though discovered in 1905, Novocain was still new in those

days and it was a novelty for folks to see teeth extracted with no pain. Eventually local dentists sued Parker for false advertising. Parker went to court and changed his first name to Painless. Wilkinson thought this was hilarious and reveled in telling the story about how "Painless" Parker got his name.

The Pike where Wilkinson walked his beat first opened July 4, 1902, on the same day the Pacific Electric railway officially inaugurated its service from Los Angeles to Long Beach. Little by little as the city grew so did the Pike. A band stand, skating rink, roller coasters, merry-go-rounds and other attractions including animal shows, dancing, novelty stores, hot dog stands, fortune tellers, and theaters were added throughout the years. It was the perfect place to take the family for a fun day in the sun, but as the sun began to set the atmosphere changed. That was when the Old Cider Mill and the illegal gambling dens along the Pike prepared for an evening of brisk business. This is when James Wilkinson went to work.

Wilkinson knew all of the pretty, bobbed hair beauties at the Old Cider Mill by name. Inside the Mill visitors found a real bar complete with foot rails and a four-piece African American orchestra turning out that "weird" jazz becoming popular among American youth. The highly rouged young ladies, clad in revealing sailor suits, served a slightly alcoholic cider (below the .5% alcohol level mandated by the Volstead Act) from big barrels, labeled Old Crow, Old Taylor, Cedar Brook and Jack Dempsey. Sometimes a little extra "punch" would be quietly added to the drink.

On the evening of June 21, 1921, Wilkinson became suspicious when he observed an elderly man anxiously pacing in front of the Old Cider Mill. Wilkinson thought the sweat on the man's brow was due to the heat and the man's age, or brought on by lusting over the scantily clad young women serving cider. Wilkinson never thought the perspiration was caused by what the man was plotting.

For more than two hours 62-year-old Henry Miller waited for his 38-year-old wife Myrtle to get off work at the John Baumgartner Tamale Kitchen. Myrtle was surprised to see her estranged husband since the two had been separated for some time. Before she could ask him what he wanted, Miller rushed at her, quickly pulled out a gun, shooting her three times.

As the first bullet entered her body, Myrtle screamed, "My God," and stumbled to the sidewalk unconscious. Miller fired the second and fatal shot just before his wife fell. She landed face down less than ten feet from the spot where her husband was standing. It was a gory scene, one witnesses would not soon forget—blood flowing from her ears, mouth and nose, covering the sidewalk. The injuries were so severe Myrtle died in the ambulance on the way to Seaside Hospital.

Distraught, Miller placed the 32-caliber revolver against his forehead and pulled the trigger. For some reason the gun did not go off. Before he could pull the trigger again two men sitting on a nearby bench rushed at him and knocked the gun from his hand.

Officer Wilkinson sped to the scene. When questioned Miller refused to say much, except to declare he was sorry he "didn't do a better job of it." He pleaded with Wilkinson and other officers to permit him to "end it all," as he had originally intended to do.

With gentle prodding, Wilkinson got Miller to talk about his relationship with Myrtle. The police officer learned the couple had married in November 1920, but for three months preceding the murder they had been separated, living in different hotels, with Myrtle Miller paying all the bills. Henry Miller, a carpenter by trade, suffered from locomotor ataxia, syphilis of the spinal cord, which resulted in an unsteady gait, incontinence and impotence. He had not told Myrtle of his condition prior to their marriage, nor did he tell her he had not been able to work for eight years. She also wasn't aware her new husband had been married before, until the couple chanced to meet his first wife one day on the street. But Henry wasn't the only one with secrets. It seemed Myrtle had a first husband she had forgotten to tell Miller about.

Mrs. Miller's employer, John Baumgartner, told Wilkinson he had never had a more efficient and willing worker than Myrtle Miller. She was always cheerful and never complained. She was a great talker, Baumgartner said, but never said much about herself. Several times she had remarked in a joking way that she was an old maid. Baumgartner had no idea she was married.

Officer Wilkinson had to deal with a lot of suspicious goings on after dark at Long Beach's version of Coney Island. As night progressed bootleggers dropped off their illicit booze to what appeared to be "respectable" establishments during the day, and would-be drinkers

knocked on doors and recited the secret password to be let in to what were now being called "speakeasies." At 3 a.m. on the morning of January 17, 1923, Wilkinson became suspicious when he saw J.B. Matteson out at such an hour. Matteson couldn't come up with a reason for being on the streets so late at night and was taken into custody by Wilkinson. As the pair reached the police call box Wilkinson swayed and fell into the arms of his prisoner. Wilkinson had died of a heart attack.

Though Wilkinson's death had been unfortunate, many of his fellow officers were relieved the old Texas Ranger hadn't had to deal with Frank McGann. If Wilkinson had still been around, his heart would have definitely given out when his old pal Frank McGann, a former sheriff, murdered Mrs. McGann's lover on Wilkinson's former beat.

It was unseasonably warm that April 28, 1923, evening, and hundreds of merrymakers were out leisurely walking the nearly mile long promenade of the Pike. Suddenly the music from the merry-go-round was augmented by five loud "bangs." Frank D. McGann, outraged to find his wife strolling through the Pike with another man, fired the shots into her friend Ralph T. McAdams.

The McGanns were separated. Their marriage hadn't lasted very long. Married in October 1922, they separated four months later. It was her husband's temper that caused their separation, Anna McGann told reporters. She had married Frank because he threatened to kill her if she refused. Throughout their short stint of matrimony Anna was in mortal fear for her life. She finally had fled after one last argument in which her husband stated, "If I can't live with you no one else can." He was true to his word.

Ralph McAdams fell at the first shot, but his assailant continued to shoot at his victim hitting him in the neck, chest, waist and stomach. Death was due to the last bullet which entered through the mouth and penetrated the brain. Anna McGann screamed and tried to prevent the shooting, but she was shoved aside by her angry husband. She would have been his next victim if good luck hadn't intervened. McGann's gun jammed on the fifth shot.

At first Anna denied any wrong doing with McAdams saying he was a friend and nothing more. Like McGann, McAdams was separated but not divorced from his wife. He was a tenant at the boarding house

which Anna ran with her mother. However, conscience got the best of Anna McGann. Perhaps it was swearing to tell the truth with her hand on a Bible that changed her mind. She told a very different story, under oath, about her relationship with McAdams at her husband's trial in October 1923.

At the trial Anna said she first met McAdams at the Silver Spray Dance Hall on the Pike in February 1923, became infatuated with him and finally left her husband. She described many of their meetings which led up the April 28, 1923, murder. She was walking with McAdams, she testified, when McGann came up to them and, catching McAdams by the arm, asked: "Do you know this woman is my wife and that you have broken up our home?" McAdams said Anna was his now, looked McGann in the eye and asked him what he was going to do about it. As he said this McAdams threw a punch at Frank McGann. McGann then drew his revolver and began firing. It seemed Anna had a propensity for attracting men with a temper. She testified that McAdams had told her that he would kill her and her husband if she should leave him.

At his trial Frank McGann claimed self defense. His story differed somewhat from that of his wife. McGann said that after sixteen years as a deputy sheriff in Inyo County he was accustomed to carrying a gun. In all his years in law enforcement he had never used his weapon, always using persuasive talking as his main tool in getting a suspect to surrender. McGann claimed he did not know his wife and McAdams were on the Pike until McAdams jostled him. McAdams had an ugly disposition, McGann testified, and though McGann wished to avoid trouble, his boasting that he had stolen Anna angered McGann. When McAdams reached towards his hip pocket saying, "I'll get you!" McGann believed he had a gun. His years of law enforcement training kicked in. McGann drew his gun and started shooting.

It was the fact that McGann fired five times that convicted him. Two times would have indicated self defense, but in the jurors' minds the fact that three additional shots were fired indicated malice. Though McGann's defense attorney tried to prove that McGann was controlled by some temporary aberration of the mind, and his brother Peter McGann testified that insanity ran in the family, an insanity plea was not recognized by the jury. Even Long Beach police officer Ralph Alyea's statement that McGann had a good reputation in Long Beach and

McAdams, arrested earlier on bootlegging charges, had a bad one, could not sway the jury. Fred McGann was convicted of manslaughter.

Wilkinson had often remarked how happy most of the people who frequented the Pike seemed. What better place to stop thinking about your problems? Dinner, dancing and maybe a little illicit drinking could make you forget your troubles, and perhaps help heal a relationship. Was that what Thomas Redus was hoping to do on July 26, 1923?

Unaritas Johnson and Thomas Redus had lived together as man and wife for five years. Despite the lack of a ring, they were a committed couple. In January 1923, when Redus came to Long Beach from Texas to work as a rig builder in the local oil fields, he soon sent for 28-year-old Unaritas Johnson and her four children. Much to his dismay his new manager almost immediately sent him on a temporary assignment to Casper, Wyoming. He hated to leave Unaritas behind in a new town, but a job was a job and if he wanted to keep it he needed to listen to his employer.

There hadn't been much for Tom to do in Wyoming, except work, drink and think about his relationship with Unaritas. The more he drank the more convinced he became of Unaritas' infidelities. When he returned to Long Beach in July, fired up on bootlegger's booze, he confronted her. Knowing she couldn't argue with a drunk, Unaritas said nothing. Enraged at her silence Redus beat her, declaring he knew she no longer loved him. As soon as she could, Unaritas and her children fled from the house they shared with Redus. Later Redus found her at her new abode, living with her friend Lucy Hutchins.

Telling Unaritas he was sorry, it was the alcohol that had gotten the best of him, a contrite Thomas Redus told her and Lucy to get dressed. The three of them would go to the Pike for a good time. Unaritas, feeling it would be a "safe" date with Lucy along, agreed. She told her children May, 14; Eunice, 11; Billie, 9; and Raleigh, 7, to go to bed by 9 p.m. She left "Teddy," their little terrier, to guard them, little realizing she was the one who needed guarding.

At the restaurant Redus didn't eat anything, but he took a bottle from his pocket and began drinking. Lucy Hutchins later told police she became frightened when Redus pulled out a handful of cartridges from another pocket and began counting them. There were twenty eight. He asked Lucy if she had seen the cartridges and when she

replied in the affirmative he told her. "I'm going to put every one of them into somebody tonight. I'm going to shot this town up and there isn't a policeman here that will arrest me." She thought he was joking and told him to shut up. He said he didn't care, that he was going to make a target out of somebody before the night was over.

After an uneasy dinner the three walked along the Pike, went into a dance hall, watched the dancers for a while then walked on. Redus, still drinking, got up enough nerve to ask Unaritas why she had moved away. Looking him in the face she told him she was tired of him, his drinking, and his abuse. She was through with him for good.

As Unaritas turned to walk away, Redus took two unsteady steps toward her and drew the gun. He caught Unaritas by the left arm and turned her towards him. He then pulled the trigger. Lucy remembered hearing seven shots and seeing her friend fall. She was too frightened to help. In shock, Lucy wasn't quite sure what happened after that.

According to another witness, Redus, after shooting Unaritas Johnson, walked about ten paces north on Hart Court and opened the door of a large sedan owned by C.J. Harper, owner of the Rose Garden dancing pavilion. Redus sat down in the front seat of the car, reloaded his gun, exited the auto and then ran along Seaside Boulevard. He climbed up the rear fire escape of the Caldwell Apartments to the third floor, halted and shot himself. An ambulance, which had already been called to take Mrs. Johnson to the hospital, stopped long enough to include Redus in the vehicle. Victim and killer were together once again. Unaritas was dead by the time they reached the hospital, Redus lingered for 35 minutes.

This was the second murder to have occurred on the Pike within a two week span. On July 4, 1923, 57-year-old George W. DeTar was killed at his shooting gallery on the Pike at 11 p.m. DeTar was another good friend of Long Beach policeman James Wilkinson. Wilkinson used to stop and talk to DeTar about some of the "hot shots" that used to hang out at DeTar's gallery. Who could tell, some of them might just be perfecting their shooting skills to use in a crime.

DeTar had been away from the gallery for the past four months, caring for his invalid wife, Margaret. He had decided to visit his manager, George Bosley, and settle a few business matters before the couple left for their newly built cabin in Sierra Madre canyon. It seemed DeTar

was standing in the east section of the gallery when a man, believed to be Mexican, walked to the counter and picked up the .22 high powered automatic pistol and pulled the trigger. DeTar, turning around to view the customer, received the bullet in the front base of the neck. Bosley, standing on the other side of the gallery and facing the targets, did not know that DeTar had been killed. The customer, on seeing DeTar fall, fled into the holiday crowd, taking the pistol with him. DeTar died en route to the hospital. Was DeTar deliberately murdered or was he the victim of an accidental discharge of an automatic pistol? Police were searching for an unidentified Mexican who held the death weapon.

This was the third time DeTar had been shot in his gallery. Three years earlier a bullet from a rifle ploughed through his scalp. The second time a drunk fired one of the rifles as DeTar stood at right angles to the targets. The bullet struck a check book in his breast pocket. It saved his life. This time he hadn't been so lucky. The suspected murderer was never apprehended. Perhaps if Wilkinson had still been alive he could have used his old tracking skills learned on the frontier to find the elusive shooter.

Wilkinson wasn't the only police officer Yancy had to give an eulogy for. How could the chief forget Orlando Bridgeman? It had been a tragic accident, one that Yancy would use as an example to all new recruits. Everyone knew you needed to be careful with a loaded gun, but Orlando Bridgeman's death only accentuated the point.

On Wednesday March 21, 1923, the 30-year-old patrol officer was on duty at Locust and Third when his revolver slipped from his holster, fell to the pavement and exploded, sending a bullet into his heart. He had been trying to help motorists Ed Sims, a teller at the Long Beach National Bank, and P.J. Hudson start their car. As Bridgeman stooped down to crank the auto, his Smith and Wesson revolver, carried in a holster on the front of his belt, dropped to the pavement and landed on the hammer. Although the safety was on, police investigation later showed the cartridge in the chamber was fired. The Phoenix, Arizona, native, who had been a member of the Long Beach police department since July 1921, was killed instantly.

Yancy was worried about Bridgeman's family. There was no pension system for Long Beach city employees (finally secured in FY 1926-27). How was Bridgeman's distraught widow Arta going to support

3-year-old Winifred, 6-year-old Orlando, 7-year-old Myrabella, and 10-year-old Eugene? Fellow officers dug to the bottom of the Police Benefit Fund and managed to come up with $500 for the young widow. Hearing of the family's plight others throughout the city contributed to the family's support. Yancy also pulled many strings to make sure the family was able to collect $15,000 from the new state Workmen's Compensation Fund, to help them through the years ahead.

Guns and safety. Yancy tried to get it into his officers' heads that a gun was a dangerous thing, and vigilance in keeping track of it, both on and off duty, was a must. Detective Fred Morrison certainly learned his lesson. Less than three months after Bridgeman's accident, Morrison's loaded pistol, which he left in an open cupboard in a Long Beach apartment while he was helping a neighbor paint, was used by a despondent mother of seven to take her own life.

Sarah Du Puy had stopped by the apartment to ask her friend, Marian Moore, for assistance. The 41-year-old mother had been ill for some time, and needed help taking care of her children aged 3-16. Three of the children had been sent to Sarah's parents back East to keep until she was better. The strain of caring for the other four prompted Sarah to visit Mrs. Moore, a trained nurse, in the hopes that Marian could care for the children until Sarah recovered. When Sarah Du Puy saw Morrison's pistol in the cupboard she saw an end to all her problems. She picked it up and fired four shots, three into her body and one into her brain, the last of which proved fatal.

Guilt. It was eating away at Morrison. He was still trying to deal with "ifs." If his gun hadn't been loaded, if he hadn't put it in such a conspicuous place, would the seven children still have a mother and Frank Du Puy, a wife?

What tragedy. Long Beach had certainly changed since Yancy's arrival in 1912, and those changes had given death a new toe hold in the city. Take the automobile for instance. Yancy recalled that when he started with the Long Beach police department there were few cars and little traffic in Long Beach. Bridgeman's accident wouldn't have happened then. There wouldn't have been a stranded automobilist to stop and help. In checking the city auditor's annual reports Yancy confirmed his suspicions—in 1912 there had only been 127 traffic violations, compared with the 3,108 the department handled in 1923, the year of Bridgeman's unfortunate accident. There also hadn't been

any police cars in 1912. The department did, however, have one motorcycle, purchased in 1909 for $310. Yancy had to chuckle when he remembered that if the police had a drunk, or someone else that they couldn't get to walk to the police station, they wheeled him in a wheelbarrow. If it was too far to do that, they called a taxi. It wasn't until after police officer Tom Borden's murder in 1912 when Clarence Moyer, then chief of police, had to walk to the scene of the crime, that the police department decided they needed to modernize their equipment.

Ah, the Studebaker. What fond memories that piece of machinery brought to Yancy's mind. In September 1912, the police department purchased a Studebaker E-M-F, which everyone knew stood for the Everett-Metzger-Flanders Company, for $1,350. Within one year they had put 4,978 miles on her. In 1914, they bought an additional car and another motorcycle. With two motorcycles the department now had a motorcycle "squad" which logged in 21,598 miles in 1914 alone. The squad appealed to those officers, mostly the young ones, excited by speed. But handling a motorcycle could be dangerous, and a motorcycle was no match against a larger vehicle. Yancy had lost four motorcycle officers in a six year span.

There had only been so many motorcycles to go around, and Alfred Houske, one of the best liked officers in the Long Beach police department, left in July 1924 for a new job with the nearby Seal Beach police department where he was given his own bike. At last he had achieved his dream of becoming a motorcycle officer. That dream did not last long. On October 6, 1924, Houske was riding his motorcycle along Pacific Coast Highway in Naples when he attempted to pass a small truck driven by W.R. Daniel of Lomita. Houske struck the rear of the truck and tumbled to the pavement, breaking his neck. The 24-year-old former LBPD officer died shortly thereafter at Seaside Hospital.

Yancy could only wince when he remembered looking at the body of 27-year-old Robert H. Halstead after Halstead's accident. Halstead, a LBPD motorcycle officer since December 1, 1925, was killed March 6, 1926, when his motorcycle collided with a Newport-Los Angeles Pacific Electric train near Atlantic and Willow. Halstead was at Esther and Atlantic when an ambulance passed him. He immediately tried to catch the ambulance so he could clear a trail for the driver; however,

Halstead had a problem with his motorcycle kick stand staying in place. Some felt if his stand hadn't loosened Halstead would have made it over the train crossing in time. Instead he was hurled 75 feet to his death.

Halstead, a former coxswain in the U.S. Navy had joined the LBPD January 15, 1924, and had recently transferred to the motorcycle patrol. He left behind a wife and 5-year-old daughter, Betty Jane. Coincidently Halstead, like his young daughter, had also been orphaned at age 5 when his father was killed in a building collapse.

Following Halstead's accident Yancy immediately requested that automobiles be purchased to replace the motorcycles. Five motorcycle patrolmen had also been within a hairsbreadth of death—Gus Russell, Ralph Powell, George Rheume and Marshall Erb had all suffered cycling injuries which made them cripples for life. Another motorcycle officer, Clyde Holland, could not join Halstead's funeral procession to Central Memorial Park in Westminster because Holland was in the hospital with a fractured leg suffered in another recent motorcycle accident.

One fortunate benefit of Prohibition was that legal authorities could confiscate cars, boats, trucks, and motorcycles used in the illicit transfer of alcoholic beverages. Though the Long Beach police department added several of these vehicles to their department's motor pool, motorcycle accidents continued, though at a much slower pace. Yancy's constant yammering of "safety," "safety," along with the accidents of fellow officers did get through to most, but not to all.

Long Beach motorcycle officer, 28-year-old George A. Walls, was found dead in the tangled wreckage of his motorcycle early in the morning of November 18, 1928. The five year veteran of the force had apparently crashed into a trailer left alongside East Anaheim Road about one mile east of Long Beach city limits. His body was found by a passing motorist. There had been no witnesses to the accident.

Brooks Gibson and his wife were killed in a motorcycle accident on June 10, 1930. Assigned to the motor squad a few months earlier, the six year police veteran had promised to give his wife Edith an off-duty ride on his police bike the first chance he had. On Anaheim Street near Wilmington, 39-year-old Gibson, with his 35-year-old wife riding behind him, swerved around a car in front of him and immediately crashed into the left rear wheel of another vehicle. Both Brooks and

Edith died shortly thereafter at Seaside Hospital. They left behind three school age children: Bernice, 12; Helen, 9; and Antoinette, 7.

Another officer death that Chief Yancy had to cope with was that of Ralph Morgan. None in the department would ever forget Morgan, the scrawny lad everyone called "the baby," who died in the line of duty. Morgan had been killed in a roaring gun battle the night of July 12, 1931. There was one good thing to have come out of the incident, however: Morgan's partner Harry Bogges, though seriously wounded, survived.

The tragic events began to unwind when Morgan spotted a suspicious looking car at 5th and Almond around 9 p.m. that Sunday night. Suspecting some bootlegging operation, the two officers stopped the car and walked over to talk to its occupants. After Bogges questioned the two men and found they had no driver's registration, he ordered them out of the vehicle. The driver, Wilbur Lilja, looked like he was about to get out, but Lilja's brother Christian opened the car door, drew a weapon and shot the wary Bogges. Morgan, trying to help his partner, was also fired upon and seriously wounded. Immediately the driver jerked the car into gear and was 20 feet down the street before an injured Bogges could muscle up enough stamina to return fire. The wounded Bogges' first bullet killed the driver, Wilbur Lilja, instantly. Christian Lilja leaped from the car as it plunged into the curb. Bogges and Christian Lilja exchanged fire and then Bogges was hit again, a bullet in his chest.

Christian fled, while Bogges staggered to a drug store and telephoned for help, staying conscious long enough to give a description of the fugitive. Meanwhile, residents in the 700 block on East 36th Street heard the two gunshots and called police. A squad was sent to the neighborhood and a search revealed a parked car. Inside was the slumped body of a dying man. Christian Lilja had tried to commit suicide in the car he had stolen ten minutes after the gun battle with Bogges.

Bogges, who would survive the ordeal, had lapsed into a coma by the time Christian Lilja was brought to the hospital. Other officers, however, declared Christian's description matched that given earlier by Bogges of the escaped gunman. Christian Lilja's body bore three wounds, two of them believed to have been self-inflicted and the third,

a minor one, the mark of the officer's gun. The 29-year-old former San Quentin inmate died shortly thereafter.

Ralph A. Morgan died at Seaside Hospital the next day. It had always been his dream to be a policeman but when the time came for him to apply he was distressed to find he didn't meet civil service requirements: he was three-quarters of an inch under height and several pounds under weight. Undersized and underweight, the 23-year-old took up body building and somehow managed to grow three-quarters of an inch. He was finally admitted to the department. Around the station they used to tease him in a friendly way calling him "the baby." Though physically the smallest man on the police force, he was not underweight in heroism, nor undersized in bravery.

At least Morgan could rest in peace knowing that his bride of less than a year wouldn't have to worry about money. In 1926, the City of Long Beach had finally granted pensions to city employees. But like everything else dealing with the city and money, Yancy had to urge the city attorney to rule that wives of dead officers could draw their husband's pension. He did. Blanche Morgan would have a steady income, though she would have liked to have had her husband alive to help her enjoy it.

Politics, Religion and the Ku Klux Klan

Facing death was just one aspect of police work, Yancy told friends and supporters at his retirement party in October 1933. It was easy spotting the bad guys when they held up a grocery store, but it was much harder nailing the ones in power. Yancy explained the sudden transformation he had witnessed in Long Beach with the advent of Prohibition and the discovery of oil. He now saw the city as a battleground between the influences of good and evil. On the "good" side were those who espoused the virtues preached by Long Beach's Reverend George Taubman, who led the largest Bible study group in the nation. Taubman saw himself as a champion of average, old-stock Americans in their battle against the wealthy and corrupt. On the other side were those practicing greed, corruption, and get-rich-quick schemes that led to the corporate chaos that hit the nation in the 1930's.

In Long Beach it seemed a victory for the forces of "good" when on January 16, 1920, America went dry. Since its inception (except for a few years when Long Beach allowed, and heavily taxed, one saloon), liquor had been banned and townsfolk were ecstatic over the new constitutional amendment. The city had long been a hotbed for the Prohibition movement and many in Long Beach active in the amendment's passage. Several of the Prohibition Party's leaders lived here. Eugene Chafin, leader of the Prohibition Party for many years and twice its candidate for the United States presidency, resided at 414 Elm until his death in 1920. Marie Brehm, first woman candidate for vice-president, also called Long Beach home. But there had always been the undercurrent of vice, those that ignored the ban of alcohol in Long Beach, who created innovative ways of hiding, and providing, the intoxicating brew.

In later years historians such as Edward Behr felt the Prohibition movement was in part the result of World War I and the anti-German hysteria that gripped the nation. Another factor was the passage of the income tax amendment in 1913 which meant the federal government no longer had to depend on liquor taxes to fund its operations. As anti-German sentiment rose to a near frenzy with the American entry

into World War I, the Women's Christian Temperance Union and the Anti-Saloon League effectively connected beer and brewers with Germans and treason in the public mind.

Yancy could testify to the anti-German feeling which enveloped America after World War I. When news of the Armistice reached Long Beach in 1918 Yancy and some of his friends "let loose." They rigged up a dummy of the Kaiser, locked him up in the department's patrol wagon, and paraded through the streets. But this proved too tame so they tied a rope around the neck of the Kaiser and dragged the effigy behind the police wagon to the delight of the crowd. Yancy had also seen the work of the American Protective League (APL), a private organization that worked with federal law enforcement agencies in support of the anti-German movement during World War I. Formed by a wealthy Chicago businessman, A.M. Briggs, it had 250,000 dues-paying members in 600 cities throughout the United States, including Long Beach.

Whatever the reason, Long Beach Prohibitionists were overjoyed with the new amendment. Since its inception in 1881, Long Beach had been a temperance town. In every deed there was a clause binding the owner of the land never to sell, permit to be sold, or give away intoxicating liquor. If this contract was violated the land would immediately revert to the original owners, the Long Beach Land and Water Company. The *Los Angeles Times* of June 14, 1885, reported that this contract had been drawn up with great care by Los Angeles County's best lawyers, and it was unlikely that it could ever be successfully evaded. This was quite a moral coup for Long Beach in a nation where alcohol consumption was the norm. It's interesting to note that by 1830 the average American over 15 years of age consumed nearly seven gallons of pure alcohol a year (3 times as much as we drink today) and alcohol abuse, primarily by men, was wreaking havoc on the lives of their families. Women had few legal rights and were utterly dependent on their husbands for support. Thousands of women began to protest and organize for the cause of temperance. Their organization, the Women's Christian Temperance Union (WCTU), became a force to be reckoned with. In Long Beach, the city founders, with avid support from the WCTU, wanted to attract the very best class of people to their community and create an environment where children could grow up without any contaminating influences.

17

With the railroad price wars of the late 1880's, Long Beach's puritanical principles attracted many with similar values. So many Midwesterners flocked here that Long Beach became known as "Iowa by the Sea." Fifty thousand former residents of the Hawkeye state would gather in Long Beach's Bixby Park each summer to renew old friendships and share memories. Former Iowan governor Horace Boies retired here, and former U.S. President Herbert Hoover made frequent visits. The Iowa connection went deep, including the fact that California Governor Frank Merriam was not only from Long Beach, he had been born in Iowa.

It wasn't just Iowans; other Midwesterners flocked to Long Beach. Here they established the values they had learned toiling in the farm fields of the prairie—hard work, Christian ideals and an abhorrence of alcohol and the evils it encouraged. As Jules Tygiel in his book *The Great Los Angeles Swindle* pointed out, Southern California was one of the few large metropolitan areas in the nation in the 1920's not dominated by foreigners. It remained a region in which white, Christian idealism still predominated. Religion was important.

Times changed quickly following World War I. The decade of the 1920's with its idealization of business, get-rich-quick mentality, gangsters, unwise tax policies, and absence of government regulation and responsibility, bred speculation, corruption, and corporate bedlam throughout the nation. It was frightening to many. In Los Angeles, Methodist minister Robert Pierce Shuler led a movement to bring back the "old-time fundamental religion." Born in a log cabin in the Blue Ridge Mountains, Shuler worked with oxen in the fields, wore clothes spun on a spinning wheel by his mother, tramped the railroad looking for jobs, and eventually became a Methodist preacher. Arriving in Los Angeles in the early 1920's Shuler condemned the sinful manifestations of the Jazz Age—music, dancing, movies, and sexual promiscuity. He saw conspiracies lurking everywhere and saw himself as a champion of average, old-stock Americans in their battle against the wealthy and corrupt. His targets also included Blacks, Jews, immigrants and Roman Catholics. He sought to become a crusader, one of God's watchmen, an avenging angel poised to expose and punish the works of the sinful. In 1926, he took his views to the air, over radio station KFEG. With his

hillbilly vernacular, Shuler played to the conservative Midwesterners who had moved to Southern California.

Less vitriolic than Shuler, but every bit as popular, was Long Beach's own preacher, George P. Taubman. Taubman came to Long Beach in 1915 as pastor of the First Christian church. What he found was a congregation of mainly women and children, but he wanted to attract more men. He organized a men's class—a Bible class. At first the attendance was meager, but as he talked about a more "manly" world and the things men of the day had to face in everyday life, his membership grew. By 1923, if you wanted to know where the power in Long Beach resided, all you had to do was look at George Taubman's Sunday Bible class, now billed as the largest men's Bible class anywhere in the world.

In Long Beach, Taubman's Bible group was much more than a class on religion, it was the city's dominating political organization. Behind Reverend Taubman were leaders of the Chamber of Commerce, the Realty Board, the ministerial body, the newspapers, a number of civic organizations, and the men in political offices. One of the foremost writers of Southern California during the 1920's was Louis Adamic, a Slovenian immigrant who worked in the harbor pilot's office at Long Beach. Writing in the *Haldeman-Julius Monthly* in May 1926, Adamic stated that the inner circle of the Bible class ran the city absolutely. You couldn't become a street-sweeper or a policeman unless you belonged to the class or were okayed by someone who was.

Not only was the Bible class important locally, it was nationally prominent. In fact, Taubman issued a challenge to any other city in the country to show a Bible class so well attended and managed. No one came close.

This is how writer Louis Adamic described a meeting he attended:

"We are greeted and hand-shaken by a series of genial, good-fellowship ushers who pass us on from one to another until we are seated. You are made to feel welcome; they want you to feel at home. Once in the seat you are obliged to shake the hands of all men within your reach. And everybody is anxious to know where we came from. 'Where are you from?' is the favorite query in Long Beach; everybody seems to have come from somewhere else. The auditorium is almost full. Attendance is perhaps close to two thousand.

Three-fourths of the heads are either gray or bald. Whiskers abound. Some of them are very, very old. Now George—George the Teacher—and his assistants and backers file onto the platform amid applause from the cornfields. My neighbor, a sturdy old farmer from Wisconsin, tells me who's who and why. Well, there is George himself, the Teacher; next to him is Charlie, the city manager; the bald-headed fellow behind him is 'Gene,' a former mayor; the man with the glasses is Doc So-and-so; the fellow on the end over there is Fred, editor of one of the papers; and so on. The leading citizens of the town are here, and everybody is just plain Charlie, Dick, Sam or Harry. The present governor of California, Friend Richardson, has his summer home in Long Beach, and whenever he lives there he attends the Bible Class every Sunday and usually has something to say.

A trumpeter blows the military assembly call and the show begins. We sing a few peppy hymns and discover that the song-leader whose name is Harry, is a prominent businessman in town. He makes fun of everybody, and now and then takes a good-humored but direct poke at Charlie, the city manager. Patriotic exercises follow. Bugles blare and we recite the pledge of allegiance, the collection is taken, then George delivers his sermon.

He talks about the iniquities of modern youth. What has become of the old-fashioned home? The young people don't respect the old ones as they used to. Is the world going to the dogs? Are bootleggers getting the best of the forces of righteousness and purity? Is a gray, bent head nowadays any less worthy of respect than one was twenty years ago. And so on. He flatters the old boys, and they are human. After the meeting the pier is crowded with men. They stand in groups, large and small, and talk, and chew and talk. They discuss George and his sermon, Prohibition and whether pipe-smoking is more harmful than tobacco-chewing. Such is life in Long Beach." [2]

Preachers such as George Taubman understood the insecurities and anxieties of the Midwestern Protestant refugees who had flocked to Southern California. Taubman recognized that some of the sinful chose to hide behind the façade of religion, but hoped the influence of righteous Christians would change those wayward souls. Retiring from the pulpit September 1, 1939, the dynamic minister, born on the Isle of Man, continued his crusade against the non-Christian values he saw enveloping the world right up until his death on March 12, 1947.

There were other Christian Church ministers, such as the Reverend Leon Myers of the Anaheim Christian Church, who openly used their

men's Bible clubs as a front for the Ku Klux Klan. Many who espoused the tenets of the American Protective League (APL) during World War I were now drawn to the rapidly growing Southern California Ku Klux Klan movement, including Long Beach police chiefs James I. Butterfield and Charles C. Cole. The APL and the Klan shared many of the same values, including "America for Americans," but only if they were white and Protestant. Both were secret societies replete with oaths and rituals.

Though he never openly became a Klan member himself, Taubman's fellow orator Reverend Robert Shuler agreed with the Klan's four fundamental principles: an undying devotion to the United States government and the Constitution; maintaining in America a white supremacy in all things social, political and commercial; a separation of church and state; and the protection of woman's honor and the preservation of the sanctity of the home. In 1922, the Reverend Shuler launched *Bob Shuler's Magazine* which became one of the primary outlets for Klan publicity in California. Shuler's support proved indispensable to Klan recruiting efforts and many in Long Beach joined the movement.

The Klan of the 1920's, John Westcott in his book *Anaheim: a city of dreams* writes, was not as monstrous as the Klan of Reconstruction and many who joined did not see the Klan for its bigoted goals until later. Its message of Americanism, patriotism and fear that Catholics, Jews, Blacks, alcohol, and waves of foreign immigrants posed a threat to the American way of life attracted many. So many, in fact, that by 1922 there were three klaverns in Los Angeles and a Ku Klux Klan marching band, which performed in local parades.

In February 1922, a journalist from the *Daily Telegram* visited a secret Ku Klux Klan meeting in Long Beach. He reported:

"The Ku Klux Klan is opposed to the foreign brand of politics that certain factions would like to inject into our government. It is opposed to foreign control of our finances, and it is fighting the attempted assumption of control of American labor institutions by foreign elements. It intends to combat the attempted destruction of American womanhood by the subtle craft of vice rings and white slave traffickers. The Ku Klux Klan is spreading like wild fire throughout the length and breath of this land, despite the lies, attacks, vilification and slanders of unscrupulous politicians,

money mongers, grafters and others. It is enlisting the real American; it is appealing to the professional man, the business man, the statesman, the college professor, the laboring man, the merchant. We avow the distinction between the races of mankind as the same that has been decreed by the Creator and we shall ever be true in the faithful maintenance of white supremacy and will strenuously oppose any compromise thereof in any and all things. There is nothing secret about the Klan as far as its principles and purposes are concerned, but its membership is secret, and that is one of its greatest secrets." [3]

The ten dollar membership fee in the Klan went towards 'literature that is disseminated among true Americans; it pays the lecturers who are sent out to preach the gospel of Americanism; it pays for offices that are maintained, defrays mailing, freight and express costs, and buys American flags and Bibles." [4]

The *Daily Telegram's* rival, the *Long Beach Press*, also published information about the Ku Klux Klan. In March 1922, it discussed how the Ku Klux Klan was created out of necessity following the Civil War.

"An irresponsible race had been liberated without intelligence enough to know the most fundamental properties. Laws were rendered obsolete and new standards had not been found. As an emergency measure law-abiding citizens banded together in secret and brought peace through the only way the 'lawless ignorant' could understand—violence and intimidation." [5]

The article went on to say that the present order of the Ku Klux Klan had little resemblance to the one of old except for one principal—to maintain order "unselfish, indiscriminate and defensive."

In April 1922, because of Klan violence in nearby Inglewood, Yancy's predecessor Long Beach Police Chief Ben McLendon declared that no member of the Police Department would be permitted membership in the Ku Klux Klan. The bulletin posted by the police chief alleged that newly organized lodges of the Ku Klux Klan were attempting to enroll police officers for the purpose of shielding violence and un-American and unlawful acts. Long Beach's *Special Order No. 17,* as issued by McLendon, read as follows:

"After an investigation of the Ku Klux Klan organization, and considering its general reputation and activity and believing the motives in seeking peace officers as a nucleus of each newly organized lodge is for no purpose other than to shield violence, un-American and unlawful acts and having knowledge that certain officers of this department have been solicited to become members of this order I hereby warn that no Long Beach peace officer shall be or become a member of the Ku Klux Klan and remain a member of the Long Beach police department." [6]

Following this mandate, Motor Officer Clifford M. Woodruff, who refused to give up his membership in the Klan, was suspended indefinitely.

In May 1922, a list of 180 Long Beach city employees who were members of the Ku Klux Klan, including several police officers and firemen, was given to the city manager, Charles Hewes. Hewes said the question of whether municipal employees should be dismissed depended on the nature of the organization and of the oath taken by those who belong to it. If Long Beach police officers and firemen subscribed knowingly to an oath which conflicted with their official oaths, they would be discharged. If other city employees joined the Klan in ignorance of the violence committed by the order and resigned from the Klan, they could retain their municipal employment. But Hewes' edict was not enough to keep the Klan away from Long Beach and out of the city workforce.

On November 3, 1922, the Klan descended in droves on Long Beach. They were here to rally against Democratic candidate for governor, Thomas Lee Woolwine, who was to speak at the Municipal Auditorium. Woolwine was aware that a confrontation was brewing and began his talk by reading a note purported to have been sent out by the Ku Klux Klan. In it the Klan asked all members of the organization to attend Woolwine's meeting. They would all get up and leave whenever the Democratic speaker started speaking against the Klan or on the subject of light wines and beers.

Woolwine, in bitterly sarcastic tones, opened his speech by asking all those who intended to leave to "do it now and get it over with." Not a person in the auditorium stirred, but about three minutes later when Woolwine started attacking the Ku Klux Klan, 500 persons arose throughout the hall and filed out.

Steven M. Mitchell, said to be an officer in the Klan, and James I. Butterfield, a former Long Beach chief of police (Mar. 1920-Nov. 1920), were arrested and charged with conspiring to break up a political gathering. Mitchell and Butterfield denied attending the meeting as members of any organization. Both claimed they did not agree with what the speaker was saying and decided to leave. Others, including another former Long Beach chief of police (1914-1919) Charles Cavender Cole and oil station owner George M. Gibler, were arrested and charged with conspiracy to break up a public gathering.

Butterfield, who was arrested at night without a warrant, filed suit against Chief of Police McLendon. Steve Mitchell, a local salesman, accused McLendon of trying to start a riot. He said the chief came to his house at midnight to arrest him, and took him off to jail. Mitchell was finally allowed to telephone a friend to arrange bail, only later to be told that the police would not accept a check.

McLendon responded, saying it was unfortunate two ex-chiefs of police were among those arrested but, he went on to state, it was also unfortunate they were members of the Ku Klux Klan. He had been told by a Klansman that Butterfield, Mitchell and Cole were all officers of the KKK. In making arrests, McLendon added, it was necessary to choose leaders and men who could be readily identified. It wasn't because they were ex-chiefs that they were arrested, but because they were prominent men in the Klan and because they could be identified without question by witnesses when the case came to trial. McLendon also stated that these men, knowing the law, should have been the last to violate it.

On November 8, 1922, Chief of Police Ben W. McLendon, who had served as chief since January 1921, was suspended by City Manager Hewes pending an investigation into the arrest of Butterfield, Cole and Mitchell, the men who supposedly led the Klan walkout. On November 15th, Hewes reinstated McLendon upon condition that McLendon resign as chief of police. McLendon, who had been a member of the police force since 1912, was demoted to the rank of detective-sergeant. James S. Yancy was appointed the new chief. During the hearing of those arrested at Woolwine's meeting the constitutionality of the law was attacked and the case against Butterfield, Cole and Mitchell was dismissed.

On November 15, 1922, Steve Mitchell, elated over his victory over McLendon, held a well-attended Klan meeting in the Long Beach Municipal Auditorium. The guest speaker was Baptist minister John H. Moore who explained the aims and purposes of the Klan. The Arkansas preacher also discussed the attitude of the organization toward Catholicism, the Negro, the Jew, labor unions, people born in foreign countries and immigration.

Using text from the Bible, Moore attempted to prove a philosophy which reasoned that God had held back the development of America for several centuries as part of a divine plan intended to make the United States the stronghold of Protestantism and prevent the settlement of Catholics in this country. As part of this plan, as seen by Moore, it was the divine desire to have the Anglo-Saxon element dominate. In discussing white supremacy he declared the Klan proposed that the Negro take second place. "No organization ever set up in America is as good a friend to the Negro as the Ku Klux Klan," [7] he stated. The organization, Moore went on, attempted to protect the Negro from labor unions and against efforts to make them Catholic.

It wasn't easy going for the new Long Beach chief of police, James S. Yancy. Upon his appointment he declared he would end dissension and insubordination in the department:

"The police department will no longer be used as a money-making machine to enrich the city treasury at the expense of citizens of this city. I intend to make the department a help instead of a hindrance to the public, especially in the enforcement of traffic laws. The enforcement of the liquor law and of the Wright law will be as rigid as it is possible to make it." [8]

To make Yancy's job even more difficult the 18th Amendment gave no definition of "intoxicating liquors." Most believed beer and light beer would be allowed. Instead the Volstead Act, which set national parameters for enforcing the amendment, defined "intoxicating" as anything more than .05 %. This upset many and eventually home wine making was legalized; for beer, however, the 0.5% limit remained until 1933 when one of the first acts of the new president, Franklin Roosevelt, was to make 0.5% beer permissible.

States were allowed to enact more stringent legislation regarding enforcement of the 18th Amendment. California's "baby Volstead" law was the Wright Act ratified by the legislature on May 7, 1921. Kept in the courts for two years, it was finally enacted at midnight December 22, 1922. It was the law that Yancy had to deal with.

California's bill, named for Assemblyman T.M. Wright of San Jose, made possession or selling of alcohol a misdemeanor for the first offense. For a second offense, however, a Federal charge, with more severe penalties was filed. Under the Volstead Act government authorities could obtain court injunctions to close for up to one year places where liquor was manufactured or sold; this provision known as the "padlock law," was one of the most effective enforcement tools during Prohibition. Bootleggers, those who manufactured, transported, or sold illegal liquor, could be fined up to $1000 and jailed for six months for a first offense, with up to a maximum fine of $10,000 and five years in jail for additional violations. The Wright Act also enabled all municipalities to pass ordinances for enforcement of the Volstead Act and to collect fines for violations. Cases were handled locally in police courts or Superior Court. Federal courts were glad to be rid of the deluge of booze cases and local government was pleased that the fines would go into city or county treasuries.

The Wright Act made the 18th Amendment and the Volstead Act part of the law of California, which prosecuting attorneys, sheriffs, grand juries, magistrates and peace officers were sworn to enforce. It also mandated that if the Volstead Act were amended or repealed, or Congress passed any other law to enforce the 18th Amendment, the new legislation automatically applied to California. It also allowed any city or county to pass Prohibition laws of its own against the manufacture, sale, transportation or possession of intoxicating liquors. The Wright Act wrote into the Constitution of the State of California all the provisions, powers and penalties of the Volstead Act; it also mandated that search warrants had to be obtained in places where liquor was thought to be stored or manufactured. It was not unlawful to have alcohol in one's private home if used for personal consumption; however the burden of proof would be upon the possessor to prove that such liquor was lawfully acquired, possessed, and used. Penalties for a first time offense remained a misdemeanor, with the stipulation that upon conviction the person should be fined not more than $1000 or be

imprisoned for more than one year, or both. Under another provision of the law, not only the intoxicated person causing death or injury to another could be sued for damages, but the person illegally selling to or assisting in obtaining liquor for the intoxicated person could also be held to answer.

In addition to overseeing the enforcement of these new laws, Yancy faced a divided police department—those who supported the Klan position of former Long Beach police chiefs Butterfield and Cole and those who admired demoted ex-chief Ben McLendon and his anti-Klan stance. As if this were not enough, Yancy soon found himself holding a political hot potato when ousted police officer William Joseph Finn came forward with some scandalous accusations against the police department.

Finn had been fired in June 1923 for alleged insubordination, refusing to accept a transfer from the Pike to one in the eastern residential sections of the city. Yancy had been attending a police chiefs' convention in the East and it had been up to his second in command Captain Claude Robberson, chief of detectives, to handle the matter. In August, Finn came forward claiming many police officers drank and protected bootleggers. He charged that a house of ill-repute was being operated with the knowledge of the police. He alleged that Long Beach Mayor Charles A. Buffum, Councilman Alexander Beck, Chief Yancy and others in the city administration were aware of the facts but chose to ignore them. Confiscated liquor, he charged, was distributed to favorites from police headquarters. Finn also maintained he was ordered by his police captain not to arrest any bootleggers or dope addicts, although, he charged, selling drugs on the Pike was rampant. Finn asserted he had received promises two months earlier that all these charges would be brought formally before the city council. No action was ever taken and Finn found himself without a job. Though Jack Yancy denounced Finn's charges as "so ridiculous they do not merit serious attention," he did order a sweeping investigation of charges of police corruption.

One of the casualties in all of this was Detective Sergeant Ben W. McLendon, once Long Beach chief of police, now assigned only desk duties at the police station. The city council had recently created an ordinance which allowed them to dismiss city employees without a hearing, if two-thirds of the council were in favor of dismissal. This

ordinance proved McLendon's undoing. The city council all agreed that Ben McLendon had to go. McLendon was accused of creating dissension in the department and fired on August 7, 1923.

Technically, Yancy requested McLendon's removal on the grounds of insubordination, breeding strife, and absence from the city without leave. There were "hints" of other charges, similar to those alleged by Finn. McLendon claimed he was innocent of all charges and that "all the bootleggers, and thieves and disreputable men are my enemies." McLendon realized he had been made a scapegoat for the misdeeds of many. He went on to obtain a law degree and ran unsuccessfully for the Long Beach City Council. The North Carolina native died April 4, 1955, at the age of 70 in Long Beach.

Cleaning House

Police department troubles continued to haunt the new police chief, James Yancy. On October 11, 1923, fourteen-year-old Velma Chambers and seventeen-year-old Clara Shipp alleged that ever since they were arrested and jailed on September 28th as "incorrigibles," Long Beach police officers would take them from their cell at night, drive them around, encourage them to participate in drinking bouts and sex, and keep them out until early morning hours. One of those arrested was Frank G. Henderson, head of the Long Beach police purity squad. The others included George M. Sheffield, Otto Faulkner, Asa Randall Cone, Charles E. Guthro, E.R. Crabtree, Chauncy H. Liston, and George T. Brown. All the officers accused of contributing to the delinquency of a minor resigned or were fired. The misdemeanor offence against these former Long Beach policemen was later dismissed on the grounds of insufficient evidence.

Within a few weeks of the latest police scandal Yancy added seven new men to the Long Beach police department's reorganized liquor squad. The identity of the new officers was kept secret, but Chief Yancy declared every member of the squad was hired because of good reports on their performance as a police officer, sheriff, deputy sheriff or ranger in other states. They were given one objective: to stop at nothing to round up liquor sellers. On their first day of service the new officers arrested ten alleged bootleggers and liquor buyers on the Pike and confiscated more than 100 pints of illegal liquor.

The new police hires continued their liquor raids in earnest. Their identities were hard to conceal as the press touted their no holds barred actions against the liquor trade. Action was swift under Yancy's new command. On November 4, 1923, Jenaro Lanares, an alleged bootlegger was shot to death by Long Beach police. Undercover officers visited the Lanares home at 350 W. State Street and succeeded in buying a quantity of moonshine whisky. They arrested Lanares after searching the premises and discovering a large stock of illegal alcohol beneath the living room, concealed by a false door. Lanares reportedly picked up a butcher knife and attacked Officer Claude C. Lewis. Lewis fell backward and Lanares jumped on top of him. The pair struggled for possession of the knife. Lewis managed to get hold of his revolver

and fired at 42-year-old Lanares, killing him. In the meantime Officer Romero was struggling with Lanares' 19-year-old son, Jesus, who was later arrested on a charge of assault with a deadly weapon.

Despite Yancy's attempts to clean up the city, not all were happy with how he was doing it. Perhaps Long Beach was trying too hard to sanitize its tarnished image, Police Judge Carl V. Hawkins told the *Los Angeles Times* January 29, 1924. Hawkins asserted that while the illegal liquor squad was given all the equipment and men it needed to suppress bootlegging operations, burglaries and hold-ups in Long Beach had become rampant because of lack of staff:

"Burglars and highwaymen have been given free rein. They virtually are invited to come in and steal the city. Criminals are learning that Long Beach is a joke so far as police authority is concerned and they are acting accordingly. The police department is in the worst condition in its history. The detective bureau has no means of capturing criminals because of a virtual lack of facilities, all resources going to curbing illegal liquor operations." [9]

Long Beach City Manager Charles Windham and Police Chief Yancy vehemently denied Judge Hawkins' allegations and charged that Hawkins' statements were nothing less than a bald invitation to criminals to come to Long Beach. Windham and Yancy did, however, appoint an independent committee to study Hawkins' accusations. The committee found it was the same story in Long Beach as elsewhere. There wasn't enough money to effectively enforce Prohibition. The Federal government wanted the States to fund enforcement; the States wanted the Feds and local governments to foot the bill. In one year alone $698,855 was the total amount allocated nationwide to police the new amendment. This was 1/8[th] less than the amount of money allocated to enforce fish and game regulations. Only 1500 Prohibition agents had been hired by the federal government to make sure the new law worked, this meant there was one federal agent for every 70,666 people—an impossible task. Long Beach, however, with its long anti liquor stance, was willing to allocate some of its own limited resources towards wiping out the scourge of alcohol. But there was only so much

money in the police budget. Would it go towards stopping bootleggers or burglars? How could Yancy please everyone?

Klan activities also continued to haunt Chief Yancy. On June 21, 1924, 7,500 citizens gathered in Recreation Park to witness 700 candidates join the local Ku Klux Klavern. According to the secretary who recorded the new members, the Long Beach Klan would now have more than 10,000 members. With a 40,000 candle power searchlight sweeping the skies, and a battery of huge lights playing upon the east slope of the golf course, the Klavern staged its first public open air initiation. High above the park, suspended from a balloon, hung a cross with the letters KKK etched upon it. A voice boomed out of the crowd toward the sky:

"God give us men, men who will stand up for the right, for the betterment of America . . . Wrong rules the land . . . Winking justice sleeps . . . God give us men."[10]

In answer to this appeal, hooded, white robed initiates marched twelve abreast through the park towards the podium to take their oath. Most of the 700 were in their 20's and early 30's, but there were also a few who looked as old as 50. Nearly half were Long Beach residents, a quarter from Los Angeles, while the rest were from Santa Ana, Anaheim, Bellflower, San Pedro, Southgate and other local communities. The Rev. J. H. Bronson then spoke. He declared:

"The Knights of the Ku Klux Klan are outnumbered in California today by a political majority of 139,000 persons. The time is not far away when this majority will be wiped out and when another will exist, for the Knights of the Ku Klux Klan will have in their hands the weapon that rules the Nation, the greatest weapon ever given to man, not the torch, not the sword, not the machine gun, but the ballot."[11]

The Klan was true to their word—they were getting into local politics. In 1924, the Klan secretly selected and sponsored a number of candidates for public office throughout California. In Anaheim, four Klansmen were elected to the Board of Trustees. After they

were elected the klavern's presence in Anaheim city government was quickly evident. The letters KIGY—for Klansman I Greet You—were painted on major streets entering Anaheim to assure visiting KKK members they were on friendly ground. Since there were few minorities living in Anaheim at that time, the Klan was limited to opposing Catholicism and bootlegging, both of which were plentiful in Anaheim. Anaheim citizens were not happy at the direction their city had taken. In February 1925, 95% of Anaheim's registered voters turned out for a recall election, which was guarded by city police, sheriff's deputies and district attorney inspectors. The Klan suffered a resounding defeat with each councilman losing by more than 500 votes. At the same time, the Klan's attempt to recall the lone anti-Klan councilman failed.

Just how far did the Klan infiltrate politics and the police department in Long Beach? In November 1924, three African American youths told a tale of torture staged by four members of the Long Beach police department. Seventeen year-old Sam Haynes, his 18-year-old brother Henry and friend George Rice, 18, told how they had been accused of car theft by the police. Taken from the Long Beach jail by two officers dressed in Klan robes, and two in regular police uniforms, the boys were strung up by their necks in a tree in the remote Willows area of the city. Despite intensive grilling the boys did not confess. They were later taken back to the Long Beach jail where they received medical attention for their injuries. Later the Klan claimed they were not involved in this incident and offered a $500 reward if it could be shown that the perpetrators of the crime were Klansmen.

It's difficult to name names of prominent Long Beach Klan members since membership was a closely guarded secret. Former Chicago dentist Oscar Hauge, for instance, elected Long Beach mayor in 1927, never had any publicly revealed Klan connections, yet his KKK badge with his name etched on it lies in the vault of Long Beach Public Library's Long Beach Collection. Born on a Minnesota farm in 1869, Hauge came to Long Beach in 1913 and served as mayor until 1930. In 1935, when Long Beach's Frank Merriam became governor, Hauge was appointed Assistant State Director of Finance. In 1938, Merriam selected him to fill a vacant Los Angeles County supervisor position, a post Hauge held from 1938-1944. One has to wonder if Governor Merriam also had

ties to the Klan and how deeply the Klan actually penetrated California and Long Beach politics.

The Klan continued to hold open rallies in Long Beach. On October 3, 1926, they gathered to celebrate the new charter granted to the California Klan by the national headquarters in Atlanta, Georgia, and the opening of a new $200,000 Klan clubhouse in San Pedro. Members gathered in Bixby Park, clothed in white robes, bearing fiery red crosses and American flags. Gazing up they saw an airplane with the letters KKK inscribed underneath in huge lights. 30,000 Klansmen paraded down Ocean Boulevard with the women's drill team, floats and color guards. Five thousand of the Klansmen were from Long Beach, according to local reports. This is amazing when one considers that with a then population of 140,000 this meant that one of every 28 residents of Long Beach marched in the KKK parade that day!

The procession reached Cedar and Ocean and then returned to Bixby Park where Dr. J.H. Bronson delivered an address on "Americanism." In his speech Dr. Bronson paid a glowing tribute to Long Beach which he characterized as "the first city in the West to extend a kindly and American invitation to this organization. Tonight is the first rallying cry of the Klan in California," [12] he said, and added that the Klan was intolerant of any man who disobeyed the law, failed to uphold the Constitution, of immigrants determined not to obey the laws and adopt American customs, men who desecrated womanhood, and those who tried to establish societies for atheism in the public schools.

The Klan was not the only problem facing Jack Yancy. On paper it appeared that Long Beach authorities were strictly adhering to the Volstead Act, but reality was another matter. Raids were staged at random times to give the appearance of propriety. But bootlegging was very much in evidence on the streets of Long Beach the *Los Angeles Times* reported September 6, 1926. So blatant was the activity, *Times* reporters wrote, that bootleggers openly delivered a quantity of liquor across the street from the police department.

The Los Angeles County district attorney had a Bureau of Investigation, whose duties were to enforce liquor laws, raid gambling joints and curtail prostitutes. They were known as the "Booze Squad." Often they encroached on other law enforcement agencies, giving no hint to local police that they were about to stage their own raid. Such

was the case on September 4, 1926, when county agents stormed an alleged gambling den at 127 East First Street in Long Beach.

This raid placed Yancy in a difficult position. He had been instructed by City Manager Charles S. Henderson several days earlier to raid the place and put an end to the alleged gambling there. Yancy said it was impossible to make arrests until officers had secured enough evidence to convict those taken into custody. The fact that county officers did not find it impossible to raid the site and make arrests aroused the ire of Long Beach Mayor Fillmore Condit, who said he was surprised to find that the district attorney's men had been able to do what Chief Yancy had assured him could not be done.

The raid by county officers marked the breaking of a truce between Long Beach city officials and the district attorney's office in Los Angeles. A series of raids conducted earlier in the year had raised the ire of Long Beach City Manager Henderson, who protested to Los Angeles County District Attorney Asa Keyes that the Long Beach police department was capable of policing the city and enforcing laws within its own boundaries without outside interference. The current raid, Keyes replied, was the result of a flood of complaints from Long Beach citizens to the district attorney, all declaring the alleged gambling place was running without apparent hindrance.

City Manager Henderson angrily responded that outside interests were anxious to make it appear that Long Beach was a city where vice ran rampant. Henderson added that Chief Yancy had done an exemplary job in clearing up the chaotic condition the department had been in a few years earlier. Henderson felt District Attorney Keyes was using Long Beach as a blind to take attention away from what was happening in the City of Los Angeles. Henderson's charges would be validated in 1929 when Asa Keyes was imprisoned for bribery and other crimes.

In response to the allegations, Yancy responded that his hands were tied because of the existing law. The problem with gambling in Long Beach, Yancy stated, was that many gambling establishments permitted customers to play with so called "trade checks" which were redeemable for merchandise by the winners. If, perchance, you were ahead when you quit, you were paid off in products such as cartons of cigarettes, which you could take down the street to someone's store and convert to cash at a horrendous discount. Yancy vowed an all-out war on gamblers once a new ordinance was passed outlawing the use of these "trade checks."

His wish was soon granted and twenty eight gambling establishments, including pool rooms and cigar stores, were soon out of business.

But many in Long Beach were not happy with the way city government was running. In 1927, a new city council, mayor and city manager were elected to office. Though many wanted Yancy fired, City Manager Henry Callahan, who was solely responsible for dismissing and appointing the chief of police, declared that he would not replace Chief Yancy. He believed Yancy's administration of the police department had been an honest one and vowed there would be no change as long as he was city manager. He was sure that Yancy would reorganize the police department, making changes in personnel, particularly heads of certain sections, to alleviate some of the discord evident in the organization. Callahan went on:

"I am told that the office of Chief of Police is worth $100,000 a year to a man willing to make dishonest use of his powers. What I want in the police department is honesty and when you have a man who has proven himself to be honest, why change and take a chance on getting one who is not?" [13]

Yancy continued to do the best he could. On August 18, 1927, the *Press Telegram* reported that in addition to 200 quarts of fine liquor a "Booze Who's Who Bluebook of Long Beach" had been confiscated during a raid on the home of Mr. and Mrs. Chelsea A. Hubbard of 556 Nebraska Avenue. They pointed out the book revealed the names of persons high in the financial, legal and business world of the city. Also included in the list were the names of prominent society matrons. It was estimated that approximately 300 names of important residents were obtained from the book, with scores of names of less prominent people neatly arranged in alphabetical order.

To save his important clients, Hubbard pleaded guilty to charges of possession and selling liquor. Had he 'stood pat' on the charges and demanded a trial, police would have been forced to expose in court the names of many of the city's leading bankers, lawyers, merchants, society women and ex-chiefs of police, whose names appeared in Hubbard's book of "Who's Who." Hubbard's guilty plea allowed sleep to come once again to weary, wakeful, liquor drinking Long Beach folks.

But Yancy was not done. On September 22, 1927, the reorganized City Vice Squad received a tip about a supposedly leaky gas meter at a

duplex at 4313-4315 East Colorado Street. Securing a search warrant the officers entered the east half of the residence and found two barrels of whiskey, two five-gallon bottles of whiskey, several cases containing pints of whiskey, two cases of High and Dry Gin, and much more. In the kitchen there was a two hundred gallon still running full blast, and in the garages under the rear of the house, which was built on the side of a ravine, police found six large vats of whiskey mash containing some six thousand gallons of mash which would have made seven hundred twenty-five gallons of alcohol or fifteen hundred gallons of finished whiskey and gin. An officer cut the wooden vats, containing the mash, to pieces and ran the contents down into the ravine amid the cheers and, perhaps, sighs of the nearby residents who had gathered to witness the raid. Within six days ten men were taken into custody for ownership and operation of the still.

It didn't help Yancy that many felt Prohibition was an immoral law. Former Seattle police lieutenant Roy Olmstead, for instance, had no qualms about becoming a bootlegger. He earned more in one week than he would have in 20 years as a policeman. He bought local officials and the entire Seattle police force, setting up a pay scale for various officers based on their rank. Called "the good bootlegger" he made sure no firearms or violence broke out in Seattle.

The Great Depression, Communism & A New Deal

As the 1920's neared an end, many were convinced that prosperous times would go on forever. On September 3, 1929, stock prices reached their highest level yet, but a slow decline began. On October 24th, an abrupt dip led bankers to attempt stemming the tide. On October 29th, Black Tuesday, a record 16,410,030 shares were traded as huge blocks of stock were dumped for whatever they would bring. By December 1st, stocks on the New York Stock Exchange had dropped in value by $26,000,000,000. The day after the crash President Herbert Hoover assured the public that the business of the country was on a sound and prosperous basis. In actuality, the Great Depression of the 1930's had begun.

Despite the stock market crash of 1929, Long Beach continued to grow throughout most of 1930. The Ford Motor factory opened, ground was broken for the Procter & Gamble soap plant, a new wharf to allow bigger cargo ships access to the harbor was completed, and a $100,000 water plant was put into service. Residential districts such as Bixby Knolls started selling new homes, and two new schools, Lindbergh and Naples, were opened to meet the educational needs of the many families moving to Long Beach. However, throughout all of this seemingly happy time, one could read the undercurrents. Yancy and the police department were dealing with more suicides, most the result of financial troubles, and the city's anticipated oil revenues were not meeting the projected amount budgeted for numerous city projects.

Long Beach did have oil, new industries, and a seemingly bright future, but it could not deal with all of the displaced workers from other areas of the country seeking employment in Long Beach. Unemployment was becoming a problem. In an attempt to remedy the situation, the American Legion asked that only American citizens be employed by business firms. Going a bit further, the Long Beach City Council passed an ordinance mandating that only residents of the city

could be hired to build the new municipal auditorium. It was up to Yancy and his crew to enforce these laws.

By late November 1930, the veneer that everything was okay began to crumble. Long Beach churches were asked to open their doors and give homeless men a night's lodging. Nearby Fort MacArthur furnished 100 cots and bedding for the itinerant men who had come to seemingly prosperous Long Beach looking for work. Business sales were sagging. Soon people began killing themselves. One little ditty published in the *Los Angeles Times* of December 13, 1929, summed up the situation:

"The cheerful multimillionaires may gamble with the bulls and bears and think the pastime grand,
 And if they lose some goodly rolls it does not lacerate their souls—they've plenty more on hand.
 They lose large bundles in the day and then at night they hit the hay and bask in dreamless sleep
 What does it matter if they blow a half a million bucks or so, there is no cause to weep.
 But one who has a meager pile can't view with a disdainful smile the market's turns and twists;
 He sees his little package slide, and all that's left is suicide." [14]

Yes, suicide seemed the only way out for many. Some took their own lives in a dramatic way: 30-year-old Ruth Van Boxtall jumped from the 13th floor of the Security Trust and Savings Bank Building on February 13, 1932; an elderly "John Doe" blew his brains out with a home made cannon fired from a paving brick in Lincoln Park on October 9, 1932. But perhaps the most bizarre death was that of Marie Norton who staged her own suicide party.

At 4 a.m. on the morning of July 29, 1932, five Long Beach residents were summoned by Marie Alvina Norton, supposed wife of a heavyweight prize fighter. Telling them she didn't feel well and that she needed cheering up, they agreed to pay her a visit. The friends dressed and went to 233 East Twenty-fifth Street and stayed about an hour. As they were saying their good-byes, Mrs. Norton stood in the dining room and fired the fatal shot through her head. Following Marie's suicide, her body was claimed by two men, each of whom said he was her husband.

Bank robberies were also becoming everyday occurrences during the dark days of the Depression. To help combat this problem, David G. Earl of Long Beach developed a bandit proof teller's window. To the customer it appeared as if the teller was standing squarely in front of him, behind the barred windows. Actually, the customer was looking at the reflected image of the teller. The mirror was so ingeniously placed that no one could detect it. The teller would actually be standing to one side, protected by walls of bullet-proof steel. If the customer was a bandit and shot at the teller, the bullet would only shatter the mirror. Meanwhile, the teller could pick up a revolver and with one movement open an aperture in the window and fire.

Earl, who also invented an interlocking door to solve the problem of the bandit who catches the bank official when he first enters the building in the morning, became an international celebrity. *The London Illustrated News, Popular Mechanics, Popular Science, Modern Mechanics* and *American Banker* all applauded his ingenuity. Universal News Reel System filmed his devices and showed the news reel in over 90,000 theaters worldwide.

In the depths of the Depression, people began to look to other political philosophies as a solution to their economic problems. One possible remedy was Communism. It was another thorn Yancy had to deal with.

The Communist Party in America had its beginnings in Chicago in 1919 when a schism split the Socialist party, then headed by Eugene Debs. With the death of Lenin in 1924 and the emergence of Joseph Stalin, the American party changed. They sought to combat the traditional unions of the American labor movement by creating rival organizations. They felt all other parties had to be opposed, and eventually liquidated, in order to prepare the Communist Party of the United States to assume its historically prescribed duty of taking over upon the collapse of capitalism, which Stalin had declared to be at hand when speaking at the Sixth World Congress in Moscow in 1928.

On January 15, 1932, Yancy's men arrested seventy-five people at an alleged Communist gathering at 532 Pine Avenue in Long Beach. The Criminal Syndicalism Act, enacted to prevent the overthrow of the U.S. government by "bloody" revolution, provided Chief Yancy the legal authority needed to make the arrests. While city and federal

authorities prepared to press deportation charges against eighteen of those arrested, telegrams from alleged workers' organizations throughout the state were sent to the governor's office in Sacramento protesting the arrests. Governor Rolph declined to interfere, stating it was a matter for local and federal authorities.

In February, forty-five of those arrested the previous month were brought to trial, accused of holding an unlawful assembly. The Long Beach city prosecutor pointed out the Communists' trial had an interesting contradictory philosophy. They demanded the protection of the Constitution, yet they would destroy it. Following their conviction a series of newspaper articles detailing Communist activities in Long Beach followed.

The March 29, 1932, *Press Telegram* article described how steps were taken to make Communist meeting places secret until the last possible moment. These locations were called "clearing houses," and there were at least four in Long Beach. Six Communist branches were operating in the city: the Young Communists League, the Young Pioneers, the Young Octoberists, the Trade Union Unity League, the International Labor Defense and the Unemployed Councils. Alarming to readers was the fact that the young were the targets of many of these groups. The Young Communists ranged from 16 to 21 years of age; the Young Pioneers from 12 to16 years old; the Young Octoberist section was comprised of children under 12.

The *Press Telegram,* on March 31, 1932, told how the Long Beach police were alerted to the first Young Communist League meetings in June 1930. Held at members' homes, the youth were lured to a picnic trip to Mount Baldy where they were made aware of the true purpose of the organization. They were introduced to the "Ten Commandments" of the group, which included: A Young Communist must be an agitator whenever he met young workers, especially in trade unions, the armed forces or sports organizations. He must report any information he gained from these groups to a higher authority in the Young Communist League. In case of arrest a member could not give any testimony to the police which could be used against other comrades.

There was also evidence the Trade Union Unity League was active in the city. The purpose of this group was to join labor unions and eventually take control, and to organize strikes and develop dissatisfaction with

working conditions among employees. In the final article on April 2, 1932, the *Press Telegram* stated that Communists were active in Long Beach, operating stealthily and under cover in many instances; in others quite boldly. It was the purpose of the series of articles, the newspaper said, to set forth the activities of the organization in Long Beach in a "frank, but unprejudiced manner."

These articles terrified readers. They so inflamed the public that reputed Communist James Lacey was kidnapped from the steps of Long Beach City Hall on April 24, 1932, taken to a remote spot on Signal Hill, and then tarred and feathered.

Lacey had been arrested on April 22nd during an open forum in the council room at City Hall. His outbursts led to his arrest on suspicion of violating the Criminal Syndication Act. When he was released, the kidnappers were waiting for him.

When word of Lacey's abduction reached the American Civil Liberties Union they were outraged. They called the kidnapping, tarring and feathering one of the most outrageous occurrences to have taken place in Southern California in recent years. The fact that the abduction took place at the very door of the police station and no officer of the law came in response to his cries for help, led the ACLU to claim that Chief Yancy and the police were in cahoots with the kidnappers.

A communication signed by "The Invisible Eye" was received at the *Press Telegram* and printed in the April 28th edition. It contained an emphatic denial of rumors of police complicity in the Lacey incident. "We wish to state at this time, for the benefit of these Communists, that there is an army of true Americans here in Long Beach who loves our Constitution and our country."

Though there were no arrests in the Lacey kidnapping, there were suspicions the Ku Klux Klan was behind it. In November 1932, the KKK took further action against suspected Communist David Milder of 2347 East Third Street. They planted a flaming cross on his front lawn and then beat the alleged Communist occupants of the house with fists and clubs. The mob was about to drive away with the victims, perhaps to tar and feather, when police arrived and stopped them. Though alleged members of the raiding party said they had been promised police would not interfere with their movements, the police loaded fifteen of the suspects into a patrol wagon and took them to headquarters.

Long Beach City Manager Edward S. Dobbin demanded a complete investigation of the affair. In February 1933, the fifteen KKK suspects and their alleged victims appeared before a jury. Clarence H. Brooks, Samuel J. Sampson, Owen J. Stearns, Ernest A. Buttram, James Henry Russell, Dale H. Elliott, A. P. Tyler, Audrey L. Jenks, Homer D. Turner, Charles H. Clark, Clyde D. Dunn, Walter R. Brooks, Earl Amos, John Lindberg and Waldo King were convicted of conspiracy to commit an assault with deadly weapons. They were sentenced to six months in county jail and fined $250 each.

Things looked bleak during these Depression years. Was Communism truly the way to go? A new President of the United States offered other solutions, and hope.

Nineteen hundred thirty-three was a year that Long Beach Police Chief Jack Yancy would never forget. On March 4, 1933, a huge crowd gathered around radios on Pine Avenue to listen to the inauguration of a new president, Franklin Delano Roosevelt. This new invention, the radio, brought the ceremonies in Washington to life. To many, it felt as if they were actually witnessing the event, listening to the music, the cheers, the vows taken and the inaugural address itself. Some thought it was actually better than being there, for how else could you get a firsthand, detailed report of things as they happened? It was definitely preferable to being part of the crowding, milling mass in Washington, D.C.

Roosevelt was quick to act to get the country on its feet again. On March 6, 1933, in order to keep the banking system of the country from collapsing, FDR used the powers given by the Trading With the Enemy Act of 1917 and suspended all transactions in the Federal Reserve and other banks and financial institutions. On March 9th, Congress met in a special session and passed the Emergency Banking Relief Act. This gave the president the power to reorganize all insolvent banks and provided the means by which sound banks could reopen their doors without long delay. As Roosevelt was "shaking up" the financial community, Long Beach experienced a "shaking up" of its own.

At 5:54 p.m. on the evening of March 10, 1933, the ground around Long Beach shook for 11 seemingly never ending seconds. The killer force quake, measuring 6.3 on the Richter scale, killed 51 people in Long Beach and an additional 91 in surrounding areas.

Only a few months later on June 2, 1933, disaster struck again when an explosion at the Richfield Oil Company at Twenty-Seventh Street and Lime killed nine men and injured thirty-five.

Despite the bad economic times, the earthquake and oil fire, there was one bright light at the end of the tunnel—the 21st Amendment, ending Prohibition. On December 5, 1933, the 18th Amendment, which had started out with good intentions, was repealed. Liquor was once more legal in the United States. But James S. Yancy would not celebrate the occasion as Long Beach chief of police.

Yancy's honesty and integrity were recognized by his fellow police officers when he was chosen president of the California Peace Officers' Association in September 1930. He later served as vice-president of the Los Angeles County Peace Officers' Association. But all his accomplishments were for naught when a new city administration took over the helm of Long Beach government. Yancy was removed from office on October 16, 1933, by new city manager James H. Bonner and Yancy's secretary, 41-year-old Joseph H. McClelland, appointed in his stead. Yancy's son Robert told Todd Houser of the Long Beach Police Historical Society that the new city council wanted to allow gambling in the city and Yancy objected. Yancy opted for retirement when ordered to relinquish his position, but his removal from office upset many.

Yancy also had the distinction of being the longest serving police chief in California history (Nov. 1922-Oct. 1933). After serving as a police officer in Long Beach for nearly 21 years and as head of the department for approximately 11 years, James "Jack" S. Yancy continued to enjoy retired life until 1965 when he suffered a heart attack at the age of 84. When he started as a patrolman in 1912 Long Beach was only beginning to develop into a major city. The population of the town was about 18,000, and there were only 23 men on the police force. At the time of Yancy's retirement the department had nearly 200 members, whose job was to protect the life and property of approximately 145,000 inhabitants.

Yancy's reputation was vindicated. In January 1934, a petition was filed to recall all nine members of the city council, the city manager and the city attorney. Failure to prosecute the oil companies, who were alleged to owe the city large sums of money on royalties, was given as

the major reason for the recall. Other charges cited were: incompetence, mismanagement, misuse of public funds, carelessness and a disregard for the rights of the citizens of Long Beach. On July 10th, voters ousted all city council members and the city attorney. Yancy was asked to return as chief of police, but declined. He liked retirement. He was tired, having dealt with most of the bootlegging and murder cases you are about to read about.

ALCOHOL MADNESS

"What marriage is to morality, a properly conducted licensed liquor traffic is to sobriety. In fact, the more things are forbidden, the more popular they become."

Mark Twain's *Notebook*, 1895

Evils of Alcohol

On February 16, 1903, the Long Beach building known as the Tabernacle was packed when anti-liquor advocate Carry Nation spoke to the gathered hoard. Many came simply out of interest in the woman, whose name was a household word throughout America. Almost everyone knew the little ditty:

> Carry Nation struck the town
> She brought her little hatchet
> Bottled Booze slunk out of sight
> Afraid she would smash it.

Though many newspapers labeled Nation and her crusade against alcohol "mad," most of those who heard her speak in Long Beach that evening were quickly convinced that she was as sane as anyone in the Tabernacle that night.

Miss Nation spoke about her work and how she was "led" to smash any saloon she happened upon. She said God told her what to do, and if anyone didn't like her methods they would need to find fault with God, for she was going to continue destroying the works of the devil that "used" people when they drank demon rum. She blamed the government for allowing the evil rum to exist, fortifying her position by reading copious extracts from the scriptures. She felt that government should be simple and that the least governed people were the best governed. She stated that none of the parties in American politics could be trusted in their efforts to suppress liquor, for they were all under control of powerful whiskey interests.

Carry Nation's description of her prison experiences in Kansas and how those tied to liquor interests tried to drive her insane, brought tears to the eyes of many. All this was done, she claimed, to make her and her fight against the liquor traffic look crazy. She told how prison officials brought a howling maniac and placed him in a cell adjoining her own in hopes that his ravings would also drive her mad. She recounted the tale about how four young men were brought to the cell opposite her own and given cigarettes and tobacco to smoke to poison the air she had to breathe. She said the treatment the jail officials inflicted upon

her would certainly have driven her insane if she had not been upheld by the power of God, whose agent she was.

At the conclusion of her speech, Miss Nation was surrounded by a multitude of fans anxious to obtain photos and souvenirs in the shape of hatchets. These quickly sold out and the money made went towards furthering the cause of temperance across the United States.

Was Carry Nation insane, as some thought? There was a streak of insanity in her family. Her own mother, committed to a psychiatric hospital in old age, believed she was Queen Victoria, and even had Carry's father husband build her a gilded royal carriage, from which she airily waved a white-gloved hand at slaves on her husband's near-bankrupt Kentucky plantation. Carry Moore, rejected by her eccentric mother, spent most of her time with slaves. She became a firm believer in slave folklore, especially when it came to clairvoyance and ghosts. Her first vision—of her grandmother—came at the age of eight. In her own autobiography *The Use and Need of the Life of Carry Nation,* Carry said she frequently conversed with Jesus Christ and claimed her powers as a rainmaker had ended many a drought.

The Civil War ruined the Moore family, turning them into wandering refugees. Eventually they settled near Kansas City where Carry fell in love with a young doctor, Charles Gloyd, who married her in 1867 after a whirlwind courtship. Gloyd, she found out only on her wedding day, was an alcoholic. After the birth of a handicapped daughter, the couple separated and Gloyd died shortly thereafter.

It was this first husband who fired her rage against liquor. Despite her unfortunate marital experience she married again, this time to David Nation. Kansas, where the family settled, was a dry state, but the local law was a joke. The Women's Christian Temperance Union, of which Carry was a leader, crusaded against those in violation of the law. Emulating her heroine, Joan of Arc, she claimed to have received a divine message from Jesus, whom she talked to regularly, and who now commanded her to act. The whirlwind war was soon to follow. Loading up a buggy with hammers and rocks, she stormed saloons in Kansas in a sudden hit-and-run raid. Local authorities were in a quandary: though she was inflicting huge losses on saloon keepers, the saloons were illegal. Consequently, she seldom spent more than one night in jail.

Kansas was soon too small for her. She began to show up, without warning, all over America, wrecking saloons. When she condemned assassinated President McKinley for his stance on alcohol, the WCTU, which had formerly supported her, decided to distance themselves from the increasingly irrational Carry. In the end, when her money ran out, and the media finally lost interest in her, she no longer destroyed real saloons but reenacted her raids on stage, reciting her poems and spouting her rage. She was to die in 1911, at the age of 65, in a mental institution, eight years after rallying crowds in Long Beach to her cause.

Everyone in Long Beach knew about the evils of alcohol, tales of drunkenness and crime were avidly reported in newspapers. Sometimes these stories were close to home, as readers of the *Evening Tribune* found when they opened their paper on December 11, 1905. The headline read: "Love of Drink Woman's Shame."

Catherine Blackwell had been arrested for attempting to burn Will McCrary's home after stealing a dozen bottles of whiskey from his secret storeroom. McCrary and his wife were away at the time and luckily a neighbor, Jay G. Lybarger, knowing the McCrary's were gone, looked out his window and saw a light in the McCrary home. He observed a woman coming from the house and, almost at the same time, saw a blaze flash up in the kitchen. He rushed next-door, burst open the door, and put out the fire.

After extinguishing the blaze, Lybarger called police. When officers arrived on the scene they were surprised to find, next to a burned dresser, four rows of boxes whose labels indicated they contained illegal whiskey, cherry cordial, ginger brandy and Peruvian bitters. There were two residences on the McCrary lot at 226 Atlantic. Officers went to the house in front inhabited by Catherine Blackwell and her family to question them about the incident. When the police knocked on the door, childish voices answered that their "mamma" was asleep. Marshal Neece insisted they wake her, but after a bit the children said that she wouldn't wake up. Upon hearing this, the officers coaxed the children, aged 8, 3 and 1, to open the door. The law enforcement officers found Mrs. Blackwell lying drunk on the floor with a nearly empty bottle of whiskey clasped in her arms. Next to her was a trunk containing eleven

full bottles of whiskey of the same brand as the stock found in the McCrary house.

When asked about their father, the oldest child said he came home on Wednesdays and Sundays and "tried awful hard to keep mamma from drinking." After sending the children to the Lybarger home, the officers waited until they could rouse Mrs. Blackwell. When she finally sobered she admitted to buying whiskey from the McCrary's but said she didn't start the fire. She had been at their home, but only to feed the dog, and had helped herself to some liquor, expecting to pay them later when they came back.

When Will McCrary returned home he was shocked to hear his liquor had been confiscated and that charges would be brought against him. A man opposed to Prohibition and it's suppression of his personal liberties, McCrary went on to endure a long court battle that eventually ruled against him. Catherine was sent away to a hospital for treatment of her disease and her husband, John Blackwell, said he would consider taking her back once she was no longer a slave to intoxicants.

One of the complaints of early Long Beach prohibitionists was that neighboring Alamitos Townsite (not to be confused with the city of Los Alamitos) allowed alcohol, though through no choice of their own. Early in 1905, the folks who lived in Alamitos Townsite were outraged when the Los Angeles County Board of Supervisors granted liquor licenses to three wineries in their area. The citizens of this unincorporated area, governed by Los Angeles County, voted against granting the permits but the county supervisors overturned their vote.

In 1904 the Yribarne brothers, Cadet and John, who had worked hard herding sheep for the Bixby ranchos in the area, had saved enough money to purchase five lots, three facing Anaheim Street and two facing Alamitos Avenue. They purchased the property on the installment plan, making a down payment and then so much a month. When they paid off their debt they acquired five more lots on Anaheim, giving the brothers frontage to Orange Avenue. Cadet and his brother John, accustomed from childhood to the moderate use of wine, established a winery on their land at Anaheim and Alamitos. John opened a

wholesale liquor store on the southeast corner of Tenth and Ximeno, where the Woodrow Wilson High School would later be built. Cadet ran the winery. Though the winery and liquor store were legal under the county license in which they operated, Prohibitionists in the area were determined to put the brothers out of business.

On March 27, 1905, the County of Los Angeles granted Cadet Yribarne a license to operate his winery over the protest of 300 voters in the district. The elected county officials completely ignored the fact that in November 1904 the precinct of Alamitos Townsite, in which the Yribarne brothers had their businesses, went "dry" by a vote of 186 to 45. To make matters worse, when time came to renew the licenses of two other wineries in the area (the Charles Thompson Winery at 4th & Walnut and the Ardans winery on Long Beach Blvd.), the supervisors approved the applications.

Why did the supervisors disregard the feelings of the people they represented? Many felt that it was Supervisor Peter J. Wilson's way of getting back at the "dry" voters, who had given his opponent 400 more votes than they had given him. At the meeting granting Yribarne's license, Wilson stated that the wishes or desires of the Alamitos people would have no effect on his vote in the matter. In his campaign for county supervisor he pledged to support the measure to permit alcohol and would do so. Though other supervisors spoke against issuing a permit to Yribarne, the vote swung against them and Alamitos Townsite became home to a number of liquor establishments.

Residents were not happy and soon had their concerns vindicated when they found that too much wine could cause trouble.

On August 5, 1907, Long Beach police officers received an emergency call from Anaheim and Termino Streets in Alamitos Townsite. Though outside their legal jurisdiction, people in Alamitos Townsite were desperate for police help—Jose Mendebles was writhing with pain and bleeding profusely from a knife wound.

It was learned that Mendebles was one of five men who went to the Anaheim Street winery and purchased wine. The men then went to the outhouse near the residence of Jose Mandez, the victim's employer. Here they became involved in a quarrel and one of the men stabbed Mendebles and robbed him of $2.30, all the money he had. All in all, Mendebles was fortunate, because if the assailant had directed his

knife inward instead of downward Mendebles would have been killed, instead he was just badly wounded.

This was just one more example of the evils of alcohol, according to the "drys" in nearby Long Beach. Eventually, the wishes of the "good" folk of Alamitos Townsite prevailed. On April 1, 1908, the Los Angeles County Supervisors refused to approve the liquor license of John Achata and Juan Ardan who had leased Yribarne's winery. On May 2, 1908, the two men were arrested for the illegal sale of alcohol and placed under a $250 bond.

On November 22, 1909, Alamitos Townsite residents voted to join the City of Long Beach, to ensure their safety from the "evils of alcohol." The fight against alcohol was spreading throughout the nation. It had been an uphill battle. In 1862, in order to pay for the Civil War, the federal government began to tax alcohol: a $20 licensing fee to start a saloon, $1.00 tax on every keg of beer; 20 cents a gallon tax on distilled alcohol. By 1900 seventy percent of the federal budget was derived from taxing alcohol, and the 900 million barrels of beer served in the 300,000 saloons operating in the United States. A saloon was important to the many foreigners arriving in America. It was an immigrant's social club, a meeting place, a mail drop, a place to discuss politics and conditions in the "old country." It was the breweries who financed the saloons, all a prospective bar owner had to do was agree to sell one brand of beer only and that brewery would put them in business, paying the licensing fee—and tossing in chairs, tables and pool tables for free.

The Women Christian Temperance Union and the Anti-Saloon League, another group against alcohol, feared the country becoming a nation of drunkards. "Real" Americans didn't need saloons, they preached, and it was time to "help" those who had recently immigrated to the United States to "upgrade" themselves by abandoning alcohol and the "evils" it created. Since the new arrivals didn't seem capable of doing it on their own it required new laws, legislation made easier by the passage of the 16th Amendment in 1913, which established a federal income tax. Now the government would no longer be dependent on alcohol taxes to fund the federal budget. The time seemed ripe to stop the scourge of alcoholism; government could make society better with the passage of the 18th Amendment.

No one seemed to notice that almost every part of the Constitution of the United States was about expanding human freedom, the 18th Amendment did just the opposite, it was telling Americans how to live. Something liberty minded Americans could not abide. What was meant to eradicate an evil instead turned millions of Americans into criminals and a nation of hypocrites.

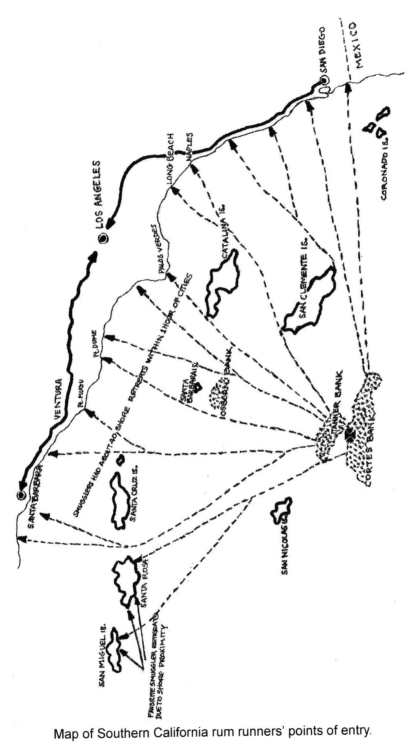

Map of Southern California rum runners' points of entry.

Rum Raids

In 1818, Southern California shores were terrorized by a French buccaneer, Hippolyte de Bouchard, and his British partner Peter Corney. The Frenchman was commissioned as a privateer—a polite word for a pirate—by General Jose de San Martin, an Argentine revolutionary. To finance his revolution San Martin needed Spanish treasure. One of the places ripe for plunder was sleepy Spanish California and its missions. Corney and de Bouchard, and their crew of 300, attacked Monterey and San Juan Capistrano, defying local authorities. One hundred years later a new type of pirate was hitting the California shores, the rum runner.

Like the buccaneers of old, the rum runner went out of his way to circumvent the law and gather as much wealth as he could. The nine offshore islands of San Clemente, Catalina, Los Coronados group, Santa Barbara, San Nicholas, Anacapa, Santa Cruz, Santa Rosa and San Miguel, which aided the pirates of bygone days, were still viable as places to hide modern day rum runners and their loot. The United States Coast Guard, local law enforcement and Federal agents were fighting a losing battle against the much faster rum running vessels. The only local ships at the Coast Guard's disposal in the early days of Prohibition were the *Vaughan*, a decrepit sub-chaser of World War I origin, and the *Tamaroa*, a cutter so slow it was often referred to as "the sea cow." The "good guys" desperately needed more and faster ships to cope with the smuggling menace. Extra help finally arrived in January 1926.

Eight 75-foot ships called "wasps" were transferred from the Atlantic Coast to the Pacific. Persistent, like the insect they were named after, these boats patrolled the waters from San Luis Obispo to below the Mexican border. Each had a one-pound gun mounted below its squat, low-browed pilot house and a powerful searchlight to scan the waters. Mothering this busy brood was a veteran battler of Arctic ice, the *Bear*.

Built in Greenock, Scotland, in 1874, the *Bear* was made of almost impenetrable wood built to withstand the crushing flows of icebergs. She was also the oldest vessel in active American service. She and her "cubs" patrolled 500 miles of coast line and maintained a rigid inspection of

nine islands and, most importantly, monitored the activities around the Cortes Bank, located 100 miles directly west of San Diego, the key point of rum operations. With these vessels the U.S. Coast Guard could now launch an all-out war against the fleet of rum smuggling vessels operating off the Southern California coast.

It seemed nature provided the Cortes Bank with everything a smuggler needed. There was a buoy that, oddly enough, resembled the steeple of an old-fashioned New England church, marking this shoal. There was also Bishop Rock, a city block long, lying in 2.5 fathoms of water in Cortes Bank. From here rum runners played hide-and-seek among the Channel Islands with the Coast Guard before landing at one of over forty favored landing places in Southern California. They preferred long sweeps of beach with only the single lamps of lone houses cutting the darkness, and hidden coves where no lights could be seen.

On these same beaches in daylight hours thousands bathed and played, but at night more than 150,000 cases of Scotch whisky valued at more than $10 million were smuggled ashore and whisked off the beach in huge trucks and hidden away in "plants" for later sale to the whisky drinking American public. It wasn't safe anymore to take your sweetheart for a moonlit stroll on the beach. Instead of seashells and romance one would find squint-eyed men armed with revolvers, shotguns and even machine guns patrolling the shore awaiting the latest shipment of illegal liquor.

In Los Angeles County the smugglers favored Point Dume, Malibu Pier, Playa del Rey Pier, Palos Verdes, Point Fermin, Los Angeles Harbor, Wilmington, Naples and Long Beach. In nearby Orange County there was Newport, Laguna, Seal Beach, Balboa and Sunset Beach. Despite the additional Coast Guard vessels, the *Times* reported that by August 1926 the smuggling of Scotch whisky had become one of the leading industries of California. It had also created a subsidiary industry—hijacking of smuggled cargo.

One could never tell who was involved in rum running. Seemingly respectable citizens, even members of Taubman's Long Beach Bible class, could be caught up in this lucrative, but illegal, trade. Most justified their illicit actions. Persons engaged in defying the national Prohibition laws looked upon themselves as "importers" and hotly denied they were bootleggers. In their eyes a shipment of whisky was the same as a shipment of grain.

Whisky brokers in Canada maintained agents all along the Pacific Coast and orders could easily be made and delivered to any large Pacific Coast town. Taubman's Bible class was the perfect place to forge contacts. These Bible toting whisky dealers vehemently deny they were bootleggers. They spoke with contempt of the "five case man, the ten case man" and even the "fifty case man," meaning the bootlegger who bought a small amount of the smuggled whisky for resale to the retail trade. These smugglers of good Scotch whisky scoffed at alcohol dealers and the gin makers. They prided themselves in having no dealings with those who made moonshine whisky or wine. They saw themselves as an elite group of business men engaged in an importing business which, although against the law, was nevertheless a recognized and well-paying business. They prided themselves on the quality of their merchandise, claiming that at least half of the liquor consumed in Southern California was not fit to drink. Their product, on the other hand, was as pure as the day it was purchased in Canada, England or China.

The major problem was that many local bootleggers and whisky dealers purchased large amounts of good Scotch whisky and then spoiled it by cutting the liquor with water, adding a little alcohol, and coloring matter, and then rebottling it in bottles purchased from local dealers. In some cases the local bootlegger even dipped his whisky containers into water to make it appear as if they had been dropped in the surf during landing. "Honest" whisky "importers" thought this very bad for business, not only because it flooded the market but because it gave them a bad business reputation.

According to figures supplied to the *Los Angeles Times* (8/1/1926) by the rum runners themselves, four fifths of the smuggled liquor coming into Southern California was Scotch whisky. Special orders of high priced wines, gins, brandy and other alcoholic liquors were taken, filled in Canada, and smuggled into the U.S. This amount was so small in comparison with the flood of straight Scotch that the drinking public didn't even realize anything but Scotch was available.

Most of the gin offered in local markets was manufactured in this country by regular commercial alcohol houses and then diverted through underworld channels to the bootlegging trade. Some used redistilled denatured methyl (wood) alcohol purchased from perfume and barber supply houses and drug stores. Since 1906 the United States government had required that manufacturers denature (poison)

industrial alcohol or else pay liquor taxes. Many Prohibition era bootleggers hired chemists to come up with formulas to help clean up industrial alcohol and make it drinkable. However, many small timers did the redistilling themselves. They quickly learned that the simplest formula consisted of just adding extra methyl (wood) alcohol into the mix. Large wholesalers, on the other hand, operated huge "cooking plants" turning out ethyl (grain) alcohol which in turn they sold to local retail men. None of these manufacturers had anything to do with the importers of Scotch whisky and it was rare for these two distinct business operations to meet.

The "importers" could be divided into several categories. First were those who owned an ocean going vessel, usually a small steamer or a large schooner, several shore boats for landing purposes, a fleet of trucks and fast cars, a good safe "spot" in which to store large quantities of liquor, and last but not least a good "mob" to protect their landings and transportation. This "first class" elite group had large supplies of cash on hand, many friends in official circles and a well-organized market of larger bootleggers. They also had local agents, as well as agents in Canada, who handled most of the work of organizing, landing and selling the liquor; so while authorities almost always knew who the heads of the various smuggling rings were, little, or no evidence could be gathered against them.

Chief among this first type of rum runner was a Southern California group known as the "Big Four," large enough and tough enough to afford their own ships, trucks, and "mob." The largest single whisky importer was Tony Cornero, a handsome young Italian-American, just into his thirties, who had an able lieutenant in his brother Frank. After Tony Cornero came Melvin Schouweiler and "Black Tony" Paragini, alias Foster. These two often operated together. Schouweiler worked as a "promoter," promoting deals in smuggled Scotch by forming a local syndicate among his friends and other small operators and then buying the whisky in Canada. Profits were split according to the amount invested by the various members of the syndicate. Schouweiler had also started his own Canadian exporting company known as Western Freighters. "Black Tony" usually worked with Schouweiler but also operated alone dealing with importers of whisky from San Francisco. Bill Nard, the fourth member of the "Big Four," hailed from San Francisco.

The second type of rum runner, and by far the largest, had two ways of obtaining their inventory of liquor. Most of them bought "over the rail." When a liquor ship owned by one of the "Big Four," or Canadian interests, arrived off the coast they bought their liquor on shore from the owner and agree to accept delivery over the ship's rail. Most of these men owned their own speed boats or rented them. In this second method, operators bought directly from the Canadian exporting house and specified delivery at certain points off the coast. They then appeared in fast shore boats and unloaded their share of the cargo directly from the ships. All shipments were paid for before the vessels left Canada. It was big business for the Canadians. More than nine-tenths of the whisky smuggled into the United States was purchased through an organization known as the Consolidated Exporters of Canada, most of the rest from Schouweiler's Western Freighters.

With this "importing" business came problems. Besides federal agents, there were the hijackers to deal with. The hijacker was the whisky "importers" chief problem. These "gentlemen of the night" who, armed to the teeth, swept down on shipments either being landed on shore or being transported to a safe spot. After shooting it out with the guards hired by the smugglers, these hijackers would steal the load and sell it themselves. To protect their shipments the "importers" had to hire additional guards at extra expense.

Other matters these whiskey "importers" had to deal with included the payment of cash to corrupt government officials, pay offs to property owners for good beach spots to land the liquor, and the expense of locations to store whisky. In addition, there was the cost to operate the ships, shore boats, trucks and cars. All of this, plus bail paid by mob members caught by honest government officials, combined to make the price of a case of "good" Scotch whisky (originally selling for $15 a case in Canada) delivered to your back door $60 or $65.

Hijackers were by far the bane of the rum runner. In the early days of Prohibition mobs of gunmen would board the rum ships and kill the entire crew. This was later given up because the size of ship crews was increased and machine guns mounted on decks. By 1926, most hijacking took place on shore where hijackers would swoop down in a swift raid, fight it out with guards and men loading a truck with whisky, and make away with the bottled goods. The battles over smuggled whisky were so common that most of them never came to

the official attention of the police, and in many cases dead men were found in rooming house, automobiles, or along the roadside with no explanation ever discovered by the authorities. When arrests were made by the police, witnesses clammed up refusing to give testimony. "We will fight our own battles," was the official word that came up from the underworld.

Many of these battles were fought in or around Long Beach. On August 3, 1925, a mob of rum runners fought a deadly battle with hijackers on East Perris Road in Long Beach. The machine gun won the day. Two of the hijackers, Harry Schwartz, alias H.C. Munson, and Harry Moran were dangerously wounded. Though arrested, the code of the gun world sealed their lips. They never squealed, even after they recovered. But some mob members didn't want to take any chances. Both Schwartz and Moran lost their lives in a flare of revolver fire in the lobby of the St. Regis Hotel in Los Angeles a year later. Jimmy Fox, an employee of Tony Cornero, was held for the murders.

Though police never arrived at the true story behind the battle on Perris Road, the account that floated through the underworld pointed to one of the largest importers of whisky, Tony Cornero, as the man who handled the machine gun. As the story went, the rum runners had been hijacked three times in a row and felt they were being picked on. Loading a truck with dummy sacks (liquor was not smuggled in crates, but in gunny sacks) and mounting a machine gun behind the sacks, Cornero let the word leak out that he was coming in over Perris Road with a load of liquor. The hijackers went out to "take over the load" and when, with weapons drawn, they leapt upon the truck they were met with a hail of machine-gun bullets.

It was hard to know the true story behind some of the battles. The code of silence was practiced by all those involved in rum running, with the hated hijackers the enemy of the "respectable" element in the trade.

In the files of the Long Beach Public Library's Long Beach Collection is a letter from one unidentified woman. Her father was a printer who provided business cards for bootleggers. He claimed that one man held the reins in Long Beach (but he never told his daughter the man's name) and that a fleet of trucks, cars, two boats and an airplane were part of his organization. The bootlegger's headquarters,

the printer claimed, was the Hill-top Tavern in Signal Hill, but the bootlegger kept the organization's airplane at the airfield in nearby Seal Beach. The airplane would scout out the scene below and let the syndicate's boats know when it was safe to land. A favorite spot was Ocean Avenue, near Alamitos Bay; one house was equipped with an underground dock for loading and unloading. But the unidentified "chief" of Long Beach bootlegging wasn't the only one using Alamitos Bay as a landing area for illicit booze.

On August 26, 1925, 267 cases of Canadian liquor, worth more than $13,000, two automobiles and a motor boat were seized in a raid at 36 Rivo Alto Canal in Naples. Also found were bankbooks, ledgers and lists of customers. The papers revealed that San Pedro was the headquarters of the operation, with Naples one of several subsidiary points where liquor was put ashore.

Long Beach Police Lieutenant William Dovey, and a squad in a police car searching for the rum runners, stumbled on the find. For weeks they had been searching for the gang which used the canals of Naples for liquor transport. They found one man, who said his name was William Wallace, sitting in a parked car in front of the Rivo Alto Canal home. Dovey, said to have a nose for liquor, became suspicious. In Wallace's expensive automobile police found 15 cases of whisky. They also noticed cargo being unloaded from a nearby motor boat. Upon investigation, they found more whisky, champagne and other fine liquors valued at thousands of dollars.

After arresting Wallace and his accomplices, police obtained a search warrant and entered the house in front of which the car was parked. Inside, piled high on luxurious rugs, officers found 100 cases of expensive liquor, apparently imported for an exclusive trade. No one was in the house at the time; however, it was revealed that W.E. Anderson of San Pedro owned the house and a car in the rear garage. Later it was found that W.E. Anderson was really Ernest W. Bartell, a prominent shipper.

On August 28th, a man who claimed to be a Federal Prohibition agent came to inspect the confiscated alcohol. He told local officials he needed the contraband as evidence, loaded it in his car and drove away. Ruth Inwood, a suspicious minister's daughter, followed the car to Seal Beach, wrote down the license number and gave it to police. She also told her father, the Reverend Edwin Inwood of the Belmont Heights

Methodist Church, what she suspected. The car was later identified as belonging to Mrs. Ernest Bartell, wife of the man thought to be the leader of the liquor gang. Miss Inwood, as well as embarrassed police, identified Percy G. Cummings, as the man seen loading the liquor into the car.

Cummings, who really was a Federal Prohibition agent, appeared to be working with the gang. He found himself in jail, charged with hijacking Long Beach police out of twelve bottles of smuggled whisky which they had seized in the Naples raid. Long Beach police officer Warner A. Outcalt, who had been guarding the confiscated liquor, was also arrested and charged with conspiring with Cummings to steal the liquor. Outcalt had been seen burying a case of liquor by Reverend Inwood, who had spotted the auto his daughter had described to him and followed it. When arrested, Cummings implicated four other Long Beach police officers in the plot. (Follow up on the case was not reported in the local press).

The confiscated rum was put to good use and distributed to Community, St. Mary's and Seaside hospitals for "medicinal purposes." The bottles were emptied into kegs before being sent to the medical institutions, "Because," as Chief of Police Yancy stated, "we can handle it better in casks; they are harder to get into hip pockets."[15]

Following numerous complaints that many federal agents were corrupt, President Coolidge changed the way Prohibition Bureau personnel were hired and after 1927 federal agents improved. No longer were Prohibition agents exempt from civil service rules. Civil service tests now screened out weak prospects. In fact, Clifford Walker points out in his book *One Eye Closed the Other Red*, when tests for beginners were given to experienced agents, most failed. Three-fourths received a score that would have precluded an applicant from taking further steps to become an agent. In California an evaluation of 227 incumbent agents showed that 47 only had a grammar school education; 123 had gone to high school, but only 44 graduated; 57 had some college but only 19 graduated.

As Prohibition continued, conditions improved for the Coast Guard's war against the rum runners. The Guard already had the reputation of being the most incorruptible government agency around, since the fairly good pay attracted mostly honest men. A much needed

boost in their battle against crime was a legal decision allowing them to use captured rum runners' boats, most much faster than existing Coast Guard craft. The government also funded a radio message interception station, installed on the Palos Verdes Peninsula, which allowed the Coast Guard to track communications about illicit liquor deliveries.

Despite these improvements, the Coast Guard had no better luck in stopping the flood of liquor. Though they succeed in stopping hundreds of ships and boats over fourteen years of Prohibition, they lost the Rum War. The flow of booze into California never stopped. Neither did the supply of smugglers willing to chance capture. It was estimated that 46,040 cases entered the coast in the year ending June 30, 1930, not counting over 7,000 cases coming from Canada into Puget Sound.

It was existing laws, corrupt officials, and wily opponents that made the Coast Guard's job most difficult. In San Pedro, for instance, the Coast Guard who suspected which boats were transporting liquor, checked daily to see which supposed rum running launches were docked and which were out to sea. When smugglers wanted to land booze on the beach, they sent a dory to shore with a cable from the launch. They pulled the booze under water to the dory. If a Coast Guard boat came up, the runner dropped the cable; the booze then stayed on the bottom waiting for another smuggling craft to come by later, when it was safe, and retrieve it. The Coast Guard knew what the rum runners were doing but couldn't arrest the man, the dory or the launch unless they had the contraband in their possession. The law gave rum runners the advantage.

Many of the rum runners were high powered professionals who were well organized and tough. Others were small time operators like Al Forgie of Long Beach. Forgie brought in booze, but he never touched the contraband. He'd dock his boat in Long Beach, walk away and return the next day. The boat was cleaned up and emptied of alcohol. In the cabin he always found an envelope filled with money.

Most of the big loads came in below Point Mugu, near the Los Angeles County line. One Ventura County Prohibition agent chanced to see a landing on a beach and went to investigate. Seeing he was outnumbered, he merely watched. When he returned to Ventura and told officials what he had seen he was told the landing had taken place in Los Angeles County: "Why, you damned fool! Don't you know

the L.A. boys are in on the racket? Probably half those guys you saw guarding the load were officers. We'd get hell blasted out of us if we monkeyed with those apes."[16] The agent stated he was beginning to doubt the sincerity of the men who made laws without making it possible to enforce them.

To some, however, enforcing the law was subjective. In *One Eye Closed the Other Red*, author Clifford Walker recounts the case of an honest cop, one who would never accept a bribe, who took a visiting federal agent to a speakeasy for lunch. When the agent asked the policeman why he hadn't shut up the place, since that was part of his job, the police officer told him it was simple. The police department also had a burglary squad and a robbery squad. They had to get information. If the police vice squad raided the joint where would the other squads get their information? A church? It was at the speakeasy where they met stoolies and their prostitutes and found out about the criminal element in town. This was police work.

Remington Murder

On March 23, 1923, Long Beach residents were shocked to read that respected citizen, Alexander B. Stewart, president of the Curtis Corporation and former president of the Long Beach Manufacturers' Association was involved in a smuggling ring bringing intoxicants into the city. His general manager, Albert C. Leahy, and sales manager, Victor C. Lord, were also taken into custody. More stunning news followed. Had those arrested during the raid at his warehouse had anything to do with famed aviator Earle Remington's murder?

It was around 11:30 p.m. the night of February 15, 1923, and Rex, an old Llewellyn setter, began to bark furiously. His deafening yowls woke his mistress who was terrified a burglar was trying to get into the house. Gathering her courage, Isabel Betts headed to the closed in porch where the dog slept. Here she discovered that Rex had pushed open an outside door and dashed away after something that Isabel could not see. She knew the dog was used to their neighbor Earle Remington's late hours and rarely raised his head when Remington's car pulled into the next door driveway, so it couldn't be Remington. She then heard a loud sound, but assumed it was the backfire of a passing car. After checking the premises and finding nothing, she called the dog back inside. Little did she know she was only steps away from a murder.

At 6 a.m. the following morning the neighborhood was woken by human screams, almost as piercing as the barking of Rex the dog. Charity Dawson, the Remington's maid, had found the body of her employer, Earle Remington, sprawled on the sidewalk of his home at 1409 South St. Andrews Place in Los Angeles. His wife of six years, Virginia "Peggy" L. Miller Stone Remington, who was asleep inside the house, claimed she had heard nothing the previous evening. The dog barking hadn't awakened her; she had been asleep until she heard Charity's shrieking.

Investigating the crime scene, police reconstructed the events leading up to the murder. It appeared the 36-year-old Los Angeles businessman had stepped from the right hand door of his small coupe and walked around the back of the vehicle. As he reached the rear of the auto the killer, or killers, stepped from behind a hedge, approached Remington

and then fired one shot from a double-barreled, sixteen gage shotgun. To protect himself, Remington raised a large briefcase stuffed with business papers and clutched it over his chest. The bullet struck the brief case, passed through the papers and lodged in Remington's coat. A second shot struck the edge of the case, cut through the leather and pierced Remington's chest just above the heart. Remington staggered a dozen steps toward the house and fell across the sidewalk. Physicians believed he died before he struck the ground. Later, following an autopsy, it was determined Remington had also been stabbed with a bayonet.

Earle Remington, an early aviator and friend to Long Beach flyers Frank Champion and Earl Daugherty, was also an engineer. His business, the Remington Company, dealt in bank designs and architecture. He was also involved in two other business ventures: the Day and Night Electric Protection Company, and the Day and Night Safe Deposit Company. Could Remington's business interests have had anything to do with his murder? One of his employees, Harry Miller, certainly thought so. Miller believed it was a murder for revenge, though he refused to disclose his reasons. Miller said it would have been easy for assassins to check Remington's movements and once having learned that he habitually stayed away from home until late at night, to wait for him.

Police found that Remington, though appearing to be well-to-do, was severely in debt. They also verified he had purchased a large quantity of liquor shortly before he was slain. Four cases of liquor were found in the Remington home and were believed to have been part of a 100-case lot ordered by Remington and split with business associates. Police remarked that the purchase of whisky in such large quantities was a dangerous undertaking. Disgruntled bootleggers might have believed Remington was attempting to double cross them and slain him. Interestingly, it appeared the sixteen-gauge double-barreled shotgun, one of the weapons used in the murder, had been stolen from Remington's offices when they had been burglarized a number of weeks before the murder. Following the burglary Remington had hired private detectives to guard him, leading police to believe that behind the gruesome murder lurked a carefully laid plot of revenge.

Following the murder, Mrs. Remington was subjected to severe questioning by detectives who believed she was not telling them

everything she knew. According to an intimate friend of Mrs. Remington, Virginia Remington had found out her husband was having an affair with a married woman and had filed for divorce a few weeks before her husband's murder. She had also hired a detective to follow him.

Though Virginia Remington had been ill for several months with influenza, the 36-year-old woman gathered her strength to reveal her life and sorrows as the wife of a society bootlegger. Earle had gotten into the "terrible business," she stated, to help recuperate his fortune. He became so obsessed with money that he gave many of his old associates up for new ones, ones she didn't like. She told how his new friends would call at the front door in the mornings, and then a few would come to the rear door of the house. Trucks would drive up and unload the "terrible stuff." Later another truck would be driven into the driveway to take the whisky away.

Virginia said she couldn't bring friends home anymore because the odor of liquor permeated every room. When asked if she knew any of the men who called at the house she declared that most of them were strangers. She said there were many telephone calls in addition to the visitors. The phone would ring. They would ask for Earle. A long conversation concerning prices, deliveries and grades would follow. She said Earle would get angry at times following the calls, saying terrible things about the person he had just talked with.

Virginia Remington told of a conversation two days prior to the murder in which Earle had called a Hollywood number. A long exchange ensued, she said, and as it progressed her husband became terribly angry, saying things so vile she couldn't repeat them. She didn't know who he was talking with but remembered that Earle was angry for hours after the conversation. He kept his business affairs to himself, she stated, and never confided in her any details relating to his illegal operations. Their relationship was strained and to escape the chaos around her, and deal with her depression, she sought something positive in her life. Virginia Remington began volunteer work with disabled veterans. It helped relieve her sorrow, occupied her time and made her forget. When asked her theory as to the murder she said she believed her husband was the victim of a bootleggers' war.

It was a plausible explanation. Illegal liquor was often seized by hold-up men who preyed on bootleggers. The hijackers, as they were called, stole only whisky known to be in the possession of bootleggers.

After the whisky had been taken by force it was resold by the thieves to other whisky dealers.

One of the most notorious gangs of whisky hijackers was led by "Blackie" Dudrey and Oscar Lund. Suspicion regarding Remington's murder pointed their way. They had made quite a bit of money through their hijacking operations. It seemed they now thought it was time to "graduate" to a more honorable, though still illegal, class of operators-importers. Six weeks after the Remington murder the pair arranged to secure 1,200 cases of whisky from Vancouver, Canada, which had been brought aboard the rum-runner *Borealis*. But someone, most likely one of their previous hijack victims, squealed to police.

For many weeks there had been reports trickling through Long Beach police headquarters that large cargoes of liquor, dropped off from rum ships at sea and carried to Long Beach in fishing boats, had been unloaded at Alexander Stewart's Curtis Corporation cannery, and later taken from there in a fleet of vehicles. An anonymous phone tip alerted authorities to a pending delivery.

Police staked out the Curtis plant waiting for something to happen. Finally, after a long, cold night hiding, police saw several vehicles approaching the canning factory in the early morning hours of March 22, 1923. In the meantime, a fishing boat approached the cannery pier. Convinced the vessel had just brought in an illegal shipment of liquor, officers ran to intercept it. The launch refused to stop and two officers fired across the bow of the boat. One of the men dropped from his seat and fell overboard. The boat then veered to shore and was seized.

K. Nagai, a 50-year-old Japanese fisherman piloting the boat, was arrested. He refused to disclose the identity of the man who fell into the water. Other officers, hidden about the factory, dashed onto the cannery grounds firing their weapons into the air to prevent other suspects from fleeing. They captured five other men, three remaining cars, two trucks and 162 cases of liquor. But a Studebaker sedan fled the scene. When police apprehended the vehicle they found Alexander Stewart, president of the Curtis Corporation of Long Beach, and five cases of the same kind of whiskey Nagai was unloading.

Long Beach residents were stunned when they opened their newspaper the next morning. Nagai, the Japanese boatman captured when the liquor was seized at the Curtis plant, had escaped amid a volley of bullets when federal agents who were transporting Nagai stopped

at a gas station in Wilmington. But even more shocking was the fact that respected citizen, Alexander B. Stewart, president of the Curtis Corporation and former president of the Long Beach Manufacturers' Association, was involved in a rum running smuggling ring. In addition, his general manager, Albert C. Leahy, and sales manager, Victor C. Lord were taken into custody. Also arrested were known members of the Lund-Dudrey gang: Jack Miller, Oscar Lund, Lewis Dudrey, W.E. Knowlton, Maurice De Leon, K. Nagai, H.L. Brown, George Chancy, Clarence Ehat, S.S. Stone and Frances Dudrey.

For weeks afterwards the raid continued to made news. Nagai was finally apprehended and brought to Los Angeles for questioning. Hazel Talbot, the wife of Captain Larry Talbot, master of the rum-runner *Borealis*, was arrested three days after the raid and found with several cases of champagne. Captain Talbot, a well-known figure in the Canadian liquor business, was arrested several weeks later, charged with being a party to the conspiracy. Frank Kobota, a prominent member of the Los Angeles Japanese colony, was also placed behind bars. He was supposed to have made the arrangements for the landing of the whisky, hiring Nagai to do the work. A bail of $25,000, one of the largest bails set in Los Angeles County up to then, was quickly met by all those arrested.

Fortunately for Blackie Dudrey he hadn't been in Long Beach the night the illegal liquor was seized. He was overseeing the arrival of the shipment at their secret facility in Topanga Canyon. Hearing of the arrests, and fearing he was next, he quickly gathered all the money on hand and set out for Calexico. His hasty departure led authorities to believe he had more to hide than just bootlegging. They began to suspect his gang had been behind the murder of Earle Remington.

Successfully avoiding authorities for seven months, Dudrey, who had changed his name to C.C. Mathews, believed it was finally safe for him to come back to Los Angeles. After all his tenth wedding anniversary was approaching and he didn't want to disappoint his wife. But Dudrey had enemies. Six bootleggers that hated Dudrey alerted federal agents to his arrival. One man, whom he hijacked for $90,000, even offered a $1,000 reward for Dudrey's arrest. No honest bootlegger's whisky was safe when Dudrey was around. When arrested and questioned about Earle Remington, Dudrey denied any part in the murder. He also claimed he had retired from the bootlegging business.

On May 1, 1923, another story regarding Earle Remington's murder surfaced. A 28-year-old woman, who her attorney refused to identify, came forward and told of her 18 month affair with Remington. Earle had promised her he would get a divorce and marry her, but she gradually came to realize there was another woman in Earle's life, and it wasn't his wife!

Earle kept coming up with excuses as to why he couldn't meet the young woman and when she tried to talk to him at his office she was thrown out. Scorned and jilted, Remington's former paramour purchased a vial of acid which she intended to throw into the faces of Remington and his new girlfriend. For days preceding the killing Remington's former lover followed the man who had once made her happy. She was tracking Earle and his new sweetheart the evening of the murder when she lost their trail. Enlisting the aid of two male friends, they drove to Remington's home to await his return. They just happened to be there when the murder occurred. While they sat in the car Remington drove up. Before they could exit the vehicle and confront Remington, two shots were heard. Two men ran back towards the auto where the former girlfriend and her friends were sitting and drove away. Remington's former love said she kept quiet for such a long time because she feared arrest, but a nervous breakdown brought about by brooding over the case led her to tell her tale.

Unable to bear the strain any longer, she went to the office of Attorney S.S. Hahn and told him she would disclose the details of the murder if the district attorney's office would assure her she would be allowed bail pending the trial. She also said she wanted to protect the two men who had helped her. District Attorney Asa Keyes refused to discuss a deal until she surrendered herself in the case. Keyes stated that murder was not a bailable offense, even though the woman did not admit to killing Remington. Hahn refused to give authorities the name of the girl, insisting it was a matter of confidence between counselor and client.

Another angle in the Remington murder developed when one of the largest bootlegging plants in Southern California was uncovered in San Bernardino County on May 5, 1923. Three huge stills, 79 barrels of corn mash, fifty gallons of whisky and other apparatus was seized. It was believed to be operated by a gang of Italian moonshiners with whom Earle Remington was affiliated. The liquor plant was set up in

a house only a few miles from a ranch Remington owned, and police had information which led them to believe the murdered man was affiliated with the gang.

Over sixty prominent people in Long Beach, Los Angeles, Hollywood and Pasadena were implicated in the March 22, 1923, Curtis Corporation smuggling operation, many of whom later proved to be business associates of Earle Remington.

At his trial on January 30, 1925, Alexander B. Stewart, president of the Curtis Corporation, stated that personal friendship for Frank Kobota and other Japanese fishermen, and fear that an unfriendly move on his part would seriously affect the business of his fish canning company, prompted him to allow use of his dock. Stewart stated that the five cases of liquor found in his sedan at the time of his arrest was a present from the rum smuggling gang. He claimed he had denied Kobota's request to use the Curtis docks to unload liquor but that Kobota had done it anyway.

On February 14, 1925, prominent Long Beach businessman Alexander B. Stewart was sentenced to four months in county jail and fined $7,500 for his part in the March 22, 1923, raid. Stewart had been found guilty of two counts of an indictment, both charging violation of the tariff laws of the nation. He was acquitted of two charges of conspiracy. His two employees, Victor Lord and Albert Leahy were exonerated of all charges.

It paid to have a good lawyer. Alexander Stewart's conviction was reversed because of one word: "feloniously." The reversal was granted May 8, 1926, on the grounds that the court permitted the word "feloniously" to be stricken from the two counts, thus altering the grand jury indictment. Stewart didn't have to go to jail or pay a fine of $7,500. But justice, of a sort, prevailed. Stewart was later arrested when several agents raided his Ocean Boulevard home, arresting seven wealthy guests, in various stages of undress, for liquor possession and immoral conduct. Mrs. Stewart, police said, tried to escape in her silk undies, stockings and a tam o'shanter. Stewart vowed never to go to jail. He was right. When the case finally went to trial Prohibition had just ended, and so did the case against Stewart. But the damage to the Stewart's reputation in Long Beach was irreparable.

Not so lucky were Stewart's lackeys. Blackie Dudrey was sentenced to 18 months in Leavenworth penitentiary and fined $10,000. Oscar Lund spent nine months in the Los Angeles County Jail and had to come up with $3,051 upon his release. The others received sentences of from 6 months to 2 years in jail and fines of from $551 to $15,000.

Though Dudrey's gang was suspected in the Remington murder, not enough evidence could be found to charge them with the crime. But the Remington murder case would not rest. In April 1924, a 39-year-old disabled war veteran walked into the Portland, Oregon, police department and confessed to the murder of Earle Remington. He said he and a number of other ex-servicemen had lain in wait for Remington and shot him as Earle was parking his car in the driveway of his home. Lawrence Aber went into the story of the murder in detail and stated he killed Remington because Remington was selling war veterans liquor and drugs.

Portland police discovered that at the time of the murder a number of war veterans were questioned by the LAPD. Aber was one of them. Three days after the murder Aber failed to report back to the hospital after he had obtained a leave and was marked "missing" on the records. When questioned about Aber, Virginia Remington, who had worked with veterans, said she did not know him. Aber remembered her, however. He said he had attended a number of social affairs given by Virginia for the disabled war veterans. However, some of the things Aver told police did not jive with the facts. He said that on the night of the murder Mrs. Remington had attended a party and entertained a group of veterans. Police knew she had been ill and was at home all day with her maid. Aber also stated he hid the shotgun which killed Remington near the house of the slain man. The weapon, police declared, was never found. According to hospital staff, Aber was mentally unbalanced. In addition, he was seen asleep in his bed at the Sawtelle soldier's home at the time of the murder. His story was not to be believed. He was turned over to Army authorities at Camp Lewis for observation and treatment.

The Remington murder investigation took another turn when Earle Remington's will was filed for probate two weeks after his death. Instead of being practically bankrupt, as police investigation indicated, he left a gross estate of $150,000 to his wife.

Misfortune followed Virginia Remington following her husband's murder. Her sister and two brothers died, leaving her terribly alone. Her finances, once thought plentiful, vanished, she said because of ill advice from alleged friends. So who killed Earle Remington? On March 9, 1971, Virginia Remington died. If she knew anything about her estranged husband's murder, she took the secrets to the grave with her.

Murder of a Bootlegging Husband

S ome wives helped their husbands in their bootlegging operations, such as Vittoria Bialo of Springfield, Massachusetts, who claimed to be the real brains behind the family operation. Others, such as Los Cerritos housewife Julia Lee Johnstone, had a hard time dealing with their husband's illicit activities.

At first when Tom Johnstone suggested to his wife Julia that they purchase a home in the upscale Los Cerritos neighborhood near Long Beach, Julia was delighted. Only later did she realize the only reason her husband wanted the house was because it had a basement and Los Cerritos wasn't actually part of Long Beach. Tom had had run-ins with Long Beach police. It was too difficult to conduct "business" when he was constantly watched by local authorities. Los Cerritos was policed by county sheriffs and Tom was sure he could deal with them. Though Tom was "officially" a barber, most of his income came from bootlegging. A new home in Los Cerritos, with "friendly" county sheriffs, was the ideal place to expand his illegal operations and venture into a new money making operation—gambling.

When Tom told his wife that he was going to turn their handsome home into a gambling den and bootlegging headquarters, she was quite upset. When she complained, Tom told her that he would turn her and their 5-year-old daughter Jewell out into the streets if Julia continued to object. The young mother didn't know what to do. When Tom and two other men made measurements of the basement for the installation of pool tables and gambling apparatus, Julia became unbalanced. She could stand it no longer. She had put up with her husband's bootlegging activities in Long Beach, but since moving to Los Cerritos Tom seemed to be associating with even more questionable characters. He was making long night trips, becoming depressed and angry, taking his frustrations out on his family.

Julia's sanity collapsed when Tom came home at 3 o'clock the afternoon of July 7, 1921, with a group of men and a shipment of liquor. She begged him to stay at home and not to leave when the

other men did. He refused and she threatened to commit suicide. He laughed at her. Then he left.

As he walked down their front walk towards the waiting car, she fired a shot meant to frighten him. He turned to the house as he heard the shot, hesitated a moment, laughed and shrugged his shoulders. He then climbed into the car with his business associates and drove away. Julia claimed she then became hysterical and lost control.

By the time Tom returned home at 6:30 p.m. Julia had regained some control of herself. When she saw him playing in the yard with their little girl, she couldn't help but think what a poor example he was setting for their daughter. Enraged at the thought that she had married a criminal and that he was corrupting Jewell, Julia again pulled the gun on her husband. She told him to keep away from the child or she would shoot. Thinking she might also harm Jewell, Tom got in his car and drove off. Around 11 p.m. he returned bringing E.F. Howard, a Long Beach realty broker, and a number of bottles of whiskey. When Tom came to the door he was met by Julia, who had the revolver hidden in the folds of her dress.

She quietly told Tom that she didn't want him back. He told her to stop making a scene in front of Howard. As he started back to the car to unload the whisky, Julia followed. While Tom was in the front seat reaching for the bottles, Julia Johnstone snatched the gun from her dress and cried hysterically, "I have stood your way of living as long as I could," as she pulled the trigger twice. One of the bullets passed on through Tom's body and shattered the windshield of the car. The other went straight through the heart.

A moment later their next door neighbor M.E. Taylor drove up to his home. He had just gotten off of work in the oil fields. Julia, with the revolver still in her hand, went to Mr. Taylor and asked him to take her to the police. While the kimono clad Julia was being driven to police headquarters in Los Angeles, Long Beach police chief McLendon, four of his men and sheriff's deputies rushed to the scene. On her way to the station Julia was quiet and cried only twice. She didn't seem to know what she had done. Young Jewell slept through the commotion.

In the county jail Julia told police about her husband's "business" and other events in her seven year marriage to Thomas Pleasant Johnstone. There was a nineteen year age difference between the two. Julia had married the 35-year-old Tom when she was 16. Tom, who

had originally come from Mississippi, worked as a cook and then a barber. He had undergone an operation a year earlier and since that time he had been unwell. She said he had used his barber shop to distribute bootlegged liquor, something she did not learn of for some time. He was reserved and seldom spoke of himself or his business. When she urged him to give up his bootlegging, he said he was making money and intended to continue. This was not unusual, she said. He often treated her as a "kid" and refused to take anything she, or any woman, told him seriously. Julia had finally snapped and carried out her threats.

Released on $10,000 bail, Julia Johnstone faced a jury of ten women and two men in February 1922. The verdict they reached was manslaughter, with a recommendation for leniency. On April 21, 1922, the 25-year-old mother was granted nine years probation based on temporary insanity at the time. She later married Oscar Conway, a Long Beach fireman. The couple, Jewell, and Oscar's son Harold moved to 5820 California Avenue in North Long Beach, to start anew.

Moonshine

It was an era of secrets and caution, hush-hush meetings, covert activities. You didn't know who to trust. A neighbor, relative, or business associate could be harboring a secret. Some wives who asked why their spouses were out all night were told "you don't want to know." Many husbands were bootleggers, trying to earn an extra buck to help the family. Others were making their own moonshine.

It was quite profitable, though risky, to make your own brew. But many ignored the dangers. According to author Clifford Walker, only ten percent of alcohol used in California during Prohibition came from Europe or Canada. Ninety percent was made right here. Five-gallon cans of 180 proof cost $25. It could make ten gallons of 90 proof gin by adding water and juniper berries. The buyers, local bootleggers who sold it by the pints, would cut it in half with water, making it 45 proof.

Los Angeles Times reporter Clark Dodge told of a young Italian who came to America in 1923 and bought a five acre chicken farm. His envious neighbors, amazed at his growing success, began to suspect he had the original hen that laid the golden eggs for the giant Jack killed. The Italian immigrant began to disappear with increasing frequency while his little farm continued to show every sign of prosperity. Suspicious neighbors notified authorities who searched the farm twice, finding nothing. The third time they succeeded. Beneath the front porch steps of the farm they found a passage which led 25 feet underground. Here they encountered the Italian chicken farmer quietly tending a giant still. In an adjoining cavern they found hundreds of barrels of mash and moonshine. At least the Italian chicken farmer was making a "safe" brew from ethyl alcohol, for many bootleggers made their concoctions from distilled industrial (methyl) alcohol, which could be extremely poisonous.

Since 1906, the United States government had required that manufacturers denature (poison) industrial alcohol or else pay liquor taxes. Bootlegger chemists came up with several denaturing formulas to do away with the poison. The simplest formulas just added extra methyl, or wood, alcohol into the mix. These formulas didn't always work in removing the poison and on average 1000 Americans died

every year during Prohibition from the effects of drinking tainted liquor.

In the summer of 1926, amid indications that bootlegger chemists were gaining on the denaturing front, dry advocates in Congress demanded tougher measures and better poisons. Their position was that if Americans persisted in flouting the law, if they continued to evade the hardworking law enforcement agents, then perhaps the best way to enforce Prohibition was to make alcohol so deadly, so undrinkable that even the most devoted boozer would have to give it up, or die.

On December 31, 1926, the Treasury Department announced it would now require that denatured alcohol be made so poisonous that the chances of bootleggers distilling it out were slim. It seemed the federal government had adopted a policy that would kill people in droves, at least those who could not afford the pricey higher-quality alcohol on the market.

Bootleggers had two types of alcohol available for their moonshine: methyl (wood) and ethyl (grain). If a drinker cared to notice, the first difference between wood and grain alcohol was in how long the buzz lasted. With wood alcohol, the period of cheerful inebriation was shorter; the sensation of a hangover could come within an hour or two. If the dose was high enough, a few drinks rapidly led to headache, dizziness, nausea, a staggering lack of coordination, confusion, and finally an overpowering need to sleep—or, far too often, to blindness, followed by a coma, then death.

Wood alcohol had been one of mankind's earliest discoveries; it had been used by ancient Egyptians in their embalming processes and had been an essential ingredient in homemade whiskey for centuries. The process was simple. As the wood cooked into charcoal, its natural liquids vaporized. That vapor could be cooled, condensed, and distilled into a rather murky soup containing methyl alcohol, acetone, and acetic acid. A second distilling would separate out the pure methyl alcohol, a liquid as clear as glass and as odorless as ice, from the other ingredients. Methyl alcohol could be used as a solvent, to make varnish, as an ingredient in dyes, and as a fuel. It was put into a host of household materials including essence of peppermint, lemon extract, cologne, aftershaves and liniments such as witch hazel. It was also used to "denature" grain alcohol, which essentially meant changing drinkable spirits into a lethal industrial product. It was so

poisonous an estimated two tablespoons of an undiluted mixture could kill a child, a quarter cup a man.

In contrast, grain alcohol was derived from the fermentation of fruits, grains, and even vegetables. Before Prohibition it went into the best corn whiskies like bourbon, and could be used to make beer, scotch, and hard apple cider. It was also essential in fermented grape products from wine to brandy. Responsible moonshiners went straight to the source, distilling "real" grains to turn into ethyl alcohol, none of that unsafe denaturing of toxic industrial alcohol involved in their brewing operations.

It was hard to keep the grain-made moonshine a secret. Moonshiners, both large and small, had a constant problem: they had to dispose of the leftover fermented mash, which called for clever solutions. Yet despite these novel methods, their illicit operations were often given away by farm animals and wildlife.

A drunken bull, staggering and bellowing, led authorities in Underwood, Washington, to a secret still. Officers followed him as he pursued an erratic course through the underbrush, back to a barrel full of mash.

John King, a North Carolina farmer, found two of his cows lying on the ground in a stupor, apparently suffering from some strange malady. A veterinarian was called and after a lengthy examination pronounced both animals as merely "beastly" drunk. A search for the cause led to the discovery of a big moonshine still in a secluded corner of the pasture. The cows had eaten a quantity of the mash used by the illicit whisky manufacturers.

Sheriffs in the California deserts watched the flies. If a fly landed on their arms and the sheriffs were able to swat it without much speed and effort, they knew the fly's motor-sensory reactions were deadened by the sweet run-off of the stills. They knew a moonshiner was in the immediate area.

The major telltale sign of a grain alcohol distillery, however, was the smell. It was almost impossible for distillers to eliminate telltale odors emanating from the boiling of fermented grains. Just the scent gave authorities enough proof to search a location. That the "nose knows" was evidence enough in most courts to justify a search warrant.

Some moonshiners boarded up the still area, trying to prevent the smell from wafting outdoors. This proved dangerous. The lack of proper ventilation frequently caused alcoholic fumes to gather and ignite. But moonshiners were a quick witted lot. They found that burning rubber (in a well-ventilated area) overcame the peculiar odor or, better yet, putting lime into the boiler stopped the smell at its source.

A major misconception about Prohibition was that it made all alcohol consumption illegal. Not so. One concession of the Volstead Act was that it allowed families to make a yearly 200 gallons of wine or hard apple cider for home use. Though beer was not permitted, wine and cider use allowed the country a little alcohol. One local man who took advantage of this compromise was Nick Papadakis of San Pedro. Papadakis started with a small Greek restaurant; with the help of Prohibition he expanded his assets to several million dollars. He sold grapes for wine, bought fields of grapes, took orders from door to door and delivered. He rented out crushers and pressers to local Italians and Slavs who made their legal 200 gallons.

It wasn't difficult to make wine. First the grapes were crushed, and then placed in a tank to ferment; after about 15 days the liquid was drawn off and remaining pulp was placed in the press to squeeze out the residual wine. Wine was then placed in 50-55 gallon casks and these were left open for a period of time because fermentation could cause a stoppered barrel to burst. The true treasure was the sediment on the bottom of the barrel after filtering; if you had a copper still (which was illegal) with a serpentine coil going through a bucket of cold water you could make grappa—a type of 110 proof Italian brandy. This grappa was sometimes run through the still again, this time coming out as straight alcohol of about 195 proof, which, when cut with distilled water, would be about 90 proof. Papadakis, who made much more than his allotted 200 gallons, prospered.

Another legal exception to Prohibition law was that pharmacists were allowed to dispense whiskey by prescription for any number of ailments. Bootleggers quickly discovered that running a drug store was a perfect front for their trade. As a result, the number of registered pharmacists and pharmacies in Long Beach tripled; one has only to look at the number of drug stores listed in city directories from 1920

onwards to see the explosive growth. Some were known by locals as "drugless drugstores." The drugstore had a sign that said it was a drugstore. It had a druggist. What it didn't have was drugs. The shelves were filled with boxes allegedly containing all the nostrums ordinarily sold in drugstores, but with one small difference: all the boxes were empty. You couldn't buy an aspirin at the drugless drugstore. What you could buy from the registered pharmacist was straight grain alcohol, the liquor of choice for many.

It was quite easy to get alcoholic "prescriptions" from your local druggist. Reputable doctors often signed medicinal whisky prescription blanks, selling the entire book to the druggist, fifty to a book. These prescription blanks resembled banknotes and were issued by the U.S. government. Each one entitled the "patient" to one pint of the finest bonded whiskey. Each drugstore was allotted pure grain alcohol in quantities necessary for prescription preparation. It was delivered in shiny five gallon cans of 180 proof. Some druggists immediately cut it in half with distilled water to create 90 proof alcohol. Some ladies bought Lydia Pinkham's tonic, regularly. It was near 20 percent alcohol. A certain drug store at Broadway and American Avenue in Long Beach would mix up a "medicine" of alcohol grape juice or whatever flavor the purchaser desired. All one had to do was place an order and wait ten or fifteen minutes before their $3.75 "prescription" would be delivered.

One young Italian remembered his dad going to the local drugstore and coming home with all the necessary extract flavors to make such things as rum, brandy, whiskey, cognac, etc. When a customer came to the house asking for any of these, his father would go to the basement, fill a bottle with 90 proof grappa extract, put in the necessary flavor, add a little color, hit it with a red hot, old fashioned curling iron to give it that mellow flavor, cork it with the corking machine imported from Italy, bring it upstairs to the customer telling him the bottles were good five-year-old stuff, imported before Prohibition. A little dirt on the bottle helped convince the customer it was aged.

Celia Ortega Villegas' father had a unique moonshine operation in Wilmington, California. During the Depression, when many other Mexicans were poor, Sr. Villegas would rent various houses, allow the down-and-out to live there rent free if they'd work his still. He supplied their food too. She remembered her father helped anyone. He lent

people money to pay their bills, gave some down payments for homes, never turned down anyone at the door for food—a one-man welfare system.

Bat Falcone of San Pedro told author Clifford Walker that bootleggers often frequented the local pool halls across from the Mission and the Lasalle hotels. When a thirsty player wanted a bottle his contact left and returned in a few minutes with a pint. If a buyer complained his purchase was clear, not brown (the clearness indicating it was moonshine not real whiskey), the bootlegger would agree to get him the "good stuff," disappear a few minutes and return with nice brown whiskey. When the customer tasted it he was satisfied he had gotten the real thing. Others in the hall nudged each other and snickered. They knew what the bootlegger had done. He went outside, spit some of his chewing tobacco juice into the bottle, shook it, looked at the color, chewed some more and again spit into the bottle until it was just the right color.

Dying for a Drink

D ifficulty walking, blurred vision, slurred speech, impaired memory; all of these impairments are usually detectable after one or two alcoholic drinks. Initially, alcohol produces a feeling of relaxation and cheerfulness, but further consumption can lead to problems including domestic violence, child abuse and even murder.

May 9, 1926, was a night Adelaide McLaren would never forget. After an evening of heavy drinking and some amorous adventures, Adelaide McLaren and her husband, Forrest, lay on the bed in their home at 900 East 8th Street in Long Beach. Still playful, but highly inebriated, Adelaide grabbed a knife from the kitchen and asked her groggy mate where she should thrust the knife and, when he had indicated the spot, she drove it home. She then passed out. When she woke in a pool of blood she gradually realized what she had done. At a loss at what to do, she turned to the one person who had always helped her out of jams in the past—her brother, John Reynolds.

Reynolds, unable to get a coherent answer from his sister as to whether Forrest was alive or dead, thought it best to immediately call a doctor. He arranged for Dr. William J. Ryan, a prominent Long Beach surgeon and physician, to meet him at the McLaren home. When Ryan arrived Reynolds gave him $3135 as hush money to keep quiet the fact that alcohol was on the scene, and for medical expenses needed to tend his sister's husband. Seeing Forrest's deteriorating condition, Dr. Ryan rushed McLaren to St. Mary's Hospital. Forrest McLaren died there on May 11th, but not before telling authorities he had fallen on the knife. The police didn't believe his story.

Upon further questioning, authorities found the McLaren's had been partying with Homer Rowe and Constance Whaley, both of Long Beach, who told another story. The four had planned to drive to Los Angeles for a show and, Rowe testified, the McLaren's had gotten into an argument over who should drive. Adelaide had struck her husband over the head with a shoe before the stabbing, and then dragged him off to the bedroom to sober him up a bit. Rowe, however, was already semi-passed out on the bed. He testified he was lying on the bed beside McLaren when Adelaide approached her husband and told him she was going to stab him. Rowe said he didn't see Adelaide fulfill her

threat, but an instant later Forrest sprang from the bed crying, "She's got me." A similar testimony was given by Constance Whaley who said she saw the knife in Mrs. McLaren's hand but didn't see the actual stabbing because she and Rowe decided things had gone too far and left the apartment.

Adelaide McLaren, who confessed to the stabbing, was charged with first degree murder; the charge was later reduced to manslaughter. Police said they were amazed over how calmly the 32-year-old woman described the stabbing that later led to her husband's death. Though efforts to have her confession thrown out on the grounds that it was made while she was still under the influence of alcohol, she was found guilty and sentenced to serve from one to ten years in San Quentin.

But this was not the end of the tale. Dr. Ryan was thrown into Long Beach City Jail on September 30, 1926, on charges of embezzlement. John Reynolds wanted his money back. He hadn't counted on his sister's eager confession. The matter was settled out of court.

———

Why alcohol, reported by many drinkers as a way to unwind and relieve stress, turns someone who can ordinarily squelch their aggressive tendencies into a raging bull looking for a fight is still not known. But liquor can fuel the fire of aggression in some people, which is what happened on a Long Beach farm. Rudolph Steiner, manager of the Los Cerritos Dairy and Cattle Company's ranch on Cherry Boulevard in North Long Beach was booked for murder. He was said to have shot and killed "Harry, the One-eyed Milker," later identified as Harry Sanders, in an altercation at the ranch shortly before 4 p.m. July 20, 1926.

According to Steiner, and ranch hands who witnessed the affair, Steiner had shot in self-defense. His life had been threatened by two drunken ranch hands, Harry Sanders and Carl Aslater, who had returned to the farm after a drinking binge. An intoxicated Aslater demanded his pay check and after getting it, wouldn't quiet down. Told to behave themselves, the men refused and Steiner had them locked in a smoke house until they sobered up.

Meanwhile, city dairy inspector Dr. A.J. Bergen, checking out the farm at the time, became alarmed at the men's behavior and tried

to get official aid from Long Beach police, without success. The area was outside of their jurisdiction, they said, the sheriff's department needed to be called. After an hour in the smoke house, Sanders and Aslater seemed to have settled down. They pleaded to be let out, and after repeated plaintive pleas from the pair that they had sobered up, the imprisoned men were released. But their anger had only increased during their hour "time out" in the shed.

When freed, Harry Sanders made good his threats against Steiner, following him to his house and slugging him repeatedly in front of Steiner's wife. Alerted by her screams, several ranch hands rushed to the scene and tried to stop the one sided battle, but the still intoxicated Sanders attacked them with his fists. Finally, a seemingly subdued Aslater dragged his drinking buddy Sanders back to the bunkhouse. Here, it was later determined, they fortified themselves with more whiskey.

Steiner, his shirt bloodied from Harry Sanders' attack, changed his clothing and went back to work. This time he had a revolver in his shirt. He wasn't going to put up with any more physical abuse from the drunken cow hands. Their courage boosted by alcohol, Sanders and Aslater followed Steiner to the cow barn, Aslater still demanding the money which Steiner had already given him. Not believing Steiner's claim that he had given Aslater his pay a few hours earlier, Sanders made a move toward his hip pocket while still approaching Steiner. Believing Sanders was reaching for a gun, Steiner pulled his own weapon and fired twice in the air. As Sanders kept on coming, Steiner fired four more shots. One struck Harry Sanders in the stomach. The wounded man turned and ran thirty feet and then fell dead.

Shortly thereafter sheriff's deputies, responding to the earlier call, arrived and Steiner surrendered to police. An almost empty whisky bottle, said to have been full when the two men arrived at the ranch, was taken as evidence. Aslater fled in his automobile after the shooting.

On July 23, 1926, a coroner's jury returned a verdict of justifiable homicide. Steiner was released. Aslater, never found.

———

Thanksgiving. A day when you get together with family and friends, eat way too much, then take a little snooze before tackling the pumpkin pie. When Willis Park found his brother Arthur lying on Willis' couch

at 1045 Redondo Avenue in Long Beach Thanksgiving Day of 1928, he assumed he was sleeping off his meal, and perhaps a little too much alcohol. Upon trying to revive him, Willis discovered his brother was dead. Of course Willis hadn't served any alcohol at the family dinner, it was illegal, he told police, but he suspected his brother, just off his shift in the oil fields, had done a lot of imbibing before coming to dinner. Had Arthur passed away because of bad moonshine?

Willis Park said it was late in the evening when he finally realized his brother was dead. He thought Arthur had died from bad whiskey, or maybe a heart attack. Willis called a doctor, who only made a cursory examination of the body, declaring Arthur to be dead and advising Willis to notify the coroner. It was later determined that Arthur had died between 4 and 5 o'clock in the afternoon, but it was not until nearly 11 o'clock that Willis became alarmed because Arthur had been asleep so long.

Willis certainly thought a poisonous batch of homemade brew had done his brother in; it couldn't have been his wife's cooking, but undertakers embalming the body disagreed. They found a bullet hole in Arthur's left breast when they were preparing the remains. The bullet had traveled downward, coming out at the back near the spine. Police later found the bullet lodged in the woodwork of Willis Park's apartment. They were positive Arthur's death could not have been suicide. Police were baffled in trying to determine how Arthur Park, thought at first to have died from alcohol poisoning, was shot through the heart.

A contrite Willis later admitted finding a .22 caliber automatic pistol on the floor beside the couch, and to having served alcohol with dinner. Willis said he picked the gun up and put it on a shelf thinking his sleeping brother had dropped it there accidentally. He said he never entertained the idea that his brother might be dead.

Marie Park, Willis' wife, told a slightly different story. While cleaning up after the holiday meal, she said she found the gun on the kitchen stove and hid it in the back yard. She confessed that she had quarreled with her husband and he had told her to get out, he didn't want her there anymore. Fearing he might find the gun and come after her with it, she fled and went to a hotel for the night. She claimed she did not know who owned the weapon and had never seen it before. She did acknowledge seeing Arthur on the couch, and thinking he was "sleeping off a drunk."

When police found the pistol in the back yard of the Park's apartment, it was empty, not even an exploded cartridge was found in it. Police believed someone following the shooting had picked up the gun, unloaded it and ejected the exploded shell. The empty magazine was later found in the coat pocket of the dead man and loose bullets were found in pockets of his vest.

Police experiments with the weapon showed that it would have been almost impossible for Arthur Park to have shot himself. They were certain that the gun's muzzle had been held at least a short distance from Arthur's breast at the time it was fired. Willis Park was arrested and held on suspicion of murder. Wide discrepancies between his stories and those of his wife led to the charge.

Willis told police his brother had been drinking heavily prior to arriving for Thanksgiving dinner, but the autopsy revealed no alcohol in Arthur's system. Neighbors told investigators they heard the brothers shouting at each other during the afternoon. They also said Willis' anger had driven his wife from the house. He had told her not to come back. Had Arthur tried to calm Willis down after Willis' argument with Marie and been shot for his efforts? Despite all of these incongruities and a possible motive, Willis continued to deny killing his bother.

On February 21, 1929, the murder charges against Willis Park were dismissed. A supposed suicide note had been found in the home of Arthur and Willis' sister. Though it was unsigned and had no address, the handwriting seemed to be that of Arthur. Additional testimony failed to produce enough evidence to determine if Arthur Park had been murdered or had committed suicide.

Alcohol can loosen inhibitions and bring out bravado in a drinker. Among friends many "cut loose" and talk about the most personal of matters. Such was the case with 42-year-old Edgar H. Rucker who, during a drinking party the night of January 18, 1932, boasted to friends that he had killed his former wife. The problem was that no one took Rucker seriously. To add credence to his claim Rucker began to describe the act in detail, insisting he had "shoved a gun against her and let it go bang, bang, bang!"

From 10 p.m. until long after midnight, Rucker, waving two revolvers, demonstrated to his drinking buddies how he had "shot up the wife." He finally became so drunk that the friend, Lee Armstrong, whose car he had borrowed earlier in the evening asked him to return the car keys. Rucker agreed, but before they returned to the car Armstrong took Rucker to a downtown café to sober Rucker up a bit.

With the much needed jolt of caffeine in his system Rucker was able to lead Armstrong to the auto parked near the apartment house on East Fifteenth Street managed by Rucker's ex-wife Jennie Curley. As Armstrong went to get into the car Rucker had borrowed he saw a huddled human form on the car floor. Armstrong couldn't believe it. Rucker had been telling the truth. It was Jennie Curley. The 42-year-old woman had been shot four times.

While the much rattled Armstrong placed a call to police, Rucker disappeared. Twenty-four hours after the shooting a now sober Rucker crawled out of a mud hole north of Signal Hill, and tramped back to Long Beach and surrendered to police. He had considered killing himself, he told authorities, but lost his gun in the mud while he was in his drunken, befuddled condition. He said he shot his ex-wife when she refused to come back to him. He kept telling police he wanted to join Jennie. He was penitent, docile and afraid of the consequences, police reported.

Rucker said he wasn't drunk when he shot his ex-wife, but later tried to drown his regret in alcohol. After making a complete confession Rucker was placed in a cell, dejected and disconsolate. In the morning following his arrest he awoke a raving maniac. Possessing tremendous strength, the 200 pound Rucker fought off six policemen before he was subdued and placed in a strait jacket.

Rucker, who continued to show belligerence, was committed to the psychopathic ward of the General Hospital following a psychiatric examination. After being held there for nearly two months he was judged to be insane and committed to the State Hospital at Patton in San Bernardino County.

Tijuana Troubles

If any Long Beach drinker wanted a "legal" swig during Prohibition all they had to do was travel 109 miles south to the Mexican border. Many paid for the trip by smuggling liquor back using ingenious ways. Women who appeared pregnant escaped across the border with liquor in soft rubber bottles around their waists. Corpulent appearing men were found to have false vests that yielded as many as two dozen pints. However, it wasn't until 1926 that U.S. authorities finally caught onto the chocolate scam. At first they found it curious that there was a remarkable increase in chocolate coming back across the border. Sampling the sweets, customs agents found that each piece of confectionary contained a large dose of Scotch. Yet not one of the owners admitted knowing the chocolates were loaded.

Only two miles south of Tijuana, and just a half-hour's drive from San Diego, lay the Tijuana hot springs, also known as Agua Caliente. Here thirsty Americans, unable to get a legal drink at home, could come and not only quench their thirst with any kind of drink known to man, but also gamble to their hearts content. Located in a spot that just a few years earlier had been a brown desert waste, it had miraculously been transformed into a beautiful 655 acre green oasis with its own airport.

The resort was becoming known as the Monte Carlo of the new world, a place where money flowed as freely as the drinks. For years the resort would serve Hollywood and Southern California as an exclusive retreat, where Los Angeles reporters knew not to snoop. Charlie Chaplin, Mary Pickford, Douglas Fairbanks, and Clark Gable were frequent visitors; likewise Harry Cohn, Jack Warner, and other studio bosses. Margarita Cansino, later known as Rita Hayworth, would be discovered there, dancing in the cabaret.

Gambling first came into prominence in Baja California in 1916, with the construction and opening of the Tijuana Jockey Club race track. Racing was held there each winter until a new $1.5 million course, considered the finest race track in the world, was constructed at Agua Caliente in 1930. Capital to build it had flowed freely, no expense had been spared; it had been built with money made through lucrative, illegal American liquor sales.

Designed by architect Wayne McAllister, Agua Caliente was a prototype for Las Vegas, where McAllister would later create The Sands casino and hotel. Considered the best resort in Mexico, everything in Agua Caliente was of the utmost elegance. And well it should be. More than $3 million had been invested in a hotel, casino and gardens. There was a huge ballroom, Roman style baths which had cost $800,000, the Gold Bar and Casino where gambling chips were made from solid gold. But alcohol was the main reason people kept coming, and the Gold Bar was the most popular attraction.

Beer could be purchased at 25 cents a glass, made at a Mexicali brewery that had a hard time keeping Agua Caliente supplied. Liquors and mixed drinks were 50 cents a glass. Many could remember the days before Prohibition when a pail of beer cost 10 cents and a mixed drink or a glass of hard liquor also sold for a dime. However, Americans were happy to get a legal drink, even if the price was a little steep.

There was much to do besides sitting around the casino drinking and gambling. In the afternoon Agua Caliente visitors could go to the dog races, drink some more and lay bets on the runners. *Los Angeles Times* reporter John Steven McGroarty was amazed at how popular the dog races had become. Weekends brought in over 1,000 visitors each day, mostly Americans. With a $1 admittance fee and gambling revenue McGroarty described "piles and piles of money everywhere." Old Tijuana now looked shabby, McGroarty wrote, its cheap gilding fading, a place for Mexican peons and poor white trash.

With all of this money, most being deposited in San Diego banks, it wasn't long before a well-planned robbery began to take shape. Long Beach gangsters, with their rum running and bootlegging operations already in place, decided to expand their operations and make a try at stealing some Agua Caliente loot.

The gang gathered in San Pedro early in May 1929, to draw lots to determine which of them should attempt the hold up. With all the information in his hands concerning the removal of the money bags from Agua Caliente to San Diego, the crime boss, whose identity was a closely kept secret, calmly ordered his gangsters to murder the men guarding the money. It was well planned. The only thing the chief neglected to consider, however, was that they were stealing from fellow gangsters. There would be a price to pay.

On May 20, 1929, armored car drivers Jose Perez Borrego and Nemesio Monroy were on their usual drive from Agua Caliente to San Diego. They were carrying over $5,000 in cash and $80,000 in checks. Being heavily armed they did not anticipate a robbery, but they shouldn't have been so confident. Near National City they were ambushed and murdered by Long Beach gang members Marty Colson and Lee Cochran in a well thought out operation. However, Borrego and Monroy didn't go down without a fight. One of them managed to shoot Marty Colson. It would be this shooting and several anonymous tips that would bring about the arrests of the Long Beach gang.

Fellow Long Beach gang member Jerry Kearney had rented a house in San Diego as part of the overall plan. He and his wife Grace had moved in a month earlier, a seemingly happy couple new to the neighborhood. This is where the two murderers headed to look after Colson's wounds and divide the loot. Kearney's wife Grace and Lee Cochran tried to extract the bullet from Colson's shoulder, but instead severed an artery. They were forced to call in a doctor. Realizing the physician had to make a report to the police, Lee Cochran, his wife Marian and Jerry Kearney fled. Before they left Jerry Kearney burned all the checks obtained in the robbery in his back yard, but they did take the $5,000 in cash.

Five days after the sensational robbery/murder police announced they had arrested five suspects in the crime. The wounded Colson and Grace Kearney, who had remained at the Kearney house because of Colson's wounds, were the first taken in by police. But the Tijuana mob was out for revenge. Because of underworld threats directed against San Diego police, coupled with information that gangsters planned to take Colson from the county hospital by force, Marty Colson was moved to a specially prepared ward within the jail and an added guard placed about him.

Marian Cochran was at her 537 Redondo Avenue home packing when Long Beach police took her in for questioning. She said she knew little of her husband's movements, but did admit going to the Kearney's San Diego home where she saw Marty Colson bed ridden with his wound. After she and her husband returned to Long Beach he told her he was leaving for San Francisco and for her to also leave town.

An anonymous underworld "tip" led police to Lee Cochran and Jerry Kearney on May 25, 1929. Lee Cochran was found asleep on a

couch in a Los Angeles apartment. Under his outstretched hand lay an automatic pistol and a pair of brass knuckles. He made a move for the gun, but seeing he had no chance of escape he surrendered. Jerry Kearney was found in a Hollywood hotel, but he claimed to have had no part in the San Diego robbery/murder. Kearney did admit, however, to taking several shotguns, a rifle and a quantity of ammunition and dumping them into the ocean off the San Pedro lighthouse at Point Fermin.

After intensive interrogation, Cochran confessed that he and Marty Colson were the two who had killed the Mexican guards and taken the Agua Caliente money. Cochran explained that although he and Colson committed the crime, they received none of the cash taken in the robbery. He said he delivered the plunder to another man, whom he did not name. This other man, he explained, was the head of a major bootleg and crime ring on the Coast. To reveal his name meant certain death to Cochran and his family.

Two other suspected Long Beach gang members were still being sought for questioning: Marcel Dellan (known as "the Greek"), a San Pedro taxicab driver and gang associate, and Jean Lee ("Queen of the Smugglers") accused of helping wounded Marty Colson. Both later gave themselves up to authorities. There was not enough evidence to implicate them in the crime. Lee Cochran and Marty Colson, however, faced the death penalty.

Their trial made front page news when a rumor surfaced that an organized attempt would be made by underworld characters to rescue the defendants. Though this did not happen, there was plenty of excitement to entertain the throngs who were fortunate enough to get seats inside the courtroom.

The drama began when an imprisoned Marty Colson tried to slash his wrists. Guilt had overtaken him when he realized that if his buddies had left him to die they would be free. Now, because he was alive, others were implicated and facing criminal charges. During the trial, a remorseful Colson begged to be sentenced to die on the gallows for his part in the crime. At the same time he pleaded that all the blame be placed upon his shoulders and that mercy be shown Cochran. His almost hour long speech was so dramatic it brought tears to the eyes of many in the courtroom. However, nothing could induce Colson, or Cochran, to reveal the name of the man behind their crime syndicate.

On August 6, 1929, Martin B. Colson and Lee Cochran were sentenced to life imprisonment.

Jerry Kearney was later brought to trial and sentenced to county jail for liquor running. Grace Kearney and Marian Cochran were released on probation. Perhaps their sentences were light because San Diego Judge Andrews showed no compassion for the Tijuana resort. Comparing it to Sodom and Gomorrah, he believed Agua Caliente should be swept from the surface of the earth by the awakened moral sense of the citizens of this country and Mexico.

But this was not the end of the story.

It was only a few days before Christmas, December 22, 1929, when Long Beach residents heard two men shouting at each other in front of Helen Blake's house at 1055 Gaviota. The angry uproar was followed by a round of gunfire. John Nelson, alias Edward Ames, fell dead in the middle of the street. The killer, Marcel Dellan, fled to Los Angeles but quickly surrendered to his probation officer, S.H. Hamer. Dellan claimed self defense.

Dellan alleged that Ames, the alias he knew him by in Long Beach, was the ring leader behind the Agua Caliente robbery and murder. Dellan had at one time been connected with the robbery but was set free and placed on probation. He now claimed Ames tried to kill him to keep him from telling authorities about the crime chief's true identity.

Dellan hadn't started out to kill Ames, he said. He had simply gone to Helen Blake's home on Gaviota looking for his wife Zelda. When Blake's two children told him that both women had gone to Ed Ames' apartment at 774 Redondo, Dellan phoned his wife there to find out how long she would be—their seven children wanted dinner! Ames, overhearing the conversation, told Zelda to stay put, he had things to discuss with her husband. He told her to tell Dellan she'd be at Blake's house shortly and for him to wait for her. A nervous, frightened Zelda agreed to the lie. Had her husband found out about her affair with Ed Ames? Ames then loaded his .38-caliber revolver, picked up a large knife, and drove to the Blake home. Zelda, trembling with fear, stayed behind, not sure of what was to happen.

Dellan was making some phone calls when Ames entered the Blake house without knocking or ringing a bell. Hearing footsteps, Dellan

turned only to have Ames come at him with a knife. A fight ensued but Ames pulled Dellan outside, saying he didn't want to kill Dellan inside and mess up Helen Blake's house.

Neighbors verified the two men battled in the middle of the street. They gave a vivid description of what they saw: Dellan gripped Ames' hand which held the knife then butted Ames in the face; Dellan then drew a .45 caliber revolver, which he later informed police he carried because Ames had threatened his life a month earlier. After Ames yelled at Dellan, questioning Dellan's manhood and saying Dellan didn't have the nerve to shoot, Ames pulled out a gun and fired a shot at Dellan. Dellan then emptied his gun at his adversary.

Though Dellan's story, substantiated by disinterested witnesses, established a good ground work for self-defense, behind the scenes police found out about Ed Ames' and Zelda Dellan's love affair. It was later revealed that Zelda Dellan sold bootleg liquor for Ames, giving her an excuse to visit him frequently, but police believed her husband was not aware of the affair until after the fatal fight.

In the background of the entire story ran the Agua Caliente murder and robbery, as well as liquor selling. Searching Ames' apartment police found a letter from Lee Cochran, sentenced to San Quentin for participating in the border shooting. In the letter Cochran complained that somebody did not help him when he was in trouble, someone who he had previously helped who did not return the favor. He asked for Ames' help.

At his inquest Marcel Dellan identified Ames as the chief conspirator in the Agua Caliente robbery and subsequent slaying of the two guards. Dellan testified he had known Ames for several years and associated with him in illegal liquor transactions. In telling of the Agua Caliente robbery plans, Dellan said Ames was the boss behind the entire operation.

Dellan was exonerated of all blame after the jury heard the story of Ames' death from numerous witnesses. A verdict that Marcel Dellan fired in self defense was returned at the close of the inquest. What happened to the cash stolen in the robbery was never ascertained, but it didn't seem the Dellan family had it. In April 1930, Zelda Dellan, now separated from her husband, sued Marcel in a Sacramento court over failing to provide financially for their children. In June 1931, their divorce was finalized.

The Long Beach murderers had been lucky they hadn't killed the Agua Caliente guards in Mexico. One thing Americans wanted to avoid by all means was the Tijuana jail. Justice was not swift, trials were slow, as a young Long Beach girl accused of murder found out.

It all started on June 7, 1931, when Rose Porter's boyfriend, Edward A. Underhill, suggested they forget all the financial turmoil taking place around them and go have some fun. What better place to forget your troubles than Tijuana, Mexico, where one could legally drink, gamble and temporarily escape the pecuniary reality that was setting in. It was getting harder and harder to find a drink in Long Beach. Just four months earlier Long Beach police had arrested a record 266 people and confiscated 1293 gallons of intoxicants. It seemed the police were getting tougher on the bootleggers and prices had risen. Underhill thought it would be safer in Tijuana, where liquor was legal. Besides, if he took Rose and got her liquored up, maybe her Puritan values would waver a bit.

Rose agreed, with the stipulation they return to her home at 746 Cedar Street in Long Beach the same evening. After all, she had her reputation to think about. In Tijuana, Underhill began drinking heavily, while Rose stuck to just a few drinks. When Rose told him it was time to go home, he tried to convince her they should spend the night. She told him "no" in no uncertain terms. Underhill reluctantly agreed. Rose decided to drive because of Underhill's intoxicated state, but as they approached the Tijuana fire station he woke up, grabbed the steering wheel and pleaded with her to get a hotel room. Rose fought him for control of the car, but it was too late. The car ran into the side of the fire station, pinning 18-year-old fireman Santiago Rivera against a fire truck. The fatally injured Riviera died a short time later. Rose was arrested because she had been driving. Underhill was released.

The Tijuana police said Rose apparently was under the influence of alcohol at the time of the accident. Underhill wasn't much help, telling police Rose stepped on the throttle instead of the break. When news of the accident reached Long Beach, the press reported 27-year-old Rose and 48-year-old Underhill were honeymooning in Tijuana when the accident occurred. Later the truth came out and tongues began to wag

over an unmarried girl accompanying a much older man to Mexico. Despite the scandalous nature of the trip, the public rallied to Rose's cause. She was an orphan, the press stated, and had no one to turn to (though it later turned out she had a brother). $2700 was needed for her release—$1,100 for the parents of the dead fireman and $1,600 for the bail bond.

On August 27, 1931, through the generosity of sympathetic men and women throughout the Southland, the pretty Long Beach waitress who had been confined in the Tijuana jail for 13 weeks was released from the Mexican prison, free to come back again to American soil.

Rose was overwhelmed by the kindness that had been shown to her by strangers. She had only a bare pair of springs on which to sleep during the first few days of her imprisonment. Then a nurse in the Tijuana hospital sent her a mattress, and a friendly couple from Coronado contributed a pair of bed sheets and pillowslips, which Rose kept laundered. Nearly all of her meals were sent in by American eating establishments in Tijuana, free of charge. All in all, Rose said, people were good to her. What cheered her the most, she sobbingly stated, were the frequent visits paid by the mother of the fireman killed in the accident. She bore Rose no malice and insisted Rose come to see her before she left town.

The manslaughter charge against Rose was dismissed in view of the fact that the dead man's family had been taken care of by donations from Americans and Mexicans and the necessary bail posted. Underhill, who had worked as a cook at an auto camp in East Port, Idaho, before coming to Long Beach, had no contact at all with Rose following her arrest, though his family reported he was doing all he could for her. Rose returned to Long Beach in company of her brother, George Porter, and to a job secured her by a Long Beach citizens' committee which had played a major role in her release.

On June 15, 1929, John Alexander McClure, a 56-year-old Long Beach real estate agent, was found wandering the desert of Baja California outside Tijuana. He had an incredible story to tell. But had he really been kidnapped by two men at Laguna Beach, and what was the real truth behind the murder of his female companion?

McClure was found walking aimlessly near Garcia Dam, 12 miles south of Tijuana, Mexico, by 19-year-old Rodolfo Garcia who had been patrolling his family ranch on horseback. Garcia said McClure was wandering about in circles and his clothing was covered with caked blood that had run down from a wound in his head. Garcia loaded McClure on a horse and rushed him to the Tijuana hospital. After treatment McClure had a long story to tell about how he ended up in Mexico.

John McClure said he had met 40-year-old Myrtle Wood Crossiart four months earlier and had dated her a few times. On June 13, 1929, he had to go to Laguna Beach to look over some real estate and thought she might like to come along for the ride. She had readily agreed. Just before 7:30 p.m. he alleged his car was forced off the road by another vehicle. He declared that two armed men jumped out, robbed him of $65, forced him into their car and drove off. He assumed that Myrtle had gotten away and would notify police of his kidnapping. He said he didn't know why anyone would try to harm either of them because neither was financially well off.

Still dazed by his days wandering the desert, McClure said he was unable to give a description of the two men who had kidnapped him except that one was young and the other a little older. He had no idea what had happened to him after the initial kidnapping or how he had ended up in Mexico. McClure's head had been grazed by bullets, perhaps contributing to his confusion. An examination of McClure's bullet riddled hat provided a few clues. It showed that several of the holes were powder marked, indicating the bullets had been fired at short range. Inside the hat were the initials "H. A. B." Though McClure recalled trading his old hat and $3.50 for this hat in a Long Beach second hand shop, he had no memory of gunplay. Had he somehow escaped with his kidnappers in hot pursuit? Had they fired at him as he ran off into the Mexican desert? Had the trauma of the kidnapping and shooting caused him to lose his memory?

Gently, police told him about Myrtle. McClure seemed stunned when told that Myrtle Wood's body had been found hidden behind a signboard at Emerald Bay in Laguna Beach shortly before he was found in Mexico. In a raspy, choked up voice John McClure answered what questions he could.

McClure told police he was married with five children but was separated from his wife. He remembered meeting Myrtle at the Long Beach bandstand near the Pike in February, but emphasized their association was merely a friendly one. He had gone out for car rides with her, he said, and for this reason invited her along when he went to look over property in Laguna.

Ina Lowell, Myrtle's daughter told investigators another story. She said her mother was about to confront McClure and break off their relationship. Police became suspicious. Had an angry McClure actually killed Myrtle and made up the whole kidnapping story as a cover-up?

An autopsy established that Myrtle Wood Crossiart (she preferred to use "Wood," her maiden name) had died from a small caliber bullet wound in the left temple. Two sets of men's footprints and tracks of an automobile similar to the one driven by McClure were found near Myrtle Wood's body. It was unclear whether the footprints came from the same individual. It seemed McClure was telling the truth until an eye witness testified he had seen McClure shortly after the supposed kidnapping.

Harry H. Huffman, who lived in the same Long Beach apartment house as McClure at 120 West Tenth Street, claimed he saw McClure at his home on Friday morning about 12 hours after McClure said he started on the fatal trip to Laguna Beach with Myrtle Wood. Officers searched McClure's room and found a hat which investigators said was covered with clay like soil where Myrtle's body was discovered. They also discovered a handkerchief which the officers asserted was marked with bloodstains, as if it had been used to wipe the hands.

On June 19, 1929, John McClure was formally charged with the murder of Myrtle Wood Crossiart. Two days later McClure admitted that the three bullet wounds in his head were self-inflicted. He also admitted that he was present when Myrtle Wood killed herself with a revolver near Emerald Bay. He said he drove his car to San Diego immediately after Myrtle committed suicide and stored it in a garage. He did not say how he got to Tijuana, but did acknowledge he shot himself there the day after Mrs. Wood died of self-inflicted wounds. He said he believed she committed suicide because she was despondent.

Police still did not believe his story. After a night of drilling, McClure finally admitted that he had killed Myrtle Wood. He said he

had been courting her for several months, although each had a legal spouse from whom he and she were separated. McClure asserted that Myrtle was depressed about her situation in life. Her separation had forced her to support herself by working as a cook. She hated her job, feared her pending divorce and said she wished she could die. In the same marital muddle as Myrtle, McClure also thought of ending it all. They frequently talked of a suicide pact, but did not have the nerve to go through with it.

On the night of June 13th, they met for a drive along the coast. Myrtle told McClure it would be their last ride, that she would not meet him anymore. They rode through Santa Ana to Emerald Bay, where they stopped on the shore. After alighting from the car McClure shot the woman through the head, killing her. He asserted that she was willing to die and that she asked him to leave her body in a conspicuous place where it would be found. Following a brief return to Long Beach, McClure contemplated what to do. He then drove to San Diego, left his car and took a taxi to Tijuana where he hired a second taxi to take him to the area around the Garcia Dam. He wandered into the hills and shot himself in the scalp three times, intending suicide. Awakening alive on June 15th he stumbled upon Rodolfo Garcia who turned him over to authorities.

McClure was sentenced to life imprisonment. But he wouldn't be alone in San Quentin. His 28-year-old son, J.H. McClure, a barber, was serving a one to ten years sentence for an attempted robbery of a Garden Grove bank in 1928.

GAMBLING SHIPS & GANGSTERS

"Nothing so needs reforming as other people's habits."

Mark Twain. *Pudd'nhead Wilson*

Offshore Temptation

You didn't have to travel 109 miles to Tijuana to get a legal drink during the 1920's and early 1930's. A novel approach to allow both legal drinking and gambling arrived seven miles off the coast of Seal Beach on June 30, 1928, just in time for 4th of July celebrations. The steam-schooner *Johanna Smith* was luxuriously equipped with gambling halls and dining salons. People flocked to the 4,000 ton former lumber carrier to eat, drink and gamble on the ship which sported one roulette wheel, three crap tables, three blackjack tables, two chuck-a-luck tables and twenty-three slot machines that could handle coins varying from 5 cents to silver dollars. The gaming equipment, which came from Tijuana, was serviced by numerous attendants anxious to trade paper money for silver dollars, which were used as chips. There was even an impressive office, which looked like a bank, with huge stacks of silver dollars and currency of large denominations stacked about.

The *Johanna Smith* presented a legal quandary that the county, state and federal authorities didn't quite know how to deal with. There was no law preventing the ship from participating in what many thought of as "nefarious" doings since it was anchored outside the three-mile limit. The only legal loophole appeared to be stopping taxi-boats from carrying passengers to the ship.

Within days of the *Johanna Smith's* arrival, Long Beach City Attorney James K. Reid began what was to be a long battle. He issued an order forbidding water taxis to load and unload passengers bound for the gaming vessel at the municipal wharf. He based his decision on the fact that any boat using the city pier had to have a regular berth and a ticket booth, which the *Johanna Smith* did not. It didn't take long for the gambling ship owners to circumvent this law. Within days operators of the gaming vessel chartered five speed boats to haul passengers free of charge. There was no law which prohibited free boat rides.

Having lost round one, another legal ploy was tried. Section 318 of the State Penal Code, which prohibited anyone from soliciting, inviting or enticing persons to go to a place where gambling or other "immoral acts" were being committed, offered another legal base for arrests. Ship operators disagreed and quickly let their attorneys loose. The attorneys argued that if it was legal for auto taxi companies to solicit passengers

for trips to Tijuana, why would it be different for water taxi companies to solicit trade for the *Johanna Smith*, since both Tijuana and the ship were outside of the defined borders of the United States?

A statewide law was needed to stop what the March 14, 1929, *Press Telegram* called a "brazen attempt to nullify the laws of the State of California" in regards to gambling. Long Beach's own state senator, Frank F. Merriam, drafted the legislation which would make it illegal to transport passengers to any gambling resort. Though a formidable lobby in Sacramento was against him, the bill passed. It was quickly challenged.

In November 1929, a Superior Court declared Merriam's state law unconstitutional on the grounds that it interfered unreasonably with commerce guaranteed in the United States Constitution. If it were legal, the law would also prohibit buses and railroads from soliciting passengers for Tijuana, which also allowed gambling. This is exactly what ship owners had been saying. But Merriam would not quit. The issue was sent on to the California Supreme Court. It would take years for the courts to decide the matter. This was fine with the gambling ship owners.

In the meantime, the battle continued. Uncovering an old federal law buried since February 18, 1793, Long Beach vowed to hinder the boats as much as possible until the gambling men decided it was too expensive for them to run their taxis from Long Beach.

The provisions of the federal law passed 185 years earlier were originally aimed at piracy. It stated that any ship that failed to follow the activity provided in its license could be seized. The *Johanna Smith* was registered for coastwise trade, however she never moved, in obvious violation of her license. It seemed the "good guys" had scored a hit.

When the captain of the *Johanna Smith* received a court order to tow his ship to shore he refused, until a display of force made him change his mind. Angry, the captain brought the ship to Long Beach harbor in August 1928, where the *Johanna Smith* was held on a $200,000 bond. Since the ship, which had been operating just over a month, had made over $500,000 before she was seized, the owners easily raised the money to make bail. The game continued. It was the gambling ship owners' time at bat.

To get around the law a new gambling ship, the *Malfalcone*, formerly a cannery ship, was overhauled in San Pedro. The two vessels simply

switched spots along the coast every month as they appeared to "engage in coastwise trade," the stipulation of their license. To help deal with the water taxi question, ship owners arranged for a fishing barge to be anchored halfway between Long Beach and the ships. Here patrons destined for the gambling ships disembarked and boarded launches bound for the gaming vessels. Some just stayed behind to fish.

With city and county attorneys saying this was just a "subterfuge of justice," gambling ship operators became more innovative. In June 1929, they anchored the former movie ship *Centennial* between shore and the *Malfalcone*. The *Centennial* was advertised as a tourist attraction where visitors could fish or view the sites used in such swash buckling films as the *Battle of Trafalgar*. Then, if so desired, visitors could move on to the gambling ship. Few fished, and the inspection of the *Centennial*, now renamed the *Pirate Galleon*, was brief.

Troubles at Sea

It wasn't just legal battles the gambling ship owners had to contend with. Those notorious hijackers, the bane of rum runners and bootleggers, now had another target.

On May 20, 1930, warfare on the high seas broke out off the coast of Seal Beach. Five men boarded a water taxi belonging to the owners of the *Johanna Smith*, pressed a pistol against the pilot's head and ordered him to steer towards the *Malfalcone*. Arriving at the side of the other gambling ship the small boat was recognized by the lookout posted on the *Malfalcone*. Why was a water taxi belonging to the *Johanna Smith* approaching their ship? Ever vigilant, they sounded an alarm. As the five men climbed aboard the *Malfalcone*, a hand-to-hand battle ensued with guards and two shots were fired. The "pirates" won the skirmish and took possession of the ship and its proceeds. Fortunately, none of the 150 customers aboard were harmed, most taking everything in stride and simply returning to the gambling tables. When the owners of the *Malfalcone* complained to police about this blatant robbery the police laughed. There was nothing authorities could do, they said, since the ship was outside their legal jurisdiction.

Bad luck continued to follow the *Malfalcone*. On August 30, 1930, three hundred people barely escaped with their lives when the 282-foot gambling craft caught fire when the ship's gas line broke three miles off Belmont Shore. This time authorities didn't look the other way. Lives were at stake. Speedy rescue work prevented the loss of a single life, the crowd of thrill-seekers being transferred safely to the *Johanna Smith*, anchored nearby. Even the ship's cat was saved.

It had been a horrendous experience for those on board. Three minutes after the fire broke out in the engine room lights went off throughout the ship. The orchestra managed to keep customers calm by playing music while crew members ushered the guests to lifeboats for transfer to the *Johanna Smith*. A check-room girl found a candle and lighted it, handing out coats and wraps to the customers. In the gambling hall players panicked as they hurriedly tried to gather the money left on the tables. Four dealers tried to stop the scuffle for the cash but one table operator was thrown overboard. Fortunately, another

dealer leaped after him and hauled him to a lifeboat. These were the only people on the ship to actually get wet.

Thousands of motorists, out for a long Labor Day weekend, crowded the Pacific Coast Highway and beaches to watch the *Malfalcone* burn. By the time fire boats arrived from San Pedro the ship was already sinking. Ironically, it was the second ship to catch fire within a month. In July the *Pirate Galleon,* a.k.a. the *Centennial,* the former movie ship used as a relay point for water taxis traveling between shore and the gambling ships, suffered a severe fire.

The sturdy three-masted barkentine, built in 1874, had lived a full life. For many years she had sailed the world as a commercial vessel before she was discovered by Hollywood. Acquired by M.G.M. studios, she starred in many films, most notably pirate pictures featuring Douglas Fairbanks and John Barrymore. Anchored two miles off Pine Avenue Pier in Long Beach, the vessel burned when a staff member went into the hold with a lighted lantern. The crew member, 20-year-old Septimus Turnball, was severely injured, but survived. Fortunately, the incident occurred at 11 a.m. when few people were on board. Fumes from the gasoline caused an explosion which ignited the ship. Nothing could be done to save the once majestic vessel. Three hours later nothing but the smoldering hull of the *Pirate Galleon* remained.

An estimated $40,000 was on board the *Malfalcone* when she sunk, most of it in silver coin. Salvage operations recovered only one safe, containing $3,000 in silver and bullion, from the ship's remains, buried seventy-five-feet beneath the sea. The owners of the *Malfalcone* said $26,000 remained on the gambling tables before the vessel went down. There was little hope of recovering this money. Another safe, estimated to contain $11,000 was never found. Fortunately for the owners they had stashed away enough money to quickly purchase a new ship. The *Rose Isle,* formerly the *Rose City,* was promptly procured and converted into a gambling vessel. By October 1930, the old gunboat had been hauled from the scrap heap, renovated and was on her way from her former home in San Francisco to Southern California.

Gambling, like liquor, was another vice which could destroy a man. As the Depression of the 1930's took hold many, unable to find jobs, hoped to ease their financial problems by trusting in Lady Luck.

Scores of individuals, like Guy Bonner of Long Beach, believed the elusive lady was just around the corner. But as he lost more and more of his meager savings, Bonner began to have doubts. With his debts mounting Bonner could think of only one solution to his problem. In April 1930 he took a shotgun and killed himself at his home at 1051 Euclid Avenue. His gambling debts had caught up with him. The suicide note reprinted in the *Press Telegram* stated:

"My uncontrollable desire for gambling has made me a tramp. I went to that ship last night and lost all my money. I wrote checks and have no money to pay. I owe $2000." [17]

His death was still fresh in the minds of righteous Long Beach folk. So fresh, in fact, that the Reverend George M. Rourke, pastor of the First Presbyterian Church, preached about the vice of gambling in a Sunday sermon. In his homily Rourke charged that the Long Beach city council was in "cahoots" with the gambling ship owners because the council had issued a permit for a bus to run to the landing dock for the water taxis. He cited the good work of the Santa Barbara police who arrested anyone returning from the gambling boat as vagrants and gamblers. Why didn't Long Beach do the same?

The city council was angry at the minister's statements, saying the pulpit utterances were libelous and Rourke should be forced to retract his statements. Rourke refused, but he kept quiet from then on. He had no need to speak out further; his sermon had done the trick. Within three weeks a Long Beach city ordinance was drafted to prohibit buses, which the city could regulate, from carrying people to the boat landing where the water taxis left for the gambling ships. City Prosecutor John Hull took Rourke's rhetoric even further by following Santa Barbara's example. In November 1930, he introduced another ordinance mandating "that anyone who prevailed upon, by invitation or device, any person to visit a place where gambling was allowed, would be guilty of vagrancy."[18] It was the only means the city had to stop the vice they felt corrupting their city. They were quick to enforce the new legislation.

On November 29, 1930, hand-to-hand fighting broke out as Long Beach police staged a surprise raid at the docks servicing the water

taxis. Twenty arrests were made, despite the fact that the gambling interests appeared to have prior knowledge of the raid. Shortly after the police went into action attorneys for the *Johanna Smith* arrived at the ship's dock and announced that persons wanting to charter a taxi for a moonlight trip around the bay could do so. This would be their way to circumvent the provisions of the new city ordinance.

Kidnapping and Vice

It soon became apparent that more than just drinking and gambling was taking place on the gambling ships. Money laundering was going on as well. On December 21, 1930, the ongoing battle between local authorities and the mob came to a head when alleged Chicago gangster Ralph Sheldon (a.k.a. James Sherman) wounded Long Beach police officer William Homer Waggoner in a gun fight at the Long Beach harbor.

Sheldon and some confederates had just kidnapped Zeke Caress, a wealthy Hollywood gambler, bookie and Agua Caliente betting commissioner. They had forced Caress to write four checks totaling $50,000 and were on their way to the gambling ships to cash them when stopped by Long Beach police. A gun battle ensued. Waggoner was critically wounded and paralyzed from the hips down. What was to result in 1931 was one of the most sensational trials in U.S. history.

The shot that rang out on the night of December 21, 1930, and crippled Long Beach policeman William H. Waggoner, was the opening round in Southern California's fight against organized crime. From that moment on there was an all-out war to prevent gangsters getting a toe-hold in the Southland. All that kept the Los Angeles area from being as gang ridden as Chicago, the *Los Angeles Times* reported March 29, 1931, was lack of organized leadership.

Thousands of new faces had appeared in the illegal liquor business, hundreds of new stills were hidden in nearby hills, and ship load after ship load of liquor dumped on California shores had lowered the price of illegal alcohol to the point that no profit remained for the poor bootleggers. Many newcomers had been drawn into the trade because of the downturn in the economy; it was a quick way to make money when there were no honest jobs around to support a family.

By 1931 there were so many different factions involved in illegal alcohol and gambling, that there was no big money left to be made. Organization was needed, gangster leaders said. Elimination of competition whether by pistol, machine gun or bankruptcy was the only way out; the criminal element was just waiting for the right man to lead them out of the wilderness. The Southern California underworld

needed a leader strong enough to rule, which is the role Ralph Sheldon hoped to achieve when he kidnapped Zeke Caress.

The investigation into Long Beach policeman Waggoner's shooting amassed a mountain of evidence against the mob which had abducted Zeke Caress. It also sent shivers through the underworld when it was discovered that other wealthy men involved in horse racing and gambling had been marked for similar treatment. What's more it led to a record five week trial which cost taxpayers $100,000.

On that fateful Sunday night in December 1930, Long Beach police staged a routine raid on the gambling vessels off shore. Officers William H. Waggoner and Chester A. Jenks were caught off guard when they were fired upon by four men waiting to board a water taxi headed to the *Rose Isle*. The men had been sitting in their Dodge sedan when Jenks and Waggoner approached the vehicle. While talking with the driver one of the passengers in the rear seat picked up a gun and began firing at Jenks. As Jenks stumbled backward Waggoner came to his aid, running into the line of fire. They had no idea the men were gangsters involved in the Caress disappearance.

Another Long Beach police officer, W.E. Slaughter, quickly sprang into action. He managed to corner two men, but another two escaped, one with a bullet in his chest. A search of the two captured men revealed a surprise—four checks totaling more than $50,000 signed by E.L. "Zeke" Caress, Agua Caliente (Tijuana) betting commissioner. Authorities weren't yet aware that Caress, his wife and houseboy had been kidnapped. When questioned, the men said Caress had asked them to cash the checks for him to raise money for a stock deal. That was why they were going to the gambling ship *Rose Isle*, to cash the checks. Authorities demanded proof they were telling the truth.

The gang quickly hatched a new scheme. On December 22, 1930, Caress, his wife and houseboy were released by his abductors. It seemed the kidnappers' plot had been foiled by Long Beach police. But as future events would show, Caress did end up giving the gang $20,000 to leave him and his family alone.

Upon his release, Caress hastened to the Hollywood police station where he reported the kidnapping. In his statement he said he did not know any of those who kidnapped him, neither did he know why they chose him as their victim. Nor could he identify any of them in any

manner. Being involved in the underworld himself, Caress knew what would happen if he squealed.

When photos of Waggoner's two known assailants were published, one of them was identified as Ralph Sheldon, former henchman of Al Capone. He had told police his name was James J. Sherman. Other than that, he refused to talk. George "Les" Bruneman was the other man captured. Bruneman, a known business associate of Caress, said he was asked by Caress to accompany the kidnappers to the *Rose Isle* to vouch for the validity of the checks. When the shooting was over he had been found attending the injured Waggoner. He had readily surrendered to police, claiming he was being forced to accompany the gunmen.

Later, alleged gangster Ray Wagner was acknowledged as the wounded man who escaped, and purported mobster Louis Frank identified as the fourth man on the scene. An unmailed letter to Louis Frank, addressed to Phoenix under an alias of Larsen, was found in Frank's wife Clara's possession. Authorities traced Frank and Wagner to the Phoenix, Arizona, address where they were arrested and charged with assault with intent to commit murder.

On December 26, 1930, under jurisdiction from the new city vagrancy ordinance, which could lead to the arrest of anyone visiting a place where gambling was allowed, and memory of the attack on Waggoner fresh in their minds, police raided both the *Johanna Smith* and the *Rose Isle*. Seven arrests were made on the *Rose Isle* and a quantity of gambling paraphernalia was confiscated. More than 100 patrons on board fled the gaming rooms in expectation of gun play when the officers appeared. The gamblers offered no resistance, however, and the raid was completed with only a single shot being fired.

No arrests were made aboard the *Johanna Smith*. The manager of the craft produced a map showing the *Johanna Smith* was on the high sea and beyond the jurisdiction of the Los Angeles county district attorney's office. The ship was searched for known gangsters, but none were found and the officers left without making arrests or confiscating gambling equipment.

The following night, Long Beach police staged a raid on the water taxis servicing the *Johanna Smith*. Taxis were seized and their crews jailed. Patrons of the gambling vessel were told they would be liable to

arrest as material witnesses if they did not disperse immediately. The next evening armed guards from the District Attorney's staff patrolled the local waterfront to prevent patrons or employees from getting to the gambling vessels. This they continued to do until after the Waggoner shooting trial. The gambling ships were effectively out of business, for a while at least.

The case against the mob involved in Waggoner's shooting opened in Long Beach on March 17, 1931. Ralph Sheldon, George "Les" Bruneman, Ray Wagner and Louis Frank were brought from Los Angeles under tight security, an escort of autos armed with machine guns accompanying them. The exploits of Al Capone and the Chicago mob were fresh in the minds of Southern California authorities; they did not want any drive-by killings or mob retaliations. Many precautions were taken to guard the courtroom, with police scrutinizing everyone entering the building. Following a day of testimony, the jury was impaneled and locked up in the Breakers Hotel until the end of the trial, for safety.

Prior to the trial an attempt had been made by a man believed to be a henchman of Ralph Sheldon to buy Officer Jenks' silence with $10,000. The bribery overtures, Chief Yancy told the press, had been made when Jenks was on traffic duty at a busy intersection. A man drove up in a car, caught the officer's eye and displayed a huge roll of bills. "It'll be worth $10,000 to you," he whispered hoarsely, "if you'll scram out of town and not testify at Sheldon's trial."[19] When Jenks angrily showed he was not interested the man sped away. Jenks later told Yancy of the incident and explained he had been too stunned to arrest the briber before the man vanished.

The Long Beach trial turned out to be a show that outdid the wildest plots of a Hollywood crime writer. The defendants were represented by a galaxy of expensive legal stars that were determined to create a suspicion of "reasonable doubt" in the minds of the jury. Their attorneys based their defense upon four contentions: Bruneman was abducted and forced into the suspects' car; Ray Wagner was back east at the time of the battle; Ralph Sheldon fired no shots and the officers themselves started the gun battle; Louis Frank was registered at a San Francisco hotel the night of the shooting.

In their first round the attorneys were successful in getting the judge to tell the prosecution they could not bring Sheldon's past criminal record into the trial. Sheldon had been arrested 124 times in Chicago, but never convicted. He was known as the "King of Alibis."

There were daily surprises and drama for the jurors and spectators. Highlights included: moving the court to Seaside Hospital and taking the bedside testimony of paralyzed Officer Waggoner, who identified the suspects as his assailants; the appearance of a Glendale doctor who cared for Ray Wagner's wounds; a San Francisco hotel man who testified that a hotel registration card and receipt introduced to prove that Louis Frank had been in San Francisco at the time of the shooting, were fake; revelation of a plot to free the defendants on the last day of the trial and the rushing of reinforcements to the courtroom by Long Beach police and sheriff's deputies.

It was the statements of Zeke Caress and his wife about their kidnapping, extortion, and involvement of Bruneman in their plan for release, which gave credence to Bruneman's testimony. Bruneman recounted that Caress telephoned him and asked him to cash some checks. He was told some men would give the checks to him at Sixth and Spring streets in Los Angeles. At that intersection, he declared, two men in a car drove up and told him to meet them at Ninth and San Pedro streets. There, he said, he was forced to enter the car. His captors also forced into the car a man he identified as Sheldon, who, he said, had been standing at the curb. He then described the gun battle with Long Beach police, denying police accusation that Sheldon fired the shot which wounded Waggoner, insisting Waggoner disarmed Sheldon before the firing started.

When called to the stand Ralph Sheldon testified the first shot was fired after police officer Waggoner had taken away Sheldon's gun. Sheldon's attorney pointed out that Officer Winford E. Slaughter had the same kind of gun as Sheldon. Could it be that Slaughter had fired the shot that permanently paralyzed his fellow officer? This, and perhaps fear of mob retaliation, was enough for the jury to acquit the foursome of the crime.

Newspapers, the populace and attorneys were indignant. Much to the public's disgust several women jurors even patted Sheldon on the shoulder, one pleading with him to be a nice boy and mend his ways.

Blayney Matthews working with the prosecution had this to say about the verdict:

"I consider the acquittal a blot on the judicial record of the Southland. We believe the evidence against the four men was irrefutable, but for some reason the jury found them not guilty.

From the information I have received I understand there was a question in the minds of the jurors as to whether the police or the others fired the first shot. Does a policeman have to wait for a suspect to fire the first shot?" [20]

The Southland was outraged that the gangsters had gotten away with their atrocities, though many could feel sympathy for the jurors, whose names and addresses were printed in the local press, and who might be marked by the mob if they turned in a decision against the vengeful gang. An attempt at justice once again presented itself when the same alleged gangsters, and more of their mob, were brought to trial again in 1932. Now they were to face charges of kidnapping Zeke Caress, his wife Helen and Japanese houseboy, Tadashi Wakabayashi, from their Hollywood Hills home.

In January 1932, new evidence presented itself in the Waggoner shooting. Small time gangster Jimmy Doolen (a.k.a. James Gatewood) was charged with assault with a deadly weapon in connection with the wounding of Patrolman Waggoner. To protect himself, 30-year-old Jimmy Doolen, who later admitted both he and Sheldon had fired at Officer Waggoner, became the state's witness against Ralph Sheldon, Louis Frank and the others in the Caress kidnapping case.

Doolen had much to say that hadn't been revealed in Waggoner's case. Doolen claimed he, Sheldon and Wagner had worked out a deal with Caress' supposed friend Bruneman to help cash the checks from Caress. Bruneman was to get one-sixth of the $50,000 for his part in the kidnapping. Doolen said he had earlier discussed the names of wealthy men in Los Angeles who might be kidnapped for ransom and the name of Caress met with Bruneman's approval. Doolen swore he had driven the car to Long Beach that December 1930 evening, not Louis Frank. Frank was at the Alhambra house where Zeke and Helen Caress, and their houseboy, were being kept. Doolen added that everybody in the automobile had taken part in the shooting of

the Long Beach policemen except Bruneman. Bruneman had gotten hit in his rear end by a pebble chipped by a bullet and had been too preoccupied by his wound to do anything except yell. After the melee in which Waggoner was shot, Doolen leapt into the ocean and swam out to a derrick about 100 yards away, staying there until the coast was clear. He then made his way to Ray Wagner's home at 534 W. Seventh Street in Long Beach where, after about an hour Wagner came in all covered with blood.

It was hard being a "snitch." Doolen was visited in prison by Sheldon, who was out on bail, and threatened with death if he did not repudiate his confession. Doolen said Sheldon was the ring leader in the Caress kidnapping and that Sheldon had connections in the jail that would "do him in" if Doolen didn't cooperate. Doolen was further confused by a telegram he received from St. Louis which stated that attorney Paul Tapley would represent him. The note had been signed by "Dad," but Doolen's parents had been dead for some time. Tapley said he had been hired by Doolen's stepfather, but Doolen said he had no stepfather.

Police believed the communications were from a St. Louis gang, not from Doolen's so-called stepfather. Doolen told authorities he feared for his life if Tapley became his attorney. Tapley countered that he did not believe what the police were telling him about Doolen's decision, and that Doolen was being held from seeing his attorney against his will. Tapley said he would plead Doolen not guilty by reason of insanity, but he wanted him back in county jail so he could interview him. Judge William C. Doran heard both sides in the attorney-client argument and released Paul Tapley as Doolen's attorney. To protect Doolen, police officers continually moved him to keep him from the alleged death threats.

On February 8, 1932, Zeke Caress told the court about his kidnapping, but said he was unable to identify any of the defendants. He described how, on December 20, 1930, he had arrived at the Santa Fe rail station in Los Angeles from San Diego and was met by his wife Helen. After purchasing groceries they went directly home. While removing the purchases from the car, an automobile drove up. Two men got out, and ordered him to "stick 'em up." Caress recounted how he and his wife were pushed back into the car, their eyes taped, and dark glasses put on to hide the bindings. While this was going

on, their Japanese houseboy, Tadashi Wakabayashi, came to help with the groceries, and he too was kidnapped. They were driven to another location and placed in separate rooms. Financial negotiations began with Caress to obtain his release. They discussed who would have $50,000 to cash the ransom checks and decided on the gambling ships. It was while trying to get to the *Rose Isle* that the kidnappers met Long Beach police.

Tadashi Wakabayashi was not afraid of mob retaliation. He was dying. In his deathbed deposition he identified Ralph Sheldon as the leader of the gang. On January 26, 1931, the Japanese chauffeur, suffering from tuberculosis, laid his hand on the shoulder of Ralph Sheldon, branding him as the "boss man" in the abduction of Caress and his wife. Forced to rest for fifteen minute periods during his questioning, he also identified Doolen as the driver of the kidnappers' car. Three days later Wakabayashi passed away, but his dying words and Doolen's testimony was enough for conviction.

During seventeen hours of testimony, Doolen revealed much about the mob. Jesse Orsatti, he said, was the "fingerman" who decided that Caress was a good candidate to "snatch," and who pointed out Caress as the victim to other gang members. Following Caress' release, Doolen said, the gang continued to extort money from Caress. Orsatti and Doolen had collected more than $20,000 from Caress after he had been freed by the gangsters. It was Les Bruneman who delivered the cash. Caress had been told his wife would be taken hostage and her ears cut off one by one, unless Caress came up with the money.

Doolen also contended that Louis Frank's wife, Clara, was the "banker" for the alleged mob, a fact she vehemently denied. Before the judge and jury she swore she had never met Doolen, never talked to him and had never seen him until the trial. A letter introduced as evidence from Clara to Doolen's wife, Georgia Browne, cast doubt over the validity of Clara's testimony. In any case, Louis Frank was in deep trouble. Not only was he charged with kidnapping, but also with perjury during the Long Beach trial (having claimed he was in San Francisco at the time of Waggoner's shooting), and violating the gun laws, since as a convicted felon it was illegal for him to carry a firearm.

When prosecuting attorney James Costello got his chance to cross examine Sheldon, a hush fell upon the courtroom. Finally, everyone thought, questions would be asked to poke holes in the obvious lies

they had been forced to listen to. They were in for a surprise all right. The only question Costello asked was if Sheldon, Sherman, or Short was the defendant's actual name. Answering "Sheldon," the accused kidnapper and gang leader stood up and began to leave the witness stand.

Jurors were outraged, and began to interrogate Sheldon themselves. "How does it come that you entered an automobile and drove to Long Beach with three other men whose names you didn't even know?"[21] a woman juror shouted. She was referring to testimony by Sheldon that he did not know the men with him and was innocent of any wrongdoing. "Well, I have done it before,"[22] was the best answer a befuddled Sheldon was able to give. For half an hour the jury continued, with the court's permission, to besiege Sheldon with questions. Some were answered but most objected to by the defense counsel and never explained by the witness. One juror later remarked that Costello's refusal to cross examine Sheldon was a "clever piece of work," very damaging to the defendant.

On March 16, 1932, despite testimony by Jesse Orsatti's brother and sister-in-law that Jesse had been at his brother's home trimming a Christmas tree and could not have been "pointing the finger" at Caress at the time of the kidnapping, justice prevailed for all three men. Convicted of kidnapping and extortion in just two hours and thirty-five minutes by a jury of eight women and four men, Ralph Sheldon, Louis Frank, and Jesse Orsatti were sentenced to ten years to life in prison.

At last there was a positive note in the Southland's war against organized crime—conviction! *Los Angeles Times* reporter David Winston ecstatically reported that "you can't get away with kidnapping in Los Angeles County!" He wrote:

"To racketeers who can read, here's the record: twenty-three crooks have tried to kidnap seventeen people in Los Angeles County in thirteen years. Two of them were hanged. Two of them are under sentence of death. The other nineteen went to San Quentin or Folsom penitentiary. Only two have been paroled."[23]

Three men, however, were still at large, Ray Wagner, Joseph P. "Bill" Bailey (a.k.a. Baillie) and George "Les" Bruneman.

Bill Bailey, out on bail, fled before the trial but was arrested in the Panama Canal Zone in June 1932 by a stroke of luck. A detective magazine had printed a story about the crime which included a picture of Bailey. The magazine found its way into a Canal Zone barber shop, where a 13-year-old boy was working. When Bailey came into the shop for a shave the lad recognized him from the photo and alerted the police. Returned to the United States, Bailey's trial began September 26, 1932.

Called on again to testify, Jimmy Doolen identified Bailey as one of the men assigned to guard Caress after the abduction. It was also Bailey's car which was used in both the kidnapping and the shooting in Long Beach, according to Doolen. On October 11, 1932, a jury quickly found Bailey guilty of kidnapping. Because of three prior convictions he was sentenced to life imprisonment, with no possibility of parole.

Ray "the Fox" Wagner, who had also skipped out on bail, was captured in Missouri in October 1932. He finally faced justice on December 12, 1932, with a "not guilty" plea. He claimed the bullet found in his chest when he was first apprehended was received in a brawl in St. Louis and that he had no part in the Caress abduction. Later he admitted being in Los Angeles at the time of the kidnapping, but maintained that Doolen had shot him after an argument in which Wagner refused to help with the Caress kidnapping. The jury didn't buy his story. He was sentenced to imprisonment for a term of ten years to life, the penalty for kidnapping under California law. He was released in 1947 and returned to a life of crime.

Les Bruneman evaded justice until February 1934. He had been living along the Canadian border, steadily maintaining his innocence through spokesmen with whom he kept in touch. Though Jimmy Doolen stated under oath that Bruneman had been in on the kidnapping plot all along, Zeke Caress testified he personally had chosen Bruneman as the go-between to cash the ransom checks. Caress said he believed Bruneman had acted in good faith throughout the entire matter and merely sought to aid him in escaping from the clutches of the gang. A dozen other witnesses added credence to Doolen's testimony including an apartment house manager who said he saw a man resembling Bruneman in Doolen's company shortly before the abduction, and a clerk in a radio store also saw the pair together days before the Caress kidnapping.

On May 25, 1934, Bruneman was sentenced to ten years to life in prison. But Bruneman appealed his conviction and in October 1935, with Zeke Caress still supporting him, the verdict was overturned. Bruneman was released. He would have been better off in prison.

On October 25, 1937, Bruneman met a violent end. Four rival gang members traced Bruneman to a beer parlor in Los Angeles and fired eleven bullets into his body. They then murdered a bystander who followed them to the door; Bruneman's companion, a nurse, was wounded in the legs by bullets which passed through Bruneman's body.

In July 1937, a previous attempt had been made on Bruneman's life, when he was walking on the boardwalk in Redondo Beach. Bruneman's slaying, investigators declared, was a result of a gambling war in Redondo Beach where Bruneman operated a club. Although Bruneman knew for months that he was on a hit list, he kept silent when questioned by police.

It wasn't until 1977, when mobster Aldadena "Jimmy the Weasel" Fratinno turned government informer and laid out the long buried secrets of the Los Angeles mob, that the truth behind Bruneman's murder came to light. It seemed Bruneman, who was active in bookmaking circuits, refused to give a percentage of his take to the L.A. mob, which by then was led by legendary gangster Benjamin "Bugsy" Siegel. After that Bruneman's days were numbered.

When crippled former police officer William Waggoner was interviewed by the *Press Telegram* on the day of Bruneman's shooting, he told the press he had no sympathy for the murdered man: "If he'd have got what he should have got in court he'd have been alive today, up in the penitentiary with the others," Waggoner said. "He got what was coming to him."[24]

William Homer Waggoner was to live for 24 years as a paraplegic, eventually dying at the age of 61 in December 1954. Seven years prior to his death, Waggoner had a kidney removed and during the last years of his life he was completely bedridden. His death was brought on when his final kidney became blocked. Funeral services were held for him on the anniversary of the famous shooting—December 21, 1954.

Jimmy Doolen was freed from prison on August 23, 1933, after spending nearly two years under heavy guard in city jail. Superior Judge Charles S. Burnell dismissed the charge brought against Doolen of

assault with a deadly weapon against Long Beach policeman Waggoner. Doolen's testimony in the trial of the Caress kidnappers had been indispensable. There would have been no prosecution without him. Since Doolen had spent time in jail awaiting trial in the Waggoner case, the court felt he had paid his debt to society. Following his release he disappeared, perhaps fearing for his life. What became of him remains a mystery.

What of Ralph Sheldon, one time Al Capone gangster? In 1943 Sheldon was transferred from Folsom prison when it was found he was head of a powerful prison gang. Warden Clyde L. Plummer resigned under accusations he allowed the mob figure favors, including unguarded trips from the prison for Sheldon and his convict friends. Sheldon died of a heart attack in San Quentin on July 2, 1944. He was 45 years of age.

Murder on the High Seas

Closed since the December 21, 1930, shooting of Officer Waggoner, the *Johanna Smith* and *Rose Isle* reopened for business on May 9, 1931. Appeals had been filed by the gambling ship operators over the closure, and though not yet ruled upon, they decided to reopen anyway. Business boomed and in May 1932 a new gambling ship, the concrete craft *Monte Carlo*, joined the *Johanna Smith* and *Rose Isle* off the Long Beach coast.

Gambling, drinking, and money laundering soon added another companion to the ships' activity log—murder. On July 19, 1932, Charles M. Bozeman, a 32-year-old card dealer and brother of one of the owners, was killed on the *Rose Isle*. Bozeman had been shot twice—once through the arm and the second time below the heart. Was it revenge, or a case of too much alcohol?

W.E. Conner, a deck hand, said he heard shots about 2 a.m. that Tuesday morning. He and chief engineer Robert Millett rushed to open the cabin door. They found bus boy Virgil Roach sprawled on a bunk in the cabin, evidently drunk, with Bozeman on the floor and another man, James O'Keefe, also highly intoxicated, exiting the cabin.

Dan O'Conner, a former St. Louis policeman and a bouncer on the ship, told officers that when he investigated he thought Bozeman had passed out from too much drink and he dragged him to the deck for fresh air. When he discovered that Bozeman had been shot, O'Conner left him on the deck to summon medical aid from shore, unaware that W.E. Conner and Robert Millett had already done so.

In the meantime, *Rose Isle* bouncer James O'Keefe headed to dry land. As he drove up to his home at 238 Savona Walk in Long Beach, police were waiting. A befuddled O'Keefe said he had been sleeping in the room next to Bozeman's. He heard a disturbance and went on deck where he discovered Bozeman propped up against the railing. He thought his friend was still alive, just sleeping it off on deck.

O'Keefe's story didn't jibe with testimony given of several others aboard the ship. Police already had the statements of several witnesses. They stated that O'Keefe, Virgil Roach and Bozeman had all been together in the same cabin at the time of the shooting. Virgil Roach

told police that he had been awakened from an alcoholic daze by the sound of O'Keefe shooting Bozeman. Why was O'Keefe lying? Or was he?

Based on the evidence at hand, O'Keefe was arrested, but the murder of John Miley in Los Angeles a few days later brought out a new angle in the Bozeman murder. It seemed that Bozeman had acted as a fence for a robbery gang and was reputed to have been carrying $15,000 in diamonds at the time of his death. A Colt automatic found on the floor of the cabin where Bozeman was killed added another angle. It had been stolen earlier in a burglary. Who did the stolen gun belong to? Had Bozeman and Miley been slain by the same gunman for fencing the diamonds, or had Miley been killed in retribution for the murder of Bozeman? Many believed a gambling war had broken out in the ranks of gambling ship owners over Bozeman's mysterious slaying. It certainly appeared so when arson struck the *Johanna Smith*.

On July 21, 1932, the $16,000 gambling ship, *Johanna Smith*, was torched and destroyed, possible revenge for the murder of Bozeman less than forty-eight hours earlier. One hundred fifty men and women barely made it off the ship alive before fire reached the fuel oil tanks, turning the whole vessel into a livid mass of flames. Fortunately, there were at least a dozen water taxis within a few hundred yards of the ship when the blaze broke out about 6:15 p.m. Most of those rescued refused to be taken ashore insisting they be transferred to one of the other two gambling ships in the area. From the decks of these ships they watched the 257-foot *Johanna Smith*, the first of the gambling vessels to be put in operation off of Seal Beach, meet her end. Ironically, instead of frightening people on shore and keeping them from making trips to the *Monte Carlo* and *Rose Isle*, the spectacle increased their business as hundreds got on water taxis for a closer look at the blaze.

It was certainly a sight to see as the exploding oil tanks tore away part of the stern and after structure of the *Johanna Smith*, sending blazing pieces flying onto the water. But the *Johanna Smith* was a hardy lass, refusing to give up her ghost completely. The ravaged hulk rebuffed Neptune's underwater realm and remained a shipping hazard, despite several attempts to sink her. More than 30 mines were exploded in an attempt to demolish the remaining pieces of the ship, but the *Johanna*

Smith still refused to go down entirely. The last remnant of the ship, the lower hull, finally floated toward shore, coming to rest about a quarter of a mile off Seal Beach.

What had caused the fire? Owners of the ship said they were satisfied the fire was started accidentally and no further investigation was needed. The truth? Or were they afraid of further retaliation?

But what of the murder of Charles Bozeman? It had taken place outside the legal boundaries of the United States. Who actually had the right to try the case?

On December 17, 1932, Federal Court Judge Frank Norcross stated that the United States had legal jurisdiction in the murder, citing Article III, Section 2 of the United States Constitution which granted original jurisdiction to U.S. federal courts over maritime matters. One of the most notable points of the case was Norcross' ruling that the international boundary extended three *English* miles into the ocean, paralleling the coast, not nautical miles which were longer than English miles. Norcross stated to the jury:

"Where a bay indents the coast line, the coast line is considered to extend from headland to headland of said bay, leaving the jurisdiction of the State three miles beyond a line drawn between the two headlands. The gambling boat was anchored beyond the State boundary of three English miles and, therefore, was without the jurisdiction of the State authorities, but not Federal."[25]

This was the first definite court ruling concerning coastal boundaries.

Virgil Roach continued to pummel O'Keefe's case with damning testimony. Roach, who claimed to have seen O'Keefe shoot Bozeman, said the highly intoxicated pair had argued over a woman. But was Roach a reliable witness? Peggy Anderson, wife of a *Rose Isle* employee, stated under oath that Roach was not only intoxicated the night of the murder but also argumentative. She thought Roach was more than likely the one who shot Bozeman, a supposition supported by S.P. Drake, the ship's cook. Drake told the jury that following the shooting Roach came to him afraid his fingerprints would be found on the gun.

Roach, in rebuttal, admitted the remark but explained it by saying he believed his fingerprints might have been left on the gun when he struggled with O'Keefe following the murder.

O'Keefe testified he had been drinking, but denied he had quarreled or shot Bozeman. Though he said he was asleep at the time, he believed that Roach, who was drunk and confrontational that night, could have been the one who shot Bozeman. When asked about witnesses who saw him in the cabin, O'Keefe had no answer.

It was a difficult case to judge, especially when several witnesses changed their statements given to investigators, relating different stories from the witness stand. Others related evidence they did not disclose to the investigators. It was not clear if Bozeman had been seen leaving the cabin following the shooting or not. All of the witnesses, it was later revealed, were from the same East St. Louis gambling syndicate, and definitely covering up something. Was it the stolen diamonds? Or how the gun taken in a burglary got on the ship?

Though the jury found O'Keefe guilty and sentenced him to five years in prison, the judge thought differently. He was not completely sure of O'Keefe's guilt. He did not feel the trial clearly showed who fired the three bullets into Bozeman's body.

"In view of the fact that this man has not followed a criminal life, at least it has not been shown he has, and that he has a wife and a growing son, it is difficult to believe a man of his type would, unless there was great provocation, kill a man, a friend, a co-worker, one with whom he had been on a fishing trip the day before."[26]

Norcross felt that probation, not prison was the best course of action in this case. O'Keefe was granted his freedom. The true story behind the diamonds, the gun and the murder was never fully resolved.

―――――

Following the burning of the *Johanna Smith*, and the loss of business suffered on the *Rose Isle* by the Bozeman murder, the operators of the sunken gambling ship purchased the *Rose Isle* and rechristened it the *Johanna Smith II*. But death continued to haunt the ship, regardless of

a change in names. In September 1933, the grim reaper appeared once more to claim another victim, ex-con Buell Dawson.

Twenty-two year-old James Walsh (a.k.a. Arthur Yeomans) had been in and out of jail since he was 15. During his most recent incarceration at Leavenworth he met Buell Dawson, two years his senior, who was in prison for auto theft. While in the penitentiary they avidly read the extensive press coverage of Zeke Caress' kidnapping. It inspired them and gave them a goal once they were released—they were going into the kidnapping business.

They entertained themselves for months planning their crime. It had to be someone with enough money to pay the high kidnapping ransom they would demand. After much thought, they decided to seek out rich men and their families. Their first victim was to be oil magnate Edward Doheny. Doheny had been in the news for years over the Teapot Dome oil scandal and the February 1929 murder of his son Ned by a trusted and put-upon servant. According to the plot the two men hatched Doheny and one of his grandchildren would be kidnapped. They were sure that Doheny would pay any amount of money to keep his surviving family members safe. Doheny would be taken to downtown Los Angeles to cash checks, while the child was held hostage, his life in danger if Doheny refused to do the kidnappers' bidding.

Walsh told police all they did was talk about the kidnapping plot. It was simply a fun way to pass the time. There was no actual action taken to implement their plans. It was just a conversation they continued to have. However, one night the pair, now released from prison, were continuing their "conversation" over a few drinks aboard the *Johanna Smith II*. After several drinks they began arguing about their respective "codes of life." What started as a philosophical discussion about degrees of murder, led to the fatal shooting of Buell Dawson.

James Walsh said Dawson's "code" prevented him from killing anyone but police. When Walsh asked what Dawson would do if Walsh killed a kidnapped victim, Dawson said he would turn Walsh in to authorities. Walsh, angered and inebriated, emptied his gun into Dawson and killed him.

James Walsh was soon back in the home he had recently left, sentenced to life imprisonment, with no possibility of parole for 15 years. By then he would have spent most of his life behind bars.

Death seemed to be like a disease spreading aboard the gambling ships. In December 1933, James L. Costello, master-at-arms on the gambling ship *City of Panama*, anchored off Santa Monica, and L. James Ford, another officer, were charged with the high-seas murder of Robert L. Moody, a 24-year-old meat cutter.

On August 29, 1933, Norman Burgess, Edna Henke, Mildred Irwin and Robert Moody visited the ship and accompanied it on one of its "cruises to nowhere." During the outbound ride Moody, described as an amateur comic, went into one of his acts. His impromptu snake dance, stories and songs annoyed other passengers. When ship's officers tried to stop him a scuffle followed in which, they claimed, Moody fell down the stairway. Other witnesses disagreed. They said Costello hit Moody, knocking him down the steps. Moody, still clowning around, was picked up and handcuffed to the rail for three hours by ship officers. Whatever the case, Moody somehow suffered a head injury and died two days later of a skull fracture. Ford and Costello were found not guilty of murder.

End of an Era

Though Prohibition officially ended in December 1933, gambling ships continued to ply their trade off the Southern California coast while legal battles over their control unrelenting raged on. Piracy, robbery, suicide and murder continued. In July 1935, gangsters got $32,000 in a holdup aboard the *Monte Carlo*; in June 1936, DeWolf Richardson of Long Beach was stabbed aboard one of the ships; in August 1937, Laurin Venor committed suicide by jumping from the *Caliente*. The same old sordid stories continued. When would they end?

Gambling did come to a temporary end in Tijuana and Agua Caliente. In July 1935, Mexican President Cardenas declared gambling and horse racing illegal. The newly elected president believed gambling was one of the ways of making poor people poorer, and it was his aim to raise the standard of living among the natives of his country. However, this ban put over fifteen thousand Mexicans out of work in the midst of the Great Depression; gambling was once again legalized in June 1936, but by then the number of Americans wanting to go to Mexico to gamble had waned.

While all the Mexican gaming casinos and race tracks were closed, Southern California gambling ship owners decided to "spruce up" their act. Newer vessels, something more luxurious, were needed to draw in the "elite" crowd used to all the grandeur of Agua Caliente. There was also a new competitor on the scene—Nevada—which had legalized gambling in March 1931.

In October 1935, the *Rose Isle/Johanna Smith II* met an inglorious end when she was hauled off gambling ship row and scrapped for her iron, steel and brass. In March 1936, the *Monte Carlo* was sold and taken to San Diego. But these old timers of the trade were soon replaced by other more palatial incarnations, including the *Tango*, *Casino*, and *Rex*.

Tony Cornero, one of the "Big Four" of bootlegging days, survived the passage of the 21st Amendment by concentrating his operations on gambling. Tony had served two years in Federal prison for rum-running and after his release he turned his attentions to off shore gambling

ships. Throughout the mid 1930's he was the king of the high seas, his gambling ship, the *Rex*, the finest gaming vessel of all.

But by 1939 the era of the gambling ships appeared to be over. With the war going on in Europe ships were in short supply and the British were willing to buy anything that would float. Most of California's gambling vessels were converted to haul supplies for the war. They served nobly. The *Rex* was re-rigged as a six-masted schooner and hauled lumber from the west coast to South Africa. She was given one of her former names, *Star of Scotland*. On November 13, 1942, the former gambling ship was torpedoed and sunk in the Atlantic off the coast of Africa. The war had made an honest lady out of the old gambling vessel, on whose decks many a Hollywood playboy and glamour girl had tried to pursue Lady Luck.

Unlike their ships, the gambling ship owners were not converted over to the war effort. If they could avoid the draft, they did. Tony Cornero managed to escape military service and during the war years served as a casino manager in Las Vegas. He was just biding his time. In 1946, Cornero headed back to the Southland, this time in command of a new gambling ship the *Lux*.

Earl Warren, now governor of California, took on the fight. He angrily wrote to President Truman complaining that Cornero had been able to obtain the necessary steel, lumber and other materials that were in short supply due to the war to use on his new vessel. Warren asked Truman to help rid the California coastline of the public nuisance. Federal agents seized the *Lux* on a technical charge (it had no engines!) and Cornero was relieved of his command. On April 28, 1948, Truman signed a bill prohibiting the operation of gambling ships in the territorial waters of the United States.

His ship now illegal, Cornero returned to Las Vegas where, in July 1955, he dropped dead of a heart attack after an all-night crap game in which he lost $37,000. At the time of his death Cornero was building the Stardust Hotel and Casino. With his death his brother Louis Stralla, mayor of St. Helena, California, was elected general manager and president of the hotel.

———

Gangsters and crime continued to flourish in the days following the demise of Prohibition. However several, including famed gangster kingpin Al Capone, were brought to justice. Many aren't aware of it but Al Capone was a resident of Terminal Island Federal Prison.

On August 24, 1936, work began on the Terminal Island facility, the twentieth prison built and operated by the Department of Justice. The rapid growth of Southern California and the increasingly large number of Federal criminal cases handled by United States courts in the area prompted the decision to build a prison in the region. Before the construction of the penal institution, Federal prisoners were "farmed out" to various county or city jails in the Southland at considerable expense and much inconvenience to the Government. The new jail put all Federal offenders and suspects in the area under one roof.

Reservation Point on Terminal Island was chosen as the site because of its relative isolation, being surrounded on three sides by the ocean. The point was formerly known as "Dead Man's Island," a term future inmates would not be allowed to forget. The fact that a local man, Frank Merriam, was also California governor, may have had something to do with the choice of locations.

The prison opened on May 26, 1938, with no fanfare or celebration. The first of the 600 male and 24 female short-term prisoners (those with sentences under eighteen months) arrived from McNeil Island Penitentiary in Washington; they were to prepare the institution for receiving other prisoners.

On May 25, 1939, J. Edgar Hoover, chief of the Federal Bureau of Investigation and Frank Murphy, United States Attorney General paid a quick visit to Long Beach and the prison. The two men, accompanied by several aids, visited the Terminal Island facility ostensibly on a tour of inspection. They had nothing to say about the visit other than that they were in a hurry. Newspaper reporters were not allowed on the grounds with them, but the press surmised that the visit had to do with Al Capone. The ex-gang leader had been moved from Alcatraz to the local jail earlier in the year after serving 10 years in other Federal prisons. He was expected to remain in Terminal Island for the rest of his sentence.

Capone had paid his back taxes and fines and had just a year's misdemeanor sentence remaining. On the night of January 6, 1939, he was ferried to Oakland from Alcatraz, handcuffed to guards, six weights

shackled to each leg. There had been talk of a vigilante attack, so the guards were also armed with machine guns. On January 7, 1939, Capone entered Terminal Island Federal Prison as prisoner number 397.

Dr. George Hess, chief medical officer at Terminal Island, had also known Capone at Atlanta and Alcatraz. He was aware of Capone's syphilis, which had progressed to the state where he had distorted speech, disorientation and a problem walking, and quickly put him in the jail hospital.

Although the prison authorities knew Capone's venereal disease had diminished his mental capacity, most government officials persisted in regarding Capone as a prized source of information about the current state of racketeering. Capone, having little idea of the consequences of his words and actions, and flattered by the attention, was happy to oblige. He talked with anyone who was willing to listen, often fabricating stories just to please his audience.

His medical treatments at the prison continued until his release on November 13, 1939, when a boat ferried him to San Pedro and a car drove him to San Bernardino where he boarded a train that would take him back east (avoiding Chicago). On November 16, 1939, the government drove Capone secretly to Gettysburg. Here they turned him over to family and doctors for continued treatment for the tertiary syphilis ravaging his mind. Newly discovered penicillin helped Capone, he was to survive until January 25, 1947, when he died of a heart attack at the age of 48.

OIL FEVER

"Where the oil monster sets its foot, beauty flees."

Syl MacDowell
Los Angeles Times,
July 6, 1924.

Transformation

Rising to a height of 365.64 feet from the flatlands of Long Beach below, Signal Hill's earliest residents took advantage of the elevation to build signal fires. Visible for many miles, the smoky patterns gave warnings about invasions of warring tribes, or told of native festivities to which all the surrounding clans were invited. "The Hill," as it was called, was later settled by Japanese farmers who established lush berry and cucumber farms on its slopes. But in 1921 things changed, fruit and vegetables gave way to oil. Almost eighteen months after Prohibition had become the law of the land, Long Beach was hit by a revolutionary discovery that would change the life of the city in many unforeseen ways. Black gold was discovered on Signal Hill.

It wasn't the first oil discovery in Southern California. Gas emanations, seepages of oil and asphaltum deposits had long been known in many places. Native Americans as well as mission fathers used these substances as roofing materials, natural lubricants and as liniments. The first oil boom actually occurred in 1859 when it was found that petroleum could be used to make kerosene lamp oil, an inexpensive alternative to whale and coal oil in use at the time. With California gold production diminishing, oil speculation seized the minds of many still eager to make their fortune. By 1865, sixty-five California oil companies had sprung into existence, though many never got further than just issuing stock certificates and pocketing investors' money. Those that did get around to drilling didn't have enough capital to bore the wells very deep, and only a small amount of oil was obtained. The modest quantity that was pumped was found to have little value. It wasn't the same grade as eastern oil, which was perfect for kerosene production and at the time the only valuable use for petroleum. Oil investors became discouraged and by 1884 there were only four California companies remaining that were actually producing oil.

In 1892, Edward Doheny was sitting on the porch of a Los Angeles hotel when he saw a decrepit wagon hauling chunks of a greasy, brown substance. Curious as to what it was, the newly arrived miner ran after the wagon and asked the driver what he was hauling. The driver replied

"brea," the Spanish word for pitch. He told Doheny it came from a great hole oozing gobs of the sticky stuff in an area of the city called Westlake Park. The driver was transporting it to a nearby ice factory where it would be used for fuel in place of coal. A light bulb went off in Doheny's head as he realized this was a new fuel which could become the new energy source of the nation. The far seeing Doheny leased a three-lot parcel of land near the "great hole" at Patton and State streets in Los Angeles. It was swampland, bubbling with the tarry crude. From this find, and convincing the Atchinson, Topeka and Santa Fe Railway to substitute oil for coal in their locomotives, the oil industry we know today came to be.

It took a while for the use of oil to catch on, but by the 1920's and the rapid rise of the automobile, petroleum was on its way to becoming the fuel of choice for the American public. The hunt for new sources of oil was on—a hunt that would lead to Signal Hill. Fortunate indeed were the heirs of I.W. Hellman, Jotham Bixby, and John Bixby, the men who had purchased the 28,027 acre Rancho Los Alamitos in 1881. Part of the acreage included Signal Hill. The company they formed, the Alamitos Land Company, subdivided all of Signal Hill except a hundred acres on the eastern slope which they considered too steep for subdivision. They subsequently leased these 100 acres to the Shell Oil Company.

Life in Long Beach and on Signal Hill would never be the same after Thursday, June 23, 1921, when the Shell Oil Company struck oil at its well at Temple Avenue and Hill Street. At 9:30 p.m., the Shell gusher came in spraying oil for a radius of 300 feet. The bringing in of the well sent the price of Signal Hill leases sky high with several leaseholders refusing as much as $8,000 an acre for their holdings. Oil fever quickly spread. Sandberg Petroleum Company, with massive Signal Hill oil holdings, was swamped with people wanting to invest in their company. Within 48 hours of the Shell discovery, Sandberg sold $112,000 worth of stock.

The possibility of sudden wealth had a universal appeal and an incessant flow of promoters, both honest and dishonest, were soon on the scene. Real estate promoters around Signal Hill could barely keep up with sales. Even the City of Long Beach, which owned 36 acres of land between the Shell and Sandburg holdings, had a grandiose dream—becoming the richest city in the world, a city that would end taxation.

The oil bonanza of 1921 continued. Shell well no. 2, *Nesa,* on the west slope of Signal Hill, struck oil at 12:45 a.m. on September 2nd. It came in with such an explosion that everyone thought an earthquake had struck. People as far away as Los Angeles were awakened by the blast. Other wells struck black gold on October 26th, November 17th and December 13th. On November 28th, the city owned municipal oil well hit pay dirt, shooting two hundred barrels of fluid above the top of the derrick. For many years afterwards this single well brought $360 a day into Long Beach city coffers.

Amid all of this oil Signal Hill, which had been renowned for its scenic grandeur, productive soil and magnificent homes, was transformed, with land prices soaring to undreamed of heights. A 1906 advertising brochure had described it as "the most beautiful home site in Southern California." But things had now changed. Building restrictions, paved streets and walks and curbs were supplanted by oil leases, oil stocks, derricks and drills. Palm trees and rose gardens were trampled to make way for boilers, tool houses and speakeasies. *Los Angeles Times* reporter Syl MacDowell summed it up: "Where the oil monster sets its foot, beauty flees." [27]

It was now dangerous living on what was now called Porcupine Hill, because of its prickly appearance from all the oil derricks; people were regularly routed from their homes by blowouts from the oil wells. Often it was so sudden residents fled like the inhabitants of Pompeii before the streams of lava. Families escaped through the rain of greasy crude oil, leaving behind everything but the clothes they were wearing. They would pile into their automobile, trying to drive to safety but finding it difficult to get through the oil that coated everything. On returning home they found their once white residences now black, trees in their orchards destroyed, stripped of branches by the clinging oil, the contents of their homes worthless, and their houses, soaked with highly flammable oil, a fire trap in which no one could safely live.

H.F. Ahlswede described his experiences:

"After the experience with the three gassers we knew that it was only a matter of time when we would have to move. I want to tell you that it is very difficult to live as neighbor to one of these roaring gas wells. The first gasser was something of a novelty and proved there was something under the ground that resembled what they had been drilling for. When

the fourth gasser suddenly developed into an oil gusher and commenced to pour sand and rocks about our premises, we knew the time had come to leave Signal Hill." [28]

Houses, streets and sidewalks were covered with sticky black tar; rocks that came up with the gushers hurdled through roofs and windows. The time to leave had come. Fortunately many left rich, having leased or sold their Signal Hill real estate.

In his novel *Oil* (1927) Upton Sinclair described the transformation of Paradise (Long Beach), from "a quiet little seaside village where retired Iowa farmers pitched horseshoes," into a bustling boom town porcupined with derricks. The road into Long Beach, Sinclair wrote, was "lined with placards big and little, oil lands for sale or lease, and shacks and tents in which the selling and leasing was done. Somebody would buy a lot and build a house and move in, and the following week they would sell the house, and the purchaser would move it away, and start an oil derrick. A great many never got any further than the derrick—for subdividers of real estate had made the discovery that all the advertising in the world was not equal to the presence of one such structure on the tract."[29]

In July 1921, the U.S. experienced a severe post-war recession due to industrial overproduction and elimination of defense related industries. The result was widespread wage cuts and unemployment that reached 5.7 million in August 1921. Because of oil Long Beach was able to escape the economic recession enveloping the rest of the United States. Long Beach was truly a city of Paradise, so aptly named in Sinclair's novel, for Signal Hill was considered the greatest oil field in the entire United States.

Despite the financial woes striking the rest of the nation, a multitude of new industries associated with oil fields and interests sprang up in the Long Beach area. Gas refineries, absorption plants, casing-head gasoline plants and several hundred miles of pipe lines were hurriedly built. Thousands traveled west to Long Beach to take advantage of the jobs and other benefits accompanying the oil boom.

On October 7, 1921, Mayor Charles A. Buffum spoke about the "propaganda" being spread through the east calling attention to the alleged employment advantages of Southern California. "We can take

care of the people we have here, but the continued invasion of the army of the unemployed will result most seriously for those who come," Buffum told reporters from the *Daily Telegram*. "Keep the idle away from the City, Long Beach can take care of its own people, but the influx must stop." [30]

But it didn't stop. People kept coming. 1920-55,593 Long Beach residents; 1921-75,000; 1922-89,321; 1923-125,000; 1924-140,000; 1932-159,320. Thousands of men poured in looking for jobs, and in their wake their families and prostitutes, competing for scarce housing. Not far behind were the speakeasy operators and their bootleg suppliers.

It was a well-advertised secret where to go to "relax" after a hard day working the oil fields. Tucked between a real estate shop, and a wedge of brick wall plastered with movie posters advertising Long Beach theaters, was a dusty little store that never seemed to open for business. But if you were an oil worker you knew that the door was unlocked at night and that behind a screen of dirty stacked boxes was a bare-bones little speakeasy, a sofa, four tables, a plywood bar along the back wall, a fair supply of whiskey, and a bartender who slept on the sofa after the bar closed. It was a new frontier, with its society of rugged men working themselves to exhaustion, and then taking their evening pleasures in speakeasies where music blared, girls danced, gambling flourished and the whiskey flowed.

Working the Hill became more difficult as time went on. At first the oil came naturally, almost gushing to the surface on its own momentum. Later it had to be pumped. By 1927 wells at Signal Hill were reaching five to seven thousand feet beneath the surface of the earth. Despite the fact that finding oil was becoming a little more difficult and expensive, "oil fever" still flourished.

Throughout downtown Los Angeles, salesmen haunted intersections and doorways insistently accosting passersby with free tickets to the oil fields. In residential neighborhoods saleswomen trooped door to door distributing passes. Every morning hundreds and sometimes thousands of people would use these free passes to depart for the oil fields. The buses arrived at the petroleum grounds by noon, and a free lunch was the first order of business. Lunch was served in tents that resembled those of traveling evangelists. While eating in what locals called "sucker

tents," "lecturers" discussed the maps of the oil fields which covered the walls. Experienced promoters knew all sorts of tricks to entice investors. Following the free lunch they would take a gullible group to a well with minimal oil production and show how it could be turned into a gusher by inserting a small pipe connected to an air compressor. They advertised astonishing oil-finding devices that guaranteed against dry holes. These gadgets generated thousands of dollars in sales, but they didn't live up to their claims.

A Sunday at the oil fields offered special treats. Tent shows included parachute jumps and brass bands. Some promoters hired clergymen, judges, politicians, and other figures of prominence to meet the crowds, reportedly paying these "respectable" people as much as $1000 a week for their endorsements. When the lecture ended, "the slaughter of the lambs" commenced. Salespeople descended into the crowd. Audiences, primed by the afternoon's promotion, responded avidly. One observer commented that the people acted less like investors than an audience at some form of séance. Intense emotion rather than cold calculation was the predominant note.

Real estate as well as oil investment became a booming business. All of these newcomers had to live somewhere. How about buying land for a home *and* keeping the oil rights under it? Such was the sales pitch used to sell property in the California Heights tract (bounded by California, Orange, Wardlow and Bixby Road in Long Beach) which opened during the oil boom of 1922.

When the Jotham Bixby Company placed 830 lots on the market on October 10, 1922, the real estate vultures descended in droves. The tract was just 1,500 feet from the Wiley No. 1 oil well *and* lot purchases included oil rights. Who was to say that oil wouldn't be discovered under the new tract, making their owners wealthy? One ad stated:

"You could stand on one corner of California Heights and with a 30-30 rifle shoot the lights off the top of dozens of rigs—where gushers are spouting thousands of barrels of the liquid gold daily. THAT'S HOW CLOSE WE ARE TO REAL MONEY.

OIL has made more rich men in Long Beach, in a shorter time, than all other interests combined. Are you among them? This is 'Your Ship' but you'll have to step lively to get aboard."[31]

Within four hours, 185 lots were sold, within 24 hours 250. A syndicate of local businessmen who planned to drill for oil purchased twenty-five of them.

There was a problem with building houses on top of a potential oil field. Why spend money on installing water and gas lines when oil might be discovered at any moment? Because the question of oil beneath the property remained unsettled, improvements in California Heights were slow. It wasn't until November 15, 1923, that water, gas, telephone and electric mains needed to build houses were complete. Once these were in and it became evident that not much oil was under the tract, residential development began. The Bixby Company got things off to a start by building 25 ready-made Spanish type bungalows that they sold on an "easy payment plan." Other homes were built on a parcel-by-parcel basis, creating a variety of home styles including California bungalows, Spanish colonials and Tudor-style homes.

By 1927 Long Beach ranked fourth in the entire nation in per capita construction. The carnival like sales techniques had proved successful; statistics revealed that cities along the Pacific Coast were growing fifty percent faster than cities of the Eastern states. To provide adequate housing for newcomers, the citizens of Western cities were investing 32% more in new buildings, per capita, than those cities of the East. In Long Beach this meant continued expansion into former farm areas including the Wrigley District, Los Cerritos, and Chateau Thierry regions. Many of these areas had ceased to grow as residential districts following the discovery of oil. By 1927 things had changed. With forests of oil derricks on two sides of the city it was time to call a halt and preserve the remaining residential areas of Long Beach. The oil madness began to wane; it was time to reclaim the town.

The Los Cerritos area (bounded on the north by the Virginia Country Club, on the east by Long Beach Boulevard, on the south by Bixby Road, and on the west by the Pacific Electric Railway tracks), had once been Long Beach's most beautiful and exclusive residential area, but following the discovery of oil it had become a mud infested area of derricks, sump holes, oil covered streets and oil spattered homes. Los Cerritos homeowners fled elsewhere in dismay. Out of the shadow of oil derricks, Los Cerritos began an upward climb in 1927 to once again become a fashionable residential section of Long Beach.

The life of the Los Cerritos oil field had been fleeting. Operations and individuals who drilled for the black gold reportedly invested $24,000,000 into the petroleum ventures but had taken out less than $1,000,000. Oil promoters decided it was time to move on, and for homeowners it was time to begin their uphill task of a "come back." State and city laws requiring the removal of derricks from abandoned wells were strictly enforced. With the persistence and perseverance of homeowners, the unsightly wooden structures slowly began to come down. By December 1927, it was estimated that 65 percent of the derricks had been removed and the ground straightened up.

As the fear of the menace of oil vanished, residents began to return to the Los Cerritos area and soon expensive houses costing upward of $50,000 were being constructed.

Long Beach was anxious to annex this potentially oil rich territory, and in an election held December 28, 1923, California Heights and other territory surrounding Signal Hill (identified on annexation maps as "Greater Long Beach") became part of the City. However, residents of the Signal Hill area, now surrounded by Long Beach, were ardent opponents of annexation. Why share the wealth with Long Beach? Why not spend it on ourselves? This philosophy led to a new birth.

On April 7, 1924, the City of Signal Hill was created when voters in the oil district cast 348 ballots in favor of incorporation and 211 against. Because of oil they were now the richest city in America.

Forty-eight year-old Mrs. Jessie Elwin Nelson was elected mayor and won the distinction of becoming the first female mayor in Southern California. A correspondent for the *Long Beach Press Telegram*, Jessie Nelson's story was the first to describe the initial discovery of oil on Signal Hill, the "spudding in" of the Shell oil well on June 23, 1921. She evocatively captured the scene:

"Gravel, shot from the vortex of the roaring gas spout, stripped the insulation from nearby electric wires. The resultant sparks ignited the gas and writhing jets of flame set a lurid light over the landscape." [32]

The Tennessee native had lived on Signal Hill for twenty years in an old fashioned yellow frame house set among a ragged cluster of trees with a grand panorama. Pigeons cooed about the home at Cherry

Avenue and Hill Street and a bay mare had the back lot all to herself. When the Nelsons settled on the Hill in 1904 only eight houses could be counted on the plains below. Jessie's husband, Zechariah T. Nelson, had relentlessly sought to preserve Signal Hill as a residential district, unmarked by industry. It was he who was instrumental in securing a scenic drive on the hill and other improvements. Perhaps it was the discovery of oil and the altering of the place he loved that caused him to die of a heart attack on July 4th 1922, at the age of seventy-three. But Jessie accepted the changes fate had brought and explained it was "taxation without representation" that forced the Hill to incorporate:

"We paid $20,000 to the county for library tax, but we had no library. We paid the county road tax of 35 cents per $100 valuation, making a $140,000 road fund. We paid $500,000 a year to Long Beach for schools, but we had no schools. We want a good, modern town when the derricks are gone." [33]

But it was no longer a place where many people chose to live. The 1500 people who called the Hill "home" in 1924 resided in three residential areas, apart from the derricks. However, they had to live with the hissing sound of escaping steam and a constant whine of noise from the pumping of machines. Signal Hill was by day an industrial landscape, sown with derricks springing like monsters from the earth. By night, when accumulations of natural gas burning with a muffled roar illuminated the sky, Signal Hill became a Dantesque landscape of flares and shadows, filled with the drone of still pumping machinery. But as an independent city it could cast its own future, and it did—one that went easy on gamblers, bootleggers and crime.

Fraud

Everyone seemed to want to make a quick buck from all the oil flowing on and around Signal Hill. Oil deals were being made every day, many of them by Long Beach businessmen like Willard C. Campbell, John McDuffie, Walter Lee Tully, Charles P. Knight and William R. Buck.

In the fall of 1922, the five original promoters of the Bay Hills Land and Oil Company contributed $5000 each to begin their corporation. Their first course of business was to buy five town lots on Signal Hill for $20,000. John McDuffie made the purchase in his name, taking title and later transferring title to the company for $35,000—the five investors pocketing the $15,000 profit. With actual land in their possession they quickly lured backers into purchasing 2250 units of stock for $100 per unit, telling investors they would drill one oil well when $225,000 was raised. The promoters promised their shareholders they themselves would derive no money from the sale of any unit until the investors had received all their money back. This was an out and out lie, for Campbell, McDuffie, Tully, Knight and Buck were drawing salaries ranging from $1000 to $1500 per month each.

Other transgressions followed. After the original stock was sold, the five set up another company, the Special Delivery Oil Syndicate, which they opened to investors. Questionable practices included purchasing an oil lease for $12,500 and then selling it to the Special Delivery Oil Syndicate for $15,000, splitting the profit between them.

On October 14, 1924, Willard C. Campbell, one of the most prominent oil stock salesmen in Long Beach, was arrested for mail fraud along with John McDuffie, Walter Lee Tully, Charles P. Knight, William R. Buck and their attorney Joseph G. Richardson. Mail fraud was one of the few legal ways to pursue the sharks who fed off the hopes of the small investor. Long Beach folk were shocked that such noteworthy members of the community had been scam artists.

John H. McDuffie, president of the Bay Hills Land and Oil Company of Long Beach and its subsidiary the Special Delivery Oil Syndicate, denied the company ever did any business through the mails. Instead, he claimed, they hired passenger buses to bring the public to the oil fields. It was common practice among oil promoters.

Every morning the buses lined the streets in Los Angeles and other Southern California communities advertising free lunches, and band concerts as well as a chance to see the gushers first hand. McDuffie neglected to mention that along the way salesmen made their pitch. As they motored past the mansions of business tycoons, movie stars and especially oil moguls, oil promoters made sure to point out that anyone could live a life of leisure if they invested in oil development. The passengers, primed by the promotion, responded emotionally, rather than rationally, and lined up eagerly to purchase shares in not only Bay Hills Land and Oil, but other oil companies as well.

McDuffie told the press that the trouble with his oil firm was brought about not through any intent to defraud anyone, but by poor management. Somehow, McDuffie said, the bills began to pile up and creditors began to demand payment until investors began to get worried. Shareholders weren't buying his sob story.

On July 6, 1925, the Bay Hills Oil partners and the company's attorney Joseph Richardson went on trial for mail fraud, having delayed the legal action as long as they could. Investors wanted their money.

"The law is full of loopholes," *Los Angeles Times* writer Walter V. Woehlke later wrote about another fraud, the Julian Pete scandal. "To the layman it is perfectly clear that a criminal fraud of vast proportions has been committed, that tens of thousands of innocent people have been bunked out of an unknown number of millions, but the way to legal proof and conviction lies through a jungle of technicalities in which it is easy to get lost." [34]

Woehlke was right. Though Willard C. Campbell, John McDuffie, Walter Lee Tully, Charles P. Knight, Joseph G. Richardson and William R. Buck had defrauded 5000 investors of $750,000, they merely got a slap on the hand, fined $2500 each and given ten months suspended jail sentences. This was just the tip of the iceberg, the first of several local oil scandals to follow.

The biggest Ponzi scheme of all involved Courtenay Chauncey Julian—"C.C." as he was known to millions—who appeared so folksy and down to earth that investors believed his sales pitch and that he really cared for the little guy. Born in Manitoba, Canada, son of an impoverished farmer, Julian had worked in the Texas oil fields before drifting to Southern California. He soon began to speculate in oil

leases, and from his point of view his luck was phenomenal. On a four-acre lease he drilled five wells and all five came in, producing gushers. Now, as a successful independent operator, he decided to form a production, refining, and distributing company to compete with the major oil companies, and open his company to small investors. Soon he was acquiring more leases, and opening gas stations which sold his appropriately named gasoline, "Defiance."

In June 1924 his new company, the Julian Petroleum Corporation, purchased the holdings of the Grump-Steele Company of Long Beach, including contracts on the production of twenty Signal Hill oil wells for $75,000. Julian also had interests in the Alamitos Heights oil field with wells near Colorado Avenue and Ultimo Avenue. This was but a small portion of Julian's supposed massive oil investments.

Julian bypassed the usual techniques used by oil promoters who laid siege to Pershing Square in downtown Los Angeles each morning. Impressive buses heading for the oil fields filled the streets advertising free lunches, band concerts as well as a chance to see the wells up close. Julian's approach was different. He didn't rely on bus rides to entice people. Instead he wrote his own ads which encapsulated the hopes and dispelled the fears of the small investor. He charmed many into putting money into his oil syndicate, despite warnings from the California Corporations Department and Harry Chandler of the *Los Angeles Times* who finally caught on to Julian's schemes and refused to print his ads. Penniless when he began, Julian managed to raise a lot of money from those he conned. C.C. Julian was the Bernie Madoff of his day. It was not long before 40,000 folks had invested $11 million in the stock of Julian Petroleum. His appeals for funds were so successful that one particular stock issue was oversubscribed by $75,000. However, the law eventually caught up with him.

Bribes and high salaries to bankers and government officials hid what was really happening—more Julian stock was being traded than was supposed to exist. But the Ponzi scheme, where early investors are paid off with the money of later investors, began to spin faster and faster, demanding more and more cash. As the "little guy" investors began to get a putrid whiff of what was really happening panic spread. The "Average Joe" saw his money in Julian vaporize.

With a federal indictment pending, Julian got out while the getting was good. In December 1924, Julian made a present of his Julian Pete

(the favored name of Julian Petroleum) common stock to Sheridan C. Lewis, general manager of the company. Though he claimed he didn't get a dime for the stock, Julian failed to mention that Lewis agreed to have the corporation pay back to Julian $500,000 the promoter had advanced.

While Julian had been a lone wolf con artist, Lewis invited the rich and powerful to join him in a swindle of outrageous proportions. Over issued stock exceeded $150 million. When fate caught up to Julian Pete, revealing a colossal new fraud, Julian stepped back in. Posing as the champion of the Julian Petroleum stockholders he launched a series of sensational attacks against those that succeeded him, accusing them of plundering the corporation he founded. Many thousands actually believed him, including the grand jury. Walter V. Woehlke summed it up:

"Los Angeles believes in miracles. It has seen the transformation of a drowsy, dusty, half-Mexican cow town on the edge of nowhere into the largest city west of Chicago; it has seen the marvelous growth of the real estate and movie industries; it has seen land values skyrocket to the ceiling and stay there; it has seen hundreds of fortunes spout out of the earth in black, smelly streams. That's why Los Angeles still believes fervently in Santa Claus. It's this powerful faith, this naïve credulity of Los Angeles that made possible the remarkable Julian Petroleum stock swindle with its aftermath of singed and tarnished reputation. Without this credulity C.C. Julian, founder of the Julian Petroleum Corporation, never could have gotten to first base." [35]

May 7, 1927, was a monumental, sad day in the history of Southern California, for on that day all trading in Julian Petroleum stock was stopped and 40,000 investors woke to the realization that they had been fleeced of $150,000,000. Legal action was swift. On June 23, 1927, the Los Angeles County grand jury indicted 55 men involved in Julian stock trading on charges of embezzlement, usury and other charges.

At first the names were kept secret by District Attorney Asa Keyes, but when leaked onto front pages, newspaper readers discovered they were the same names which appeared so frequently in society and celebrity columns. The accused criminals were the most powerful and most respected businessmen in Southern California. Later dozens of

business leaders were indicted, including Long Beach residents Charles E. Reese and his son, R.M. Reese, both of whom acted as stockbrokers for the Julian Company. Most never faced trial; the Reese's case dismissed on grounds of insufficient evidence.

A 1928 jury found Sheridan C. Lewis, general manager of the company, and other Julian Pete officials not guilty of conspiracy to defraud. (Lewis, and a half dozen others eventually went to prison for various crimes, but no one was ever punished for the Julian swindle itself.) Six months later Southern Californians learned that Julian Pete official Jacob Berman had bribed Los Angeles District Attorney Asa Keyes to undermine the prosecution while Lewis had bought off several jurors. Los Angeles District Attorney Asa Keyes had been paid tens of thousands of dollars to throw the case, accepting thousands of dollars in bribes from those Julian officials being brought to trial. Keyes retired shortly before the truth emerged and was succeeded by his former assistant Buron Fitts. It was up to Fitts to bring his former boss to justice. Keyes was sentenced to a five year prison term in February 1929, but was released after serving only 19 months. Despite the lenient prison term, the stress was too much for Asa Keyes. He died of a stroke on October 18, 1934, at age 57.

The man who started it all, C.C. Julian, went bankrupt and, after being indicted for a second scam in Oklahoma, fled to Shanghai where he committed suicide on March 25, 1934. He had come to Shanghai in 1933 in default of $25,000 bail in Oklahoma where he was charged with fraud in connection with his financial operations. He steadfastly maintained his innocence in the Oklahoma case, saying he fled because he could not obtain a fair trial anywhere in the Sooner State. Through a friend in Canada he obtained a passport made out to T.R. King and attired in shabby clothing, and posing as an Irishman, he departed Seattle for China. Julian's year in Shanghai was marked by the failure of one enterprise after another. Invariably he would find that the people he contacted about "business ventures" were as penniless as he himself. Finally he had had enough. Julian took poison at 1 a.m. and died five hours later, penniless at death and a fugitive from justice in the United States.

The Julian fiasco was merely the prelude to the devastation that came after 1929. When the Richfield Oil Company went into receivership in 1931, an audit revealed an operating loss of $54 million. Items such

as alimony, hotel rooms, purchases of jewelry, repair of speedboats and so forth had been blithely charged to the company. Then the Guaranty Building and Loan Association failed (its president had embezzled $8 million), then the American Mortgage Company failed for $18 million. Nearly every major financial debacle involved some political figure, a judge, public official or some well know fixer, Carey McWilliams wrote in *Southern California Country*. McWilliams also pointed out that in earlier times investors had purchased something physical, such as property (at whatever inflated price), but with Julian stock certificates all they had were pieces of paper.

The Julian scandal, coinciding with the onslaught of the Depression, pauperized at least 500,000 Southern Californians. Its consequences would ripple on and on, gaining force until in 1930 the region led the nation in the number of bankruptcies and in the amount of net losses in bankruptcy proceedings. The scandal contributed to the collapse of the First National Bank, the election of former Ku Klux Klansman John Porter as mayor of Los Angeles, and the defeat of California Governor C.C. Young in his bid for re-election.

Greed and Murder

Repercussions from the Julian fiasco were widespread. Long Beach businessman W.W. Compton returned to Long Beach in October 1927, expecting to find the new $500,000 hotel he was building on West Seaside Boulevard completed. Instead he found the contractor he had hired, H. J. Kimmerle, in prison. Kimmerle had been sentenced to two years jail time for assaulting Arthur M. Loeb, who worked for the Julian Petroleum Company. Kimmerle had attacked Loeb after finding his investments had been compromised. Loeb had been lucky to escape with his life. Julian promoter Motley Flint was murdered in a Los Angeles courtroom in July 1930 by an investor in Julian stock, Frank Keaton, who, at the time of the murder, had exactly ten cents in his pocket.

Long after the Julian stock crash the effects of the scandal continued to incite additional crimes of bribery, murder, and embezzlement. The double murder of Charles H. Crawford, Los Angeles politician, and Herbert Spencer, newspaper man and "exposure" writer," committed on May 20, 1931, was partially motivated by a fight over some of the spoils of the Julian case. But an earlier murder, with C.C. Julian vouching for the murderer, has escaped notice, until now.

It's said that money is the root of all evil. Besides destroying marriages and estranging families, it can kill a friendship, which is exactly what happened to Charles Dorris and Henry Meyer on June 30, 1924. It all involved money invested in Julian Petroleum.

By 1924 oil surpassed agriculture as the leading industry in California. In Southern California alone that year 230 million barrels of crude oil was pumped out of the rich "oildorado" ground. Oil from Signal Hill alone caused ship traffic through the Panama Canal to double in 1923. It was a time to make a fortune, C.C. Julian told prospective investors; instead, those that heeded his sales pitch would become victims of the biggest swindle in the 1920's oil boom. The only thing was that in 1924 they didn't know it.

It was economic ambition and a swindle in the making that led to the murder of a millionaire real estate owner and the wife of his

former business partner. While Henry Meyer's two young children sat eating ice cream in the parlor below, Mrs. Therese Dorris and Henry D. Meyer were shot and killed in suite 31 of the Eleanor Apartments at 59 Atlantic Avenue. What followed was one of the most sensational murder stories in the history of Long Beach.

It came about after an argument over money, a distraught Charles W. Dorris told authorities. Meyer, irate at Dorris' insistence that Meyer pay back a debt, was preparing to shoot Dorris when Therese unexpectedly entered the room. Seeing the revolver held against her husband's breast, Therese attempted to rustle the gun away from Meyer when the gun went off killing her. Dorris told the *Long Beach Press* that when he heard the shot he grappled with Meyer and in the struggle another cartridge was fired and killed him.

Charlie Dorris and Henry Meyer had been friends and sometimes business associates for ten years. Though Meyer was the owner of the Meyer Department Store in Pasadena and Dorris owned the Eleanor Apartments, they frequently joined forces to purchase additional properties. Like many others in Southern California they were smitten with the get-rich-quick scheme of C.C. Julian. Both had been lured into Julian's web and though they had agreed to sell their jointly held properties, they disagreed on how much to invest in Julian Pete.

Meyer believed Julian's sales pitch which promised to pay $30 on the dollar when Julian's wells came in; Dorris was a little more wary. But Meyer was hooked, especially when some of Julian's wells actually began to generate a small profit. According to Dorris, when the two men decided to dissolve their partnership Meyer wanted more cash to invest in Julian Petroleum stock. He was sure that the additional money invested in Julian Pete would pay off threefold. Dorris, a more cautious investor, agreed to loan Meyer $25,000, with the stipulation that Meyer pay him back the $25,000 in May 1924.

The oil profits hadn't come rolling in as quickly as Meyer hoped and Meyer was able to convince Dorris to extend the loan a bit longer. Things looked promising for Julian Pete, Meyer told Dorris. Julian just needed more time for a well to hit pay dirt. But Dorris could only extend the loan so long; he had bills to pay. On the morning of June 30, 1924, Meyer came to Long Beach, Dorris thought, to pay off the $25,000 note.

After some initial chit chat in which Meyer appeared nervous, Dorris asked for the money. According to Dorris, Meyer said he didn't have it, drew a gun, and forced Dorris to go to his desk and get the IOU. Holding a gun against Dorris' chest, Meyer made Dorris tear off Meyer's signature on the note before flushing the rest down the toilet. Once done, Meyer brusquely informed Dorris he was going to have to kill him. Pleading, Dorris persuaded his would be murderer to let him get his mother's prayer book to hold, Meyer curtly agreed. In the meantime, Mrs. Dorris walked into the room and couldn't believe the scene before her. Their good friend Henry Meyer was pointing a gun at her husband. She confronted Meyer and told him there must be some mistake, he didn't want to shoot his friend, besides Meyer's children were downstairs. When Meyer refused to put down the weapon she grabbed for the gun and in the scuffle was shot by Meyer. Charles Dorris claimed he then struggled with Meyer for the revolver, shooting him in the melee.

Henry Meyer's brother, Reverend H.O. Meyer, argued that Dorris was lying. He claimed that instead of Meyer owing Dorris $25,000, as Dorris told police, Dorris was indebted to Meyer. Also, Meyer did not even own a gun, his brother asserted. But could the minister explain why five cartridge shells were found in Meyer's automobile? The only reason, the Meyer family openly charged, was that Dorris' attorneys had planted fake evidence.

Was it true? Long Beach police swore they had searched the car earlier and found nothing. Later, a second search, insisted upon by Dorris' lawyers, had turned up the shells. The car was in the unlocked garage at the Meyer home. It would have been easy for someone to hide things in the auto while the family of the slain man slept.

Then there was the slip of paper found in Henry Meyer's pocket with his signature on it. Did this prove the existence of an IOU? Again, Meyer's family claimed it could easily have been planted by Dorris. They said Dorris was well aware of Meyer's habit of tearing his signature off of notes he had paid.

Two guns would play a pivotal part in the investigation, one a .32 caliber the other a .38 caliber revolver. Dorris admitted the .38 caliber weapon was his and claimed the .32 belonged to Meyer. But did it? Though Meyer and Therese Dorris were killed with a .38

caliber revolver, Dorris repeatedly stated that the trouble began when Meyer drew the .32 caliber gun. By tracing the .32 weapon through its partially filed off serial number, Long Beach police learned it was last sold by a San Francisco firm in May 1919. Dorris was in San Francisco at the time the pistol was sold, according to investigators, and Meyer had never been to that city. Was Dorris, the only witness to the tragedy, lying?

Gerald Walters, a former janitor at the Eleanor Apartments, certainly punched holes in Dorris' tale. Walters told authorities that Dorris and Meyer had quarreled violently five months earlier and that Dorris had pointed a revolver and threatened Meyer with it. The 26-year-old Walters claimed he grabbed Dorris' wrist and forced him to put the gun away before he could harm Meyer. He also professed that Dorris nearly always carried a gun as did Mrs. Dorris. He believed the .32 weapon found in the apartment belonged to Therese Dorris.

Dorris seemed to have a Dr. Jekyll/Mr. Hyde personality, Walters testified. Walters had personally witnessed Dorris' violent temper and womanizing, mentioning the day Dorris flew into a rage and locked himself and his wife up in their apartment. Neither came out for three days. When they did Mrs. Dorris had a black eye. Walters told the judge he didn't want to get mixed up in the case and vowed that Dorris was like a father to him when he wasn't in one of his rages.

An unexpected telegram came to Dorris' rescue during the initial grand jury investigation. Oil promoter C.C. Julian was an intimate friend of both Henry Meyer and Charles Dorris. He knew the two heavy investors in Julian Pete well. Julian stated that earlier in the year Dorris had shown him a note he held from Henry Meyer. Several times Charles Dorris had stepped in to pay Meyer's debts to Julian, Julian stated. When Julian asked Dorris how he expected to be paid back, Dorris showed him the IOU from Meyer.

Was this proof that Meyer was indebted to Dorris at the time of the double shooting? Did Julian's telegram substantiate Dorris' claim that Meyer was frequently in need of money and that Dorris paid his bills? It certainly seemed so when Ethel P. Evans signed an affidavit declaring she had been in Meyer's office and heard Meyer speak of the $25,000 note. She also added Meyer had proclaimed he would see Dorris in hell and as old as Methuselah before he paid the money back.

Despite the testimony of C.C. Julian and Ethel Evans, the grand jury indicted Charles Dorris on July 15, 1924, stating there was enough evidence that he had shot and killed Therese Dorris and Henry Meyer for him to stand trial. There were discrepancies in both the evidence and in Dorris' story. There were sufficient indications to show that Meyer did not come to Long Beach with a gun. The grand jury believed Meyer's quivering 12-year-old daughter who told of seeing her father get dressed on the morning he was killed. She tearfully stated she did not see him place a gun in his pocket. But the real nail in Dorris' coffin was forensic evidence.

Crime data revealed that Therese Dorris was shot *after* Meyer, not before. Then there was the testimony of Mary Puddifoot, who lived in the adjoining apartment. She told of hearing a single shot, but after a lapse of six or eight seconds of silence she was startled by two more shots, fired in rapid succession. Rushing out of her apartment to find the cause of the gunfire, she saw the door to the Dorris apartment open, two guns on the living room floor besides the body of Therese Dorris. Other witnesses who appeared on the scene later claimed the two weapons were found within a few inches of Meyer's hands, in the dressing room. With this evidence the prosecution hoped to prove Dorris had a deliberate plan for killing his business associate, while Mrs. Dorris' death was perhaps accidental.

During the subsequent trial Dorris stuck by his original story. His attorneys openly accused Dorris' former employee Gerald Walters of lying. They tried to prove that Walters hated Dorris and had sworn to "get" him. They called witnesses who swore Walters had swindled one of the tenants out of $300 and Dorris found out. When Dorris said he was going to pay the money back out of Walters' pay, Walters quit. J.B. Doswell, a tenant in the apartment house owned by Dorris, testified that Gerald Walters had said he would "get even" with Dorris by giving evidence against him.

May Tompkins, a Long Beach banker, swore she had held a written copy of the disputed $25,000 promissory note, said to be the cause of the trouble between the two men. The signature on the original note, she declared, was the correct signature of Henry D. Meyer. Why a copy? Frank McComas, a former business partner of Meyer, had advised Dorris to have a duplicate made of the disputed promissory note. From

149

his past experiences with Meyer, McComas felt Meyer might try to deny any money was owed.

William Brown, a Long Beach building inspector who lived at the couple's Eleanor apartments, was called as a character witness for Dorris. He declared that Dorris daily expressed his love for his wife by carrying her breakfast up three flights of stairs from the first floor kitchen to their apartment. Charlie Dorris' stepson, motion picture director Wesley Ruggles, refused to believe his stepfather guilty. He described his mother and stepfather as a loving couple.

Dorris had much to say when called on to testify. He began his story from the witness box, recounting his courtship and twenty-three year marriage to Therese Maria Heinsch Ruggles. He loved his wife, he tearfully stated, and missed her greatly. He told how Therese had been born in Los Angeles in November 1869 to German immigrant Herman Heinsch, a saddle maker, and his New York born wife, Mary. In 1885, at age 16, she had married her first husband, Charles S. Ruggles Sr., a pharmaceutical salesman, but that marriage ended. Dorris went on to explain that he had met and married Therese in Redwood City, California, in 1901.

What Dorris didn't reveal about his 55-year-old wife was the truth about her first marriage. Though Therese and Ruggles split up sometime before 1900, both listed themselves as widow and widower in the 1900 census. Had they been too embarrassed to mention a divorce? Had there even been a divorce?

Dorris also told of his first meeting with Henry Meyer, fifteen years earlier, in which they formed a partnership and pooled their small savings from which each built a fortune. He related in detail the disputes over the $25,000 promissory note which Meyer wanted to keep secret so it wouldn't interfere with his bank credit. He described the day of the shooting in detail.

Charles and Therese, Dorris related, greeted Meyer and his two small children in front of the Eleanor apartments. Charles, who enjoyed children, made it a practice to take the Meyer youngsters to a nearby shop to buy ice cream whenever they visited. Having made the customary trip, he told them to finish their ice cream outside and then come into the downstairs parlor, where he thought their father would be. However, when Dorris suggested to Meyer they wait for the

children in the parlor, Henry Meyer insisted they go up to the Dorris' apartment.

Once there Meyer confessed his investment with Julian Petroleum hadn't been paying as much as he hoped and asked for another extension on the loan. Dorris told Meyer he was sorry, he had obligations too and needed the $25,000 to pay his bills. Meyer then asked Dorris if he had the note on him and if so could he see it. Dorris pulled the IOU from a nearby drawer, but Meyer said he needed to look at it in a better light and walked to the bathroom. As Dorris entered with the note and turned on the light, Henry Meyer pressed a .32 caliber gun against Dorris' breast. He demanded that Charlie Dorris tear off the signature then destroy the IOU. With a gun aimed at his chest, Dorris said he had no choice. He tore up the IOU. Meyer put the signature in his pocket, telling Dorris that every time he looked at it he would remember the only man who ever beat Henry Meyer in a deal. Though Dorris did as asked, he told Meyer it wouldn't do any good; he had a copy of the note at the bank.

At this point Dorris said Henry Meyer went wild. Dorris pleaded that if he must be killed to please let him hold his mother's Bible while he prayed to God to take his soul. Meyer agreed he owed his old friend that much. As Dorris opened the drawer for the prayer book Meyer spotted Dorris' .38 pistol, also in the drawer, grabbed it, and pointed it and the .32 gun at Dorris. At this moment Henry Meyer heard Therese Dorris enter the room. She couldn't believe what was happening. She tried to get between the two men telling Meyer to give her the guns. Meyer then reached with one arm, pressed one gun against her head and shot. As she fell at her husband's feet, Dorris grabbed for the guns. A fight ensued in which three shots were fired. Furniture was kicked over and as the melee continued Henry Meyer fell on top of Therese Dorris and Charles Dorris fell on top of his former business partner. As Meyer was half-way down, the fourth shot rang out and Meyer sank into a corner, the guns falling to the floor beside him.

Dramatically, Dorris knelt to the floor before the jurors, weeping and bending over an imaginary body. He told them:

"I lifted my wife's head. I kissed her. I called to her to speak to me. I laid her head tenderly back on the floor, got up and ran out into the hall, calling

for a doctor. I ran back into the room. Again I picked up my wife's head and pleaded with her to speak to me. The little spot of blood on the carpet had known grown to a big pool. She wouldn't speak to me." [36]

Dorris then sank back into the witness chair. Following four hours of nonstop cross examination Charles W. Dorris refused to deviate from his story, though he did admit to having once been an actor. The social high point of the day was when C.C. Julian, dressed in a spotless white serge suit, purple silk shirt, white shoes and socks, natty bow tie and a straw hat, ascended the stand, a scent of delicious perfume wafting about him. He testified that he had heard of the disputed note and had actually seen it several months previous to the homicide.

On August 12, 1924, Charles W. Dorris walked out of the Superior Courtroom a free man. After forty-five minutes deliberation, the jury decided too much of the evidence was circumstantial. Though Dorris' story had holes in it, the jury felt much could be attributed to a confused memory surrounding the traumatic events. Following his release Dorris made a brief statement in which he said he wished to thank the friends who came forward to aid him, particularly C.C. Julian. It had not been the usual murder case prompted by love, jealousy, hatred or revenge; this one was one of mortgages, trust deeds, interest payments and oil.

On August 8, 1925, almost a year to the day following his acquittal, Charles Dorris was awarded $24,200 from Henry Meyer's estate. It wasn't the full $25,000. Dorris admitted he owed Meyer $800 at the time of his death and subtracted that amount from his suit. He didn't have long to enjoy his money.

On September 10, 1925, the 50-year-old Dorris was fatally injured while on his way to visit a sick friend at St. Vincent's Hospital in Los Angeles. He was getting off a street car near the hospital when he slipped on a traffic button. Before he could recover his balance he was struck down by another street car traveling in the opposite direction. Both his legs were crushed so severely they had to be amputated. He died a few hours later from loss of blood and shock. Besides his three sisters, Charles Dorris was survived by his stepsons, film director Wesley Ruggles and Therese's actor-son, Charles Ruggles.

This was not the end of the story. On July 17, 1928, the California Supreme Court ruled that there was no proof Meyer had signed a

$25,000 promissory note to Dorris. When authorities examined Meyer's body they had discovered a fragment of the alleged note in one of his pockets, handwriting experts now testified it had been written by Meyer's book keeper and it did not appear to be part of a promissory note. Had a $25,000 IOU ever existed? Though several witnesses had claimed to have seen it, no copy had ever surfaced. The court, acting on the handwriting experts' testimony, ruled Dorris was not owed any money from Meyer's estate. It was up to his heirs to give back the funds awarded him in 1925.

Was God Angry?

To many it seemed that God smiled on Southern California; a special halo encircling the area. Consider, for example, the exemplary weather, the good luck in having both the motion picture and oil industry call the Southland "home." It seemed the perfect Eden for those escaping frigid Midwestern winters, for those wanting to start again in a new bourgeoning economic climate. In the decade 1920-1930, over 2,000,000 people moved into California, 72% of whom settled in Southern California, with Los Angeles County recording a gain of 1,272,037. The migration into Southern California in this decade was the largest internal migration in the history of the American people.

Long Beach tried to cope with this influx of newcomers and tourists by letting them know what behavior was expected of them while in this city dubbed the "Queen of Beaches." Long Beach prided itself on its "moral" character and wanted to keep it that way. In 1920 the following ordinance was drafted by mortician turned police commissioner William Peek:

"No person shall appear in or upon any highway or other public place, upon the sand or beach along or near the shore of the Pacific Ocean, or in the Pacific Ocean, in the city of Long Beach, clothed in a bathing suit which does not completely conceal from view all the trunk of the body of such person and each leg from the hip joint to a peripheric line one-third of the way to the knee joint, except that the chest and back may be exposed to view, and without such bathing suit having attached thereto a skirt made of the same kind of material as the bathing suit, completely surrounding the person and hanging loosely from the peripheric line at the waist to the bottom of such bathing suit." [37]

Improper conduct on the beach was also branded a misdemeanor by Long Beach law, and stiff penalties prescribed for violations. Bathers were not to loiter on the sand unless they wore cloaks over their suits. Sand throwing and wrestling between persons of the opposite sex were also violations of city statutes. Public dance halls had already been regulated with certain dances, such as the shimmy and the bunny hug, and any cheek to cheek dancing blacklisted.

Maximum punishment for violating the ordinances was six months imprisonment, a fine of $500 or both. But Peek's "Peek-a-boo" ordinance was repealed in 1923. It was too draconian, some thought, and hurt the tourist trade.

Was God angry? This was the question Reverend George Taubman asked of his Long Beach Men's Bible class in May 1924. Had Satan's influence infiltrated paradise? Drunkenness, graft, corruption, gambling, lack of public morals, and greed seemed to permeate American as well as California society. Long Beach sinners had even profaned the dead in their greed for oil, Taubman reminded his flock. The City of Long Beach had contracted with A.T. Jergins to search for oil on municipal land on the north side of Orange Avenue, just across the street from the cemetery. The City flagrantly allowed the mud and oil from three wells drilled adjacent to the cemetery fence to run down the slope and onto the graves. Slant drilling under the graves was also permitted. Perhaps Long Beach's angry dead had convinced God it was payback time. Had man's licentiousness and disregard of God's commandments caused the terrible disease now sweeping the state?

What was this "terrible" disease that Taubman was preaching about? In March 1924, the dreaded "hoof and mouth disease" that had ravaged the United States in 1914-1916, broke out in Northern California. By early April it had spread to Los Angeles County where, on April 6th, a quarantine went into effect.

The "cattle" disease, also known as aphthous fever, was extremely contagious among cloven footed animals, including such wild animals as deer; but horses, dogs and birds were also known to be carriers. Germs could also cling to shoes and clothes, even the tires of cars, while spreading for miles in the air. The disease usually appeared in infected animals anywhere from three to six days after exposure to the infection, but there had been instances where the symptoms did not appear for eighteen days.

An infected animal showed blister-like eruptions and lesions usually on the tongue and around the mouth. Often the udders of cows became infected and lesions would sometimes appear between the cleft of the hoofs. Cows become dry, steers lost quite a bit of weight, and all infected animals become lame. Old and young animals succumbed, others lived, but those that lived still carried the contagious disease and spread it to others. Though rare, humans could become infected.

On April 6th all roads leading into Los Angeles County were barricaded with barbed wire, and 500 extra deputy sheriffs and 100 extra horticultural commissioners hired to supervise the few roads open into the county. Checkpoints were set up at these open roads and cars had to pass through fumigated sawdust patches to disinfect the tires of the automobiles. The following instructions were issued:

1. *Stop all movements of manure, feed and livestock, including dogs, cats, poultry and rabbits, and all live stock products except eggs, and unless they have an official permit arrest them and send them back to point of origin.*
2. *Deliveries and collections must not be made except at public roadsides.*
3. *Horses in harness and under saddle may be moved on country roads without permit, but if found off of highways or off the premise of the owner an arrest should be made.*
4. *If any dead animals are found they should be watched and not allowed to be moved until the State Department of Agriculture is notified and can make an inspection and disposition of such animals.*
5. *If stray animals are found the owners should be located and arrested: if animals are not immediately confined telephone State Department of Agriculture for instructions.*
6. *All persons are prohibited from entering or trespassing on public or private premises where livestock is kept. This includes pleasure seekers, campers, flower pickers, mushroom hunters, salesmen, patent-medicine vendors, solicitors, etc.*
7. *Dogs must not be moved except when in crates and by official permit and by common carrier.*
8. *Milk trucks collecting milk in cans must not accept delivery except at roadsides.*
 All violators of the above rules should be arrested.[38]

The quarantine posed a serious threat to bootleggers. The law mandated that every vehicle coming into Los Angeles County be stopped, searched for infected produce (it was thought fruit and vegetables could be infected because of the soil they were grown in), and driven through two troughs of creosote to kill the disease. Of

course the first thing rum runners did was bribe some guards so that their vehicles would not be searched. However, not all the guards could be bought off.

Shell Oil Company employee, S.M. Robinson, was shot in the shoulder by an Orange County patrol when he refused to stop at one of these barricades. Robinson said he suspected a holdup when a man flashed a light and attempted to stop him on the county line. To escape, he put on the gas, sped ahead and was shot.

Lloyd Ross, a Long Beach business college student driving home to Anaheim, had a similar experience when a sentry attempted to stop him on the road. He drove ahead and the guard fired at him four times. But were Robinson and Ross really telling the truth, or were they in fact bootleggers trying to get their illicit booze into Orange County?

On April 7th, Long Beach officials received notice from county health officials that they should organize local gun clubs or groups of men with guns. These gun totting hunters needed to be prepared at a moment's notice to clean up all the stray dogs and birds in the area. Birds and dogs had proved to be particularly bad carriers of the infection in the past. On April 25th, Chief Clerk George L. Buck of the city manager's office was ordered to mobilize Long Beach hunters. Long Beach men got out their weapons for a slaughter of massive proportions.

On April 26th, following an outbreak of 31 cases of the disease, all 7784 pigs at the Long Beach city hog farm, and a herd of 376 milk cows at the Franco Dairy, had to be destroyed because of the hoof and mouth infection. At the hog farm, north of Signal Hill, a steam shovel dug a pit eight feet deep, twenty feet wide and 300 feet long to bury the slaughtered animals. Quicklime was placed over the corpses to hasten decomposition. As long as the animals were above ground there was grave danger of the disease still spreading. With the gun clubs mobilized, all cats, dogs, squirrels, goats or any animal straying into the Signal Hill area were immediately shot.

No one other than those officially connected with the quarantine were allowed inside the infected zone. There was one exception: Bixby School teacher, Miss Matilda Jahn. Federal authorities in Los Angeles granted her permission to enter the quarantine area to conduct school, with the stipulation that she remain inside the lines until the quarantine ended. People could also be carriers of the disease.

Memory of the 1914 epidemic which had spread to 22 states and lasted two years was still fresh in the minds of neighboring states. Eight western states and Hawaii laid down trade restrictions forbidding importation of California livestock, fruits and vegetables—in effect closing the California agricultural market. During Easter 1924, Governor Hunt of Arizona declared an embargo against automobile travelers from California wishing to pass through his state. An urgent appeal for help went out from Mayor C.E. Stauter of Needles, California, on behalf of the Arizona-bound motorists stranded in Needles as a result of Governor Hunt's edict. Mayor Stauter faced a daunting situation, with around 750 cars held up at Needles his town was running low on food to feed the 2000 motorists. A similar cry for help went out from El Centro, California, which was caring for 500 tourists. At the border with Arizona a line of some two hundred cars, carrying about seven hundred passengers, stretched westward from the Colorado River bridge at Yuma, Arizona, a mile and a half into the desert. Finally the Arizona governor relented, but not until all cars were fumigated—a process taking 20 minutes per vehicle.

Stringent quarantine rules remained in effect throughout Los Angeles County until early May, gradually diminishing as the outbreak lessened. Nearly 110,000 California farm animals were killed during the outbreak. Wranglers drove them into broad trenches dug by steam shovels. Marksmen gathered at the rim and shot the animals dead. By summer the disease invaded the Stanislaus National Forest. Hunters were hired to kill more than 22,000 deer suspected of carrying hoof and mouth disease. State officials called it one of the worst economic disasters to ever hit California.

Following the destruction of the animals on the hog farm, Long Beach no longer had pigs to eat and dispose of the city's garbage. The city hurriedly rushed forward to build an incinerator to take care of the garbage. In the meantime the city leased Bixby land northeast of Signal Hill and dug six trenches fifty feet long to handle the approximately forty tons of garbage collected daily. In August, Long Beach decided to experiment again with garbage eating hogs, but mandated that the hog farm be outside city boundaries. They also passed a measure forcing all dairy farms out of the city limits—a wise move since the disease appeared once again at a Montebello hog ranch in 1929, but Long Beach fortunately escaped.

During the 1920's, Reverend Bob Shuler of the Trinity Methodist Church in Los Angeles considered himself in a battle for the soul of the City of the Angels, what he considered the last purely American town in the nation, the only such city not dominated by foreigners. He saw this Southland metropolis as the lone city in the nation in which white American, Christian idealism still predominated. This fierce, patriarchal, bigoted preacher personified the Bible belt in all its relish for hellfire and damnation. He loved the Bible, but hated Jews, Catholics, foreigners and non-whites. When 1924 continued to be a year of death and quarantines, he knew the reason: the "Mexican disease." Immigrant Mexicans had brought unsanitary conditions with them to God's holy city. They were now being punished for their sins with a scourge right out of the Middle Ages—the Black Death.

The Black Death, which had once devastated Europe's population, came to the Los Angeles area in the fall of 1924. The nightmare began on October 26th when Guadalupe Samarano, a 37-year-old Hispanic resident of the 700 block of Clara Street in Los Angeles (now the site of the Twin Towers jail complex), was admitted to County Hospital with what appeared to be lobar pneumonia. He died the same day.

Just one week earlier the victim had attended his wife Luciana's funeral. Within the next two weeks twelve of the mourners at Luciana Samarano's last rites died of the same ailment. On October 29th, six members of the Clara Street family were admitted to County Hospital, suspected of having epidemic meningitis. On the same day a relative, 15-year-old Francisca Loujon, died in the hospital of the mystery illness. Four other members of the family were taken to the hospital on October 30th, all ill with pneumonia. Six other pneumonia patients, all relatives and friends, were admitted a day later.

The dying continued. One of the victims was Father M. Brualla, a 48-year-old Catholic priest. He had administered last rites to a boy ill with the disease. The priest became sick on October 28th, dying on November 2nd. An ambulance driver who handled one of the victims also died. In County Hospital a nurse became ill with the mystery malady. She was one of the few who recovered. Soon frightened attendants were wearing emergency masks made of pillow cases with a celluloid window held in place by adhesive tape to try to keep out

whatever germs were causing these cataclysmic deaths. Meanwhile, the mother, brother and sister of the original victim succumbed to the still undiagnosed illness.

The medical community was perplexed. Doctors at first suspected meningitis, influenza, pneumonia, even typhus. It wasn't until October 30th, nearly a month after the disease had claimed its first victim, that Los Angeles County pathologist George Maner identified the killer bacterium—plague!

In their mad race to stop the spread of plague, health authorities found 114 persons who had come into contact with victims who did not contract the infection. On October 31st, the Los Angeles Health Department decided to quarantine an area of about seven blocks surrounding the Clara Street address. None of the 1600 people inside the quarantine zone (bounded by Alameda Street, Macy Street, the Los Angeles River and Alhambra Avenue) was allowed to leave. No one was permitted to enter, except a half-dozen employees of the Los Angeles Health Department. Once inside, they were not allowed to depart until the quarantine was lifted.

Nothing, not even Reverend Shuler's rants about God's revenge, could prevent Miss Nora Sterry, principal of the Macy Street School, from being with her students and their families. Though police tried to keep her out of the quarantine area, she went in anyway.

Her presence instilled new hope into the hearts of those of Little Mexico, as the area around Clara Street was called. She found many within the quarantined zone who didn't live there. They had been caught in the net of the quarantine with nowhere to go. The courageous school principal opened the doors of her school and with the aid of two missionaries she established a kitchen, preparing food for the stranded ones and for those whose food supplies were so suddenly cut off. To ease the tension and the fear, she gathered a band of Mexican musicians who gave a concert in the school yard each afternoon. Each night they serenaded those whose homes and families had been stricken with the plague. When the quarantine was lifted on November 13th, Nora Sterry was not permitted to leave the area until the people of Little Mexico awarded her with a gold medal for all she had done. She later had a school (1730 Corinth Ave. in Los Angeles) named after her.

Miss Sterry had done much to assuage the fear of those trapped in Little Mexico. Many spoke little English and did not understand

the reason the police did not permit them to leave the area. At the outset, the Los Angeles Police Department furnished 75 men to patrol the outskirts of the quarantine area. There were 25 officers on each watch. Once, when a group of residents tried to go through the lines to the outside world, the police sent sawed-off shotguns to its quarantine guards. The residents decided to stay and returned to their homes. Inside the lines, Health Department workers set up headquarters in a church. Since the plague was caused by a germ called bacillus pestis, carried by a flea that rides around on rats, the health workers' job was to find rats and fleas in the quarantine area and destroy them before the infected fleas bit humans.

Dr. Walter M. Dickle, secretary of the State Board of Health explained that the plague was carried only by rat fleas; unlike dog fleas, which also attacked humans, rat fleas preferred other rats. A bite from an infected flea could produce the bubonic type of plague in humans. Bubonic plague was characterized by swollen lymph nodes and a high fever. It developed slowly over a few days and was not very contagious. However, if not treated with common antibiotics, it could be fatal. Pneumonia plague could also result. This form of the plague attacked the lungs, but progressed so swiftly treatment often came too late. The average time from start to death was 1.8 days. It could be spread to other people by direct contact, coughing or sneezing.

The Los Angeles city council tried to keep the situation quiet to avoid fear and panic sweeping the entire city. Reverend Shuler agreed to tone down his rhetoric.

In the meantime, the council quickly appropriated $25,000 to get rid of the rats. For two weeks the health department sprayed 1300 structures with an emulsion of kerosene and soft soap to kill the fleas. Thirteen structures were burned to the ground to destroy rats and little squares of poisoned bread were planted throughout the quarantine area to take care of any remaining rodents. Their bodies were then burned.

An ordinance was also adopted requiring that all local and foreign vessels entering Los Angeles harbor be equipped with metal rat guards placed on the hawsers connecting the vessels and the docks. The guards prevented rats reaching the docks from the vessels.

In rapid succession thirty-three succumbed to the Black Death. Many were people who had visited the ill-fated family at 742 Clara Street. Most of the bodies were cremated in the county incinerator.

Final toll: 31 cases of pneumonic plague, 29 deaths; 6 cases of bubonic plague, 4 deaths.

The last case of pneumonic plague developed on November 6th, and the quarantine was finally removed on November 13th, since one week was considered the maximum incubation period for pneumonic plague. But the work of local, state and federal health officials had just begun. From November 4, 1924, until June 20, 1925, Los Angeles health authorities killed 141,356 rats in the city. One hundred eleven of which turned out to be plague infected. Seven plague infected squirrels were also located. In the same period, 9,470 buildings were disinfected or rat-stopped, which meant opening up the foundation and plugging holes in walls and floors.

In the 1940's officials theorized that a flea-carrying ground squirrel came into the Little Mexico area on a load of hay from Northern California. The infected fleas left the squirrel and attached themselves to rats in the area. Eventually a single flea bit a human, and this person became the epidemic's first victim. This theory was disputed in 1986 by medical historians who believed the plague that infested Los Angeles came from San Francisco aboard a ship that had entered San Francisco Bay from the Orient. It seemed more was being unloaded from the rum running boats than just alcohol.

Perhaps Long Beach had been punished enough with the devastation caused earlier in the year by the hoof and mouth disease. Had it just been chance that Long Beach escaped the 1924 plague? Or was God giving the city one more chance to redeem itself? But decadence continued throughout the Southland. Author Mary Austin, for instance, was convinced that a stern God would someday render just retribution upon Los Angeles for the crime it had committed in underhandedly obtaining water from the Owens Valley.

It was only a matter of time before God would cast another blow against the land that many considered a new Eden. On March 10, 1933, God would crack down a great hammer of divine retribution, with a powerful earthquake which would shake not only buildings, but the soul of Southern California residents. Some said it was the first manifestation of an awful curse which Reverend Shuler had placed upon Southern California after he failed to be elected to the United States Senate.

At 5:54 p.m. on the evening of March 10, 1933, memories for thousands were flash frozen—preserved for a lifetime—when the ground around Long Beach shook for 11 seemingly never ending seconds. The killer force quake, measuring 6.3 on the Richter scale, occurred at the optimum time to save lives. Most people were home for dinner, off the streets and away from the schools that would face almost total destruction. Still, 51 people were killed in Long Beach and an additional 91 in surrounding areas.

Eyewitnesses stated they heard a rumble, a strange sound the likes of which they had never before encountered, and then the earth started writhing around them. Some recalled their pets seemed to sense something amiss before the quake. Dogs barked nervously, canaries fluttered wildly in their cages and cats dashed away. Seconds later the deep rumble began. The earth lurched, surging up from an epicenter six miles deep, 3 1/2 miles off Newport Beach.

Bricks and debris rained down on Long Beach streets, loosened by the powerful movement of the earth. Buildings crumbled, streets buckled and fires erupted in several spots. Telephone poles swayed and snapped, putting the city's 32,052 phones out of service. Electricity was gone, but an alert gas company worker turned off the city's gas lines during the temblor preventing further fires.

Fortunately the city had a disaster plan, and the help of the Pacific Fleet anchored off the Long Beach coast. Electricity was restored to the downtown area by 7:30 p.m., but outlying hospitals were without power. The city disaster center got on their portable radio and called on anyone with access to bootleg liquor to bring it to the command center immediately, not to confiscate and pour down the drain, but to take to hospitals to sterilize surgical instruments. Within an hour after the first jolt, all roads leading into Long Beach were patrolled with the help of 2,000 Navy men who came ashore with loads of blankets and supplies immediately after the first shock. They stayed for almost a week, helping anywhere they could.

Many interesting stories appeared following the quake: a hen laid three eggs a few moments after the first shock was felt; a woman who had been suffering from paralysis for years was immediately cured by

the vibrations of the quake and walked from a hospital room without assistance; an automobile on a Long Beach street shook so hard during the quake that it lost all four tires.

In the Southern California area affected by the earthquake, 4,883 people were injured; 1,893 homes were destroyed, 31,495 damaged; 207 buildings were declared uninhabitable, 1,550 were deemed repairable. All of the Long Beach schools suffered considerably, as did the city's churches.

On March 13th, the State Legislature voted $50,000 for emergency relief in the way of food and clothing. Later $150,000 was appropriated for rehabilitation work in the quake stricken area. On March 14th, the U.S. Senate passed a bill appropriating $5,000,000 as an outright gift for relief. Long Beach, however, declined to accept any of this money, advising Washington authorities it did not desire charity, but rather an opportunity to borrow the money needed to carry on the work of rehabilitation. Acting on this, Congress amended the act permitting loans from the funds.

Long Beach bounced back quickly. Rebuilding operations began the day after the quake. By March 16th, more than 5,000 men were employed at removing debris and putting the town back together. Business activities resumed as quickly as possible. By March 15th, 75 stores had reopened. Things were indeed looking up, especially in April when Congress ruled 3.2% beer "non-intoxicating." Now relief and construction crews could legally enjoy a little alcohol after a hard day rebuilding the city.

———

But did the earthquake, followed as it was by the appearance of a mighty meteor on March 24th, presage the beginning of the end? Would German geographer Alfred Wegener be right in suggesting that Southern California might one day be severed from a continent to which it has always been capriciously attached and float gently westward into the Pacific to become, as it has perhaps always destined to be, a charming Tahiti in some glazed and azure sea?

Images of Armageddon continued when on June 2, 1933, disaster again struck Long Beach. This time it was an explosion at the Richfield

Oil Company at Twenty-Seventh Street and Lime Avenue which killed nine, and injured thirty-five.

It was a horrible tragedy that began with a tremendous refinery blast that was felt in cities thirty miles away. The fire that followed reached two homes, but the heroic efforts of 500 men, armed with shovels, prevented the oil that flowed from broken storage vats from igniting and spreading the fire further into residential areas. All in all fifty dwellings were damaged and a dozen other small buildings destroyed.

One body taken to Seaside Hospital was so mutilated staff could not tell if it was a man or woman. A belt buckle was all that helped identify what was left of 34-year-old Robert Bennett, of 3056 East Second Street, whose remains were pulled from beneath a pile of charred building materials the following day. Equipment numbers found near other remains were traced back to those who had checked them out, allowing for further identification. One of the victims was Carl Robinson (226 ½ Covina Street), whose wife told local police that the day of the blast had been the first work her husband had been able to obtain in nine months.

Not all casualties were oil workers. Mrs. Lottie Carlyon and her 8-year-old daughter Marilyn were burned to death before firemen could get near enough to put out the flames that engulfed their home. The mother and the little girl had been knocked unconscious by the blast and were unable to get out of the house before it caught fire. Ironically Lottie Carlyon's husband, Tom, was directing a crew of men in a derrick near his home when the blast snuffed out the lives of his family. He was closer to the explosion than his wife and daughter, but was able to stagger from the burning area before being trapped by flames. The rest of the dead were trapped inside the absorption plant when the blast flattened it.

Witnesses said there were actually two explosions. The first, a minor one, caused the second. The second blast was so intense it wrecked homes and other structures within a radius of several blocks and shattered plate glass windows thirty miles away. At first everyone thought another earthquake had hit, but they quickly realized it was an explosion when an immense column of smoke and flame shot skyward.

Five hundred firemen, police, sailors, marines and volunteers fought for four hours to put out the fire which razed an area of two city blocks. Fifteen thousand spectators gathered to watch the inferno and the thousands of barrels of crude oil which flowed through Long Beach streets like a river.

A storage tank failure was ruled as the cause of the explosion which was the worst in the history of the Signal Hill oil field.

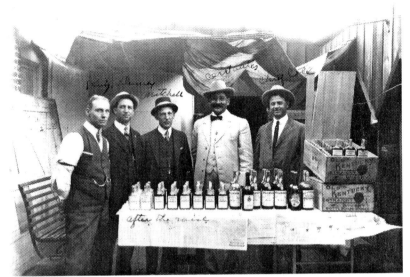

Liquor consumption was illegal in Long Beach even before Prohibition.
This raid is from 1914. Left to right: Fred B. Kutz, Edwin V. Denney,
Oliver C. Mitchell, T.G. Cervantes and Police Chief Charles C. Cole.

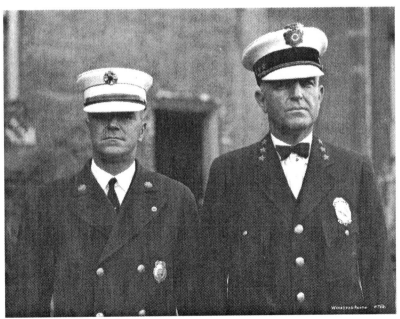

Long Beach police chiefs, Ben McLendon (left), and his successor,
James Yancy (right), had to deal with enforcing Prohibition.

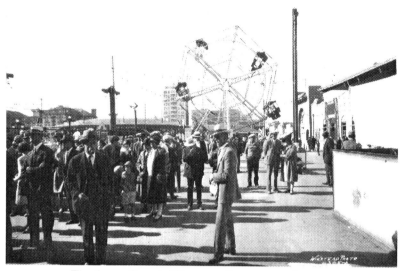

The Long Beach Pike was the scene of many
illegal liquor operations AND murder!

ROBT. H. HALSTEAD

J. R. WILKERSON

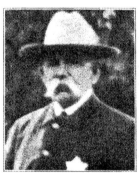

THOS. C. BORDEN

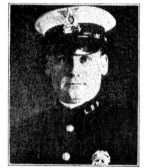

ORLANDO E. BRIDGEMAN

Four Long Beach policemen who lost their lives during Prohibition.

The First Christian Church was presided over by Rev. George Taubman, leader of the largest men's Bible class anywhere in the world.

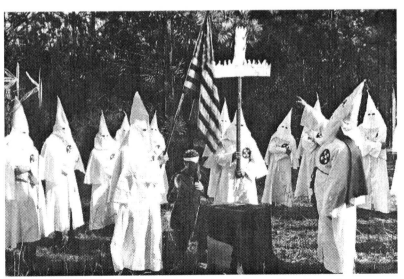

The Ku Klux Klan was active in Long Beach and Southern California during Prohibition.

KU KLUX KLAN

of Long Beach

Offers Reward

$500.00

$250.00 will be paid for information resulting in arrest and conviction of person or persons alleged to have beaten up three negro prisoners in Long Beach on or about November 18th last.

The Ku Klux Klan will give $500.00 if it is proven that the persons guilty of such a crime are Klansmen.

The Ku Klux Klan has posted this reward with a committee of three reputable business men, of which City Manager C. H. Windham is Chairman.

Every Klansman takes oath to uphold the law and to assist duly constituted authority in enforcing the law. Beating up helpless prisoners of any race is not law enforcement but a cowardly crime.

For Information Phone 617-09

Members of the Long Beach Ku Klux Klan disavowed any wrongdoing in the torture of two African American youths.

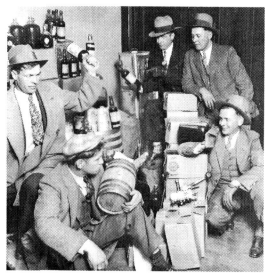

Long Beach police stage a raid at a Colorado Street bootlegging operation, September 1927.

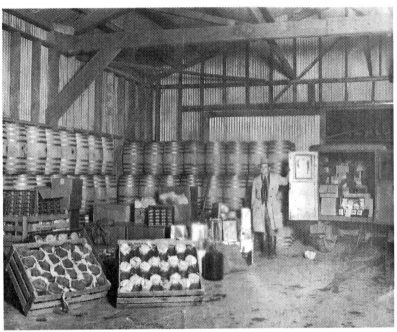

Illegal alcohol seized in a raid by Long Beach police.

The Curtis Corporation in Long Beach was used
as a drop off point for rum runners and its owner,
Alexander Stewart, involved in a smuggling ring.

TOM and TOOTS

6 6 0 - 2 7

OUR MOTTO:

"SERVICE and QUALITY"

6 6 0 - 4 6

BOB

E A R L

8 8 0 - 1 7

W. C. ROBINSON
OPEN 'TIL MIDNIGHT

649-19

619-59

OUR MOTTO:

"SERVICE and QUALITY"

660-46 BOB and HOT

1078 EAST OCEAN—Apt. 4

6 1 1 - 4 4 2

"Business" cards from several Long Beach bootleggers.

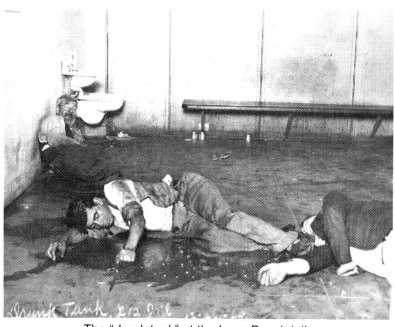

The "drunk tank" at the Long Beach jail.

The gardens at Hotel Agua Caliente, Tijuana, Mexico,
where many flocked to get a legal drink and gamble.

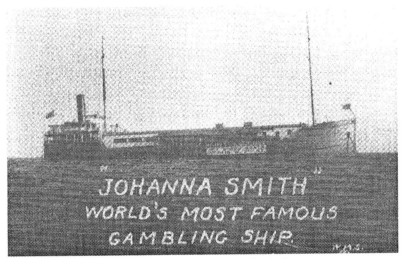

The "Joanna Smith" was the first of many
gambling ships to arrive off Long Beach.

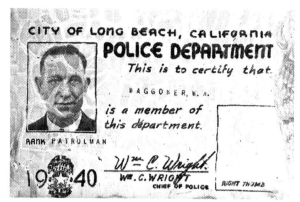

Long Beach police officer, William Waggoner, was shot and permanently paralyzed in a gun battle with gangsters on December 21, 1930.

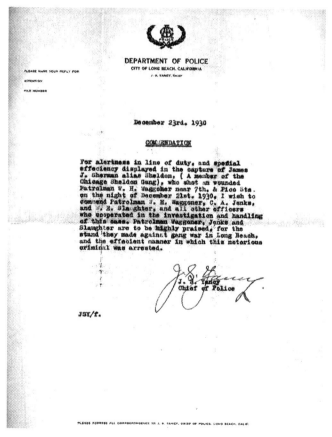

Commendation, dated December 23, 1930, given by Chief Yancy to officers Waggoner, Jenks and Slaughter for heroic work in the capture of Ralph Sheldon, a Chicago gangster.

Property damage from a Signal Hill oil gusher, Jan. 21, 1922.

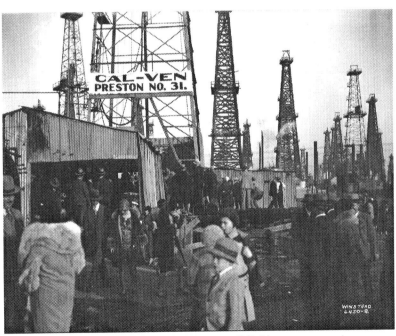

Signal Hill, 1929 - Excursions to oil fields were popular
ways to sell shares in future oil ventures.

Julian Refuses to Accept Your Money Unless You Can Afford to Lose! Widows and Orphans, This Is No Investment for You!

I cannot conscientiously tell you that there is no element of chance in my project for I have learned through **my fifteen years of drilling** that sometimes they do go wrong.

I don't tell you I am offering you a **"Gold Bond"** backed by a ten million dollar deposit in the Bank and, if you are drawing out your little savings account that you cannot afford to lose, to support me, my advice to you is, **leave it in the bank.**

My appeal is addressed to the people who can legitimately afford to take a chance. **"And, Mr. Thoroughbred,"** I have tried to offset this element of risk in my offer to you by laying **my cards face up upon the table** and offering you the **cleanest, squarest** opportunity that any human ever made to another.

What have I Got?
SANTA FE SPRINGS

4 acres in the very heart of the biggest production in the greatest oil field in America, bounded on four sides by the **Standard Oil Company,** the **Petroleum Midway, the Dutch Shell** and the **General Petroleum Corporation** and practically offsetting the big 4000-barrel Agee well of the latter Company, which came in two weeks ago today, and since then I have refused **$100,000.00 for my lease.**

"And where do you come in?" I am calling for $175,000.00 to insure the completion of this well, and my incentive in asking this amount is to be in a position to protect your investment no matter what conditions may arise. And for your support **I am assigning 70% of my total net production to you** from this well, together with **one-third of my holdings** at Santa Fe Springs, and this assignment to be held in trust by one of the leading Banks of Los Angeles for a period of 25 years. **They will receive the proceeds of this 70% of my production** direct from the pipeline company and same will be distributed to you **pro rata every thirty days by this Bank.**

Every $100.00 you shoot with me will bring you an assignment, legally executed, of one-1750 part of 70% of my total net production and should bring you a return of not less than **100% each month.** I am not asking you to place a bet on something that I have not already bet mine on. For I want to tell you here and now that when I stepped up and laid $30,000.00 cash on the **"Come Line"** to the Globe Petroleum Corporation, it took every dime that I could **beg, borrow and scrape together.**

I have fifteen husky drillers, every one a picked man, all drawing top wages and a **$2000.00 cash bonus to have my well on production in 90 days** from July 1st. And I want to tell you that each and every one will stand behind me, like a **stone wall, to make good my promises to you.**

My rig is up. My sump holes are dug. My boilers will be set up Monday. My brand new Rotary drilling machinery is ready to be delivered, but all this costs real money.

I have to be **spudded in** by July 4th. If you feel I am worthy of your confidence and support, I want to here promise you that until my well is on production, I will extend every ounce of energy and ability that I possess to protect your investment, **and will stick by you** until the last **"dog is hung."**

C. C. JULIAN

Suite 321-24 Loew's State Theater Building,
7th and Broadway

Los Angeles, California Phone 824539

Offices Open Every Evening Until 10 o'Clock

Eagle Rock City Representative

Witcher & Macauley
116 So. Central Ave.

Glendale Resident Representative

Brooks E. Miller
Care Roy L. Kent Co.

Promotion for Julian Petroleum stock.

The March 2, 1933, Long Beach earthquake occurred at 5:54 p.m.

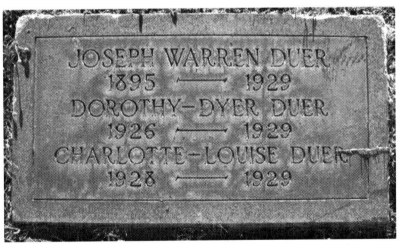

JOSEPH WARREN DUER
1895 ——— 1929
DOROTHY-DYER DUER
1926 ——— 1929
CHARLOTTE-LOUISE DUER
1928 ——— 1929

In January 1929 a Long Beach father killed his two daughters
then himself. Had he hated his wife so much that he would
kill his children rather than let them be with their mother?

Convicted murderess Clara Phillips (shown here), maintained her Long Beach friend, Peggy Caffee, had killed Alberta Meadows.

This diagram, along with the description of each tooth, was one of the first times in history that the dental record of the murder victim helped in identification. It was pivotal in discovering the identity of the victim in the 1929 Torso murder case.

Louise Peete was released after serving 18 years of a life sentence for the 1920 murder of Jacob Denton, but again resorted to murder. On April 11, 1947, Louise Peete became the second woman to die in the lethal gas chamber.

William Desmond Taylor, who got his start as a film director at the Balboa Film Studio in Long Beach, was murdered February 1, 1922, his killer is still unknown.

Long Beach City Auditor Myrtelle Gunsul was not afraid to take on the big boys when it came to cleaning up the city she loved.

Aloha & Walter Wanderwell. Walter was murdered on his yacht docked in Long Beach on December 5, 1932.

LOVE
&
MURDER

"I don't know whether I killed Alberta Meadows or not, but if I did it was for mother-love. I fought with Alberta to protect the only love I have ever known. I did what any mother in the world would do if she saw her baby being taken from her. Armour L. Phillips is my baby. He has been my only baby. He is my very life, and when I realized he was being taken from me I fought-fought-fought-so that I might always have him."

Clara Phillips
Los Angeles Times
Nov. 17, 1922

Bluebeard

In May 1905, E.P. Dewey, assistant Long Beach city engineer, surveying residential lots near the top of Signal Hill was approached by an old man. The stranger asked his assistance in locating a monument he had placed on the summit 50 years earlier. The two men searched for the stone, but it took a few days to locate it, and only then it was discovered by accident. Engineer Dewey, at the summit of the hill, attempted to drive a stake into the ground and found the monument two inches below the surface. It was granite, 8 inches square and 18 inches long with a drill hole exactly in the center.

The old man introduced himself as John Rockwell, a visitor to the city. He told Dewey he had been a member of the United States Coast and Geodetic Survey crew whose mission was to plot latitude and longitude of prominent points in California after it became a state in 1850. The first few years they spent plotting points for light houses, but by 1853 they started to concentrate on other high points including the hill then known as "Los Cerritos." At the summit, at an elevation of 365 feet, they planted one of their latitude and longitude markers. They built a fence around the stone tablet to keep out the horses and cattle that roamed everywhere. The also posted several handbills printed on cotton cloth written in both English and Spanish, telling the public the marker was the property of the United States and requesting that it not be disturbed. Evidently the fence and signs didn't work, since the ground around the monument was plowed many times.

In 1905, the Signal Hill Improvement Company decided to set aside a 60 x 130 foot area on the summit as a public park and camping ground. In the center of the trees and flowers rested the monument. Included were the coordinates: Latitude 33 degrees, 48 minutes north; longitude, 118 degrees, 9 minutes, 46.7 seconds west from Greenwich; height above mean sea level, 365.64 feet. Little did the Signal Hill Improvement Company realize that in 1920 this stone tablet would also come to memorialize one of the most brutal murders and murderer in Southern California history.

In the year before oil was discovered, Signal Hill was still a beautiful place with a commanding view of the Southern California basin. Its

scenic setting attracted a number of campers to its two eucalyptus groves near Temple and Summit.

The shortage of housing during and immediately after World War I, and the increased popularity of the automobile, brought about the resurrection of an old past time—camping. With camping, people could get into their autos and escape their cramped, shared quarters, if only for a little while. In the 1920's motor camping became a popular activity, especially since it was something you could do for free. Magazines such as the Auto Club's *Touring Topics* gave readers suggested itineraries, a list of reliable garages and mechanics and, if camping was not your thing, recommended hotels.

Because of poor road conditions, it was always best to find a place to stay before night set in. The motor camper of the 1920's could find himself in a city park one night, a farmer's orchard the next. It wasn't difficult to find a spot, for many western cities maintained camping grounds for touring motorists. Very often there were electric lights, stoves, water, firewood, toilet facilities, sometimes even tables, chairs and showers. In almost all cases these accommodations were free, and campers could remain and enjoy a city's hospitality for as long as they wanted.

However, there was one unforeseen disadvantage in camping, which Nina Lee Deloney experienced in a remote area of Signal Hill on January 26, 1920—a secluded spot for camping was also an ideal spot for murder. The isolated grove of eucalyptus trees atop the Hill proved to be the perfect location for the infamous "Bluebeard" killer—Nina's husband—to beat her brains out with a hammer.

She wasn't the first wife to be disposed of. On April 29, 1920, James P. Watson calmly told of murdering at least four of his wives, possibly more. Called the "Bluebeard" killer, a term used for any man who murdered a series of wives or fiancées, Watson told police he had married at least 15 women, using various aliases, as far back as he could remember. He often used Long Beach as the base for some of his matrimonial operations, he said. Though he currently lived in Santa Monica, Long Beach was a convenient location for sending numerous telegrams and letters to his various wives. If they tried to find him there, they'd be out of luck. However, one of them did find him, and his little black bag full of incriminating evidence.

From his bed in the Los Angeles County hospital, where he was recuperating from two suicide attempts, Watson apologized for not being able to recall all the details of his crimes. He indicated he did not kill the women for their money—he only married them for that—but said it gave him a strange pleasure to put them out of the way.

He did remember the first wife that died, how could one forget the first of anything? Her name was Alice Ludvigsen. He was in a boat with her, fishing in a river in Idaho, when the boat jammed against some logs. When they tried to free the vessel the woman lost her balance, fell into the river and drowned. At least that was the story he told authorities.

He had used the name Andrew Hilton when he married Alice Ludvigsen, a Seattle widow, on October 6, 1917, at Port Townsend, Washington. For some reason the marriage was kept secret for two years. Alice's property, papers and personal belongings were found in Watson's possession. She was last heard of by relatives December 11, 1919, through a forged letter, saying she was on her way to South America.

Bertha Goodnick's death, Watson said, came about in a similar manner. They were on a boat on Lake Washington, near Seattle, the water was rough and she fell over, with a little push. He made sure she didn't get back in the boat by holding her body under water with a pole until she drowned. He had married her June 11, 1919, using the name H.L. Gordon. They had met through a matrimonial advertisement.

Watson had wed Bertha just two days after murdering Betty Prior, who lived nearby. Shortly after Bertha and Watson married they were to leave for California, then to Honolulu and Australia. Friends and family never heard from Bertha again. Deeds and legal papers, also several blank sheets of paper with her signature, were found in Watson's possession.

In the Elizabeth "Betty" Prior case, Watson stated, the woman attacked him with a hat pin and he had no choice but to defend himself. He did so by shoving her so violently that she fell and struck her head against the corner of a box. He believed she was dead, he declared, but to make certain he got a hammer and struck her on the head with it. This happened near Olympia, Washington, on June 8, 1919. He burned the house to conceal the crime. He had married Betty Prior, a waitress, under the name of Milton Lewis in Coeur d'Alene, Idaho,

March 25, 1919. She had considerable property in Weld County, Colorado, tax receipts on which were found in Watson's effects.

Watson's account of the Signal Hill murder was the most complete. This, he said, was because it was still fresh in his mind. While on a camping trip he and wife Nina stopped at Signal Hill on the evening of January 26, 1920. He said he found a perfect spot to spend the night by the stone monument in the park. Regrettably, Watson stated, while unpacking Nina found letters from one of his more recent brides. When she saw them Nina became enraged, yelling at him about his affairs with other women. He had no choice but to add her to his list of victims, he serenely told police.

He struck her on the head with a hammer, later beating her skull in with it to make sure she was dead. Fortunately, there were no other campers to hear her screams, or so he thought. Watson then wrapped the corpse in a blanket and a piece of canvas, loaded it into his car and drove to El Centro where he disposed of the body. Throughout his statement he was hazy over details. He asserted he had periods when his mind would go blank and he would not know afterwards what he had done during these clouded intervals.

Though Watson appeared detached during his narrative, a *Los Angeles Times* reporter noticed how Watson constantly moved his hands while telling authorities about Nina's murder. Watson's hands acted as emotional indicators, able to twist themselves into almost any shape. They were the hands that slew Nina Lee Deloney, hands that wrote her forged letters to her relatives while she lay in a sandy grave; hands that held his other wives under water until their bodies grew lifeless.

Authorities were able to determine Nina and James Watson had married December 5, 1919. Nina, a divorcee from Eureka, Montana, believed the man she married was Charles N. Harvey. She had $20,000 in property which Harvey, a.k.a. Watson, ended up with.

For days authorities searched for Nina Deloney's body, with no success. It seemed Watson's story just didn't add up. Watson said he had buried her in El Centro January 27th, but Watson was seen that same day in Sacramento, a nearly impossible distance for him to have traveled in so short a time. While Long Beach police continued to hunt for the body in Signal Hill, Imperial County authorities futilely searched the hills in Devil's Basin, at the foot of the rugged Cerro Pintos Mountains,

for Nina's grave. If Watson was to be believed, he needed to be brought to El Centro to show where he had buried Nina.

On May 4, 1920, an emotionless Watson led a cadre of police officers to a rocky ledge he used as a landmark to mark the grave. Using the ledge as a guide he walked some distance over sand and gravel until he came to a rock marking Nina's final resting place. As a score of men dug into the ground Watson's story was vindicated, the body was found just where Watson said it was.

It appeared Watson knew how to pick the perfect burial spot. The corpse was below a ledge where a waterfall fell during the rainy season bringing more sand and rock to cover the grave. Authorities had a hard time envisioning Watson carrying the heavy, stiffened body up the rocky slopes, but Watson said he climbed up there with Nina's remains strapped to his back, resting every few feet. He claimed he often got superhuman strength at such times.

The corpse was in a good state of preservation, the *Los Angeles Times* reported. It lay on the left side, the legs drawn up and under it and one arm twisted behind. The dark brown hair was matted around the head. There was a hairpin and one safety pin, two silent tokens Watson failed to remove when he burned the clothing and blanket in which he brought the body. The face had been trampled with some heavy object such as a hammer, just as Watson told police. One hand had been badly crushed, as if it had tried to block the first blows. While buzzards circled overhead, authorities removed the remains.

As Watson was brought back to El Centro, he casually mentioned he often didn't remember things, painting himself a victim of a double personality, a man who had no control over the crimes he committed. However, he had no trouble remembering and identifying the remains of his latest wife and victim.

As the sheet covering the partly decomposed corpse was drawn away from the head, Watson, for the first time, showed some emotion. His hands shook, he sagged on his feet, and his mouth twitched. As he took off his glasses and rubbed his eyes he said in a voice hardly audible, "Yes this is Nina Lee Deloney, whom I murdered in Los Angeles County." [39]

One confusing point was that it appeared Nina had been murdered around January 20th, not January 26th as Watson originally stated. Authorities uncovered conclusive evidence that Watson was in

Sacramento at 2:30 p.m. on January 27, 1920—hours before he said he buried Nina in El Centro, a place hundreds of miles from Sacramento. He was there visiting another of his wives, Elizabeth Williamson, in the hospital for a minor operation. Mrs. Green, Watson's Santa Monica landlady, had claimed Watson checked out of the apartment where he and Nina were living on January 26th, telling her he and Nina were going to take a trip to Mexico, the Grand Canyon and then back to San Francisco. He had a woman with him, but Mrs. Green could not claim for certain that it was Nina.

To add to the perplexity, several Signal Hill residents reported hearing a woman's screams the night of January 26th, not the 20th. Had Watson gone back that evening and murdered another woman? There would have been enough time for him to have driven from Signal Hill and be in Sacramento the following day. He refused to tell, again claiming his memory was "fuzzy." No other body was ever found and the identity of this "screaming" woman remains unsolved to this day.

The coroner's jury verdict was swift. After hearing the autopsy report that Nina came to her death from blows on the head administered with a blunt instrument, a hammer or a hatchet, and that the woman had been dead three or four months, they returned the verdict of "death caused by a blow on the head by James Watson." [40]

As a mob gathered at the railway station shouting, "Lynch him! Kill him!" Watson was spirited away by train to a secret location. He was badly shaken and nervous.

By the time he was returned to Los Angeles authorities had uncovered several other bits of information about Watson. He had married Mrs. Gertrude Wilson under the name of J.P. Watson in Seattle in 1917. She was a widow, the mother of a young boy. He left them on a farm in the Hood canal district in July 1917. After he returned to Seattle he sent for them and soon afterward both mother and son dropped out of sight. No word on what happened to them ever surfaced.

In 1917 he married Agnes Wilson, a maid, under the name of Charles Newton Harvey in Canada. Shortly after the marriage she disappeared and was never heard from again, though Watson had postcards in his effects which placed her in Honolulu. The signature of Agnes Wilson was believed to have been forged. Watson later admitted to killing her as well, saying he drowned her in Lake Washington.

He married Beatrice M. Andrewartha in Tacoma, Washington, February 10, 1919, under the name of Harry M. Lewis. Beatrice was a wealthy widow who had moved to Vancouver from England. The last word from her was received by her sister in Spokane, dated March 25, 1919, posted in Sacramento and written on a typewriter. Found in Watson's possessions were her notes and legal papers and unmailed post cards with Honolulu scenes addressed to relatives. Watson admitted to drowning her in Lake Washington, but he didn't remember the date.

Helen Gordon of Vancouver, British Columbia, was probably one of Watson's earliest wives. Her name appeared as beneficiary on an insurance policy carried by Watson in 1912 and 1913. When asked about her, Watson refused to say anything.

How had he attracted all these women? When questioned about these details Watson said he did not remember, but the scraps of paper, receipts, letters and other records found in his little black bag showed the methods involved. He was always well dressed, soft-spoken and mild-mannered. He lured them in by posting matrimonial advertisements in newspapers, mentioning he owned his own home and had a good income as a banker. As further enticement, he added that he planned a honeymoon trip around the world or to Honolulu, or Australia with his new wife. These advertisements always brought many replies. Stacks of letters written on dainty stationery from school teachers, widows, shop girls and others who thought they saw a chance to make a good catch were found in Watson's possession.

The ads were step number one. Correspondence followed, and then personal meetings. It was hard work mapping out appointments so that they would not conflict. Large first-class hotels were the meeting places. Then came the wooing, quick marriages and, at intervals of about three months, sudden deaths by violence. But one of his intended victims became wary of his stories.

The investigation which resulted in Watson's arrest was started by Mrs. Kathryn Wombacher who married him (he used the name Walter Andrew) in Seattle in November 1919. The couple was living in Hollywood when Kathryn became suspicious of Watson's mysterious trips. His favorite excuse was that he was an agent for the United States government, operating against diamond smugglers. This gave him a chance to leave suddenly and stay away weeks at a time, to visit the other wives in the vicinity. He also carried a black bag which Katherine tried

desperately to open. Who was this mysterious man she had married? What was in the bag he always had nearby? She paid a visit to the Nick Harris Detective Agency to find out.

Since the dates of Watson's absences corresponded to some big robberies in the area, detectives thought he might be the thief police were looking for. Three weeks after hiring the detectives, Mrs. Wombacher received a telegram from Watson, sent from a nearby town, asking her to meet him for dinner at a neighboring hotel. The detective agency was called to follow him after the dinner.

From dates at hand, police later came to believe that he had just killed and buried Nina Deloney and was still under the influence of one of his murderous spells. He plainly showed it in his face, detective J.B. Armstrong later testified. After dinner Watson and Mrs. Wombacher went downtown and then home. Armstrong, believing he had a dangerous criminal on his hands, called in the police. They trailed Watson to his home and in the morning, when he went out for a walk, came in and broke open the lock on his valise. In it they found four marriage licenses, bank books from various places, and other documents which led to the unraveling of all his murders.

Watson fought like a fiend when he was placed under arrest telling police he was a government man, but he refused to show his credentials. He said he could clear up the whole business if he were taken to San Diego. Authorities agreed to take him there. Perhaps he was looking for an opportunity to escape. Somewhere near Oceanside he pulled a small knife from some hidden place on his body and proceeded to cut his throat. Pulling his overcoat collar above his chin he hid the wound until they reached San Diego. He had almost bled to death. Taken to the hospital he again tried to commit suicide by cutting his wrists. When it was determined the trip to San Diego had all be a rouse to gain time, authorities brought him back to Los Angeles.

The contents of his bag were dumped on a table at police headquarters. Law officials began going through the contents. In it were wedding rings, jewelry belonging to the dead women, letters from and to them, deeds to their property, tax receipts in their names and storage receipts for trunks stored under different names. Bigamy, forgery, swindles and murder began to pile up against the Bluebeard. Finally, Watson offered to make a clean breast of his crimes for a chance to save his life. An agreement was made where Watson would not suffer

the death penalty if he disclosed the details of his crimes. He also made a plea to the public, reported in the May 4, 1920, *Los Angeles Times*: "My every act shows I am to be pitied more than to be blamed for having developed into this strange and uncontrollable condition, for I am anything else but my natural self."

Not everyone agreed. Authorities believed no insane man could have devised such a cleverly constructed confession. He avoided mentioning any dates. He admitted killing only the women whom the authorities had positive proof he had done away with. He could not be tricked into answering questions which he had not seriously thought about.

It was later revealed that "Bluebeard" Watson was born Joseph (some sources say his name was Charles) Gilliam, son of farmer George Gilliam, near Paris, Kansas, in 1870. In his infancy his parents separated and his mother later married a rural blacksmith named John Holden, a man with a furious temper who beat his stepson, then known as Dan Holden, almost every day. The boy ran away from home, pursuing various jobs before ending up working at a doctor's office. Whenever he had time he went to school, learning all he could to better himself. He married his childhood sweetheart, Marie Hollingsworth of Coffeeville, Kansas, in 1903, but that marriage ended in divorce. He eventually adopted a third alias, Lawrence Harris, to avoid financial complications of a real estate "deal" involving his ex-wife.

Along the way he married at least fifteen women, maybe as many as twenty. He couldn't remember all their names but believed his second wife was Olive Green, who he just couldn't get along with. Upon divorcing her he met and married Alice Freeman of St. Louis. They were married for two years before splitting up. Soon after, he fled to Canada to avoid charges of mail fraud, ending up in the arms of Katherine Kruse Watson. He vowed he didn't kill any of his "early" wives but did come to remember some he had "forgotten" he had killed: Eleanor Frazier, drowned in Spokane River; Marie Austin, beaten to death with a rock and drowned in Lake Coeur d'Alene, Idaho. Mrs. M. A. Watt, drowned in 1919 in Lake Coeur d'Alene.

On May 10, 1920, James P. (Bluebeard) Watson was sentenced to life imprisonment. The judge found Watson physically unsound, mentally deficient and morally degenerate. On May 18th he was shaved, bathed, photographed and given his prison number, 33,755, as he began his life sentence at San Quentin. In 1921 his marriage

to Katherine Wombacher was annulled, but she was not the last of his wives. In May 1924 Elizabeth Williamson Lewis was granted an annulment to Watson, who she knew as Harry M. Lewis. The two had married in Davenport, Washington, in 1919. It was she he was visiting in Sacramento on January 27, 1920, his apparent alibi to murder.

Sixty-one-year-old James P. (Bluebeard) Watson died of pneumonia on a hospital cot in San Quentin on October 16, 1939. His years in prison had changed him from a fiendish killer to a kindly hospital attendant. Only the bodies of wives Nina Deloney and Elizabeth Prior were ever found, nor were authorities ever able to trace any of the large sums supposedly accrued from his numerous victims. Watson dropped alluring hints that he had converted his assets into $50,000 worth of Liberty bonds which he stuffed into two or three Mason fruit jars, screwed on the caps to preserve the contents and buried near Nina's grave. Numerous treasure hunters scoured the area where Nina's body was found looking for the hidden jars. Watson refused to cooperate saying he would only reveal where his "wealth" was secreted if it could be used for the benefit of a little daughter of his twenty-fifth wife, whom he legally adopted.

But was the buried treasure real? In his will Watson declined to make public the extent of his estate or tell where it was. However, it was reported that he had several thousand dollars in various banks. He is buried in San Quentin's Boot Hill Cemetery in a grave marked only with his prison number. His assets still missing.

Killer Moms

Today we know that depression is not just something you "snap out of." It is believed to be caused by an imbalance of brain chemicals, along with other factors, and may be genetic. It can overwhelm and engulf a person. In the 1920's not much was known about depression, except that it could be unrelenting. There was little, if any, relief in the days before antidepressant drugs—except suicide. Unfortunately, in many cases the suicide victim didn't want to die alone.

It was an unforgettable Christmas Eve. One that Long Beach folk could not stop talking about. In years to come, it would be remembered that it all started shortly before noon on December 24, 1921, at the Terry Apartments at 425 E. Ocean Avenue.

A Texas family had come west to spend the winter, choosing the fashionable Terry Apartments as their home for the holidays. It was hoped that Della Connelly could continue to recuperate from an operation she had undergone back in April without feeling she had to undertake the exhausting Christmas preparations she always faced back home. The 53-year-old woman had never fully recovered from the surgery, and questioned whether she would ever again be well. She was having a hard time remaining cheerful while everyone was happily preparing for the next day's celebration.

The Christmas season was here, shopping and cooking needed to be done, but Mrs. Connelly didn't have the energy, or the Yuletide spirit to participate. She angrily told everyone that she wanted nothing to do with Christmas, even demanding that there be no singing of Christmas carols in the apartment house. She had perked up a bit when her husband, 52-year-old Jewell Thomas Connelly, arrived from the family home at Lockhart, Texas, the previous evening. Guests at the apartment reported the couple seemed happy. When the pair was seen downstairs they were holding hands and appeared very affectionate. However, as Jewell Connelly was resting on the couch that Christmas Eve day, Della snapped. She retrieved the family gun, pointed it at her sleeping husband's head and pulled the trigger. He died instantly.

Their 23-year-old daughter, Lanier, was in the kitchen when she heard the first shot. She rushed into the living room and saw her father's

blood stained body. Della screamed at the sight of Lanier then pointed the gun at her distraught daughter. Luckily for Lanier the trigger failed to work and the girl ran out of the room.

Lanier Connelly's screams were heard by janitor Otto Wiest, who rushed up the stairs thinking a fire had broken out. Grabbing a rug he dashed into the Connelly's apartment. He saw Della Connelly lying on the floor and thought she had fainted. It seemed that Della had taken her own life. She had pressed the gun against her liver and pulled the trigger. This time the trigger worked. Della Connelly lived but a few moments.

Mrs. Connelly, her daughter and her 10-year-old niece, Eloise Robertson, had come to Long Beach in early November. Shortly before the tragedy Della claimed she was losing her mind. From her actions, one can assume she was right.

Like Della Connolly, Ila Mae Rice suffered from depression, upset over what she said were the "inequalities and injustices of life." On April 2, 1926, she took a butcher knife and slit the throat of her sleeping 5½ year-old daughter, Margaret, and then proceeded to cut her own throat, partially severing the windpipe. She had enough strength to lock the front door, barricade the rear door, and turn on the gas in the kitchen and living-room. Ila then lay down on the floor by the bed of her dead child, waiting to die. Found by a neighbor and rushed to Community Hospital, the despondent mother said she had killed her child because she didn't want her to "go through the hell I have been through."[41]

Distraught, George Rice testified his wife had been ill for some time and became depressed when doctors told her she could have no more children. She loved children, he tearfully told the court, and wanted more. For two weeks before the tragedy she had seemed to be on the edge of a mental and physical breakdown, he revealed. He should have insisted she see a doctor, but when she refused he hadn't pursued the matter. He had not wanted to upset her further.

Rice berated himself, saying he should have heeded the signs. Ila had been so devoted to her daughter she hardly left the child's side. When he suggested they get a babysitter and go out for an evening, she refused. She said she could not trust Margaret in the hands of others. At first Rice thought it was just motherly affection. He told how from

June until October little Margaret suffered from whooping cough and Ila had been up with her every night. She refused any help. Insomnia had resulted, he said, which he believed played a part in causing Ila to become mentally unbalanced.

Ila Mae Rice recovered from her wounds but was declared too mentally unbalanced to face trial for the murder of her daughter. She was placed on suicide watch at Los Angeles General Hospital.

———

Some mothers killed by more devious means. Up until the early days of the 19th century it was almost impossible to detect a toxic substance in a corpse. Murder by poison flourished. It became so common in eliminating "family problems," such as a wealthy parent who stayed alive too long, that the French nicknamed the metallic element arsenic "poudre de succession," the inheritance powder.

A major problem in finding a poisoner was that arsenic was easily obtained. Every day people walked into drugstores, grocery stores, garden supply stores and bought some version of the poison for practical reasons. Arsenic was used for skin conditions, mixed into tonics like the popular Fowler's Solution, and dispensed at pharmacies. It was available as a weed, bug and rat killer. There was Rough on Rats, a grayish powder made of 10 percent soot and 90 percent arsenic trioxide; Rat Dynamite, 9 percent bran and 91 percent arsenic; Lyon's Poisoned Cheese, a soft pale block containing some 93.5 percent white arsenic. William's Fly Paper, Dutcher's Fly Paper, and Daisy Fly killer were all laced with arsenic, easily leached out simply by soaking them in water. Arsenic was also the primary ingredient in a number of dyes which were used to color fabric, the artificial leaves on hats and wreaths, cardboard boxes, greeting cards, candles, Venetian blinds, carpets, soap and faux malachite for jewelry. Even untainted wallpaper could be made poisonous by paperhangers who often mixed a little arsenic into their horse-hoof paste to help keep rats out of the walls. There was one common element, however, that often led police to a perpetrator who murdered by poison: if they got away with it once they were likely to try it again.

On April 13, 1930, tragedy *again* struck the Hartman family of 1726 Lime Avenue, Long Beach. Fourteen-year-old Ruth Hartman

had just died of a mysterious illness similar to the one that had taken her 22-year-old brother Henry less than a year earlier. Their father, Oluff Hartman, had also died (October 10, 1927), presumably from a blow on the head thought to have been inflicted by a burglar. Ruth's dedicated doctor, unable to determine the exact cause of her death, asked for an autopsy. He was suspicious. Some of her symptoms indicated arsenic poisoning.

Many chemists consider arsenic detection as the foundation of forensic toxicology. Though lab technicians had learned to find evidence for arsenic poisoning in cadavers in the early 1800's, the results had been very unpredictable. It wasn't until 1846 that a truly reliable test was discovered by an outraged English chemist named James Marsh, who realized his own flawed test results had enabled a poisoner to go free.

After being found not guilty, the man had mockingly admitted to the crime and an angry Marsh worked feverishly for several years until he found a sure fire way to detect arsenic poisoning. Basically, his test involved finely mincing suspect tissues, mixing in sulfuric acid, and exposing the bubbling mess to hydrogen gas in a heated tube. If the mixture contained arsenic, the resulting chemical reaction would plaster a gleaming blackish-brown layer on the glass of the tube, which Marsh called an "arsenic mirror," and its dark shine was a sure way to tell arsenic had been present in the body.

When Ruth's autopsy revealed that she had indeed died of arsenic poisoning, Ruth's mother, Mary Hartman, remembered that she had spread ant paste, which contained arsenic, around the kitchen three weeks prior to her daughter's death. She thought that some of it might have gotten into the food by accident. Mary's surviving daughters, unsettled by the autopsy results, said that was not true, there had been no ant paste around the home as their mother had claimed. They did remember Mrs. Hartman giving Ruth a glass of grapefruit juice the day before her death. Ruth had remarked that the juice tasted bad, and Edith Saunders (one of the surviving daughters) said the color was darker than normal. A neighbor visiting the sick teenager said she too had seen Mrs. Hartman give Ruth a drink which the girl said tasted bad. Protesting, Ruth was told by her mother to either drink or be taken to the hospital for treatment. When Ruth pretended to drink Mrs. Hartman is said to have exclaimed, "You can't fool me, I have a rubber band around the glass to tell how much you drank." [42]

Following the revelation of poisoning, and suspicious circumstances surrounding Ruth's death, friends remembered that Ruth's father, Oluff Hartman, had lived for two weeks following a supposed burglar attack, unable to recall any details of his ordeal. Mr. Hartman's pants, with $4 missing from its pockets, were found on the lawn outside the house, earning the perpetrator of the crime the name "Pants Burglar."

Remarkably, no one else in the family had been awakened by the break in and Hartman could not remember anything about the crime, or being struck. He woke from a sound sleep to find blood streaming down his face from a scalp wound inflicted with some blunt instrument. Hartman had no idea how it happened, but his wife, who found the pants outside, told him he had been attacked by a burglar. No burglar had been seen or heard by the victim or by anyone else in the household. Why Mary Hartman, who slept by her husband's side, was not awakened during the attack was not questioned. Though the wound was not serious, Mr. Hartman died suddenly, supposedly of the head injury.

There were other instances in which slight injuries, such as those supposedly inflicted on Oluff Hartman, resulted in death. Take the case of 66-year-old Rose Bailey who was hit by a cuspidor, thrown by an old soldier on a Southern Pacific train. Mrs. Bailey and her son were on a train bound for Los Angeles from Portland, Oregon, on October 19, 1924, when 84-year-old David Carlton began to act strangely. When a porter attempted to quiet him down there was a tussle and Carlton got away. Without any warning he picked up a spittoon and hurled it through the car. It struck Mrs. Bailey on the head, knocking her unconscious. A doctor pronounced her injury not serious and she returned home to Long Beach. The following day she became ill and suddenly passed away. It seemed she died from a blood clot resulting from the injury to her head. Carlton was taken to the psychiatric ward of the Veteran's Home in Los Angeles where he soon joined Mrs. Bailey in death. He had died of pneumonia eight days after the woman he mistakenly hit. Had Oluff Hartman, like Rose Bailey, also died of a blood clot?

At the time, no one doubted Mary Hartman's story about the burglar attacking her husband. Delegations of irate Long Beach citizens demanded the City Council do something to capture this "Pants Burglar." The Council agreed and authorized a reward of $500

for the burglar's arrest and conviction. Tracking down stolen items led police to sixteen year-old Richard Haver. The teenager was arrested November 23, 1927, charged with eight burglaries, and the murders of both Oluff Hartman and 85-year-old Civil War veteran Frank Foster.

Haver admitted burglarizing Foster's house and struggling with the old veteran and pushing him down the stairs, but denied any knowledge of burglarizing the Hartman home, though he did admit to burglarizing several other houses in the neighborhood. Everyone had always assumed Haver was lying. Now, however, authorities decided they wanted to look at the bodies of Oluff and his son Henry.

The bodies of the Hartman men were exhumed from their graves in Sunnyside Cemetery on Signal Hill. Arsenic was found in the corpses of Mary Hartman's husband and son, though it couldn't be determined that the arsenic was given to them by Mrs. Hartman and that it was the cause of their deaths. However, Mary Hartman was arrested and held by police on suspicion of having poisoned her husband, her son Henry and her daughter Ruth.

Ptomaine poisoning was initially reported to be the cause of Henry Hartman's death and it was thought that Ruth had died from the same thing. However, police considered it suspicious that all of the three dead Hartmans carried insurance policies listing Mrs. Hartman as beneficiary. Early in June 1929, Henry had announced he was about to marry, and a few days later he was stricken with stomach cramps and died.

Shortly before his death Henry told his mother he was going to let his $2700 policy lapse. The oil company he worked for provided an accidental death policy which would support a wife should he die, but Mary told her son that as a wedding present she would give his soon-to-be wife extra protection and pay the premium herself. However, she had to act quickly, before Henry married and changed the beneficiary. It seemed poisoning ASAP was the only answer.

The surviving Hartman daughters admitted their mother had collected the insurance money, totaling $4700 on all three family members, but they had no idea how she spent it. Police said the Hartman home was heavily mortgaged, but the money had not been spent to pay down the loan.

Daughter Nettie, who also lived with her mother, was apparently the next target. Nettie reported receiving several boxes of candy from

an anonymous sender who was later revealed to be her mother. Could this too have been poisoned? Nettie had felt ill after eating some of the candy and thrown it away, however, no trace of the candy remained for testing. Investigations also revealed there was also the possibility Mrs. Hartman was responsible for the death of an elderly woman whom she cared for.

Physicians testified they had treated Mary Hartman for scars on her arms, which she said were the result of rabbit bites. The doctors felt they were self-inflicted due to mental illness. Psychiatrists reported they felt Mrs. Hartman's mental problems began with a desire to hurt herself, and then developed into a mania for causing pain to others. The court bought the insanity plea and pronounced Mary Hartman mentally ill. She was sent to Patton State Hospital, the State mental asylum. Later it was revealed she suffered from a brain tumor.

What of Richard Haver, the "Pants Burglar" accused of murdering Frank Foster? He was sentenced to eighteen months at the Preston Industrial School in Ione, California. Shortly after he was released he was arrested again for burglary and robbing several gas stations.

Revenge of the "Wronged" Wife

During the 1920's, as oil wells sprang up across Southern California, Armour Phillips began a career as an aggressive, persuasive oil stock salesman for Sun Oil Company. Charming and handsome, he showered his 23-year-old wife Clara with everything a woman could desire. She had run away from her home in Houston, Texas, when she was only 14 to be with 17-year-old Phillips. Theirs had been a perfect marriage Clara told her friend Peggy Caffee, until Armour took up with "the other woman."

Clara and Peggy, who had first met when they were chorus girls in a Broadway theater, commiserated over their marriages. Peggy's husband was also involved in the oil industry on Signal Hill. She too had marriage woes. The two women decided to forget their troubles for a while at a speakeasy close to Peggy's Long Beach home. However, the liquor only helped fuel Clara's desire for revenge.

It was early on a Wednesday evening, July 12, 1922, around 4:45 p.m. when Mrs. Fred Weitz drove up desolate Montecito Drive, two miles from downtown Los Angeles, to pick up her father, Fred L. Johnson. Johnson had lived in the Montecito Heights district since 1911, when the area was first developed by the Mutual Home Building Corporation. The neighborhood was continuing to grow with the new 200 acre Montecito Terrace tract, and old-timers such as Fred Johnson welcomed the improvements.

As Mrs. Weitz entered the road off Griffin Avenue she smiled, remembering her father's glee over the new heavy retaining walls which had been built on the terraces; the one on Montecito Drive, he bragged, was 9,000 feet long, nine feet high, six inches broad at the top and twelve inches at the base. This colossal amount of concrete had cost developers more than $150,000, but Johnson believed the outlay for the road was well worth it for it offered the subdivision a great advantage—a sweeping view of the city.

Descending Montecito Drive around 6 p.m., Johnson was pointing out the lots set aside for popular-priced cottages and those for big estates

when the pair spotted the body of a woman on a hillside about three feet from the road. It hadn't been there when Mrs. Weitz had driven up the road an hour earlier.

Mrs. Weitz, fighting off hysteria, hurried to the nearest phone, almost a mile down the winding road, and called the police. When officers arrived they found a well-dressed woman, beaten practically beyond recognition, lying in a ditch. One detective remarked that it looked like she had been mauled by a tiger. The slain woman's right arm was pinned beneath a fifty-pound boulder, which had evidently rolled on top of the body after the struggle. Nearby was a broken hammer handle, stained with blood, apparently the weapon used by the killer. Not far away was a dove-colored felt and straw hat, also bloodstained and apparently torn from the victim's head by the blows from the hammer. Also found was a piece of wrapping paper and some twine which had been used to wrap the hammer. There was no identification on the victim, but she appeared to be about five feet, two inches tall, 120 pounds. She had brown bobbed hair, blue eyes and well-manicured hands. She remained unidentified until Armour Phillips and Peggy Caffee came forward.

Armour loved his wife Clara, but sometimes she was too gushy. She was always trying to please him, treating him at times as if he were her baby instead of her husband. As credit problems caught up with him, and his oil business faltered, he started turning his attentions to someone who treated him as a man—21-year-old widowed bank clerk, Alberta Tremaine Meadows, a friend of his wife. Alberta's husband, Jesse, had been killed a year earlier in a Pacific Electric trolley accident. Armour offered Alberta the solace she needed.

Despite his financial problems, Armour bought Alberta a car and other expensive items, while telling his wife they could no longer afford the luxurious lifestyle they had been enjoying. Because of money difficulties the couple was forced to move in with Clara's mother. However, Clara became suspicious and began following her husband. She soon found out it was her friend Alberta Meadows that her husband had been seeing. Seething with anger, Clara decided to take matters into her own hands. She stopped by a dime store and bought a hammer.

Peggy Caffee, wife of Long Beach oil worker M.D. Caffee, came forward two days after the murder. She claimed she had kept quiet for

her husband's sake. He was applying for a promotion and she didn't want him to be nervous or upset when he had his interview. Perhaps this was true, but more likely she was fearful of being implicated in the murder. In any case, he got the job and Peggy came forward with her tale.

Peggy said she was in the car with Clara and Alberta on their way to Clara's sister's home in Montecito Heights the afternoon of July 12, 1922. At the scene of the murder Clara asked Alberta to stop the car. Alberta, who knew Clara had been drinking and was perhaps getting car sick, complied.

The women got out of the vehicle and Clara confronted Alberta, accusing Alberta of having an affair with Clara's husband, Armour. When Meadows denied it, Clara grasped her newly purchased hammer and began beating her husband's supposed lover. Fleeing down the hill, Alberta fell when the heel of her shoe broke. Clara caught her and continued the brutal beating, bringing the hammer again and again straight down into Alberta's face before the unbelieving eyes of 20-year-old Peggy Caffee. Peggy said she would never forget how Clara had plunged the hammer over and over again into the head of Alberta Meadows until the "blood was flying everywhere."[43]

When asked about her relationship with Clara, Peggy said she and Clara had met when they were chorus girls in a Broadway theater. After their four week stint they didn't meet again until they bumped into each other two years later. Clara called Peggy a few days afterwards and asked her to go shopping. Peggy agreed but was surprised when Clara bought a silk shirt, a pair of hose—and a hammer. Clara confided to Peggy that her husband, Armour, was seeing another woman. Up for a little adventure, Peggy agreed to help Clara gather evidence.

Together the two women staked out Alberta's apartment, but Alberta never came home. The next day the pair went to Long Beach where they drowned their woes in bathtub gin and exchanged more confidences. In an alcoholic daze, Clara vowed to get even with Alberta. The now inebriated pair went to the bank where Alberta was employed and asked her for a ride to Clara's sister's home. Seeing that her friend Clara was a little tipsy, Alberta agreed. As they drove up Montecito Drive, Clara asked Alberta to stop the car. Shouting hysterically, she confronted Alberta with the affair. When Alberta denied it, Clara struck the young widow on the head with the hammer.

Peggy testified she had tried to stop Clara from attacking Alberta, but Clara came at Peggy with a hammer telling her to get out of her way. Peggy said she was stunned, everything happened so quickly, she didn't know what to do. When a panic-stricken Peggy had finished vomiting in the grass, Clara dropped her off at Peggy's Long Beach home, telling Peggy she would kill her if she ever said anything about the murder. Clara then casually drove home in Meadows' new Ford.

Armour Phillips panicked when he saw his wife drive up in his girlfriend's car. The blood splattered woman proceeded to throw her arms around her man and said, triumphantly: "Darling, I have killed the one you love most in this world. Now I'm going to cook you the best supper you ever had."[44] Terrified that Clara's mother, who was living in the same house, should come in on them, Armour insisted Clara quickly change her clothing and flee before Clara's mother found out what had happened.

With her husband following in his car they drove to Pomona, abandoned Alberta's car, threw away the bloody clothing and hammer head broken from the handle of the hammer that killed Alberta, returned to Los Angeles, and spent the night in a hotel. Armour Phillips then put his wife on a train heading toward Texas. Soon he began to have second thoughts and turned to his attorney, John Haas, for advice. Haas insisted Armour tell the police everything. If he didn't, Armour could be prosecuted as an accessory after the fact. Armour complied, telling authorities his wife was insane and dangerous to the community; but really Armour was hoping to save his own neck.

On July 14th, while Alberta's mutilated body lay in a funeral parlor, Clara was arrested in Tucson, Arizona. Clara denied she was Clara Phillips, insisting she was Mrs. Clara McGuyer, but Tucson authorities were able to verify her identity by the clothes she wore and a pasteboard box in her possession which had her true name written on it.

Brought back to Los Angeles on July 21st, Clara appeared bored. But she carried herself defiantly, with a touch of insolence. She pleaded not guilty. Her husband and sisters stood by her, and she did not seem the least upset by the fact that Armour had "given her away." When she met her husband in Los Angeles County Jail she threw her arms around him and told reporters he was the only man she ever loved, her first and only sweetheart.

Jailer Bob Cronin said Clara seemed to have no conception of what she had done; the only thing she worried about was seeing her husband:

"I went up to see Mrs. Phillips today and she continually asked if her husband was coming. She said he was all she had, and she wanted to see him. Yesterday I watched her as she sat talking with her husband. He was all that seemed to matter. Nothing else bothered. She felt his hair and face and was always putting her hands on his shoulders and feeling him, seeming to think it was almost too good to be true that she was with him again." [45]

Female reporter Alma Whitaker couldn't believe that any woman could consider Armour Phillips worth murdering for. To Whitaker he looked like a mediocre sort of chump, a not-too-bright mechanic immeasurably impressed with his own important role in the proceedings.

Clara, nicknamed the "Tiger Woman" by the press because of the comment by police that Alberta's face resembled that of someone mauled by a tiger, faced a jury of nine men and three women on October 20, 1922. Her defense chiefly rested on the plea of temporary insanity brought on by a jealous rage. Throughout the course of the trial Clara maintained her facade of bravado and defiance, until Peggy Caffee testified. Clara almost leaped from her chair as Peggy told her story, screaming at her to tell the truth.

As her tirade against Peggy continued, Clara's voice began to waver, her face grew whiter and tears began to roll down her cheeks. Clara Phillips had a different tale to tell—it was Peggy Caffee who killed Alberta Meadows.

Between sobs, Clara told how she followed her husband to the home of Julia McElroy, who Clara called a "backyard gossip," and heard Armour tell Julia he was going to leave Clara for Alberta. She had told Peggy what she heard and Peggy, who had imbibed liberally while on the way to the scene of the killing, decided to come to the rescue of her friend and take matters into her own hands. Seeing that Alberta was getting the best of Clara in an argument by the side of Montecito Drive, Peggy picked up the hammer and struck the terrific hammer blows.

Was Clara telling the truth? Prior to her outburst Clara's entire defense had been that Clara was insane at the time of the murder. Clara's sisters testified that their father was an imbecile, their brother subject to mental hallucinations, and many other family members suffered from mental aberrations. Clara was said to suffer from epileptic convulsions and, according to her attorney Bertram Herrington, had the mentality of a child. Harrington believed that because of this Clara's every action that day was guided by Peggy Caffee.

On November 16th, after deliberating for 12 hours, the jury returned a verdict—guilty. The three women jurors wanted to see Clara hang, but compromised on second-degree murder. Allegedly, Clara's smile had softened the hearts of the male members of the jury. Clara was sentenced to prison for a period of from 10 years to life, a verdict that many felt too lenient. Was ten years in prison punishment for wantonly taking the life of another? Had she been a man she would have been subjected to the death penalty. Some, however, thought she should have been declared insane. One besotted spectator whispered to her as she left the courtroom that he would set her free. Her attorney overheard and laughed at the notion. Little did he know what was soon to transpire.

Clara opened her heart to the press the day after her conviction. In the November 17, 1922, *Los Angeles Times* she stated:

"I don't know whether I killed Alberta Meadows or not, but if I did it was for mother-love. I fought with Alberta on the top of Montecito Drive to protect the only love I have ever known. I did what any mother in the world would do if she saw her baby being taken from her. Armour L. Phillips is my baby. He has been my only baby. He is my very life, and when I realized he was being taken from me I fought-fought-fought-so that I might always have him. I remember when we first met. It was love at first sight. It was the only love I had ever known and it is still the only love I have ever had. It's true I was young, just 14, but I was more than willing to devote my life to him and when he asked me to marry him I was the happiest girl in Texas. I was just getting started good in my education but I would have given up anything in all the world to prove my love for Armour." [46]

Finding she was unable to bear children, Armour became her baby. She stated "Before long I became contented for I had found my baby in Armour."[47]

On December 5, 1922, Clara Phillips escaped from the Los Angeles County Jail after shearing off the bars of her cell. It was one of the boldest and most sensational jail breaks ever recorded in Los Angeles. Clara had diligently been working on severing the steel bars for some time, holding the completed ones together with chewing gum. She escaped from the 3rd floor cell with the help of at least three accomplices who provided her with a rope long enough to reach ground level.

Authorities suspected Clara planned to wreak vengeance against Peggy Caffee, whose testimony practically convicted her. Peggy Caffee, who was living at 324 12th Street in Long Beach under the name of "Gladson," also disappeared. Gladson was Peggy's mother's maiden name. Did Peggy fear Clara would come after her? When located several weeks later, Peggy stated she had left for Philadelphia to visit friends and relatives, not because she feared an attack by Clara. But why had she left her husband a note saying she would be home in an hour and never returned? Perhaps the abandoned automobile found in Long Beach with Clara's fur wrap still in it was the real reason for Peggy's quick departure.

Witnesses the day of Clara's escape reported seeing a woman who resembled Clara and a man answering the description of her husband in an automobile about five miles from the jail. Armour Phillips, who had suddenly disappeared following his wife's flight, later gave himself up to police stating he had no part in Clara's breakout, but he did admit that he hoped she would not be recaptured.

Harry Karst, a witness for the defense who said during Clara's trial that she would never go to prison, was also seen driving toward the county jail the night of Clara's jailbreak. The young musician was a friend of both Alberta Meadows and Clara Phillips. Karst believed Clara's story about Peggy Caffee saying he didn't believe Peggy intended to strike the first blow as hard as she did, but she came to the aid of Clara when she saw that Alberta was getting the best of Clara in the argument they were having. Like Armour he maintained he had nothing to do with the escape.

Ed "Gold Tooth" Johnson, promoter of a new gambling resort at Tijuana, Mexico, who had formed a friendship for Clara while both were in the county jail the previous summer, was taken into custody and questioned. He was released after an unfruitful search at his resort showed Clara had not been there.

It was *Los Angeles Examiner* reporter Morris Lavine who figured things out. He learned that three days before Clara's break out Armour Phillips had withdrawn $570 from his bank account. After her escape another $119.25, and later another $140. Lavine wrote to the *Examiner's* correspondent in Mexico City and suggested the money transfers be watched. It proved to be a good idea. Lavine found that money was being sent to a Jesse Carson from Galveston, Texas. It was wired to Carson from Armour Phillips' sister, a Sunday school teacher in Galveston.

For a month Lavine followed alleged leads into Clara Phillips' whereabouts. She was spotted Mexico, El Salvador and finally located in Honduras in April 1923, along with her sister Etta May Jackson and Jesse C. Carson, an unassuming grocer who had helped in her escape. Lavine quickly headed to Honduras and convinced Clara, who was free at the time by order of the Honduran Supreme Court to come or go as she pleased, to come back to California for a new trial. Lavine told her the newspaper would help get her a new trial and a fair hearing in the courts and in the press. If she was indeed guilty she could stay in Honduras where she was assured of freedom.

Clara agreed to come home. She was sure if her attorney had only kept on cross-examining Peggy Caffee when she was on the witness stand Peggy would have broken down and told the whole truth.

Over a thousand on-lookers gathered at the dock when Clara's ship arrived in New Orleans on May 29, 1923. She told how she had been kidnapped from the Los Angeles County jail and had not left the prison of her own free will. She went on to explain that once free she decided to pose as Mrs. Jesse Carson and had fled Los Angeles to New Orleans before taking passage for Mexico where she met her sister. Carson's drinking and other actions attracted attention forcing them to move farther south, finally stopping in Honduras. She had left Carson in jail in Honduras awaiting investigation by Honduran authorities that he was involved in a revolutionary plot. She didn't say much about Carson,

but when asked about her husband's knowledge of her whereabouts she said he didn't know where she was "all the time."

As her train proceeded west she was welcomed at Houston by Armour's mother and father who told her they were behind her one hundred percent. On her way across Arizona, Clara's confidence began to wear thin. She heard that her long journey might not end in Los Angeles, but at San Quentin. When the train stopped at Colton, Los Angeles District Attorney Asa Keyes got on board. He told Clara that a judge had ruled she must go to prison without a new trial. It seemed that the law required notice of appeal to be filed within five days, specifically; and the late Bertram Harrington, Clara's attorney during her trial, had waited nine. The law was the law. No appeal was possible.

On June 2, 1923, Clara arrived in Los Angeles by train and was greeted by her husband who cried: "I would give my life to be able to undo the wrong I have done this little woman, and I shall never rest an instant until I have freed her." He went on to say he did not believe she had killed Alberta Meadows and that it was a drunken Peggy Caffee who had committed the murder. Their reunion was brief. Clara continued on her way to San Quentin prison where she was booked later that day. The 7,000 mile chase after Clara Phillips, now Prisoner No. 37,944, had ended.

Years later (May 1932), Jesse Carson, who viewed himself more as a soldier of fortune rather than a simple grocer, told authorities about Clara's prison break. He claimed he had been misled. He had been told by men he refused to identify that Clara was crazy. They said she had valuable oil lands in Mexico and they promised to pay Jesse well if he helped her escape and took care of her until they fixed up some trouble about the oil properties. He claimed that she simply walked out of the jail accompanied by a man who delivered her to him. No legal steps were taken to return Carson to Los Angeles from Central America to face prosecution because no evidence was obtained to corroborate his tale.

Though in trouble with the law himself for operating a fraudulent film school, assaulting a guest at a Christmas party, and numerous traffic violations, Armour stood by his wife throughout her years in prison. She continued to deny she struck the fatal blows and stated

she had suffered in silence during her years of incarceration with the belief that God would right all wrongs. Perhaps God did intervene, for during her years in prison Clara fell in love with Thomas J. Price, a handsome 24-year-old Los Angeles burglar who entered San Quentin October 26, 1929. Because of his good behavior, Price was employed as a runner between the main supply depot and the dental office in the woman's prison. There he met 32-year-old Clara Phillips, employed in the dental office as a dental assistant.

It seemed the pair was romantically involved when, in September 1932, a matron of the women's prison entered the dental office just as Clara was passing a note to Price. Clara had written Price: "An adequate description is impossible of the feeling that pursued me today when I stood so near to you. My heart was filled with an idolatrous passion that" [48] Prison authorities would not give out more, but ordered Price into solitary confinement and Clara was notified that for 2 ½ months she would not be permitted to receive or send mail, meet visitors, borrow books from the library or have any recreational privileges.

Clara admitted she handled the note, but claimed she didn't write the letter and it was not intended for Price. It was for a couple of other prisoners, but rather than tell on anyone Clara and Price took the fall. However, the prison parole board didn't buy her excuse. Her parole bid in 1933, and again in 1934, was denied.

Liberty would eventually come. On June 17, 1935, despite protests from citizens and politicians throughout California, Clara was released from prison. Her sisters greeted her as she stepped towards freedom. Her husband, who said he would be waiting for her, was not present. If he had been he would have been arrested. A warrant for Armour's arrest for grand theft growing out of an alleged swindle in a bond deal in August 1934 awaited him.

For a time Clara lived in San Diego, caring for her mother, Mrs. A.H. Weaver. She later went to Texas where she got a job in a dentist's office. The dentist, but no one else, knew her identity. In May 1938 Clara, now living in Pittsburgh, Pennsylvania, filed for divorce from Armour Phillips. In the petition she stated she wished to remarry, but the name of the man she intended to marry was not disclosed. And there, she vanished from public view. But one person knew her whereabouts.

A.R. O'Brien, publisher of the *Ukiah Republican Press* and chairman of the State Board of Prisons of California, kept track of her. In June 1939, he told newspaper readers details that had never come out in Clara's trial, namely that Clara belonged to one of the wealthiest families in America. Her uncle held one of the highest cabinet posts in the nation, and another was one of the country's top lawyers. O'Brien believed her family had provided $1,000 to bribe a prison guard to help Clara escape from the Los Angeles jail and supplied her with a large sum of money to help in her flight. In O'Brien's latest correspondence with Clara she had written that she was happily married and all was forgotten and forgiven. She only wanted to be let alone and forgotten.

Breaking Up is Hard to Do

Many murders surround a husband or wife who can't bear the thought of their spouse leaving them. There were several such tragedies in Long Beach in the 1920's: Gus Estis, a motorman for the Pacific Electric company, who shot and killed his wife on October 16, 1920, and afterwards attempted suicide by shooting himself in the mouth; Lewis Rodriguez, who mistakenly shot his mother-in-law Rose Dyer, instead of his wife Mildred on April 18, 1929. Then there was the case of Long Beach mail carrier, Joseph W. Duer, who suffocated his two baby daughters in their bed rather than surrender their custody to his wife.

It was a diabolical act, taking the life of one's own children. On January 9, 1929, a manhunt extending from Los Angeles to all of California and Arizona was in place seeking the father who had taken the lives of his own offspring. Had Joseph Duer hated his wife so much that he would kill his children rather than let them be with their mother?

It was a well thought out act, authorities surmised. Investigators believed Duer used some sort of an anesthetic to kill the children, Dorothy, age 2½ years, and Charlotte, age 9 months. The bed clothing near where police found their bodies, and a towel on the bed, had been soaked with a liquid of some kind. A bottle, marked "chloroform" was nearby. But their deaths had rattled him. What was he going to do next? A distraught Joseph Duer fled to his sister's home in Los Angeles. Perhaps she could give him some direction. But no one was at home and Duer left before Los Angeles officers, placed on guard, could intercept him.

Police suspected he might return to the scene of the crime at 6022 Olive in Long Beach, and stationed officers inside the home. Sometime after 3 a.m. on January 10th Duer did return, but he bypassed the house and entered the garage. Slipping noiselessly into the small building he hanged himself. Shortly after daybreak officers hidden in the house all night went out to search the premises and found the body in the garage.

The deranged father and his tiny victims were buried together in Long Beach's Sunnyside cemetery.

———

Manhunts seemed to be popular in Long Beach in 1929, especially if a police officer was the victim of a shooting. On June 22, 1929, every available policeman in Long Beach was out searching for 55-year-old Jack Keller. Keller had just slain his 28-year-old wife, shot policeman James M. Bullard, and wounded another man, Eddie Fink. The report was that Keller was armed with three revolvers and extremely dangerous.

The shooting occurred at 1617 Stanton Place in Long Beach where Mrs. Keller had been living apart from her husband. Police were called by neighbors who excitedly reported that Mrs. Keller, who had earlier confided in them that her husband had threatened to shoot her, had just been approached by an angry man. Policeman Bullard, accompanied by two reporters anxious for a juicy story, rushed to the Keller house. As officer Bullard cautiously walked up to the porch he was greeted by gun fire. Though shot through the stomach, Bullard staggered towards his assailant. A second shot pierced Bullard's left breast. He collapsed while the unarmed reporters rushed away and called for help. They had certainly got their story!

When police squads arrived they found Mrs. Keller and her friend Eddie Fink lying wounded. Keller had fled with his two revolvers and Bullard's service pistol. Mrs. Keller soon died at Seaside hospital. Bullard survived but Eddie Fink died four days later. Jealousy over his wife's alleged meetings with other men was given by police as the motive for the shooting.

The intensive man hunt was brought to a close during the early morning hours of June 23rd as Jack Keller entered his dead wife's home. Police had been lying in wait, anticipating the probability that Keller would return to the scene to get clothing, money and other belongings before he fled the city. At 1:40 a.m. Keller opened a window and climbed into the house. Because he was known to be armed with two automatics and a heavy caliber police revolver, officers Reuben H. Holt and John F. Clausson had instructions to "take no chances."

As Keller stepped over the window sill the policemen switched on the lights, covered him with their guns and shouted for Keller to put up his hands. Instead of complying, Keller plunged both hands into his pockets looking for his own weapons. As he did so, Holt and Clausson opened fire before Keller could draw one of the guns. They then disarmed him and took him to Seaside Hospital. Keller lived sixteen hours with three bullets in his body. Doctors cut away part of his liver in hopes of reviving him, but he died the next day.

Keller had married his wife in 1916 in Murray, a suburb of Salt Lake City. At that time he was known as Joe Kendall. The couple had six children, ranging in age from 3 to 13, who were now orphans. The combination of liquor and desperation over his wife's refusal for reconciliation was blamed by police for the shooting.

Keller's captors, Reuben Holt and John Clausson were cited in the daily police bulletin for extraordinary heroism.

They had been childhood sweethearts, growing up together in California's Central Valley. Joseph Casterot, whose parents came from the Basque area of France, had become a machinist in Bakersfield, a profession that allowed him sufficient income to marry and support the love of his life, Ruth Mooney. But Joe wanted more for his wife and family, so took a second job driving a cab. The extra money would buy them the little things that made Ruth happy. But tragedy intervened on a cold winter's day in early January 1920, when the cab he was driving was held up and robbed. Ruth had almost lost her husband when a bandit's bullet entered Joe's neck and nearly killed him. Following a long recovery, Ruth, Joe and their two children moved to 851 Orange Avenue in Long Beach, where Joe easily secured a job as a machinist in the oil industry. Ruth hoped the move, along with a better climate, would help not only her husband's physical condition, but his mood as well.

But Joe was never the same after the shooting. Recently he had turned to alcohol to dull the constant pain throbbing in his head. His behavior was becoming more and more irrational, and his temper flared at the smallest things. Ruth was beginning to get worried. What had happened to the man she had married?

In September 1932, Ruth had no choice but to call the police when her intoxicated husband came at her with a gun. Joe was jailed for five days for carrying a concealed weapon. When he was released, he was fine for a while, but then the verbal abuse and drinking resurfaced. Ruth, fearing not only for her own safety, but that of the children, sent her children to her mother in Bakersfield and filed for divorce. Though she was granted temporary alimony, Casterot refused to pay, forcing Ruth to take a job as a waitress at the Bryant Café on Signal Hill.

On November 5, 1932, goaded by the prospect of divorce, 34-year-old Joseph Casterot entered the Signal Hill café in which Ruth worked and shot her. He then turned his gun on the Bryant Café cook, Paul Buchler, and Lester S. Edison, a customer. From fragmentary statements gasped out by Ruth Casterot and Paul Buchler before they lapsed into unconsciousness, and from what Edison could tell of the encounter, police reconstructed the scene.

Joe Casterot had entered the café at Wardlow and Cherry Boulevard as Ruth Casterot was behind the counter and Buchler in the kitchen. It was not known if Joe said anything to his wife, but he did aim point blank at her, firing twice. As bullets struck her right temple and neck, 30-year-old Ruth Casterot collapsed. Hearing the commotion, 25-year-old restaurant cook Paul Buchler came from the kitchen and was shot in the right side. At this point 42-year-old Lester Edison entered the café for a cup of coffee. Casterot yelled at Edison, a Richfield Oil Company executive, to "get out," but before Edison could retreat Casterot fired at him three times. Two shots went wild. The third struck Edison in the hip. Casterot then stormed from the café and fled the scene in his convertible.

An all-points bulletin was issued by police to catch the shooter who many feared was driving to Bakersfield to murder his children. Shortly following the gunplay, police learned that a man had telephoned the hospital to find out the condition of Ruth Casterot. She was alive, but barely. Would he seek her out to finish the job? Then came reports from those who knew Joe that they had seen Casterot driving around downtown Long Beach. A radio broadcast by his brother Frank, assuring him of legal aid and compassion, brought no results.

For three days Casterot remained a fugitive then, on November 8, 1932, Joseph Casterot was spotted in nearby Los Alamitos. Somehow he had managed to slip past the city road blocks and taken refuge in

a box car. With this information, and armed with sawed off shotguns and tear gas, five detectives went after him. They located the box car on a siding adjoining the Los Alamitos sugar factory and demanded that Casterot give himself up. Casterot answered with a single shot. Officers crept up to the car and entered with guns drawn. They found Casterot dead on the floor, a single wound to his head.

Casterot's brother, Frank, was not convinced of the suicide verdict. He asked that his brother's body be exhumed from a Whittier cemetery and an autopsy performed to check the bullet against the pistol carried by Casterot. The Coroner confirmed that the death was due to a gunshot wound of the head suicidally inflicted.

All of Casterot's victims survived.

A divorce party! What better way to celebrate the end to a long and troubled marriage, unless one of the exes wasn't happy with being single again.

On September 9, 1921, thirty-five-year-old Carrie Routt was having a party to celebrate her son Albert's 13th birthday, and the divorce decree just granted her from her 75-year-old husband. Married to the "old man" since she was 15, Carrie was glad to be rid of him. But he had given her five things she loved—their children. The party had barely started when a man with an immense white beard was seen knocking at the door of the Routt home at 338 Termino Avenue. Going to the door, Carrie sensed that something was wrong. Although she did not recognize her former husband, she went with her feelings and quickly closed the door on the caller.

Enraged, Edward Routt smashed his fist through the glass portion of the door, yelling at Carrie that he was coming in. Terrified, Carrie ran towards the back of the house. Just as she reached the back entrance Routt barged through the front door and began firing. The first shot knocked her down. He fired two more times. One bullet lodged in her right side, another in her left shoulder and the third, which was fired at her head at close range, was deflected by her skull. Miraculously it only caused a minor scalp wound. After shooting his former wife, Routt jammed the muzzle of the gun into his mouth and fired a bullet into his brain, his body falling across hers.

Regaining consciousness, Carrie Routt pushed her former husband's body aside and screamed for help. Their five terrified children, who had hidden themselves in another room, ran to the kitchen where their one parent lay dead and the other seriously wounded. Police rushed to the scene and Mrs. Routt was taken to the hospital where she survived. She attributed her escape from death to the fact that the bullet dazed her, making her ex-husband think she was dead.

It was a birthday their son Albert would never forget.

———————

Everyone knows that mother-in-laws should mind their own business. It was a lesson that 39-year-old Rose Dyer had to learn the hard way—with her life.

Rose had told her 16-year-old daughter that she was too young to marry, but Mildred was in love, she told her mother, with a 23-year-old sailor, Lewis Rodriguez, who she had met at the Pike. The Long Beach amusement zone was a favorite place for young people to gather, and find romance, which had happened when Mildred met the handsome, young Latino. Rose finally agreed to meet the young sailor, and found she liked him. Perhaps he was the catalyst needed to rope in her reckless daughter and help settle her down.

But Lewis was a sailor, most often at sea, and Rose found that in her daughter's case marriage, and absence, did not make the heart grow fonder. Mildred continued partying and going out with other men, which Lewis found out about. In the spring of 1929 Lewis was confined to the navy hospital in San Diego, being treated for tuberculosis. All he could think about was Mildred. Why didn't she visit him, why didn't she write? She was all the young sailor could think about.

On April 18, 1929, Lewis, who had just gotten out of the hospital, confronted his bride at her mother's home. As he walked into 455½ West Ninth Street, he calmly told Mildred he was going to kill her.

Rose, hearing the confrontation, kept her composure and calmly asked to speak to Lewis alone. Things could be worked out, she explained. But Lewis didn't seem to hear her. With his eyes glazed over, his hands shaking, he suddenly fired. He had been aiming at Mildred, but it was his mother-in-law he hit. Rose Dyer toppled to the floor, dying instantly.

A screaming Mildred fled to a room where Elmer Easling, her mother's boarder, was reading. Elmer barred the door against the crazed husband but was shot when a bullet passed through the wooden door. Suddenly realizing what he had done, Rodriguez fled. The dazed, confused, assailant was captured after a dragnet had been thrown over the city.

Clarence Hunt, Long Beach deputy district attorney, demanded that jurors impose the death penalty against Rodriguez for killing his mother-in-law and find him guilty of the additional counts of attempting to murder his wife, and assault with intent to murder Elmer Easling, the boarder in the Dyer home. Rodriguez' brothers testified that their grandfather and aunt were mentally unbalanced, and that Lewis suffered from the same family illness. A jury, however, did not buy the insanity defense. On June 12, 1929, Lewis Rodriguez was found guilty of second degree manslaughter and sentenced to five years to life. His wife, Mildred, pledged to wait for him.

A Just Verdict?

O n the evening of November 30, 1926, at their apartment at 3010 East Third Street in Long Beach, Lee Daniel Murphy took his frustrations out on his bride of three weeks. Infuriated over a quarrel, Murphy beat his new wife continually for two hours, breaking both of her jaws, and flailing her with his belt buckle until her flesh was a mass of cuts and welts. He continually struck her in the stomach and hit her in the knee with a liquor bottle from which he had been drinking. Sixty percent of her body was covered with bruises.

Cornelia told police her husband, shell-shocked during the war, sometimes turned to alcohol to ease his horrific memories of combat. When he drank he became a different man. She was afraid to cry out during the beating because he said he had killed a girl in Fresno and he would do the same to her if she yelled. She didn't know if she believed him about the killing, but decided to keep quiet and play dead in the hope that he would lose interest and stop the abuse. But was Cornelia telling the truth about her husband?

Shortly after the beating Murphy left the apartment, returning a few hours later to beg her forgiveness. She told him to leave her alone and after he complied she managed to crawl to her landlady's apartment for help. Murphy came back to see her the following day and then disappeared when the landlady refused to tell him where his bride had been taken. Twenty-seven-year-old Cornelia Buttles Murphy died December 11, 1926, at the home of a friend, Mrs. John B. Welch, 1050 Elm Avenue.

Lee Murphy and Cornelia Buttles had met a year earlier at a banquet at Fresno where Cornelia was playing piano. Murphy told her he was an "automobile promoter" and had just returned from a trip around the world. Meanwhile, he was living a leisurely life at an expensive hotel. A rapid courtship ensued in which 34-year-old Murphy proposed again and again. Cornelia's parents were against the match because they knew so little about their daughter's suitor. Finally, when Murphy threatened to kill himself unless Cornelia married him, she accepted. The two were married on November 17, 1926.

Murphy insisted they leave Fresno for Long Beach. He told his new wife he could find much better employment in the advertising industry

in the Southern California city. Cornelia resisted the suggestion for some time, but eventually gave in. She hadn't wanted to leave behind the music school she owned in Fresno and her career as a musician.

Murphy was described as six feet tall, dark haired and always smiling. At one time he was Vice President of the Lions Club of Fairfield, California, and was a member of the American Legion and Veterans of Foreign Wars. He supported himself by selling advertising specialties and had also worked as a reporter on several newspapers. It also appeared that Murphy was a bigamist. He had not been divorced from his first wife, Maude McMay Murphy of Peoria, Illinois, when he married wife number two, Mildred Merrill of San Francisco, or wife number three, Cornelia Buttles. Neither Maude, a public school teacher, or their son had heard from him for three years.

According to wife number two's mother, Mildred Merrill intercepted a letter from Cornelia to Murphy, and while she did not learn the contents, she said they were enough to cause her daughter to fly off in a rage. Wife number two then telephoned Cornelia after getting the letter to warn her to keep away from her man. Somehow Murphy convinced Cornelia it was all a mistake, the woman who contacted her was a jealous ex-girlfriend; she had lied when she said she was Murphy's wife. It was Cornelia he loved and wanted to marry. He was through with Mildred.

It was believed that following their marriage Cornelia had second thoughts about Murphy's relationship with Mildred. She confronted him and wanted an explanation. His refusal to discuss the matter led to an argument which resulted in the thrashing. Upset over her assessment of Murphy, and not wanting to admit that her parents had been right about his character all along, Cornelia didn't tell her mother, or the police, all she knew about her new husband. Though badly beaten, Cornelia believed she was going to live. She promised her mother that someday she would tell all the indignities which she suffered. She did admit that "He did things that father has never heard of nor thought possible."[49] But Cornelia did die from the wounds suffered during the beating and it took the Coroner's jury less than five minutes to decide that Lee Daniel Murphy was responsible for Cornelia's death. They issued a warrant for his arrest, charging him with murder in the first degree. On December 15, 1926, Cornelia Buttles Murphy was laid to rest in Fresno after services by the same minister who officiated at her wedding.

Murphy was traced to San Francisco, where he hooked up with wife number 2, then to Banning and San Diego. Long Beach police issued an alert asking police officers of nearby states to be on the lookout for Murphy's new car, a 1927 Hudson Brougham, which he had obtained since fleeing Long Beach. They described Murphy as being 34 years of age, six feet tall, 225 pounds, dark complexioned, smooth shaven with a V-shaped scar over one eye and a straight scar over the other. Wife number 2 was described as being between 35-40 years of age, 5 feet 6 inches tall, 160 pounds, dark brown bobbed hair, fair complexion, full round face, good looking and fairly well dressed.

Mildred Merrill Murphy, called the "San Francisco wife" by the press, was found in San Diego on December 21, 1926. She professed complete ignorance of Murphy's crime. She said Murphy came to her four days after Cornelia's beating, asking Mildred to go on a sales trip with him. He professed his love and said the whole thing with Cornelia had been a misunderstanding. He never mentioned he had married her!

Mildred told authorities Murphy earned money by selling an automated printing device which was attached to rolls of wrapping paper which printed the name of and business advertisements of the merchants using it. He wore no disguise, she said, and didn't seem to know police were looking for him. When they reached San Diego they were almost broke, between the two of them they had $1.50, but it was enough to get them a room for the night. Mildred claimed Murphy started out looking for a job and found one with an automobile agency in National City. The day before he was to start his new job she believed he read about the death of Cornelia and that the police were looking for him. The following day he left Mildred for his new job. She gave him 50 cents to buy gasoline to get there. She didn't think he could have gone very far with so little money.

Mildred was asked to confirm her mother's story that she had warned Cornelia that Murphy was married, Mildred said she had. Asked if she could explain why Cornelia had gone through a marriage ceremony after that she replied: "Lee Murphy is a wonderful salesman. I believe he could sell an idea to anybody. He must have just talked her into it." [50]

Murphy's car was later found abandoned in El Centro. It was believed he had fled to Mexico. In the meantime another wife, who

asked that her identity be kept secret, was discovered by Fresno police. She was really the second wife, if one kept track of the dates Murphy headed to the altar.

For seven years Murphy evaded arrest. In February 1933, Long Beach police, diligent in their hunt for Murphy, placed his picture and description of the crime in a detective magazine. A private detective in Austin, Texas, recognized Murphy's picture and contacted authorities in Long Beach. The Texas detective said the fugitive's present wife claimed she had married her husband under the name of Callahan, but she suspected he was Murphy.

Sensing the law on his tail, Murphy/Callahan, along with his current wife and young son, disappeared from Phoenix where they had been living. With the aid of postal authorities, Murphy's trail was picked up in Pittsburgh, Pennsylvania, where he was arrested on July 7, 1933.

Jack L. Vaughan had read the story about Murphy in the detective magazine. His curiosity was aroused when a San Antonio waitress wearing glasses she apparently did not need saw the photo in the magazine Vaughan was reading. The woman, startled at what she saw, told Vaughan it was a picture of her husband, the father of her child. His name was J.R. Callahan, not Murphy. Confused, she confronted her husband with her suspicions, Vaughan reported, and after confessing the suspect disappeared. Vaughan then picked up the trail again, tracing Murphy to Phoenix where he was using the name Hubert McCarty. His waitress wife and their 14-month old son had joined him there. As authorities closed in they fled, hitchhiking their way to Pittsburgh.

Murphy was brought back to Long Beach to stand trial in late July 1933, and held in the county jail. On September 21, 1933, he took the stand in his own defense tearfully testifying that he was intoxicated at the time of the alleged beating and remembered nothing of any attack on his Long Beach wife. In describing his flight from justice Murphy claimed he did it for his mother. He couldn't bring any more sorrow into her life. Though his mother had died two years ago, he said he had only learned of her death recently. Breaking into tears on several occasions he told how he purchased a bottle of bitters while wife Cornelia was buying a present for her mother. Murphy claimed he drank the bitters and was heavily intoxicated.

Although penniless, Murphy's current wife, Bertha Hindman Murphy, and their son, followed Murphy to Long Beach to be at his side during his trial. His only defense for his actions was that he was intoxicated and did not remember what happened. He believed he would receive no more than two or three years in San Quentin and did not request a jury trial. However, the prosecution demanded a first-degree verdict, citing a statute that made a killing by torture, murder in the first-degree, whether premeditated or not. After much deliberation, Judge Frank Collier found Murphy guilty in the first-degree and sentenced him to hang for the brutal fatal beating of his wife, Cornelia Buttles Murphy. Judge Collier declared it was one of the most brutal and diabolical murders he had ever heard of.

In numerous appeals, Murphy sought the council of physicians. Two brain surgeons testified that Murphy apparently was a victim of traumatic epilepsy. In such cases, the doctors testified, the victim was subject to periods of amnesia in which he might commit acts wholly foreign to his nature. Murphy's attorney said that when the prisoner was a child he had suffered a serious head injury when his sled collided with a water hydrant. The surgeons said such an injury might have contributed to his affliction. Another friend of Murphy testified that Murphy was a man of good character and had once been involved in an automobile accident and later had no recollection of it.

On May 17, 1934, the California Supreme Court affirmed the conviction and death sentence given Lee Daniel Murphy (also called Leo Dwight Murphy) stating that "voluntary intoxication is never an excuse for a crime"[51] But his wife Bertha would not give up. On August 23, 1934, the day Murphy was to have died on the gallows, California Governor Merriam granted a 90 day reprieve to allow Murphy's attorneys to present additional evidence in his behalf. No new evidence was presented and on December 6, 1934, the last appeal of Lee Daniel Murphy to escape the death penalty failed when Governor Merriam refused to intervene. That evening Murphy slept fitfully. He awakened twice and chatted with the guards. On December 7, 1934, he walked up the thirteen stairs to the San Quentin gallows with a half-smile on his face. He said nothing, but in the cell he gave the warden a note:

"*I have never in my right mind hurt any living creature. I die with no thought in my heart except forgiveness for those who have mistakenly given me this unjust punishment and sorrow for those I have unintentionally wronged.*" [52]

He died nine minutes after the gallows trap was sprung, for the murder of his bride of thirteen days.

The Torso Murder

The Los Angeles River was where Ramon and his father Juan worked, where they tried to make enough money as river scavengers to support their family. They never knew what they'd find, especially after a flood, but 15-year-old Ramon Manriquez got the surprise of his life with what he discovered on April 4, 1929.

It looked like a promising day to see what treasures the river had brought them. Two days of heavy rain had swollen the river and Ramon hoped he'd be able to salvage something he could sell to help put food on the table that evening. He saw an interesting shape floating in the river near a box. Surely it was a mannequin, though it looked like a body, but he couldn't be sure. Thinking someone may have drowned in the flood he decided to notify the police.

Following Ramon's lead downstream, police saw the odd object described by the boy washed up on the banks of the river near Lynwood. Surely it was just the chest part of some dressmaker's dummy caught in the floodwaters, but they decided to have a closer look. They were stunned by what they found—the nude torso of a girl, possibly 18 or 20 years old.

A horrifying scenario unfolded. The limbs had been neatly severed from the remains, definitely done by someone who knew what they were doing. The body itself didn't have a single scratch, other than the clean cuts which removed the head, legs and arms. When the torso was taken from the water the wounds where the arms, legs and head had been severed were still bleeding. This, physicians said, indicated the victim had not been dead much longer than twelve hours.

Who was the woman? The torso provided no clue to the murder victim's identity and police believed that only by checking the disappearance of every woman reported missing would they possibly get a lead to the murderer. It was a daunting task. Parking garage attendants and car rental agencies were asked to report any instances where they noticed blood on the vehicles. Trash bundles that might contain the missing portions of the woman's body were ordered inspected, and the finding of knives or guns was to be reported. Police didn't know what they were in for.

News of this horrendous murder spread across the country. Police were inundated with letters from parents of missing girls hoping to identify the victim. Mrs. Herman Timm of North Dakota sent Long Beach police a lock of her daughter's hair, hoping police could use it as a clue. Mrs. Timm said her daughter Erma had come to Long Beach the previous August. She had received a letter from Erma in November saying she was going to marry James Morgan, a taxicab driver. The mother never heard from her daughter again. Investigators followed Morgan's address and were told by the landlady that Morgan had brought home a young woman whom he introduced as his wife. The pair left the following day.

Police were also looking into the disappearance of Mrs. Ruth Fleming. The 20-year-old woman had last been seen in Long Beach on March 23rd complaining she was ill. A druggist sent her to the emergency hospital, but she disappeared without leaving a trace.

On May 8, 1929, the *Times* reported that ever since the armless, legless and headless body was found in the river on April 4th, more than 300 missing girl reports were received from all parts of the country. Of this number, 102 missing girls were located.

After investigating hundreds of leads, police thought they had their killer. All the pieces seemed to fit. Ray L. Martin, who worked at a local warehouse, told authorities that two days before the torso was discovered fellow employee Leland Wesley Abbott had told him his wife had left him because of another man. Was it only a coincidence that Mrs. Abbott had moved to Lynwood, where the torso had been found, and that shortly after the discovery of the body Abbott had disappeared? More incriminating evidence surfaced when Martin told police that Abbott habitually carried a surgeon's knife in a leather sheath, and that he also carried an automatic pistol.

As Martin revealed more details, police became convinced Abbott was their man. On April 3rd, Abbott had come to Martin telling him it was stormy and raining, an ideal night for him to get even with his wife. Martin told Abbott he was crazy to think such a thing, and that he would be caught. Abbott replied that there was plenty of quicksand in the Los Angeles River close to where she lived and asked Martin to give him a ride to Lynwood. Martin refused. That was the last anyone at the warehouse saw of Leland Wesley Abbott. Another warehouse employee, William Spence, confirmed Martin's story about Abbott. According to

Spence, Abbott frequently mentioned that the Los Angeles River had quicksand which would hide a body.

With this slim clue, the Sheriff's homicide squad wired Cincinnati, Indianapolis, Louisville, New York, Philadelphia and eight other cities where Abbott had been known. He was described as 33 years of age, 5 feet 6 inches tall, 145 pounds, with dark hair and dark brown eyes. He had a scar on each wrist and one on his right forearm. From eastern police departments Los Angeles sheriffs learned Abbott had served a two-year sentence in Leavenworth prison for smuggling arms and ammunition into Mexico. When he was released he went to Cincinnati where he was married. His wife was described as about 22, with blond hair and fair skin.

Abbott's mother was located in Indianapolis and said the man they were looking for couldn't be her son. He had never been in prison and had never married. She said she had received a letter from him saying he was working for the U.S. Forestry Service at Mount Wilson. Police decided to follow her lead. When he was found he was so nervous he could barely speak. He denied he had a wife, but did admit that he had told some people that he had. He did acknowledge serving time in Leavenworth prison, but said it was for a military offense not in the ordinary criminal classification. He admitted he had owned a surgical knife, but he said he thought he had left it in Los Angeles. He claimed his stepfather was a surgeon who had given him the knife in hopes Abbott too would become a physician. He also admitted to owning an automatic pistol, but claimed he had pawned it. Was he lying? More incriminating evidence surfaced when stains were found on the lid of a small trunk belonging to Abbott.

When questioned on how the stains got on his trunk, Abbott said he had washed the lid with gasoline, though he couldn't explain why he needed to clean the stains from his trunk. Abbott certainly had dug himself into a deep hole. He did admit telling fellow employees in a Los Angeles warehouse that he had a wife whom he "intended to finish." He explained to sheriffs that he told the warehouse officials his wife had been giving him trouble so that he would have a good excuse to leave his job then come back to it again when construction work in the government forestry service ended. Was it only coincidence that he did not return to work at the warehouse the day the murder victim was found? Or that he tried to borrow a car from a friend on April 3rd, the

day before the torso was discovered? Nor could he offer an explanation as to what happened to the surgeon's knife with a five-inch blade which he owned.

In searching the storage trunk Abbott had left behind in Los Angeles no knife was found. Police did unearth two shotguns, a rifle, four pistol holders and five pocket knives. Had Abbott gotten rid of the knife following the murder? Abbott continued to maintain he did not remember where he put the surgeon's knife. Several days later Abbott walked into the Sheriff's office with the missing knife. He had found it in an old coat in one of his trunks. Lying had gotten him into a lot of trouble.

Abbott was absolved of the crime by the unwitting help of young boys playing by the Florence Avenue Bridge over the Los Angeles River. The river was a fun place to spend time, full of bamboo to make forts out of, turtles and frogs to catch, and water to splash around in. It was a place where fantasies could run wild, where kids could pretend they were explorers trekking up the Amazon River making important discoveries that would change human kind. On May 18, 1929, two boys stalking imaginary prey along the river found something that put their imaginations to shame. They were in for a big surprise.

Ten-year-old Winton Pettibone picked up a piece of bamboo and poked the end of it into what he thought was a turtle shell and lifted it up for his friend to see. Then, to their horror, they realized it was a human head. With the head on the end of the stick they ran up on the roadway and waved it at a woman motorist. She loaded the boys and their find into her car, drove to a phone and called police. When sheriffs arrived the boys showed them where they had discovered their grisly find.

The boys had found the missing head four miles north of where the torso had been unearthed six weeks earlier. Authorities surmised the body cavity contained air spaces and floated downstream in the river which was swollen from rain. The heavier head had sunk into the river bed. Though investigators believed the missing arms and legs would be discovered somewhere near the head, they were never found.

Authorities now had a valuable clue. They hoped the teeth might help identify the victim (though the boys who found the head pushed some of the teeth out when they poked the head with the stick, these teeth were never located). Winton Pettibone and 14-year-old Floyd

Waterstreet would remember that day forever. By finding the head they were rich. They had earned the $1000 reward offered by the *Los Angeles Herald Express*.

Elmer Smith knew the Pettibone family well. He contacted me when he learned I was writing about the case. 91-year-old Smith said it was all the boys talked about for years to come. Winton Pettibone used to tell his friends about testifying at the murder trial. It was important, he told them, that he tell how the head he carried slipped from the bamboo stick and fell to the pavement, most likely causing the skull fracture. Smith said Winton gave $15 of the reward money to his brother Tom who bought a donkey and kept it in his back yard.

Earlier, police confronted a major obstacle when tests made on the body of the slain girl failed to reveal the cause of her death, but when the head was discovered May 18th, in the quicksand of the river bottom at Florence Avenue in Bell, hope resurfaced. The victim had died from a blow from a carpenter's hammer which fractured the skull back of her left ear. The blow caused instant death. The most astonishing information, however, was the revised estimate of the age of the victim. The head appeared to be that of a woman from 40 to 60 years of age, not the 18 to 20 years of age determined from the torso. This announcement threw an entirely different light upon the torso case, since authorities were working under the impression the victim was a younger woman.

The head revealed a rounded forehead, high cheek bones and fair skin. The hair had been blond or gray. When joined together with the torso the vertebrae matched evenly and physicians verified the head and torso belonged to the same woman. The head had been severed from the body at about the fifth vertebrae and slightly more than an inch from the collar bone. The incision had been made with a very sharp knife and it appeared the decapitation had not been done hastily. It had taken more than three hours to sever the limbs and head. It seemed to be the work of a skilled surgeon.

The newly found head and its teeth provided the much sought after clue to the identity of the victim. Following a publication of the corpse's dental work in newspapers, dentist Dr. Edwin Hyde identified the records as matching that of his patient Mrs. Laura B. Sutton, last seen alive on March 28, 1929.

Why hadn't her family reported her missing? Had she been killed in a domestic dispute and then dissected, which would explain why no report of a missing woman of that description had been made to authorities? Laura Sutton's brother, Emerson De Groff, said he was uneasy about his sister's strange departure but thought she had left Los Angeles for personal reasons. He was concerned that prior to her disappearance she had appeared agitated and fearsome of her life. She had just gone through a tough divorce and the death of their mother. He wasn't sure what his sister's mental state actually was and hoped a change of scenery was all she needed to get back to normal.

De Groff didn't know what to make of it when she left a paper with him stating she had purchased a piece of property that was unrecorded and that if anything happened to her the lot was his. De Groff said he became uneasy about his sister but feared to report her missing unless he obtained more definite information. When he read that the torso victim's head had been found, and the age and hair color of the victim reevaluated, he reported the matter to police.

Why do women open up to their hairdressers? Does the clipping sound of scissors unlock channels in the brain, as well as the lips, making the client feel compelled to reveal their deepest secrets? Such seemed the case with Laura and her hairdresser, Harriet Jordan, who came forward with startling new information.

In mid-March, Laura came into Mrs. Jordan's shop for her usual hair appointment and Harriet was appalled when she noticed scratches on Laura's face. In a quivering voice Laura told her that she had been brutally assaulted by a mysterious man a few days earlier. Her assailant had jumped from a clump of bushes, scratched and beat Laura's face, breaking her eyeglasses. When Harriet asked her if she had reported it to the police, Laura said she hadn't. She couldn't identify her assailant and didn't want to bother the police. A few days later Laura dropped out of sight.

But was Laura really missing? On May 26, 1929, Laura's friend, 57-year-old Dr. Frank P. Westlake, told police he had received messages from the missing woman written after her supposed disappearance on March 28th. One of the notes had been typed, the others hand written. Each communication pertained to the care of several canaries which Laura had left with Dr. Westlake. In one of the notes she requested that Westlake reply in the personal column of a newspaper. Westlake

complied and showed police a copy of the newspaper in which he responded.

There were many unanswered questions. If Laura was indeed alive why didn't she come forward? Why did she write such a letter and ask for a reply through newspaper advertisements when she could more easily have telephoned? Westlake claimed Laura was distraught over her mother's death and the assault Laura had suffered a few weeks earlier. She wanted to leave the area. He had personally taken her to the rail station for a trip to Ventura, after that she communicated by letter.

Was Westlake telling the truth? Westlake seemed a likely candidate for murder. A former Army surgeon, he would have had the skill and tools to perform such an expert limbing of the victim. Police began to follow him. Shortly thereafter he made a late night trip to his son's home in Pasadena.

Police observed Westlake entering the garage and, after climbing on top of a box, tossing a small package in back of the rafters. When deeds, bank books and a life insurance policy naming him as a beneficiary were found in the package, Westlake revealed that he was Mrs. Sutton's fiancé and she had left these in his care. He denied all knowledge of the murder and asserted he didn't believe Laura Sutton was dead. He said he became involved in her business concerns six years earlier before she obtained a divorce. Since then Westlake took care of all her business affairs as her "manager."

After two days of probing into Dr. Westlake's connection with Laura Sutton, Westlake astonished police by showing them a note for $200 which he claimed had been signed by Laura on April 3rd and mailed from Arizona. Handwriting experts declared the signature on the note and the letters Westlake had in his possession forgeries. But all of this, and Westlake's surreptitious late night visit to his son's garage, was circumstantial evidence. More solid proof was needed before an arrest could be made.

In going through Laura's effects, deputies found a list of eight houses which had been advertised for rent. Dr. Westlake admitted he and Mrs. Sutton had gone house hunting several days before her disappearance. Deputies began to search every house on the list in hopes of finding where Laura had been killed. It wasn't quite as daunting as following up on the hundreds of missing person reports that had flooded their office after the torso was found.

On May 31st, bloodstains were found on the walls and floors of a vacant house in the Edendale district of Los Angeles. Besides the bloodstains, deputies found a glove which contained traces of human blood. A similar glove was later unearthed among Laura's effects which had been stored in Westlake's house. Further investigation revealed the house where the bloodstains were found had been rented during the last week in March by a man who resembled Dr. Westlake, and a woman who matched the description of Laura Sutton. Two months' rent was paid by the man, according to the owner.

On June 1, 1929, Dr. Frank Westlake was formally charged with the murder of Laura Sutton. Traces of human blood had been found in the water trap of the bathtub in Westlake's home. Another link to Laura's murder surfaced when Mrs. Lena Price came forward and told police that Dr. Westlake had given her a gingham dress saying it was one belonging to his dead wife. The dress was identified by Laura Sutton's roomer, Ben King, as the one worn by Laura on the day of her disappearance.

The evidence against Westlake continued to mount. Another unsettling fact was that Westlake placed fresh flowers on Laura's mother's grave every Sunday. Laura had done this on a regular basis. Was Westlake doing it to show Laura was still alive but in hiding? What of the suspicious injury Westlake had on his hand? He said he had been injured by a screwdriver. Or did he cut himself slicing up Laura's body?

On August 27, 1929, a calm but angry Frank Westlake faced a jury of nine women and three men. He silently listened as the Los Angeles autopsy surgeon, Dr. Wagner, testified that the torso victim's death was caused from a fractured skull by a hammer or hammer-like instrument. Spots on the torso, Wagner said, showed that the victim had been treated with silver nitrate. Dr. John Clayton, Laura's personal physician, was on hand to verify that he had treated Laura's plantar warts over a period of several years with silver nitrate. Dr. Edwin Hyde, Laura's dentist, identified certain dental work in the jaw bones of the skull as work he had performed. Ten-year-old Winton Pettibone was called to the witness stand and told how he had found the head. He said the head had once slipped from the stick he carried it on. The defense intimated this could have played an important part in connection with the skull fracture.

Jurors heard from the prosecution that Mrs. Sutton had put her property and finances in a joint account with Westlake and that Westlake had murdered her to gain sole possession. The prosecution also maintained that within three weeks after Mrs. Sutton's disappearance Westlake liquidated her estate and forged her signature to withdraw money from a bank account. The State charged he made use of his medical skills to dissect the body and dispose of portions in the Los Angeles River and had done so to gain control of her estate.

Now it was the defense's turn. Bringing in another angle in the already complicated case, Defense Attorney William T. Kendrick, Jr. revealed that Westlake wasn't the only one of Laura Sutton's male acquaintances who knew how to wield a knife. Ben King, who rented a room in Laura's home and who was also a rival for her affections, had been a butcher and meat cutter. Could he have killed Laura Sutton?

Following the testimony of florist Jack Nathan, who stated he had sold carnations to Dr. Westlake similar to those said to have been found on Laura's mother's grave, attorney Kendrick stated the doctor had placed flowers there out of his respect for the mother with whom he had been acquainted. Dressmaker Bertha Hibbs shot holes in the story that the dress given to Lena Price by Dr. Westlake was the dress Laura had on the day she died. Hibbs said the doctor had commissioned it from her for his daughter-in-law a year earlier. She also stated Mrs. Sutton told her she was going away where no one would ever see her again. Kendrick also attempted to prove that the dentist was wrong in identifying the victim as Laura Sutton. Hadn't young Winton Pettibone admitted he had dropped the skull, dislodging several teeth and fracturing the skull?

Throughout the proceedings Westlake alternately toyed with a rubber band, a pair of tortoise shell glasses, or conferred with his attorney. What was hard to refute was the forensic evidence which indicated the human blood found in Westlake's bathroom was that of Laura Sutton, and the hair taken from the dismembered head corresponded with hairs retrieved from a carpet sweeper in Westlake's home. Though Westlake testified he and Laura were lovers, and she could have left the blood and hair in his shower and living room during one of her "visits," he wasn't sure that the jury believed his story. His main defense strategy was to prove that Laura was still alive.

A love letter from Westlake to Laura, dated following her disappearance, was found between pages of Laura's Bible in the doctor's home. Along with it were several fern leaves which Westlake said Laura had taken from the hands of her mother just before the elderly woman was buried. Was this enough evidence to convince the jury Westland and Laura were more than just "good friends" and that she was still alive? The defense rested their case with Dr. Westlake's final words. When called to the witness stand Westlake was asked by his attorney William Kendrick, Jr. if he had killed Laura B. Sutton. "No, I certainly did not,"[53] answered Dr. Westlake.

On September 7, 1929, the jury returned their verdict after 36 hours of exhausting debate. Westlake had been so calm, so earnest, and so absolutely impervious to bitter cross examination that he made a tremendous impression on the jurors. Finally they returned their verdict—guilty. He was sentenced to life in prison. One of the jurors later told reporters they would have brought in a guilty verdict on the first ballot but one of the women in the jury said she was a psychologist and from her observations did not believe Westlake was the slayer. Throughout the trial, Westlake maintained his innocence.

Westlake appealed the case. His appeal for a hearing before the California Supreme Court was based on the grounds that the evidence was insufficient to support the verdict; that the district attorney was guilty of misconduct prejudicial to the rights of the defendant; and that the court erred in relation to instructions given the jury. His appeal was denied in July 1930. He was sent to San Quentin penitentiary.

Westlake was paroled on July 12, 1944, after serving 14 years of his supposed life term. He stepped jauntily to freedom saying "Laura is alive and will come forward to vindicate me."[54] However, she never did. Frank Pulliam Westlake died January 30, 1950, in San Joaquin County, California.

MURDER MYSTERIES

"Every unpunished murder takes away something
from the security of every man's life"

Daniel Webster

The Unsolved Murder
on Signal Hill

Latitude 33 degrees, 48 minutes north; longitude, 118 degrees, 9 minutes, 46.7 seconds west from Greenwich; height above mean sea level, 365.64 feet—the perfect spot for murder!

1920 seemed to be a popular year for mysterious deaths on Signal Hill. Another body was found on the picturesque mount, close to the stone monument marking the Hill's geographic location, on September 11, 1920. It was not far from where "Bluebeard" Watson had slain Nina Deloney a few months earlier (see chapter *Bluebeard*).

A road crew working in a hollow near a eucalyptus grove at Temple and Summit Street came across the grisly find. The man had been strangled to death by a piece of rope wrapped around his neck not once, but a half dozen times. It seemed the perpetrators wanted to make sure their victim would not survive.

Besides the creases made in his neck by the rope, there were bruises on the top of his head and another bruise mark on his knee. His body was found lying on the left side and wrapped in a reddish blanket. He had apparently been bleeding from blows on the head. An unopened bottle of strychnine tablets was found in his pocket.

The only clues to his identity were a handkerchief with the initials J.S.M. and a belt buckle with the initials J.S. engraved in old English style. He was described as being dark complexioned but smooth shaven, about 5 feet 7 inches in height, 150 pounds, somewhere between the ages of 30 and 35. He was wearing an olive drab army shirt, a pair of khaki trousers, a light union suit and a pair of black shoes with black socks. He had been dead about 48 hours.

An autopsy confirmed the man was killed as a result of strangulation and blows to the head. No trace of poison was found in his system. Police theorized the bottle of strychnine tablets was planted by the murderers in the victim's clothing. They also surmised, based on the weight of the body, that more than one person was needed to move the corpse to the Signal Hill site. Long Beach forensic expert Fred Kutz concluded the victim was probably murdered for personal revenge.

Every indication, Kutz stated, pointed to the fact that the killing was deliberately and methodically planned:

"Whoever committed the crime apparently approached the victim from behind and struck him three or more severe blows over the head, rendering him unconscious. In order to make double sure that death ensued the murderer or murders twisted the manila rope found on the victim's neck until strangulation had been accomplished. That the man was strangled while in an unconscious condition is indicated by the lack of signs of distortion or agony in the man's countenance. Had he been conscious during the choking process his hands and face would have carried such indications in tenseness and other evidences of a death struggle." [55]

Despite possible protests by conservative city officials, the *Daily Telegram* ran photos of the dead man in hopes of identifying him. His fingerprints were sent to criminal bureaus throughout the country. At one time Joe W. Stewart, a fisherman from Venice, California, was believed to be the murdered man. The Stewart clue was advanced in an anonymous letter written by a woman who signed her name "Gertrude B." The letter, addressed to the Long Beach Chief of Police read:

"Saw in the paper where man found on Signal Hill was, or might have been, a fisherman. Not knowing anything of the poor fellow found, but that this might lead to something or somebody that did know, I send this. Joe Stewart wore a belt like the one on the man found. He mingled with the underworld of Los Angeles and visited a house near the tunnel on Hill Street, where his father went. He knew a woman who ran this house. He used to room at my house in Ocean Park." [56]

Investigating the few similarities, detectives on the case satisfied themselves that Stewart was not the murdered man. Long Beach police forensic authority Fred Kutz, however, became convinced the Signal Hill murder victim was killed because he knew too much about one of the most ghastly murders in Southern California history, the murder of Jacob C. Denton.

The Denton case had been front page news for several months. Jacob Denton was a wealthy mining engineer who lived in a palatial English Tudor home not far from the swank Hollywood Ambassador Hotel being built nearby. The good-looking, colorful, stocky 46-year-old had been married twice; divorced by his first wife, widowed by his second. His daughter, Frances, resided with her mother in Arizona. Denton had lived a rough-and-tumble sort of life, making many friends, and, certainly, some enemies. On September 23, 1920, his body was found buried in his mansion at 670 South Catalina Street, half a block away from fashionable Wilshire Boulevard. It was covered by a mound of dirt mixed with fertilizer, about eighteen inches high, seven feet long and three feet wide. It was lying on the cement floor of the basement and the earth had just been shoveled over it. Also in the basement was a larger pile of earth from which the dirt for Denton's grave had been taken.

Denton had a woman, Louise Peete, living with him. Some said she was Denton's live-in girlfriend, others saw her simply as a housekeeper, while she identified herself as a renter. In any case, the 37-year-old brunette was good looking, poised, and endowed with one of those wonderful complexions that never age. Louise told authorities she had learned that Denton was going east and wanted to lease the house while he was gone. Though a lease was never signed, Denton agreed to rent the house to Louise in late May of 1920, with the understanding that Denton would keep his own room until he was ready to go east, early in June.

Louise Peete claimed she had last seen Denton alive on June 2, 1920, the date fixed as that of his murder. She told police of Denton's mysterious enemies and of a scuffle he had with a "dark woman" on the day of his disappearance. But police believed the dark haired beauty knew more than what she was telling them. It was the fertilizer that gave them the lead they needed.

Detectives established that on June 8, 1920, six days after Denton's apparent murder, a man came to the Denton house with a bill for some fertilizer; the same kind later found covering the body of the victim. Louise said Denton had told the gardener to carry the excess fertilizer which had been mixed with dirt from the garden into the cellar. The gardener testified that he had never seen Denton and that the order came from Louise. He also questioned why anyone would want the

smelly stuff stored on a cement floor in a confined space, rather than outside where it belonged.

Suspicion about Louise Peete arose again when a friend of hers told authorities that Louise had given her bank books, note books and clothing that belonged to Denton. The friend was later asked by Louise to pawn a diamond ring. Further incriminating evidence surfaced when it was learned that Louise Peete had written checks and signed them with Denton's name. When confronted with this information she said it was because he asked her to. One fact remained unresolved. Louise Peete claimed Denton had lost his right arm through a gunshot wound from unknown enemies shortly before his disappearance. The corpse found in the basement, however, had both arms intact and they were not even scarred.

At first, the absence of any signs of violence on Denton's body led police to believe that poison was used to kill Denton and that more than one person was involved in the plot. Later evidence revealed Jacob Denton *had* been shot. Even more puzzling was that the mining man had apparently anticipated his death. Two weeks before his disappearance he wrote a new will which incorporated expressions indicating he expected something to happen to him. But the will was declared suspect since it had been typed and not witnessed by two witnesses, as required under California law. Had it been planted as evidence by Mrs. Peete?

Further facts indicated Denton was slain within a few hours of the time he had expected to leave on a trip to visit his daughter in Phoenix and his brother in Kansas City. His packed luggage was found in his house. When relatives became concerned when Denton didn't show up, Mrs. Peete assured them that Denton had frequently "gone missing" for weeks at a time. In August, when Denton still had not returned, Mrs. Peete, who claimed she had leased the house from Denton in May, rented the house to others and went to Denver where, she told friends, her husband had sued her for divorce. She had to leave California to appear in the case. But Denton's relatives were worried and suspicious. They didn't trust Mrs. Peete. With her gone, it was a perfect time to search the house. They contacted authorities.

On September 23, 1920, police searched the house in which Denton and Mrs. Peete lived. In the basement they found a small, vault-like room, constructed from unpainted lumber. Not far away was

a pile of loose dark dirt with fertilizer in it. When police broke open the door to the vault they saw more dirt which was covering a heavy quilt. Wrapped inside the quilt was a horribly decomposed body. The corpse was fully clothed and the hands and feet were tied with a rope, as if for convenience in carrying it down the stairway. Denton's nephew identified the body, but claimed a diamond ring his uncle always wore was missing from the dead man's finger. But was it really Denton?

Over the next few months a parade of questions and theories came forth. Did Denton have a double? Was he in hiding? How many former wives did he actually have? Who was the mysterious Spanish woman that Mrs. Peete said frequented the Denton home, leaving only at night? Did the bloody gun found hidden in the Denton fireplace really belong to Mrs. Peete? Finally Louise Peete, who for months seemed to have an answer for every question the police put before her, was accused of murder and put on trial.

Louise Peete claimed that Denton was not shot until August 14, 1920, and that from June 3rd, the date of his disappearance, to August 24th he was in and out of the city, presumably on business. On the night of August 14th she said Denton and a woman she did not recognize arrived at the house. Shortly thereafter two men paid a visit. Mrs. Peete testified she and the other woman were on the second floor when they heard a shot. The two women entered the servants' dining room and saw Denton reaching for his revolver. One of the other men held a gun in his hand and fired at Denton. Denton fell to the floor. Mrs. Peete claimed the men told her they were taking Denton to a hospital. That was the last she saw of Jacob Denton, she said.

A jury, however, did not believe her. In December 1921, she was sentenced to life imprisonment. Her husband Richard, who dropped earlier divorce proceedings to stand by his wife during the trial, divorced her in November 1922. To avoid approaching poverty and ill health, Richard Peete committed suicide in August 1924. Their 8-year-old daughter, Betty, was now without either parent.

In an interview in July 1926, Louise Peete continued to claim her complete innocence in the Denton murder. She asserted she had concealed the identity of the real murderers because they threatened to kill her daughter. She also avowed she didn't believe it was Jake Denton's body found buried in the cellar. She believed Denton was still alive and

would one day let the world know. Could the unidentified Signal Hill murder victim have confirmed Louise Peete's story?

On April 12, 1939, 58-year-old Louise L. Peete won her long fight for parole. But she was not yet out of the news.

On December 20, 1944, Los Angeles Police Captain Thad Brown, rang the bell at 713 Hampden Place and found Louise Peete and her husband going through the contents of Margaret and Arthur Logan's strong box. Arthur had recently died and neighbors had become suspicious since Margaret hadn't been seen since May. Why were Louise and her husband Lee Borden Judson living at the Logan residence?

Louise told how Mrs. Logan had been kicked and beaten by her 74-year-old husband, who suffered from what today would be known as Alzheimer's disease, and was undergoing plastic surgery. Louise went on in great detail about the fight, how she had tried to stop it, the blood over everything, and how Margaret no longer wanted to live in the house where she had been beaten. Louise said she and her husband were looking after the place and working out a deal with Margaret to purchase the property.

Captain Brown, who recognized Louise and knew that she had been released on parole under Mrs. Logan's supervision, asked why Mrs. Logan hadn't signed Louise's parole papers since May. Louise went on to explain that she was helping her friend by attending to all of Margaret's business while she was away and that she had signed the papers herself. Asked why no one but Louise had seen Margaret Logan, Louise explained that Mrs. Logan didn't want anyone but Louise to see her face since Margaret's first plastic surgery operation had not been successful. Not buying Louise's story, Captain Brown searched the Logan property and found Margaret Logan's body lying in a shallow grave in the back yard.

Louise's story quickly changed. She told how Arthur Logan had killed his wife in an insane frenzy and she was honoring Margaret's last wish to protect Arthur. Unfortunately, Arthur could not give his side of the story; Arthur Logan had died at the Patton State Hospital for the Insane two weeks before his wife's body was discovered. Louise Peete did finally admit burying the body of Margaret Logan, her longtime friend, in the back yard of Mrs. Logan's Pacific Palisades home.

On December 22, 1944, Louise Peete's husband, 67-year-old Lee Borden Judson, told what he knew about the Logan murder. It was embarrassing to admit, but the former reporter had no idea his wife was really Louise Peete; she had told him her name was Lou An Lee. He confirmed that his wife helped care for Arthur Logan, who was out of his mind, while Logan's wife Margaret worked nights at Douglas Aircraft Company. Judson claimed his wife called him one evening and told him Mr. Logan had attacked and beaten Margaret Logan so terribly that Mrs. Logan had to be hospitalized. Louise told Judson she had called an ambulance for Margaret but needed his help to take Arthur Logan to the General Hospital to commit him to the psychopathic ward. Mrs. Logan, it seemed, had already filed a petition for her husband's commitment. Afterward, Lee Judson declared, he helped his wife clean up the bloody mess in the house.

Judson said for weeks he kept asking about Margaret and was told by his wife that Mrs. Logan had just telephoned or that she had come home and gone away again and so on like that. It went on in a similar vein until the day police found Margaret's body and took Louise and Lee away to jail. Louise later admitted her current husband had nothing to do with Margaret's disappearance, but Louise's actions proved too much for Lee Judson to live with. He had been deceived and manipulated by the woman he loved.

On January 12, 1945, Lee Borden Judson was released from jail and went to the thirteenth floor of the Spring Arcade Building, a downtown Los Angeles office building, and threw himself down the stair well. Plummeting down the stairs, the battered body fell nine floors before thudding onto a landing between the fourth and fifth floors. Louise appeared to be genuinely remorseful over the tragedy. Did she mean it? Maybe. It sounded as authentic as anything that she had ever said. But then again, feigning emotions was one of the characteristics of a psychopath.

What was it about Louise Peete that drove two, possibly more, men to suicide? Born September 20, 1880, in Bienville, Louisiana, Louise L. Preslar's first love was H.R. Besley, a traveling salesman. The couple eloped on November 10, 1904, and later divorced in March of 1912. Some sources say Besley, like Louise's other husbands, also committed suicide. Louise was later accused of stealing a diamond ring from a woman she knew in Texas with the help of young Harry Faurote. Harry,

too, supposedly committed suicide, but his sister believed Louise had shot Harry and made it look like a suicide so he wouldn't implicate her in the crime.

People seemed to die around Louise. When she was released from prison in 1939 she took a position as a housekeeper for Jessie Marcy, who passed away not long afterwards. She then worked for Emily Latham, who had helped secure Louise's parole. Latham also died. Louise had no answer to these many deaths, except to say it was just coincidence. She also stuck to her story that Arthur Logan had beaten his wife to death. But an autopsy showed Mrs. Logan had been shot through the head, as had Jacob Denton, and buried in a similar matter.

Louise Peete was a good storyteller. Even in prison she had a loyal following convinced of her innocence. Since her release her lies had kept her free. But no more. The evidence in the Logan case could not lie. There were numerous inconsistencies in Louise's testimony that did not add up: only one bullet was found in the room, whereas Louise had later "remembered" that Arthur Logan, besides beating his wife to death, had also fired a gun three or four times. Louise had claimed Margaret must have been shot by Arthur Logan while she was lying on the floor. If it were true, the bullet would have gone into the floor. It was found in the wall. The State also stressed the numerous similarities that existed between the Denton murder and the Logan murder. In his closing statement to the jury Deputy District Attorney John Barnes said: "Mrs. Peete, who was a Dr. Jekyll and a Mrs. Hyde, must have sat in her prison cell figuring what went wrong the first time and plotting this new crime."[57]

The jury agreed with him. On May 28, 1945, one day short of one year after the murder of Margaret Logan, the jury found Louise Peete guilty of murder in the first degree. On April 11, 1947, Louise Peete was executed for the murder of Margaret Logan. She was the second woman to die in the lethal gas chamber. Her body was brought back to Los Angeles and cremated and her ashes interred at Rosedale Cemetery. There was not a single flower at the privately attended funeral.

What of the unknown Signal Hill murder victim? Further details released to the press by Long Beach forensic officer Fred Kutz indicated the young man was taken by surprise. His face bore a very calm and placid expression, and Kutz was sure the victim would have put up a

good struggle had he had a chance. Had Louise Peete been telling the truth about the August 14, 1920, shooting of Denton? Was Louise's tale of the two men involved in the Denton murder actually true? She was very persuasive, and made everything she said sound plausible. Had the Signal Hill murder victim indeed been mixed up in the Denton murder?

As further details of the Denton murder surfaced, Kutz concluded the Signal Hill victim more likely was involved in the illegal liquor trade. The battles over smuggled whisky were so common that most never came to the official attention of the police. In many cases dead men turned up in rooming houses, automobiles, or along the roadside with no explanation ever discovered by the authorities.

Over twenty possible leads came forward as to the identity of the dead man, buried in the potter's field area of the Long Beach Municipal Cemetery. Yet to this day the identity of the Signal Hill murder victim remains a mystery. Perhaps time, and a renewed interest in a remarkable tale, will reveal the truth.

Did He Know Too Much?

It was a cloudy evening, with few stars, but Oscar Clampitt's headlights picked up a stranded motorist as Clampitt was driving along Anaheim Road near Long Beach in the early morning hours of October 18, 1929. What was odd was that the driver's door was open. Pulling over, he noticed a man slumped over the wheel. Was it just someone who had had too much to drink at one of the illicit speakeasies in the area? In trying to revive the driver, Clampitt placed his hand on the man's chest. A sticky liquid enveloped his hand. Blood. The driver appeared to be dead.

Was it murder or suicide? That was the question Long Beach police were asking after responding to Clampitt's frantic phone call. Earl C. Boruff, a 41-year-old private detective, had been shot below the heart with his own gun. Three empty cartridges were found in the weapon. One bullet had penetrated the body to the backbone. He had no other wounds or bruises. There were powder marks on his shirt, but none on his coat. His clothing did not show any evidence of a struggle. Though his watch and wallet were missing, a diamond ring had been removed from his finger and stashed in a pocket of his coat. Had he taken the ring off and placed it in his pocket to make it easier to pull the trigger? Had his wallet and watch been stolen by someone who just happened to come upon the body? Why was no suicide note found?

There were many puzzling aspects to the case. Boruff rarely carried a gun while on or off duty, his co-workers told police. Why had he borrowed a weapon from a friend and asked to keep it for some time? Boruff had reported off duty at the private detective agency in the Heartwell Building where he worked at 10:30 p.m. that evening. What had happened in those four hours leading up to his death? Police looked at the evidence.

The car door which faced the highway was open and the vehicle had run off the pavement a short distance, headed toward Long Beach. This indicated Boruff had driven towards home from Orange County. But why had he gone to Orange County so late at night rather than return to his Long Beach apartment after his evening shift? Also suspect was the angle of the wound. Boruff would have had a difficult time

using the thumb of his left hand to pull the trigger. His wallet, later discovered beneath a bridge one mile away, offered no clues.

Though Boruff was still alive when found, he died six hours later at Community Hospital before he could reveal what happened to him. He had been working on a domestic case and police were sure it had no connection with his death. Could he have been killed by a bandit in a struggle for the gun? That is what Oliver C. Mitchell, formerly a detective with Long Beach police and now head of the private detective agency which employed Boruff, believed. Mitchell decided to test his theory.

Boruff's revolver cartridges had contained black powder, but the bullet that killed him was smokeless. Mitchell decided to experiment with guns fired from various distances at which a man could hold a weapon pointed at his own head. It was clearly shown that Boruff was killed by a shot propelled by a smokeless powder, fired by another person, and that Boruff had fired his weapon three times at the person or persons who attacked him.

As a private detective Boruff knew many things. Three months before his murder he confided to a friend that he knew more about the February 1, 1922, murder of Hollywood film director William Desmond Taylor than any other person in Southern California. He claimed he would have solved it if he hadn't been removed from the inquiry and ordered to "lay off." At the time Boruff was working for the Department of Justice, according to officers. Boruff further stated that if the identify of Taylor's slayers became known, and the case cleared up, it would rock the nation from San Francisco to Washington, D.C.

What of Boruff's assertions? Los Angeles deputy district attorney William Doran believed there were only three possible motives in Taylor's murder: a crime committed by a narcotic drug ring; love and jealousy; and revenge. The single person who could directly substantiate these allegations was actress Mabel Normand. Two months before new evidence was to be presented in the Taylor case Boruff was murdered and Mabel Normand was too ill to testify. Normand would die before she could again tell her side of what had happened the evening of Taylor's murder. She passed away in the early morning of February 23, 1930, of tuberculosis. With her passing many secrets went with her.

Had Normand been Taylor's lover? She claimed they were just good friends, others said she was the love of Taylor's life. What of the other woman in Taylor's life, Mary Miles Minter? Throughout her remaining years the then 18-year-old beauty admitted she was in love with the 49-year-old Taylor, but she stood to lose $1.3 million if she married and tarnished her screen image of the all American girl.

What had Boruff learned about the case that could have led to his death? Had Taylor's murder been linked to his knowledge of the drug dealings so prevalent in the film world of his day? Lover or friend, Mabel Normand was indeed an important figure in Taylor's life. The film director had reportedly taken the law into his own hands several times by beating up drug dealers at Mabel's home and confiscating their drugs. Robert Giroux in his book a *Deed of Death,* revealed that Taylor spent as much as $50,000 of his own money trying to rehabilitate Normand, who just couldn't seem to shake her narcotic habit.

Cocaine, hailed as a wonder drug in the late nineteenth century, was long available without a prescription and was not outlawed until 1914, when the Harrison Act was passed. During World War I drug abuse became a serious problem not only among the wealthy elite of Hollywood, but among the general population as well. In 1919 a special Congressional committee addressed the alarming spread of the narcotic habit in the United States. The findings, released six months prior to the implementation of Prohibition, indicated that the number of people in the U.S. addicted to drugs exceeded one million and there was fear that national Prohibition would swell the number of addicts even further.

Illegal supplies of drugs were being smuggled in from Canada and Mexico, and by 1919 federal authorities had a list of 1800 organized "dope" peddlers engaged in the illicit trade. The report, detailed in the June 2, 1919, *Los Angeles Times,* went on to state that native born Americans made up most of the army of drug addicts, and the United States probably led the world in the per capita consumption of opium and cocaine. The committee's investigation further showed that the present Federal law was not curbing the traffic, that most of the State and municipal governments were doing nothing effectual against it, and that outside of the larger cities there was no realization, either

among officials or on the part of the public of the extent and danger of drug addiction in the U.S..

Anita Loos, who lived and worked in Hollywood during the early days of movie making, described the beginnings of the Hollywood drug culture in her 1966 book, *A Girl Like I*:

"The underworld, quick to take advantage of any new field, very soon moved in on Hollywood and set up headquarters in a suburb called Vernon. Movie actors quickly deserted the Hollywood Hotel as a playground and ventured out to the Vernon Country Club . . . Hanging around the Club bar were pushers of dope. They had an easy time converting those simple young drunks into drug addicts, and among their first victims were two stars of the first magnitude, Wallace Reid and Mabel Normand." [58]

Anita surely knew what was happening to Mabel since Anita's brother, Clifford, was Mabel's doctor.

A program similar to Nancy Reagan's "Just Say No" campaign against drugs in the 1980's and early 1990's was suggested in the 1919 government report, but by 1921, one year into national Prohibition, fears of an increase in drug addiction were substantiated. On August 15, 1921, New York state hospital statistics showed that drug addiction had tripled since Prohibition went into effect and that Prohibition had not perceptibly lessoned the number of alcoholics treated in hospitals. The government decided to actively advertise their campaign against the illegal use of not only alcohol but of drugs. What better way to do so than by publicizing what was going on in the movie industry. They started with Roscoe "Fatty" Arbuckle.

September 9, 1921, was a day that would live in infamy in Hollywood history. At the time no one had an inkling that what transpired that day with Fatty Arbuckle would forever alter the course of twentieth century movie making. The most popular funnyman in filmdom was accused of murdering a young starlet named Virginia Rappe during a supposed violent sex, drug and alcohol orgy in a San Francisco hotel. Arbuckle became the scapegoat for all the "evil" going on in the film industry. What followed made headlines around the world.

Mabel Normand was a good friend of Fatty Arbuckle, having starred with him in thirty-six Mack Sennett Keystone Studio films

between June 1913 and May 1916. Together they created the most popular boy-and-girl team in silent comedy. The appeal of Fatty and Mabel, according to author Betty Harper Fussell, was their innocence. Instead of battling marrieds they were kid sweethearts, country kids fighting and courting over milk pails. They portrayed puppy love for a public who believed in love without sex so well that when Arbuckle was charged with rape the public felt betrayed.

1916 was a pivotal year for both Mabel and Roscoe, according to Arbuckle's former wife Minta Durfee. Mabel began to get sick with a hacking cough while filming *Mickey*. She became addicted to cough syrup laced with opium which led to her later addiction to cocaine. In reality Mabel was suffering from tuberculosis, a disease which would lead to her death in 1930. Mabel hated doctors after her experience with Dr. Raymond Sweet, who tried to blackmail her over her addiction to narcotic medicines. Minta called in a private detective who discovered Sweet's scheme to extort money from Mabel and stopped him. Could Earl Boruff with his private eye connections have known of this? Fatty, Minta recalled, also became addicted to morphine and heroin that same fall of 1916 when he was treated by a medical hack who allowed a superficial leg wound to become gangrenous and who then wanted to amputate.

Mabel and Fatty left Keystone and Mack Sennett behind, stating publicly they felt they were not being paid the salaries they deserved. For Mabel it was for a different reason. The night before her marriage to Sennett she found him in bed with another woman. A bloodied Mabel rushed to Roscoe and Minta Arbuckle's home after she had been struck by a vase wielded by Mae Busch, Mack's bedmate and a fellow actress whom Mabel considered her friend. Though their paths would cross professionally through the years, things were never the same between Mack and Mabel.

Mabel went on to work for Sam Goldwyn, lured there in 1917 as his "mystery" star. Goldwyn's scheme was to upgrade movies by adding culture and class to his films. His first mission was to transform the vulgar pie-throwing Mabel into a glamour girl. Soon after, Mabel was introduced to a suave, cultured, director named William Desmond Taylor. Taylor and Normand found they were neighbors, both had apartments in the Baltic, at 1127 Orange in Hollywood, Mabel on the second floor and Taylor on the fourth. Taylor, at Mabel's request,

began to refine her image by introducing Mabel to art and literature. At the time Taylor was involved with actress Neva Gerber and Mabel with Sam Goldwyn.

After Taylor's engagement to Neva was broken in 1919, and Mabel broke up with Sam after losing their baby in a miscarriage, Taylor and Mabel became intimate friends. The fact that the letters Mabel wrote to Taylor mysteriously disappeared after his murder, only to reappear a few days later with no "incriminating" evidence of a romance or drug addiction, led many to believe a studio cover-up had taken place. Could Mack Sennett, who never married because he could never find another woman like Mabel, or Sam Goldwyn, who fathered Mabel's child, have killed William Desmond Taylor over a fit of jealousy? Author Sidney Kirkpatrick in his book *A Cast of Killers* thought so.

Following his split with Mack Sennett, Roscoe Arbuckle decided to form his own film company. On October 3, 1917, Earl Boruff and other readers of the *Daily Telegram* were overjoyed to learn that Fatty Arbuckle comedies were to be made in Long Beach. Roscoe, the most famous funny fat man of the screen, was coming back to the old town where he used to appear.

It had been in the spring of 1908 that Arbuckle first arrived in Long Beach. His original job was as a "barker" at the doors of the Byde-a-Wyle vaudeville theater on the Pike. The manager, Charles E.W. Moore, discovered Arbuckle had a talent as a singer and gave him his chance in musical comedy. His break-neck falls and humor made him the star of the show. It was there that he met his future wife, chorus girl Minta Durfee, and on August 6, 1908, they were married on stage. (Some say August 5, but Andy Edmonds in *Frame-up* found the document in the LA. County Hall of Records which listed August 6).

The wedding ceremony began with Roscoe stepping out from behind the stage curtain to greet everyone and then sing a love song. But the reception from the audience upon seeing Roscoe was so overwhelming that it was five or ten minutes before the clapping quieted enough for him to begin. A twelve-piece orchestra accompanied Arbuckle in a chorus of "An Old Sweetheart of Mine." The newlyweds received numerous gifts which were put on exhibition in the window of Buffum's department store. A heart shaped sign below the display announced they were some of the presents of "local stage stars Roscoe

C. Arbuckle and Arminta E. Durfee, married at the Byde-a-While Theatre." Their reception was held at Long Beach's grand hotel, the Hotel Virginia.

In July 1909, Minta and Roscoe had a son, born at Long Beach's Bethlehem Inn. For some reason Minta listed herself as Mrs. Nicholas Cogley, but hospital matron Clara Robinson knew who Minta really was. What happened to the child is also a mystery, since no mention of him was ever printed in the press or biographies of the couple.

In 1917, Arbuckle leased space at Long Beach's Balboa Studios and brought his entire production unit from his secretary to his valet. He was the one who introduced pie throwing and egg tossing at the studio. Balboa president H.M. Horkheimer and Arbuckle used to have a daily combat in the street until they learned that many people were appalled at the waste of custard and eggs. Arbuckle was planning to remain in Long Beach indefinitely and purchased a home on Ocean Ave. (current address is 1821 E. Ocean, his neighbor, actress Thea Bara, lived at 1300 E. Ocean) His production company included some other well-known stars such as Al St. John, who at one time was a lifeguard in Long Beach, and Buster and Joe Keaton.

Roscoe Arbuckle did tremendous work throughout World War I, heading many liberty bond drives and investing much of his own money in the interest-bearing securities. In April 1918, he led a pep rally at the Long Beach Municipal Auditorium and announced that if the audience would subscribe $50,000 worth of bonds he would match the sum himself. The audience raised about $20,000 and Arbuckle declared he would still invest the $50,000.

In July 1918, Arbuckle needed more space for his Comique Film Corporation, but the Balboa Studios, stressed for money, could not find financial backing to erect two large permanent street sets required for Arbuckle's next picture. Arbuckle needed a landlord that could meet his producing needs. He was forced to move.

Few today realize that Long Beach was once the center of a flourishing movie industry and could have become the film capital of the world if oil hadn't been discovered on nearby Signal Hill. On Thursday, June 23, 1921, Shell Oil Company struck black gold at its well at Temple and Hill Street. Long Beach would never be the same. By 1923 the population of Long Beach had increased from 55,593 in 1920 to 126,833, as thousands rushed to the area seeking employment

in the new oil industry. The land at the corner of Sixth Street and Alamitos, which had housed several motion picture studios since 1911, was sold, the film studio torn down and the land subdivided into twenty-one lots.

Many actors who had gotten their start in Long Beach transferred their allegiances to the new home of the motion picture trade—Hollywood. Had Earl Boruff known many of the performers personally, including Roscoe "Fatty" Arbuckle and William Desmond Taylor? It had been a small town prior to World War I. Had Boruff's film industry connections led to his death? Had he known too many secrets?

Arbuckle's career continued to soar after leaving Long Beach. In 1921 he was earning one million dollars a year at a time when the average Los Angeles County home cost two thousand dollars and the average income was about six dollars per week. Roscoe Conkling Arbuckle was among the wealthiest, most popular and most loved movie comedians in the world, then suddenly things changed. He became the most hated, all because of a party, a sick girl, and blackmail. Cries of murderer, rapist, degenerate, and pervert followed him wherever he went. Fortunately for Mabel Normand she hadn't been able to attend the Arbuckle party. If so, her name too would have been smeared through the press. But fate would soon intervene and her name would make headlines in the William Desmond Taylor murder investigation.

When Mabel Normand read the newspaper headline dated September 10, 1921, she was stunned to find that Virginia Rappe, the current girl friend of Mabel's old associate Henry Lehrman, had died during a weekend party given by Roscoe Arbuckle. Fatty, now divorced from wife Minta, had reserved a twelfth-floor suite at San Francisco's St. Francis Hotel to recover from a grueling film schedule. He had begun to dispense the usual bootleg gin to a dozen or so guests around noon that Labor Day weekend.

By 3 o'clock guest Virginia Rappe was violently sick in one of the bathrooms. She then started to scream hysterically with pain and tried to rip her clothes off. Arbuckle called the hotel doctor and everything seemed to be okay, except for a girl freaked out on gin. Several guests tried to help Virginia sober up but without success. They immersed her in a cold bath, pouring bicarbonate of soda down her throat and put ice cubes on her nude body. Nothing seemed to stop her pain except gin

and morphine. The next morning Arbuckle left Virginia in her friend Maude Delmont's care and returned to Los Angeles. Three days later Virginia died of peritonitis. With Virginia's death Maude Delmont decided to cover up the truth about her dead friend and extort money from Arbuckle.

In reality, the 27-year-old Virginia Rappe was not the saintly victim depicted by the press. She had had an illegitimate baby at 16, had undergone several abortions since then, was suffering from gonorrhea at the time of her death, and was once again pregnant. She also suffered from chronic cystitis and had been told to stay away from alcohol. Whenever she drank her bladder caused her such pain that she often screamed and tore off her clothing. The entire fiction behind the rape was not uncovered until 1976 when David Yallop in his *The Day the Laughter Stopped* exposed the real truth behind Rappe's death.

Reporters of the day alleged that Virginia's bladder was fatally ruptured by a combination of Arbuckle's weight (266 pounds) and a Coca-Cola bottle with which he abused her. The public reaction to the lurid newspaper stories that followed was hysterical. In Hartford, Connecticut, a group of women ripped down the screen of a movie theater showing an Arbuckle comedy. Some Wyoming cowboys shot up the screen of a movie house during an Arbuckle short.

From the beginning, factual evidence had almost nothing to do with the three successive Arbuckle trials. At his first trial on September 22, 1921, the judge recognized the lack of evidence and reduced the charge from murder to manslaughter. On December 4th, Arbuckle's first trial ended in a hung jury, ten to two for acquittal. On February 3, 1922, his second trial also ended in a hung jury, this time ten to two for conviction. Had William Desmond Taylor's murder reported the previous day had anything to do with most of the jury coming in with a "guilty" verdict?

On September 19, 1921, the very day that Virginia Rappe was buried in Hollywood Cemetery, the head of the Motion Picture Directors Association, William Desmond Taylor, announced to the Public Welfare Committee of Los Angeles that Hollywood was "cleaning house" and in the future would only produce the "cleanest of films." The Association was afraid. Senator Henry L. Myers was drafting federal regulations to oversee the movie industry. To counter the Montana senator's legislation, a new organization, the Motion Picture Producers

and Distributors Association, headed by movie moguls Adolph Zukor, William Fox, Sam Goldwyn, Lewis Selznick, and others was also formed. Their first course of action was to hire former postmaster general Will Hays, a member of President Warren Harding's cabinet and chairman of the Republican National Committee, to institute controls and act as a morals czar. How could Hays refuse? He was promised a salary of $100,000 a year, greater than that of the President himself. He joined the team in January 1922, and quickly instituted a new "morality clause," better known as the "Arbuckle clause," into the Association's directive. Any performer who tended to shock, insult or offend the community or outrage public morals and decency was subject to immediate firing.

Mabel was the first of the "bad" girls of Hollywood who became as famous for their wildness off the screen as on. She was reckless, spectacular, gutsy and unorthodox. Sam Goldwyn's efforts to refine her image had failed; her attempts at serious drama were disastrous. She was a comedian and the public loved her in that role.

Personally, however, the girl who called herself shanty Irish yearned for learning and culture. She grew studious and continued her "book learning" with William Desmond Taylor's help. Taylor knew that Mabel's entire career, based on shock, insult and outrage would automatically be banned by the Hays morality clause. The comic outlaw she both lived and portrayed on screen was barred by the changes of the time. Taylor realized that if Mabel was to have a future in the movie business, she needed to "clean up her act," which meant no more booze or drugs. He introduced her to music, painting and writing. He gradually steadied her wildness and he took her aspirations seriously. He was creating a new Mabel, one that could survive in the newly regulated Hollywood.

They were good friends, nothing else, Mabel told the press (though most thought differently). She was also the last person to see Taylor alive. For a while she was both the chief witness and the chief suspect in his murder. The story Mabel told for years to various authorities investigating the murder was always the same. Also, witnesses could corroborate every movement she had made on the afternoon of February 1, 1922, when she saw Taylor alive for the last time.

Mabel had stopped at Taylor's around 7 p.m. to pick up two books Taylor wanted her to read. When she arrived she heard Taylor talking on the phone. He told her he had been talking to his tax accountant

about the mess of canceled checks his former valet, chef, chauffeur and personal secretary, Edward Sands, had forged. Taylor had entrusted all his affairs with Sands when Taylor had taken a brief European vacation the previous summer. When he returned he found that Sands had disappeared, along with Taylor's checkbook, jewelry, clothing, and car. Sands had also cashed large sums on the blank checks Taylor had signed for household expenses during his absence.

In August 1921, Taylor had charged Sands with embezzlement and the district attorney had issued a warrant for Sands' arrest. But Sands had gone for good. But had he? In December, Taylor's apartment was again robbed and more jewelry taken. Taylor was also receiving phone calls at odd hours and when Taylor answered the caller hung up. Now Taylor had a new servant problem. The very morning of his murder Taylor had to bail his valet, Henry Peavey, out of jail. Peavey had been arrested the night before for soliciting young boys.

Mabel and Taylor's conversation turned to literature and after a discussion about several books Mabel said she was going home and straight to bed. She was tired. When Taylor walked Mabel from his apartment to her car 45 minutes later, Mabel blew him a kiss by pressing her lips to the side window. Detectives found the imprint of her lipstick there the next day.

At 7:50, five minutes after Mabel left, neighbor Faith MacLean heard what she thought was a gunshot. Later she dismissed it as car backfire, but she did go to her door and look outside where she saw a man standing in Taylor's open doorway. He was around 5'6", weighed 165 to 175 pounds, and wore a rough woolen jacket with a muffler and a tweed cap. MacLean, who knew Taylor's former butler, said it definitely was not Edward Sands.

For some reason neither the police nor the press circulated a description of the stranger Faith MacLean saw leaving Taylor's house after the murder. The police theorized that the killer "may have been" a woman, providing reporters with the conjecture the murderer could have been Mabel Normand, Mary Miles Minter or Minter's mother Charlotte Shelby. In reality, author Giroux points out, Faith MacLean's description was the only solid evidence the police had and it did not fit the description of any of the women suspects. But Giroux leaves out one point: perhaps the killer was hired by one of the women to murder Taylor. If so, the belief of author Sidney Kirkpatrick and King Vidor

that Charlotte Shelby was responsible for Taylor's murder is indeed a possibility.

Henry Peavey had a terrifying surprise when he opened the door to the Taylor residence the morning of February 2, 1922. Lying on the floor of the living room Taylor's valet saw the body of William Desmond Taylor, an overturned chair covering the legs. Peavey ran from the house screaming, alerting neighbors to the scene. As a crowd gathered, a man identifying himself as a doctor stepped forward, looked at the body and declared Taylor had died of a stomach hemorrhage. Interestingly, when Taylor's body was rolled over it was discovered the 49-year-old film director had been shot in the back. A steel jacketed bullet apparently had been used and the wound had practically closed up, making detection at first difficult. This was just the start of the mystery surrounding the case. What of the supposedly secret closet which held pink underwear monogrammed with the initials MMM, for Mary Miles Minter? Or was this "evidence" only a cover-up for Taylor's alleged homosexuality, as *Long Beach Press* reporter H.C. Connette wrote?

Newspapers found the Taylor case sold papers, largely owing to the Hollywood connection. The pink underwear was mere fiction, according to author Giroux, a story made up by newspaper woman Adela Rogers St. Johns to boost circulation for her employer William Randolph Hearst. Though Connette and others had suggested that Peavey was out soliciting young boys for Taylor, not himself, it appeared the homosexual angle was just another attempt to spice up the intrigue around the murder. In fact, as more and more details of the earlier life of William Desmond Taylor emerged in the press, they seemed to mislead and confuse reporters and readers and to make it more difficult to understand what had really happened.

Until his murder Hollywood and the public knew Taylor as a first-rate director full of wit and charm. In 1914, the elegant actor joined the Balboa Studios in Long Beach. The Horkheimer brothers, who ran Balboa, were delighted. William Desmond Taylor had acted in fifteen movies before approaching the Horkheimers requesting they consider him as a director. In his forties, Taylor knew his acting days were numbered, so he decided to switch and work behind the scenes. Fortunately, Taylor heard of an opening at the Balboa Studios where

they needed someone with previous movie experience. His mature and self-assured manner got him his sought after job of director.

Press releases from Balboa were quick to stress Taylor's many talents, including his gift with makeup. Taylor had found that green rouge was the best color to put around an actor's eyes, because it photographed as a natural color and helped take away the shadowy look. Taylor also recommended staining an actor's cheeks a pale yellow because it photographed well. Filming must have been an interesting sight to behold.

During World War I, Taylor enlisted as a private with the Canadian Army, quickly rising to the rank of major. After the war he returned to Hollywood and a job at Paramount. Here he personally witnessed what narcotics were doing to so many in his own profession.

Following his murder, Taylor's mysterious past came to light. He was denounced as the seducer of young women, who got what he deserved—a bullet in his back. He was also accused of being a drug addict, something his friends vehemently denied, and it was learned Taylor had tried to escape his past by changing his name. What had he been hiding?

Taylor had been born William Cunningham Deane-Tanner on April 26, 1872, in Cork, Ireland, the second of four children. His father, whom William hated, had been a British Army officer. As soon as he could William ran away from home, became an actor, ended up in New York marrying actress Ethel May Harrison by whom he had one daughter. At age thirty, a married man and father, he began a new life as an antiques dealer, but in 1908, after seven years of married life, he deserted his family taking on a new name and identity. He worked as a hotel clerk, factory worker, gold miner, timekeeper and railroad surveyor, traveling as far afield as Alaska and Hawaii. In 1912 he returned to the stage and was discovered by movie maker Thomas Ince, who persuaded Taylor to put his acting skills to work on film.

The only one who knew about Taylor's past was Neva Gerber, the heroine of the first film Taylor directed at Balboa. They became engaged, but could not marry because Neva's husband refused to give her a divorce. She knew about Taylor's wife and child and realized he was free to marry since his wife had won a divorce. However, after five years, Neva and Taylor called their engagement off. She claimed

she had never known a finer or better man. She was impressed by his honor, education, refinement and generosity, but his black moods frightened her.

Shortly after Taylor's death Taylor's old friend Balboa president H.M. Horkheimer revealed details about the director's life that he had sworn to keep secret while Taylor was alive. According to Horkheimer, Taylor came from an Irish background and had been engaged to the daughter of a rich family. The sister of his fiancée had gotten into some trouble with her gambling debts. In order to pay them she tried to rob the safe in her parent's home. Taylor caught her in the act and insisted she return the money and bonds. While arguing, the gambler she owed the money to found them by the safe, the woman grasping a revolver, dressed in her nightgown, and Taylor standing beside the opened safe with the money in his hand. Taylor assumed the blame and was sent to prison for three years. After serving his time he came to America. The gambler followed and tried to blackmail him. To escape, Taylor changed his name and came to California, where he was hired by the Balboa Studios as a director.

Journalists expecting the juicy details of Taylor's earlier life to provide clues to his murder found they led nowhere. They would stop at nothing to sell more papers, as the following story from Robert Giroux illustrates:

Florabel Muir, the Hollywood correspondent of the *New York Daily News*, reached her own conclusion that Taylor's African American valet, Henry Peavey, was the murderer. In order to prove her point she thought she could trick him into a confession. From the movies she held the stereotypical belief that Blacks were deathly afraid of ghosts. With the help of two friends she offered Peavey ten dollars if he would identify Taylor's grave at the Hollywood Park Cemetery. While one of her fellow conspirators went on ahead with a white sheet (knowing where Taylor was buried), Muir and her other friend drove Peavey to the cemetery. Here a white sheeted apparition jumped up from behind the crypt in the mausoleum where Taylor's body was interred and cried out, "I am the ghost of William Desmond Taylor. You murdered me. Confess, Peavey!" Henry's reaction wasn't what Muir expected. Henry Peavey laughed out loud. Muir had been unaware that Taylor had a distinctive British accent, not the Chicago hoodlum twang used by the supposed specter.

More than a dozen individuals were eventually named as suspects by both the press and police in Taylor's death. Yet the Taylor murder case is still unsolved. It has occupied the imagination of the American public for decades. Here was an attractive movie producer loved by two actresses—the popular Mabel Normand and the young Mary Miles Minter. In 1967, film director King Vidor was determined to solve the mystery behind William Desmond Taylor's death and put it on film. What Vidor uncovered was so explosive he knew he could never go public. He filed his facts away. After Vidor's death in 1982, Vidor's biographer, Sidney Kirkpatrick, gained access to the evidence and reconstructed the story of Taylor's murder and Vidor's investigation. He published his findings in 1986 in the book *A Cast of Killers*.

Looking through King Vidor's notes, Sidney Kirkpatrick came to believe Charlotte Shelby, Mary Miles Minter's mother, was so enraged by her daughter's flirtation with Taylor that she shot the director, possibly in her daughter's presence. Kirkpatrick recounts the lawsuit Charlotte Shelby filed against her accountant Les Henry in 1931 claiming Henry had stolen $750,000 from the family accounts between 1918 and 1931. Henry admitted to having made improper transactions with Shelby's money. But, he said, everything had been done with Shelby's consent and knowledge, and Shelby had insisted there be nothing in writing regarding these transactions. Henry did submit evidence showing Shelby made monthly $200 payments to a Carl Stockdale—one of two men who had provided Shelby with an alibi the night of the Taylor murder. Kirkpatrick furthermore learned from Vidor's investigation that Shelby's other alibi, Jim Smith, was an employee of Los Angeles District Attorney Thomas Woolwine. During his trial Henry also related a conversation he had with Shelby in 1923. He claimed she asked him to transfer an unusually large amount of money into negotiable bonds because the new Los Angeles district attorney, Asa Keyes, would require "a great deal more money than former D.A. Woolwine" had. Henry was convicted of falsifying the Shelby books and making improper financial transactions—but not of stealing the $750,000. Vidor, Kirkpatrick writes, believed that money was used as pay offs for the police and others who "knew too much" about the case.

For years police searched for Edward Sands, Taylor's former valet, a forger and thief. In 1937, then District Attorney Buron Fitts announced

that Sands was dead. He did not explain where or when Sands' death had occurred or how he knew about it. According to Kirkpatrick, Woolwine hid the fact that a body found in the Connecticut River six weeks after Taylor's death, with a self-inflicted bullet wound, had been positively identified as that of Sands. Yet it seemed that Sands was the prime candidate for Taylor's murder. It appeared Woolwine wanted everyone to believe he was still searching for Sands, to draw their attention away from the cover-up, if Kirkpatrick's informant is to be believed.

Robert Giroux offers a different theory in his book *A Deed of Death*. Giroux believes Taylor was murdered by the mob because of his active stance against drug use in the Hollywood community. He dismisses the Mary Miles Minter connection by showing that though the 18-year-old actress had a crush on the debonair Taylor, Taylor wanted nothing to do with her and had severed ties with her months before his death. Edward Sands, Giroux goes on, had nothing to gain by killing Taylor. Giroux also believes Mabel Normand and Taylor were indeed lovers, the letters proving such having mysteriously disappeared from Taylor's apartment, most likely cleared out by studio personnel before police arrived. Giroux is certain Mabel knew why Taylor was killed, but not who killed him.

On February 23, 1922, Assistant United States Attorney Thomas Green, in charge of narcotics prosecutions in Los Angeles, told reporters that William Desmond Taylor had asked for his legal help in fighting the pushers who were selling narcotics to "a film star of the first magnitude," with whom Taylor was in love. Even though Mabel was never mentioned by name, most insiders in the movie industry knew who he was talking about.

According to Green, Mabel had confessed her habit to Taylor shortly after meeting him and asked him to do everything possible to save her. Green had assigned two men to check out the studios and to make every effort to wipe out the ring. Green also said that Taylor had had a fight with the leader of the drug ring whom he punched in the jaw and kicked into the street near the actress' home. Taylor had provided the ring with a serious reason to kill him. Author Giroux believed the mob hired a hit-man to kill Taylor. When Taylor escorted Mabel to her car the night of his murder he left his door open or unlocked. The murderer had ample opportunity to slip into the house

to await Taylor's return. Taylor reportedly had an appointment with the FBI to tell them of the drug dealings in Hollywood the day after he was murdered.

Giroux goes on to explain that Hollywood was in a precarious moral position because of the Fatty Arbuckle case, and actors Wallace Reid's and Jack Pickford's deaths by drugs. Hollywood did not want more adverse publicity and kept the truth about Taylor's death away from the public. Had Earl Boruff known the truth that Robert Giroux believed he rediscovered decades later? Or had Boruff known about the pay-offs by Charlotte Shelby to cover up her part in Taylor's murder?

One former Los Angeles detective, Bill Cahill, told what it was like to be a member of the police force in the early 1920's:

"I joined the police force in 1909. Los Angeles was a rough place in those days. We never would have guessed it, but it got even rougher years later, during Prohibition. Those days were something else. Brothels, speakeasies, dope. It was impossible to keep tabs on all the criminal activity going on. The best we in the department could do was to do what we were told. If they said to raid one joint and ignore another one, that's exactly what we did. Maybe someone had an arrangement with the owner of the place we ignored, or maybe they just chose our targets out of a hat—we didn't ask questions. Because if we did, and believe me I knew a lot of good officers who asked the wrong questions, we were told to find another line of work."[59]

Both Kirkpatrick and Giroux agree that Los Angeles District Attorney Thomas Lee Woolwine had much to hide. Woolwine, a native of Tennessee, joined the Los Angeles District Attorney's Office as a deputy in 1908 and made a name for himself by crusading against prostitution and liquor interests. Woolwine became the head district attorney in 1914 and ran for governor of California in 1918, and again in 1922, losing both times. He was well connected socially in the Hollywood community, with many friends in the movie industry including William Desmond Taylor and Charlotte Shelby. Woolwine was also aware the police had bungled the Taylor murder scene, having left their own fingerprints and cigarette butts scattered around Taylor's apartment, destroying any evidence that might have helped solve the crime. Woolwine also ignored the fact that a number of letters had been

removed from Taylor's apartment, mysteriously reappeared, and could have been tampered with. He couldn't have these ineptitudes brought to light if he hoped to win the governorship later in 1922. Following his unsuccessful second run for governor, Woolwine was asked to serve as attorney for the newly created Independent Producing Manager's Association at the then lucrative salary of $25,000 a year. Had his role in helping "cover up" the sins of Hollywood led to this offer? Had money from Charlotte Shelby helped fund his ill-fated campaign for public office? Ill health caused him to refuse the offer and also forced him to resign as district attorney. Woolwine died in 1925 of liver cancer, taking all he knew with him.

What of Earl Boruff's murder? It seemed he was a detective who had unearthed many secrets, including importance evidence about the illicit doings of several Long Beach officials. He had also personally investigated the numerous threats made against Long Beach City Auditor Myrtelle Gunsul.

One doesn't usually think of the city auditor's office when discussing municipal government. In many cities it's an appointed position, but in Long Beach the city auditor is an independently elected city official bound by the city charter to monitor city finances. It's often difficult to reign in the spending of the mayor, city manager and council, as numerous Long Beach auditors have discovered.

Ever since the bureau was created in 1908 there have been many bombshells thrown at the Long Beach city council from the auditor's office. Long Beach's first auditor, attorney Ira Hatch, had to gather up the tangled and broken pieces of the city's finances, which included $50,000 in unpaid property taxes, and straighten out the mess. He was also hampered by a poorly written city charter which he was legally obliged to obey. In May 1910, he refused to pay three men their salaries, even though they had clearly done the work, because their salaries hadn't been fixed by a city ordinance, a provision of the charter. Later that year he made enemies in city government by returning the city's budget to them with $100,000 in cuts stating there just wasn't enough money to support the increases they sought. Hatch's grasp of city finances put him in the director's chair, so to speak. In 1911, he was elected mayor, a position he held for two years.

Hatch's successor, Lewis Shuman also had his run-ins with other city officials. In August 1913, City Auditor L.W. Shuman resigned. He stated his reasons:

"I have been a thorn in the administration flesh ever since I took office simply because I have a mind of my own and have been independent. My term of office has been one continual round of imposition. I have tried to do my work and do it well. I attempted to introduce a system of book keeping in the various departments that would be practical, up to date and render easier and more efficient work to the people. I have asked that the books be audited and brought up to date, but have been blocked at every turn of the game. Work which should have been done by other departments was turned over to my office in an uncompleted condition, and when I complained I was ordered to do the work. Harassment and imposition have followed every step of my official life."[60]

An elected official, he was replaced by David M. Rankin until an election could be held to replace him. Though he had resigned, Shuman still had much to say. He was aghast when Rankin transferred $5000 from the Water Department and placed it in the Bond Redemption Fund. The Bond Redemption Fund, Shuman pointed out, was fully covered up to January 1, 1914. He couldn't figure out why Rankin had made the transfer unless there was something "sneaky" going on. A war of words resulted in which Rankin told Shuman it was none of his business since he was no longer running things. This remark spelled the kiss of death for Rankin and his quest for a permanent job as Long Beach city auditor. In his stead, Harvey Durkle was voted into office.

But there were problems with Durkle. In March 1914, Mayor Whealton and the city council asked Durkle to resign. They alleged he was too old and untrained in fiscal management. They openly accused him of incompetence. To support this accusation Mayor Whealton produced a pile of complaints from citizens against the auditor. But as a veteran of the Civil War, Durkle had his G.A.R. cronies backing him. He refused to resign and sought a second term in 1915. His competition in the 1915 election included old city auditor Lewis Shuman, and city clerk Charles O. Boynton. New blood was elected to the tempestuous auditor position with Charles Boynton taking the reins in July 1915.

All the turmoil in the auditor's office was too much for Chief Deputy Auditor Eva Bibeau, described by the *Los Angeles Times* as "young and pretty," her degree from a prestigious business college barely mentioned. She had been running the auditor's office almost single handedly since Shuman's resignation in 1913. Miss Bibeau had been the logical choice to replace Shuman in 1913, having been both Shuman and Hatch's chief deputy, but she had been passed over because of her sex in favor of Rankin. Now Durkle's ineptitude and the council's refusal to give the auditor's office more help were too much for her. She resigned. The competent accountant of the female persuasion was replaced by another woman, one who would not take things lightly, or be described as "young and pretty"—46-year-old Myrtelle Gunsul.

Gunsul, with many years experience in banking, would become Boynton's assistant, as well as a thorn in his side. A woman not afraid to speak her mind, she came head-to-head over several issues with her boss. In 1919, when Boynton decided not to seek re-election, Gunsul entered the race against three male opponents: Harry H. Porter, John H. Kenner and William P. Freeman. With the united support of the women of Long Beach behind her, Myrtelle Gunsul won by a landslide, receiving 4,093 votes, her closest competitor, John Kenner, receiving 2,022. On June 4, 1919, Boynton, not happy with Gunsul's victory, fired her during one of his last acts in office. Gunsul had requested a paid vacation before she took the auditor's reins and Boynton refused. To make sure Boynton didn't "win" their last battle, Myrtelle Gunsul resigned, only to return as head of the department on July 7, 1919.

Controversy followed her. In July 1922, Miss Gunsul was purposefully late in writing Assistant City Manager Walter Barber's paycheck. Barber had been out ill, but was still paid because he was guaranteed sick leave under the new city charter. In effect, Miss Gunsul was making a point and giving Barber a lesson on life. Earlier, he had refused to pass a sick leave ordinance for day laborers employed by the city. If they were out of work for a few days because of illness, they were out of both luck and money. Their income was much less than that of the assistant city manager, and in Gunsul's opinion performed a much harder job. She revealed her reasoning to the *Long Beach Press:*

"I am a servant of the people, and my desire is to serve each and every one fairly and justly. Because a man is a day laborer and not in a position to help himself, it is all the more reason that he should be treated in a fair and just manner, and his interest protected by the ones in authority. I feel confident that every taxpayer in Long Beach believes that I am doing right in carefully protecting the interests of these men, who have all the disagreeable outside work to do in all kinds of weather, and subject to every infection from the filth and trash they are obliged to handle. Since every hour and fraction of days had been deducted from the pay of these men by the heads of their departments, I see no reason why Mr. Barber should be shown any consideration in this matter. Because Mr. Barber and Mr. Hewes (the city manager) personally interfered and held up the payrolls for these men was the reason for such a rigid investigation on my part of Mr. Barber's illness." [61]

Then there was the question of booze. In March 1922, a grand jury investigated the alleged secret employment of Charles C. Nevens by City Manager Hewes, who had hired Nevens to clean-up the bootleggers of Long Beach. Nevens told the city manager he was a government agent and would rid the city of alcohol for a wage of $100 a day. Chief of Police McLendon and some members of the city council were consulted and Nevens secretly hired.

A demand for $1,589.20 was presented to Miss Gunsul, as salary and expenses for Nevens. Upon the arrest of 22 accused bootleggers, Nevens told City Manager Hewes he needed his money quickly to flee Long Beach because his life was threatened by the alcohol element of the town. Miss Gunsul refused to authorize his pay because she felt the demand was illegal and a waste of the taxpayers' money. Later mysterious marks, "K.K.K. 27722," evidently intended to intimidate the city auditor, appeared on Gunsul's front door. The following day a man, obviously dressed to shield his real features, visited Miss Gunsul. He declared the Ku Klux Klan was not behind the threat but that 2900 Klansmen in the city were standing behind her and would protect her in every way. He stated the marks were not made by the Klan.

Upset that the press had gotten wind of their situation, Councilman Alexander Beck, City Manager Hewes and Mr. Peck from the city purchasing office visited Miss Gunsul and tried to have her return

the written request to pay Nevens. Miss Gunsul refused, stating the demand was a legal document in her possession and she would hold on to it. Undaunted, Miss Gunsul started her own investigations with the help of Earl Boruff and later had Nevens, a.k.a. Fred Seay and several other aliases, arrested for impersonating a government official.

Since 1926, when Charles Windham resigned as city manager, scandal and intrigue became synonymous with Long Beach government. In January 1929, upset residents filed a petition demanding the recall of councilmen Nicholas H. Alexander, William L. Evans, Edward L. Taylor, and Robert M. Hicks, known as the "Solid Four." They were accused of controlling the appointment of city employees and the "letting of city contracts without reference to the wishes of the taxpayers for the good of the city."

Though the four city councilmen threatened to sue signers of the petition, thousands flocked from all over Long Beach to add their signature to the recall document. Despite the city clerk's assertion that the petition was valid, and enough signatures had been gathered, the "Solid Four" blocked the recall campaign, declaring it illegal. The proponents of the recall were forced to carry the issue to the State Supreme Court. In June 1929, the court found that the recall proceedings had been within the law and ordered the city council to call an election as soon as possible.

But the "Solid Four" had a plan. Following the Supreme Court decision, Councilmen Hicks and then Evans resigned. Each of the four would quit the city council one by one. Those remaining would pick new leaders who would support their cause, ensuring that city business would continue to come to their syndicate. But they didn't have much time before the recall election set for July 11, 1929. Councilmen Hicks and Evans quickly resigned and other "syndicate" members, Carlos B. Michener and Frank H. Church, were appointed to fill the vacated council positions. However, time was not on the side of Councilmen Alexander and Taylor. Before they could resign and get their cronies appointed in their stead, the date set for the recall was upon them. They were both recalled by the citizens of Long Beach by a three-to-one vote.

Though the recall had succeeded, there was still much remaining to do to make Long Beach "clean." In September 1929, City Auditor Myrtelle Gunsul again took on city hall. She was aware of the government

corruption still going on and enlisted the help of the Reverend Neal D. Newlin, executive secretary of the Long Beach Church Federation and secretary of the Long Beach Law Enforcement League. With the help of private detective Earl Boruff they obtained enough evidence to warrant a grand jury hearing into malfeasance on the part of various Long Beach city officials.

Soon Miss Gunsul began to receive menacing telephone calls. The caller intimated her home at 243 Prospect Avenue would be dynamited unless she ceased cooperating with authorities investigating the town. These threats and the mysterious death of Earl Boruff on October 18, 1929, concerned her.

Even though she was considered an "old maid" by the standards of the day, she had her mother to take care of. If she had been living by herself she would have stood her ground and taken whatever came her way. But apprehension over her mother's safety forced Myrtelle and her mom to move into a secret residence. She began to believe Boruff had been murdered for his part in the corruption investigation and to prevent his testimony to the grand jury.

Things got even more alarming when Los Angeles County District Attorney Buron Fitts was targeted to stop his examination into Long Beach government malfeasance. This time the weapon was scandal.

The October 31, 1929, *Los Angeles Times* reported that a scheme had been hatched to frame Fitts in a compromising position. The plan was to lure Fitts by a telephone call, ostensibly from the Los Angeles police department, announcing that a murder had been committed at a Laurel Canyon home and that he was needed. Once Fitts arrived at the murder scene he was to have been seized, robbed of most of his clothing, drugged, and photographed in a compromising position with a woman *and* liquor. The conspirators believed they would be able to force Fitts from office with the threat of exposure. Though many police departments in Los Angeles County wanted to end Fitts' campaign against their illicit operations, this plot definitely had links to Fitts' Long Beach investigation.

But the grand jury investigation into Long Beach corruption was not to be stopped. On November 20, 1929, the county grand jury started their wholesale investigation into Long Beach city affairs which included: alleged protection of vice, bootlegging, gambling, bail-bond rackets, and the assignment of contracts for civic projects involving

alleged graft. Politics, with alleged plots to intimidate honest city officials and force them from office, were reported to play a major part in the evidence.

During the grand jury hearing of November 30, 1929, interesting evidence was presented detailing how several Long Beach police officers were "on the take" from various bootleggers. It seemed officers were telling those arrested for bootlegging that police would look the other way while the liquor offenders escaped from the Long Beach prison farm. The only stipulation was that they do so in small groups of two or three, so it wouldn't look so obvious. Besides police receiving pay backs, these escapes were never reported and the names of the prisoners remained on the prison rolls so Long Beach could continue collecting county money to pay for their keep. Also under investigation by the grand jury was the theory that Earl Boruff had been killed because of his knowledge of narcotic, liquor and vice conditions in the city.

Intimidation to thwart testimony in the grand jury investigation into Long Beach politics continued. A not-so-original scheme to prevent the appearance of Long Beach attorney James W. Barbee was reported in the *Times* of December 2, 1929. Barbee had been arrested with Margie Cummings, a 22-year-old woman operative of the Long Beach police vice-squad, in a hotel room. Barbee said Miss Cummings had earlier contacted him about helping her in a divorce matter and he had agreed to meet her in her hotel room. At a prearranged signal from the woman, police officers, waiting in an adjoining chamber, entered the room occupied by Barbee and Cummings a few minutes after the attorney arrived.

The sting had been for Miss Cummings to purchase liquor from Barbee, who police suspected had bootlegger connections, but had not succeeded. Instead, police came up with another ploy—arresting Barbee on a disorderly conduct charge. An irate Barbee declared his arrest had been a frame-up designed to prevent his testimony before the grand jury. Margie Cummings was ordered to appear before the grand jury to give her side of the story. She failed to appear. A warrant was issued for her arrest.

On December 11, 1929, District Attorney Fitts announced the grand jury findings. The verdict: Long Beach was a rendezvous for crooks and confidence men. Though the grand jury decided to shift to Long Beach officials all further responsibility for ferreting out and

taking action regarding the charges, Fitts stated that unless the Long Beach city council did something to clean up the mess he would come down, clean up the town and indict the council for malfeasance or misfeasance in office and neglect of duty. Fitts added, "Such a condition exists in a city where the police connive with the criminals."[62]

The Long Beach city council was livid, but it was hard to dispute such a well-publicized war veteran. In World War I Fitts had part of his right knee blown off at the Battle of the Argonne, where he also suffered mustard gas burns, episodes he didn't hesitate to rehash for the benefit of the press. The council quickly passed the buck to City Manager Buck, saying they were outraged at the findings which could not possibly be true. At a special city council meeting called by the city manager on December 30, 1929, Buck presented the data furnished by Fitts. The council found the evidence "was not of sufficient importance to justify official action."[63] They sent a registered letter to Fitts demanding he publicly retract his previous statements. No retraction was issued.

Why this attack on Long Beach? Fitts was in the race for governor of California. This report on Long Beach could only help his campaign; after all he was running against San Francisco Mayor James Rolph and Rolph's running mate for Lieutenant Governor, Frank Merriam of Long Beach.

City Manager George L. Buck, recognizing a "no win" situation, and realizing he would be the scapegoat, resigned. (Buck went on to become the city manager of San Diego in 1934).

On June 3, 1930, Long Beach citizens went to the polls in an attempt to "clean house." They overwhelmingly voted to keep Myrtelle Gunsul as city auditor, and in a narrow vote retained Ben Stakemiller, John J. Barton and Frank H. Church as city council members. Added to the council roster were Asa Fickling, Edward S. Dobbin, Harry C. Waup, Oliver S. Peacock, Ralph C. Christie and Oscar H. Wolter.

The big question in everyone's mind was who the new council would appoint as city manager. The new manager turned out to be former city councilman Claude C. Lewis. Lewis had previously been implicated in a Gas Department fraud case. An attempt by voters to recall Lewis as City Manager in February 1931 failed. It appeared the house was still dirty.

In this era of Prohibition where graft was the rule, rather than the exception, Long Beach was left with at least one honest city official.

The Los Angeles County grand jury praised Miss Myrtelle Gunsul, city auditor of Long Beach, as a highly efficient employee and applauded her bravery in bringing the illicit activities of city government to the grand jury's attention. Unfortunately, they could find no evidence supporting the theory that Earl Boruff had been murdered because of his knowledge of Long Beach corruption.

Upset that her husband's murderer was not found and angry that not much was being done by police to solve his murder, Esther Boruff decided the family had had enough of Long Beach. She and their son Omer returned to Mercer County, Illinois, along with her husband's body. In a simple ceremony attended by his wife, son, brothers Martin, Stephen, Stanford and twin brother, Everett, Earl Boruff was buried at Norwood Cemetery.

Miss Gunsul continued to serve as Long Beach city auditor. She retired March 1, 1951, after 32 years on the job, and died in 1958 at the age of 89.

Boruff was a man of many secrets, and apparently of many enemies. His murderer was never apprehended. Miss Gunsul could never be certain whether her connection with Boruff had anything to do with his death. Nor could anyone prove that Boruff's death had any ties to Buron Fitts' reopening of the unsolved William Desmond Taylor murder case.

On December 22, 1929, the press revealed that Los Angeles District Attorney Buron Fitts had found a new witness who would "prove" Taylor had been shot by a motion picture actress. It appeared that Fitts had uncovered information, perhaps supplied by Earl Boruff, that then Los Angeles Deputy District Attorney Asa Keyes had purposely suppressed evidence. It seemed that Taylor's valet, Henry Peavey, had told Keyes he had heard a movie actress quarrel with Taylor on the day of the murder. The rumor spread that Charlotte Shelby, the mother of Mary Miles Minter, would be indicted for Taylor's murder.

If there was a single honest Los Angeles County official during Prohibition years it was not Buron Fitts. Kirkpatrick writing in his book *A Cast of Killers*, believed King Vidor had uncovered evidence that Fitts had actually located the gun that had killed Taylor. The tip came from Shelby's other daughter, Margaret. Vidor's informant, a former Los Angeles police detective named Leroy Sanderson, claimed

Fitts had worked for then District Attorney Thomas Woolwine back in 1922 and knew Shelby had killed Taylor, but Fitts kept his mouth shut to protect his job. Fitts did the same thing through the Asa Keyes administration. When Fitts became district attorney himself he let Shelby know he could put her behind bars and got himself a little extra income. In exchange, he took care of the evidence for her.

Author Robert Giroux does not believe Kirkpatrick's story. He reports that when Charlotte Shelby learned that her name had turned up in the investigation she arranged a meeting with Fitts who later acknowledged there was no evidence for an indictment.

One doesn't know which author to believe. Giroux does point out that Thomas Woolwine, the Los Angeles County district attorney heading up the initial investigation, ignored the fact that letters had been removed from the scene of the murder and possibly tampered with. Could some of the letters have also incriminated Charlotte Shelby?

In any case, on March 29, 1973, 78-year-old Buron Fitts, former Los Angeles County district attorney, raised a .38-caliber pistol to his temple and took his own life. Police reports indicated the pistol used in his suicide was a vintage Smith and Wesson blue breaktop revolver, similar to the one used in the Taylor murder 51 years earlier. Or was it the same weapon?

Fitts himself was indicted for bribery and perjury in 1931, and again in 1934. He was accused of taking a bribe to drop a statutory rape charge against millionaire real-estate promoter John Mills. He was acquitted in 1936, and remained as the Los Angeles County district attorney until 1940. Samuel Marx in his book *Deadly illusions* accuses Fitts of having been bribed by MGM studio officials to help avoid scandal in the suicide death of screenwriter Paul Bern (married to actress Jean Harlow) in 1932. Was it all true?

Mabel Normand was of no help in a renewed 1929 investigation into the Taylor murder. Her doctors refused to allow her to be questioned. The 37-year-old actress died soon afterwards on February 23, 1930, of tuberculosis. Five days after Mabel's death, Asa Keyes was sentenced to San Quentin for conspiracy and bribery in the Julian Petroleum scandal, and twenty-two months after Mabel's death Henry Peavey died of alcoholism in a Napa hospital for the insane. Mary Miles Minter eventually found someone to replace William Desmond

Taylor in her affections. At age 55, following the death of her mother, Mary married her business partner Brandon O. Hildebrandt. She was the longest survivor of the Taylor murder case dying in August 1984, at the age of eighty-two. Up until her dying day she claimed neither she nor her mother had any part in Taylor's murder.

What of Roscoe "Fatty" Arbuckle? Two juries could not reach a verdict on his involvement in the death of Virginia Rappe, the third found him not guilty and "in no way responsible." But the public would not forgive him. Managers of theaters in Long Beach and across the nation put a ban on Arbuckle movies. Clay Kniss, manager of the Rialto Theater summed up the sentiment:

"I feel that the public does not want to see Arbuckle now, and that to open an Arbuckle engagement would be an affront to the decent people of Long Beach."[64]

Despite the acrimony against him, Roscoe Arbuckle did return to Long Beach. On June 30, 1924, he stood before the Long Beach city council and requested the right to appear at Hoyt's Theater. The Long Beach Ministerial Union had protested his appearance because of Arbuckle's involvement in the Rappe murder case. They felt his presence would contribute to "moral delinquency" in the city. Arbuckle had been accused of murder, but had been acquitted. Now the conservative element of Long Beach was trying to stop him from returning to the city that once loved him.

Councilman Fillmore Condit scathingly denounced Arbuckle's appearance in Long Beach as an insult to the people of the city, Councilman John Arnold agreed with him. Unknown to anyone, Arbuckle was in the audience. Arbuckle stood up and faced his prosecutors at the council meeting.

"Upon what facts do you base your motion?" Arbuckle asked Condit. The council was taken aback, according to the *Long Beach Press* of July 1, 1924. Condit said he had made a general and careful statement of common knowledge. "Be specific," charged Arbuckle. "What is the objection based on now, since I was cleared of the murder charge by a jury of twelve Americans?"

"Drunkenness," replied the Councilman. "That in itself was a violation of the laws of this State."

Arbuckle stiffened as he commenced his plea. "I had no liquor in my apartments. There is no evidence of drunkenness in the record. I was the victim of circumstances and bad company that time. But, gentlemen of the Council, I found my God in that prison cell in San Francisco. I decided to change. I am a decent man now. My heart is clean. I went through the fire and it purged me. I am in debt $134,000 and I ask the chance to earn and pay it in the only way I know how." [65]

Arbuckle was interrupted by hearty applause; the support of the audience silenced him. Other members of the city council moved to table the resolution to keep Arbuckle from appearing in the city, only Condit and Arnold voted no.

Arbuckle dominated the bill at Hoyt's Theater playing to an S.R.O. house. His appearance was greeted with applause that amounted to an ovation. Not once, but continuously throughout his talk with the audience, applause swept the theater. His act opened with a short film showing his preparations to appear on the stage, he then walked out from behind the curtain when the film was finished and talked about how he wanted to be given a second chance with the theater public.

Arbuckle became the scapegoat for the sins of Hollywood; the Hays Commission was appointed to look into the morality of the motion picture world and Roscoe Arbuckle became the first actor ever blacklisted. For ten years he remained in obscurity. He divorced his first wife Minta Durfee, who stood by him in the trials, and married Doris Deane. That marriage too ended in divorce. He attempted to direct comic shorts under the pseudonym "William Goodrich," but it was a no go.

On February 29, 1930, he said goodbye to his good friend Mabel Normand. She had always been there for him. One of her last requests had been to have him as an honorary pallbearer at her funeral. He was happy to comply, escorting her coffin to her final resting place in Crypt No. D7, Block 303, in the thirties wing of Calvary Mausoleum in Boyle Heights.

In 1931, the ban against Roscoe Arbuckle was lifted and Warner Brothers signed Arbuckle to do six films. But Will Hays would not give Roscoe a full pardon. Word of Roscoe's return to the film world

sparked controversy; Roscoe retreated to alcohol to help ease the pain. On June 29, 1933, after completing the picture *Tamalio,* he died in his sleep at 2:30 a.m. He and his third wife, Addie McPhail, had just celebrated their first wedding anniversary with a party. After the guests had left Arbuckle retired. A few moments later his wife called to him. She received no answer and discovered he had died.

Arbuckle's body was put on public display in the gold room of a funeral church at Broadway and 66th Street in Los Angeles. It was the same place where thousands had battled seven years earlier to view the remains of Rudolph Valentino. It would be the last time for fans to pay their respects, for unlike Valentino, whose gravesite was to become a place of pilgrimage, Arbuckle's body was cremated.

Many Long Beach folk made the trip to Los Angeles to pay their last respects to the actor the beach city viewed as a "boy from home." They remembered the dramatic rescue he had made of a drowning man off East Seaside Boulevard, his valiant efforts in selling liberty bonds, and the tears he shed in the council chambers as he told the councilmen how he was trying to make a "comeback" in the film world.

The cause of Arbuckle's death was given as angina pectoris and coronary sclerosis—heart disease. Actor Buster Keaton said that Roscoe actually died of a broken heart. It wasn't until 1976 that the true details in the Virginia Rappe case came to light with the publication of David Yallop's biography of Roscoe Arbuckle, *The Day the Laughter Stopped.* Hopefully the actor, who loved Long Beach so much, is finally resting in peace. We can hope, too, that Earl Boruff and William Desmond Taylor, their murders still unsolved, have also found serenity and closure.

Murder on the Schooner Carma

It was a strange case, indeed—just the fodder for a Hollywood film. Here was a suspected German spy, his much younger wife, a soldier-of-fortune with a grudge, a mysterious "man in gray," allegations of mutiny aboard a barely seaworthy ship manned by a crew of amateurs out for adventure. Years later Southern California newspaper writers would look back and reminisce about the bizarre killing of world adventurer Captain Walter Wanderwell.

The German Pole, born Valarian Johannes Tieczynski, had been everywhere and done everything. His was a life that most people could only dream of. In 1912, he started on a five year 82,000 mile walk around the world beginning in Poland ending up in Atlanta, Georgia. In 1918, he conceived the idea of making another tour around the world by auto. Along the way he traveled to Siberia, journeyed through the Amazon and trekked across the scorching sands of the Arabian and Saharan deserts, even witnessing the opening of King Tut's tomb. Besides making movies of his exploits he also made enemies. About 9:30 p.m. on December 5, 1932, in a cabin aboard his yacht in Long Beach, he was shot in the back. Ten feet away his two small daughters slept, unmindful of the tragedy.

On that cold, damp December evening, Wanderwell and four passengers were seated in the dining salon of the *Carma* when a well-dressed man appeared at the screened porthole and asked to speak with Wanderwell. Wanderwell excused himself and left the dining room. A few minutes later his guests' conversation was interrupted by a gunshot. His concerned companions rushed to a passageway leading to a cabin which the 37-year-old Wanderwell used as an office. Slumped in a corner, with his right hand covering his face and a bunch of keys dangling from his left hand, the body was found. The unidentified male visitor had fled.

Police later determined the slayer fired from a kneeling position and that Wanderwell had opened his purse containing $835, or had begun to open it and changed his mind, when the shot was fired. It was also determined that the .38-caliber bullet which killed Wanderwell

273

was fired from a gun which was of a make unknown *except* in tropical lands.

Aloha Wanderwell, who for many years traveled with Wanderwell as his "sister," said her husband had been threatened by a man she knew only as "Guy" and "Curly" who accused Wanderwell of abandoning women members of a former cruise in ports far from their homes. Several of those who had been in the dining room of the *Carma* positively identified William James "Curly" Guy as the mysterious stranger who had appeared at the porthole just before Wanderwell's murder.

Guy, like Wanderwell, had lived the life of an adventurer. Born in Cardiff, Wales, in 1909, Guy's parents died while he was quite young. Not happy with his guardian, he ran away at the age of 15 for a life at sea. Roaming the world, he eventually became a prize fighter and ended up in Buenos Aires where he met his wife Vera. She didn't like the fight business, so Guy quit when the couple spotted an ad offering a position to a woman who could speak both English and Spanish. They answered the ad and met the Wanderwells.

Captain Wanderwell was organizing one of his expeditions and the Guys signed on to accompany him to Peru. They weren't aware until later that Wanderwell had no money of his own, but they were quick to learn Wanderwell had a natural salesman's ability to get others to subsidize his adventures, usually by taking the bored children of wealthy families on tours to exotic locales and making sure their parents paid a high price for the experience.

Wanderwell's next adventure was an automobile tour from Buenos Aires to Los Angeles and once more the Guys were recruited to accompany him. The trip was supposed to have been made entirely overland, but the automobiles were loaded on a ship and most of the trip was made by water. Guy said Wanderwell worked the crew like dogs, forcing them to pay their way by selling his travel pamphlets at shore stops. They were poorly fed and generally their lives made miserable. They started calling Wanderwell "Little Admiral." Conditions became so unbearable that the crew protested and threatened mutiny. Upset with the attitude of those he had befriended, Wanderwell abandoned the Guys and several other members of the party in Panama.

The Olympic Games lured Curly Guy to Los Angeles where he happened to see one of the automobiles Wanderwell had purchased in Buenos Aires for Wanderwell's trek to Los Angeles. Guy followed

the car to an apartment and found the man who had ignominiously dumped his crew in Panama. Guy confronted Wanderwell, demanding the return of money he had paid him for his passage from Buenos Aires. Guy said he didn't get the money, but did get into a rather heated argument with the Little Admiral which led to his present predicament—on trial for the murder of Walter Wanderwell.

In a spectacular media covered murder trial, Guy admitted he hated Wanderwell, that he might have killed him given the chance, but said he'd never shoot a man in the back. The personable, handsome, 24-year-old convinced the jury. He persuaded them he was not the man whom witnesses declared was "the man at the porthole," a man in a gray overcoat with the collar turned up and a cap pulled over his eyes, who stopped at the mess room porthole and asked for Captain Wanderwell five minutes before he was shot.

Curly Guy had an air-tight alibi in Eddie De Larm, a Glendale aviator friend, who swore Guy was in his home when Wanderwell was killed. Though the prosecution characterized the alibi testimony given by De Larm and other members of the De Larm family as "a mass of untruths," Guy was acquitted and no one else was ever brought to trial for Wanderwell's murder.

Questions continued to surround the case. For instance, how did the New York office of United Press know Wanderwell was killed before Long Beach newspapers learned of the tragedy? Did a note in Spanish which disappeared from the murdered man's wallet have anything to do with his death? What happened to the mysterious gun from the tropics that killed him?

Walter Wanderwell had indeed lived a colorful life. In 1917, the 22-year-old was arrested by United States government officials as a suspected German spy. His first wife, Nell, said it was true, he was a spy. His father was a major in the German army. Nellie Miller Clark had met Walter while he was interred as a prisoner of war in Atlanta, Georgia. The former New York Follies show girl was assigned missionary work among prisoners when she joined the Volunteers of America during World War I. Following Wanderwell's release they married and embarked on a round-the-world auto tour, traveling the globe from 1919 until 1924, visiting 37 countries.

They competed with each other to see who could travel the longest distance in five years. Nell traveled with her four person team on

one continent while her husband traveled another. They supported themselves by selling pictures and giving lectures. Along the way they filmed their journeys, later going on a vaudeville circuit showing their adventure films. But Nell discovered there were too many women in her husband's life and filed for divorce. She didn't have the slightest idea who could have killed him, but knew he undoubtedly had enemies, including many cuckolded husbands.

Not only Wanderwell, but the ship *Carma,* seemed to have a checkered past. It appeared the *Carma* had brought bad luck to its owners ever since it was launched at Mahons Bay, Nova Scotia, in 1913. During her first few years she was just another fishing schooner. Then one day she was caught in a hurricane and her captain killed when the force of the wind caused her spar to break. In the meantime the Volstead Act had become law and the *Carma* was sold to a French liquor syndicate and renamed the *Jeanette.*

In her life as a rum runner she was caught too close to shore and was confiscated by the United States government who sold her at auction to a retired navy physician. The doctor refitted her with a new engine and set out on a long cruise to regain his health. When the ship finally reached the west coast she was traded for California real estate. The *Carma* went on several short trips but was eventually bought by some Scandinavians in June 1932. Though told she needed extensive engine repair, the men purchased her anyway. They took her on a long run and were later arrested for rum running, several hundred cases of liquor cunningly stowed in her water tanks. The vessel was seized by customs authorities. In October 1932, Wanderwell bought her for $2,500 at a marshal's sale. Despite warnings by navigation experts that she was unseaworthy, Wanderwell fitted her up for a cruise to the South Seas. His ownership, however, lasted only a few weeks.

To this day, the murder remains unsolved. Some later speculated Wanderwell was killed because of an organization he created known as WAWEC. The Work Around the World Educational Club, or WAWEC, was his idea for an international police force that would make war obsolete. Though he had been trying to interest the League of Nations in the idea without success, many individuals eagerly enlisted in his cause. To join, members paid an initial sign-up fee of $5, which quickly rose to $200 when WAWEC proved to be a popular idea. In

effect it was a burgeoning private army which many, including J. Edgar Hoover, kept a close eye on.

Curly Guy, deported after his Long Beach trial, continued his wanderings around the world. He went on to lead a gallant life fighting Loyalists in Spain, the Chinese in the Orient, and flying for the RAF. He was to meet his end on October 15, 1941, when his bomber went missing over the Atlantic.

Aloha Wanderwell, a.k.a. Idris Hall, continued traveling the U.S. showing the latest adventure film "The River of Death," which she had made with her husband before his murder. The film featured Aloha as the heroine of a thrilling air flight along the course of the Amazon River through the jungles of Brazil. Aloha, too, had a colorful past. She had supposedly posed as a man and joined the French Foreign Legion, but was soon unmasked. In China she was captured by bandits and was only released when she taught them to set up and fire machine guns. She had met Wanderwell while he was on his round-the-world auto tour in 1922.

The 14-year-old Canadian was attending a convent in Paris when she met the intrepid adventurer. The 6-foot tall, honey-blonde was quite mature for one so young. She lied about her age and joined the expedition as an interpreter, posing as Wanderwell's sister. On April 7, 1925, 29-year-old Walter and 18-year-old Aloha were married in Riverside, California. The newlyweds took their lecture tour across country, playing mostly in vaudeville houses. They took additional trips to Africa and Europe, integrating their films into their lectures.

On December 28, 1933, the 25-year-old widow married 21-year-old Walter Baker, a member of the troupe touring with the movie. In 1935, they repeated the round-the-world auto trip which had launched Aloha's fame. When the U.S. entered World War II Walter Baker left the lecture circuit and became a fireman for the Union Pacific while Aloha ran a motel they built in Laramie, Wyoming. Following the war they settled in Newport Beach, California, on Lido Isle, where Aloha died on June 4, 1996.

Walter Wanderwell's death remains unsolved. The mysterious adventurer had achieved in death the notoriety he courted in life.

EPILOGUE

B y the end of 1928, people were becoming increasingly aware that enforcement of Prohibition was not working. Many became convinced that with a new president, Herbert Hoover, Prohibition would at last be effective and the country would truly be dry. Hoover acted less than decisively.

At the new President's request, Congress passed an act forming the National Commission on Law Observance and Enforcement, known as the Wickersham Commission, to study and investigate crime and enforcement of the Eighteenth Amendment. Twelve commissioners studied the faulty Volstead Act and Amendment 18 for over a year and a half. They found what most people already knew: Prohibition was not working, people and many officials disregarded the law, big crooks were seldom prosecuted, while little guys served hard time. Los Angeles Police Chief Davis told the commission:

"Of those convicted only 11% received straight jail sentences; 78% received choice of jail sentence or fine, paid the fine and returned to do business until caught again. Because a limited number of officers can be detailed to work on securing the conclusive evidence required to convict a bootlegger, L.A. cannot hope to do more than curtail the business so long as the fine-license system is in vogue." [66]

Fine-license referred to the bootlegger receiving a small fine and going back to bootleg again, thus amounting to no more than a license to bootleg.

The Wickersham Commission presented its findings to Hoover on January 1, 1931. They reported that some improvement in enforcement had occurred since 1927, but the present enforcement was inadequate. The report opposed repeal, opposed reestablishing the saloon or having the federal government or state go into the liquor business and opposed modifying the sale of wine and beer. They recommended more money for enforcement. In essence, the Wickersham Commission recommended keeping Prohibition. But now another factor forced itself into the middle of the Prohibition struggle—the Great Depression.

By the spring of 1930, the October 1929 stock market crash proved to be more than an economic crisis. Effects spread throughout the United States, hitting every part of society—lay-offs, insolvent banks, lost savings, few sales, and delinquent taxes. These were but a few effects of the Crash of '29 and a sick economy. These economic problems buried the moral issue of Prohibition.

To some, Prohibition was the reason the state treasury was so low and counties bankrupt. Taxes should have been coming from bars, nightclubs, breweries, wineries and distilleries, filling the depleted state and local treasuries. Many had believed that Prohibition would bring a new economic growth to America: real estate developers and landlords expected rents to rise as saloons closed and neighborhoods improved. Soft drink companies and candy manufacturers all expected increased sales. Theater owners anticipated new crowds as Americans looked for fresh ways to entertain themselves without alcohol. None of this happened.

Instead restaurants failed, as they could no longer make a profit without legal liquor sales. Theater revenues declined, as the public found more engaging entertainment in frequenting illicit speakeasies and nightclubs. Many lost their jobs as breweries, distilleries and saloons closed, and in turn thousands more jobs were eliminated for barrel makers, truckers, waiters, and other trades.

Before Prohibition many states relied heavily on excise taxes in liquor sales to pay their bills. Ken Burns' television series on Prohibition points out that 75% of New York's state revenue was derived from liquor taxes. With Prohibition, that revenue was immediately lost. At the national level, Prohibition cost the government a total of $11 billion in lost taxes, while costing over $300 million to enforce. Illegal bootleggers and moonshiners made millions of dollars and paid no taxes from the ill-gotten gain, while legitimate businessmen lost their businesses.

It seemed the perfect time for the Democratic Party and their presidential candidate, Franklin D. Roosevelt, to come out for the repeal of Prohibition in the spring of 1932. There was no doubt how Roosevelt stood. If elected, Prohibition repeal would be submitted to the states to vote on; the Volstead Act would be modified immediately.

In 1931-32, California wets obtained enough signatures to place Propositions 1 and 2 on the November 8, 1932, ballot, abolishing

the Wright Act (the state's version of the Volstead Act) and modifying Prohibition laws. It passed 2-1. The Jones Act, making possessing a liquor still a felony, was not part of the Wright Act and therefore remained on the books. As a result of the election, "wet" California governor Jimmy Rolph stated he was going to let liquor violators out of prison when the Wright Act came off the books at midnight December 18, 1932. He kept his word. One hundred and twenty-three men and six women walked free on the 19th. Roosevelt also won the presidential election that November and immediately got the lame duck Congress to enact the first step to repeal: calling for state conventions to ratify Amendment 21 and do away with Prohibition once and for all.

Roosevelt took office on March 4, 1933, and two weeks later urged Congress to amend the Volstead Act. Congress acted swiftly, passing a bill legalizing 3.2 percent beer by volume. In early April 1933, beer became non-intoxicating. It was then up to the states to allow or not allow this new non-intoxicating beer. California quickly agreed to accept the new legislation.

At 12:01 a.m. on April 7, 1933, now legal beer left breweries all over California. Prohibition agents were kept busy making sure beer did not leave the breweries prematurely. The frothy brew had arrived early and illegally in Long Beach, but it flowed anyway—into the gutters as police caught a truckload trying to sneak into the city.

In June of 1933 California voters quickly approved what some called the "1933 Miracle of Congress." Even Long Beach voted for repeal of the 18th Amendment with 22,465 in favor, 13,505 against. Like the federal government, California could now tax the once illicit brew. State on-sale permits would cost $50 per year and off sale consumption $10 a year. The manufacturing license fee was $100, and a tax of $.62 was placed on every barrel of beer under 32 gallons.

On Tuesday, December 5, 1933, Prohibition officially ended. Five minutes after the issuance of the repeal proclamation the first shipment of foreign liquors was cleared through the Port of Long Beach. The French Line freighter *San Francisco* arrived with 1000 cases of champagne and 280 cases of wine, brandy and cognac. Hundreds of gallons of wines, whisky, brandy and other strong liquors were rushed to more than 10,000 retailers in Southern California, but the anticipated rush to purchase failed to materialize and drinkers took the repeal in a quiet and orderly manner that surprised authorities.

In Long Beach, liquor was now sold legally for the first time in thirty-three years and there was only a single arrest that day for drunkenness. There was no public demonstration to welcome the overthrow of the dry laws because Long Beach folk were confused.

In Long Beach there were legal issues. An old city ordinance prohibited drinking in public places, dance halls and streets. Police reported numerous inquiries as to proper legal procedure in purchasing and consuming the newly legalized beverages. Was drinking *really* legal in Long Beach? It would take some time to figure out.

Forfeiture clauses prohibiting the sale of liquor on land sold in the original townsite were challenged. This included virtually all of the downtown area. According to the land deeds, all land purchased from the Long Beach Land and Water Company would revert back to the company, or its successors, if it was found the owner of the property allowed selling, or even drinking, alcohol on any town lots. Two different approaches were being used to determine the legality of this clause. One sought a test in court to determine if the restrictions were valid under present conditions. The other sought an agreement with the original sellers to void the deeds.

A decision couldn't come too soon for confused citizens. One liquor dealer at 430 Pine Avenue had been ordered to vacate the store where he had been selling liquor because of the original forfeiture clause. The Masonic Temple Association, which owned property at 228 Pine Avenue on which Bernstein's Café was located, asked the court to keep M.E. Bernstein from selling liquor in his café. They believed that such a sale would endanger the association's title to the property.

On January 5, 1934, quiet-title judgments granted under defaults in Los Angeles Superior Court seemed to have solved the problem. Liquor *was* legal in Long Beach. But the matter wasn't "officially" settled until January 1937. Despite attempts by E.O. Miller and other trustees of the Long Beach Land and Water Company to defend the original intent of the deeds, the Third District Court of Appeals upheld the 1934 Superior Court decision—the deed banning liquor on Long Beach property was not valid.

It seemed that the original owners of Long Beach, a consortium headed by William Willmore, had vigilantly placed the clause forfeiting the title to property if liquor was ever sold on the property, in the deeds themselves. Not so the Long Beach Land and Water Company, who

took over the unsold property in the town in 1884. It appeared they sold many of the lots *without* the restriction placed in the deeds. In 1889, the unsold portion of the Long Beach tract was sold by the Long Beach Land and Water Company to the Long Beach Development Company *without* the restrictive clause. According to the court (Wedum-Aldahl Co. v. Miller, 18 Cal.App.2d 745), the Long Beach Land and Water Company waived and abandoned the restrictive clause at that time.

It seemed for a time the end of Prohibition would bring jobs, as well as taxes. The stock market rallied, but the economy again took a down turn. Many people continued to make moonshine, smuggle and bootleg alcohol. The main reason was, of course, financial.

In 1933-34, the depths of the Depression, up to 13 million people were unemployed. Thousands had become skilled in making moonshine, or diluting it and creating gin and bourbon and scotch. It was natural to continue. They needed money. It was how they made a living. They had a ready market in local bars and with wholesale distributors who could pocket the money that was now supposed to be paid in taxes.

Was there a lesson to be learned from Prohibition? Newspaper reporter Walter Lippmann thought so. He wrote:

"This generation of Americans, at least, has learned from it a more certain feeling for the truth that legislation, however noble in purpose, cannot effectively become the law unless its purpose is the actual purpose of the great mass of a community." [67]

Hopefully American lawmakers of today have learned that the Constitution is not to be tampered with lightly, and to watch out for solutions that end up worse than the problems they hope to solve.

Footnotes

1 "Sensational raid: Long Beach officers put stop to carnival of vice running in hotels on Signal Hill." *Los Angeles Times*, March 27, 1922, p.17.

2 "Long Beach, California—Yokels' Paradise, *Haldeman-Julius Monthly*, May, 1926.

3 "Klansmen, in cowland robe, assemble for initiative ceremonies." *Daily Telegram*, February 12, 1922, B-2.

4 Ibid.

5 "Ku Klux Klan of old southland defensive." *Long Beach Press*, March 22, 1922, p.4.

6 "Klan membership barred to men on city police force." *Long Beach Press*, April 27, 1922, p.11.

7 "Klan lecturer has Biblical text; Arkansas minister states he believes he has holy mission to assist Negro." *Long Beach Press*, November 16, 1922, p.13.

8 "New police official at Long Beach; Sergeant takes position on force made vacant by McLendon's removal." *Los Angeles Times*, November 25, 1922, p.II-1.

9 "Scores police of Long Beach: judge declares that city is unprotected, asserts favoritism shown, vice squad rapped." *Los Angeles Times*, January 30, 1924, p.10.

10 "Thousands see Klan initiation; spectacle amazes throng." *Long Beach Press*, June 22, 1924, p.1.

11 Ibid.

12 "Klan throngs stage parade on streets." *Press Telegram*, October 3, 1926, p.1.

13 "Reformers all out of luck; efforts to oust police chief of no avail at Long Beach." *Los Angeles Times*, August 16, 1927, p.A-8.

14 Mason, Walt. "Rippling rhymes; rich men's fun." *Los Angeles Times*, December 13, 1929, p.A-4.

15 "Rum seized in Naples raid is saved; use as medicine allowed by edict." *Press Telegram*, September 15, 1925, p.17.

16 Walker, Clifford James. "One Eye Closed the Other Red: the California Bootlegging Years." Barstow, Back Door Publishing, 1999, p. 235.

17 "Losing patron of gambling ship ends life; Guy L. Bonner aims muzzle at heart." *Press Telegram*, April 28, 1930, p.A-8.

18 "Council bans line to gambling pier; drastic bill hits ships' business." *Press Telegram*, November 21, 1930, p.B-1.

19 "Police offered gangster bribe." *Los Angeles Times*, February 12, 1931, p.A-8.

20 "Four acquitted in gang trial; Long Beach jury returns surprise verdict." *Los Angeles Times*, April 19, 1931, p.A-1.

21 "Caress kidnapping case expected to reach jury tomorrow." *Los Angeles Times*, March 1, 1932, p.A-2.

22 Ibid.

23 Winston, David. "A notice to gangland: Kidnaping won't pay in Los Angeles." *Los Angeles Times*, June 17, 1934, p.J-4.

24 "Memories are grim; gangster gun victim sees retribution in killing of Bruneman." *Press Telegram*, October 25, 1937, p.B-1.

25 "Gambling boat floorman sentenced to five years for killing but probation granted." *Los Angeles Times*, December 17, 1932, p.A-2.

26 Ibid.

27 MacDowell, Syl. "Cucumber patch becomes America's richest town." *Los Angeles Times*, July 6, 1924, p.B-21.

28 "Signal Hill residents quit handsome homes in wake of gusher." *Long Beach Press*, February 5, 1922, p.M-5.

29 Sinclair, Upton. "Oil." New York, Albert & Charles Boni, 1927. p.161.

30 "Officials sound note of warning; keep idle away from city. Long Beach can take care of own people but influx must stop." *Daily Telegram*, October 7, 1921. p.9.

31 "Heights tract sales are 400 lots in ten days." *Daily Telegram*, October 19, 1922, p.19.

32 MacDowell, p.B-21.

33 Ibid.

34 Woehlke, Walter V. "Receivers save little from Julian wreckage." *Los Angeles Times*, October 17, 1927, p.A-2.

35 Woehlke, Walter V. "Spotlight again turned on Julian crash prelude." *Los Angeles Times,* September 18, 1927, p.B-5.

36 "Dorris acts death scene." *Los Angeles Times*, August 9, 1924, p.A-1.

37 "Solons administer knockout to one piece bathing suits." *Daily Telegram*, September 25, 1920, p.9.

38 "Pasadena herd affected. Hoof and Mouth disease breaks out in new area after epidemic is thought checked." *Los Angeles Times*, April 8, 1924, p.1.

39 "Here's Bluebeard's own defense of himself." *Los Angeles Times,* May 4, 1920, p.II-7.

40 "Watson spirited away to escape lynching." *Los Angeles Times*, May 5, 1920, p.II-1.

41 "Long Beach wife kills girl, tries suicide." *Press Telegram*, March 30, 1926. p.1.

42 "Mother held for quiz in Long Beach poison death investigation; girl's viscera show arsenic. *Los Angeles Times*, April 24, 1930. p.A-2.

43 "Coroner's jury holds Mrs. Phillips guilty." *Los Angeles Times*, July 18, 1922, p.I-2.

44 Ibid.

45 "Suspect's only topic is husband." *Los Angeles Times*, July 19, 1922, p.II-2.

46 "I don't know whether I killed her, but if . . ." *Los Angeles Times*, November 17, 1922, p.II-1.

47 Ibid.

48 "Clara Phillips trapped in San Quentin romance." *Los Angeles Times*, September 9, 1932, p.1

49 "Asserted bride beater charged with murder: Lee D. Murphy is sought as wife killer." *Press Telegram*, December 13, 1926, p.1.

50 "Hunt for wife-slayer suspect centers in Imperial Valley." *Los Angeles Times*, December 21, 1926, p.A-2.

51 "Bride slayer's doom affirmed: drunkenness held no excuse for Long Beach crime." *Los Angeles Times*, May 18, 1934, p.5.

52 "Penalty paid; slayer dies on gallows." *Los Angeles Times*, December 8, 1934, p.2.

53 "Torso murder case near end." *Los Angeles Times*, September 6, 1929, p.A-20.

54 Reynolds, Ruth. "Too many loves spark that set torso murder." *Port Standard*, August 6, 1950, p.51.

55 "Mystery goes to the grave." *Los Angeles Times*, September 18, 1920, p.I-6.

56 "Joe W. Stewart mystery murder victim, says letter to police." *Daily Telegram*, October 20, 1920, p.9.

57 "State concludes Peete testimony." *Los Angeles Times*, May 15, 1945, p.9.

58 Loos, Anita. "A Girl Like I." New York, Viking Press, 1966, p.116.

59 Kirkpatrick, Sidney D. "A cast of killers." N.Y., Dutton, 1986, p.211.

60 "Auditor resigns, gives up fight with administration." *Daily Telegram*, August 7, 1913, p.1

61 "City Auditor's version of salary dispute." *Long Beach Press*, July 13, 1922, p.13.

62 "Council asks proof of Fitts; official quizzed on asserted Long Beach corruption." *Los Angeles Times*, January 1, 1930, p.16.

63 Ibid.

64 "Arraign Arbuckle on murder charge." *Long Beach Press*, September 12, 1921, p.1.

65 "Noted comedian in role of tragedian at Council session." *Long Beach Press*, July 1, 1924, p.9.

66 Walker, p. 472.

67 Lippmann, Walter. "Today and Tomorrow: Lawlessness." *Los Angeles Times*, December 5, 1933, A-4.

Bibliography

GENERAL

Blum, Deborah. "The poisoner's handbook." New York, Penguin Books, 2010.

Gardner, Robert. "Bawdy Balboa." Brea, CA, Sultana Press, 1992.

Pegram, Thomas R. "Battling demon rum: the struggle for a dry America, 1800-1933." New York, Ivan R. Dee, 1999.

Rayner, Richard. "A bright and guilty place: murder; corruption, and L.A.'s Scandalous Coming of Age." New York, Doubleday, 2009.

Rice, Craig, editor. "Los Angeles Murders." N.Y., Duell, Sloan and Pearce, 1947.

Tygiel, Jules. "The great Los Angeles swindle: oil, stocks, and scandal during the roaring twenties." Berkeley, University of California Press, 1996.

Walker, Clifford James. "One Eye Closed the Other Red: the California Bootlegging Years." Barstow, Back Door Publishing, 1999.

POLICING LONG BEACH

Gone But Not Forgotten

"Aged carpenter kills helpmate; tries to suicide." *Daily Telegram*, June 21, 1921, p.1.

Blake, Nan. "Pike proves mecca for many visitors." *Press Telegram*, December 31, 1925, p.PT3-7.

"Burbridge makes big bluff; wants $5,000 to cancel his lease for his space under old wharf." *Evening Tribune*, February 4, 1904, p.1.

"Children of Brooks Gibson bereft; hope to continue in united family." *Press Telegram*, June 13, 1930, p.A-10.

"City's new police quarters." *Long Beach Press*, May 6, 1923, p.E-1.

"Crash fatal to policeman and wife; blood transfusion fails." *Press Telegram*, June 11, 1930, p.B-1.

"Ex-Long Beach policeman is crash victim. Alfred G. Houske rams rear of truck rounding turn in Naples." *Press Telegram*, October 6, 1924, p.A-1.

"Fate of McGann in murder trial soon to rest with jury." *Long Beach Press*, October 27, 1923, p.13.

"Frank M'Gann on trial for alleged murder of oil man." *Long Beach Press*, October, 22, 1923, p.13.

"Husband kills rival in Pike crowd: wife sees spouse shoot, city employee slays man as merrymaking throng watches murder." *Long Beach Press*, April 29, 1923, p.F-1.

"Invalid mother ends own life. Seven children survive as woman shoots self." *Los Angeles Times*, June 2, 1923, p.19.

"Long Beach man is shot to death in his shooting gallery by Mexican." *Long Beach Press,* July 5, 1923, p.1.

"Long Beach motorcycle officer dies in crash; machine jams into truck trailer; George A. Walls killed on highway leading to City of Anaheim." *Press Telegram*, November 18, 1928, p.A-1.

"Love tilt is cause of tragedy; Long Beach oil rig builder murders companion on Seaside Boulevard." *Long Beach Press*, July 27, 1923, p.1.

"Marriage of year ended by cruel tragedy; bride grieves for man slain by bandits." *Press Telegram*, July 14, 1931, p.B-2.

"McGann faces charge of murder." *Long Beach Press*, May 2, 1923, p.13.

"McLendon ousted as police officer: removal is made for harmony." *Long Beach Press*, August 7, 1923, p.8.

"Mounted patrolman Thomas Borden slain by desperate thug." *Long Beach Press*, March 18, 1912, p.1.

"Mrs. M'Gann takes stand; tells sensational story of relations with man her husband killed." *Los Angeles Times*, October 26, 1923, p.2.

"Murder cause denied by wife. Slaying victim not wrecker of home, woman says." *Los Angeles Times*, May 1, 1923, p.I-9.

"Murder or accident, is theory: George W. De Tar is struck by bullet when he turns around." *Long Beach Press*, July 5, 1923, p.1.

"Officer J.R. Wilkinson drops dead as he arrests prisoner." *Long Beach Press*, January 17, 1923, p.1.

"Officer, two bandits dead after fight; one policeman is wounded seriously." *Press Telegram*, July 13, 1931, p.A-1.

"Performing kind act, officer is killed: attempt to aid motorist results in death of Orlando Bridgeman, bullet flies as revolver drops." *Long Beach Press,* March 22, 1923, p.1.

"Policeman is killed in crash; traffic officer and fast Pacific Electric train collide on Atlantic." *Press Telegram*, March 7, 1926, p.1.

"Widow of officer, tragically killed, awarded $5,000 by state." *Long Beach Press*, July 6, 1923, p.15.

"Woman kills self when despondent over poor health." *Long Beach Press*, June 1, 1923, p.1.

Politics, Religion and the Ku Klux Klan

"Arrest alleged Klansmen in Woolwine demonstration." *Long Beach Press*, November 4, 1922, p.11

"Boys tell torture tale. Police in Klan robes string them to trees in trying to get confession from them, Grand Jury told." *Los Angeles Times*, November 26, 1924, p.A-2.

"Chief McLendon dismissed; Yancy named acting head." *Long Beach Press*, November 21, 1922, p.13.

"Chief of Police McLendon, reinstated, will soon resign; successor appointed shortly." *Long Beach Press*, November 15, 1922, p.13.

"Chief suspends Cliff Woodruff after Klan talk; won't say that is the reason." *Daily Telegram*, April 28, 1922, p.9.

"Dr. George P. Taubman, long-time pastor, dies." *Press Telegram*, March 12, 1947, p.B-1.

"Dr. G.P. Taubman plans farewell to pulpit Sunday." *Press Telegram*, August 23, 1939, p.B-1.

"Dr. Taubman delivers last sermon; 3000 attend church to hear pastor say his farewell." *Press Telegram*, August 28, 1939, p.B-1.

"Grand jury probe of raid expected; City Manager denounces outrage; Dobbin demands complete report of attack made in home of David Milder, 2347 E. 3rd. St." *Press Telegram*, November 17, 1932, p.B-1.

"J.S. Yancy is made chief." *Long Beach Press*, November 24, 1922, p. 11.

"Klan lecturer has Biblical text; Arkansas minister states he believes he has holy mission to assist Negro." *Long Beach Press*, November 16, 1922, p.13.

"Klan membership barred to men on city police force." *Long Beach Press*, April 27, 1922, p.11.

"Klan offers $500 reward in beach beating charges." *Press Telegram*, November 30, 1924, p.10

"Klan throngs stage parade on streets." *Press Telegram*, October 3, 1926, p.1.

"Klansmen, in cowland robe, assemble for initiative ceremonies." *Daily Telegram*, February 12, 1922, p.B-2.

"Ku Klux Klan of old southland defensive." *Long Beach Press*, March 22, 1922, p.4.

"Manager Hewes suspends Chief McLendon; action by manager comes as sequel to Ku Klux Klan affair." *Long Beach Press*, November 8, 1922, p.13.

"New police official at Long Beach; Sergeant takes position on force made vacant by McLendon's removal." *Los Angeles Times*, November 25, 1922, p.II-1.

"Secret conference indicates appointment of Yancy; Sergeant may be chief." *Long Beach Press*, November 17, 1922, p.11.

"Thousands see Klan initiation; spectacle amazes throng." *Long Beach Press*, June 22, 1924, p.1.

Westcott, John. "Anaheim: city of dreams." Chatsworth, Calif., Windsor Publications, 1990.

"Yancy demands probe of charges; Finn raps city heads in attack." *Long Beach Press*, August 2, 1923, p.1.

Cleaning House

"Brayton is given charge of raid probe; man and wife injured in attack on home testify." *Press Telegram*, November 23, 1932, p.B-1.

"Eight policemen face probe on girls' charges: joyrides and escapades alleged." *Long Beach Press,* October 11, 1923, p.9.

"Fights police in dry raid. Alleged bootlegger slashes Long Beach officer before being killed; son arrested." *Los Angeles Times,* November 5, 1923, p.II-6.

"Five officers suspended; to face girl charges; one-fourth of Long Beach police force involved in complaint of wild orgies." *Los Angeles Times,* October 12, 1923, p.II-1.

"G.L. Buck defends Yancy; will not resign; manager says police chief is capable." *Press Telegram,* January 14, 1930, p.A-1.

"Grand jury to quiz police on girls' charges." *Long Beach Press,* October 12, 1923, p.11.

"Officers raid beach resort; reputed bootleggers caught at Long Beach. *Los Angeles Times,* September 6, 1926, p.A-16.

Pinnell, O.J. "Large still captured." *Long Beach Police Officers Pictorial,* Long Beach, Police Department, 1928.

"Pleas to oust Chief Yancy revealed: Minute Men, W.C.T.U. and Law Enforcement League demand change." *Press Telegram,* August 14, 1927, p.1.

"Police launch gambling war; Long Beach officer puts lid on card games." *Los Angeles Times,* September 28, 1926, p.12.

"Police scandal at Long Beach; Chief Yancy will ask county for grand jury quiz; action outgrowth of charge by dismissed officer." *Los Angeles Times,* August 3, 1923, p.II-10.

"Prominent men listed in rum 'blue book;' police may question Long Beach folk named as bootleg customers." *Press Telegram,* August 18, 1927, p.15.

"Reformers all out of luck; efforts to oust police chief of no avail at Long Beach." *Los Angeles Times,* August 16, 1927, p.A-8.

"Row on beach police bitter; City Manager denies court accusations." *Los Angeles Times,* January 31, 1924, p.10.

"Rum clean-up in Long Beach. Seven new officers hired on previous reputations." *Los Angeles Times,* November 3, 1923, p.I-7.

"Scores police of Long Beach: judge declares that city is unprotected, asserts favoritism shown, vice squad rapped." *Los Angeles Times*, January 30, 1924, p.10.

"Yancy faces raid inquiry." *Los Angeles Times*, September 7, 1926, p.A-16.

The Great Depression, Communism & A New Deal

"Chief of Police, J.S. Yancy ends 20 years service." *Press Telegram*, July 1, 1932, p. B-1.

"City Charter interpreted variously; ousted ten may vacate at once." *Press Telegram*, July 11, 1934. p.A-1.

"City faced by grave financial problem; Council learns need of rigid economy." *Press Telegram*, August 21, 1930, p.B-1.

"Communist activities among youth of city reported by police." *Press Telegram*, March 31, 1932, p.B-1.

"Complaints are filed in communist raid; forty-one of eighty-two are accused. Plans reported for deportation." *Press Telegram*, January 19, 1932, p.B-1.

"Council recall petition is filed." *Press Telegram*, January 26, 1932, p.A-1.

"Efforts of Communists to penetrate ranks of workers are revealed." *Press Telegram*, April 1, 1932, p.B-1.

"Explosion death list now nine; injured list compiled at 35." *Press Telegram*, June 3, 1933, p.A-1.

"Grand jury probe of raid expected; City Manager denounces outrage, Dobbin demands complete report of attack made in home of David Milder. *Press Telegram*, November 17, 1932, p.B-1.

"Home, County, State and Nation will help restore Long Beach." *Press Telegram*, March 11, 1933, p.A-1.

"Klan plea for retrial due today. Fifteen convicted in raid facing sentence if their arguments fail." *Los Angeles Times*, February 20, 1933, p.14.

"Klan raid case action sought; asserted Communists beaten by light of fiery cross." *Los Angeles Times,* November 18, 1932, p. A-1.

"Lewis makes demand for economy; retrenchment by city held imperative; five-day week is one proposal." *Press Telegram*, May 28, 1931, p.B-1.

Mason, Walt. "Rippling rhymes; rich men's fun." *Los Angeles Times*, December 13, 1929, p.A-4.

"Meeting places held secret." *Press Telegram*, March 29, 1932, p.B-1.

"New body found in blast ruins and another hunted." *Los Angeles Times*, June 4, 1933, p.1.

"Pine Avenue crowd hears inauguration." *Press Telegram*, March 4, 1933, p.B-1.

"Political ambitions of Communists related in party publications." *Press Telegram*, April 2, 1932, p.B-1.

"Protests sent to governor in arrest of alleged reds release asked for 75 in Long Beach." *Press Telegram*, January 18, 1932, p.B-1.

"Student describes raid: victim of asserted Klan attack on supposed Reds paints vivid picture at trial." *Los Angeles Times*, February 1, 1933, p.A-2.

"Sunday visitors are estimated at one million." *Press Telegram*, March 20, 1933, p.B-1.

"Tar and feather episode probe asked." *Press Telegram*, April 28, 1932, p.B-1.

"Testimony started in radicals' trial; many spectators are turned away." *Press Telegram*, February 2, 1932, p.B-1.

"Woman gives death party. Long Beach resident invites friends to home and kills herself." *Los Angeles Times*, July 30, 1932, p.6.

"Yancy resigns; McClelland to get post; veteran police out on October 16." *Press Telegram*, October 2, 1933, p.B-1.

ALCOHOL MADNESS

Evils of Alcohol

"About the winery; little inside history of local blind pig." *Evening Tribune*, September 20, 1904, p.2.

"Achata and Ardan arraigned yesterday; charged with illegal sale of intoxicants." *Long Beach Press*, May 5, 1908, p.1.

"Carrie Nation in town; the noted hatchet wielder greeted by an audience of 1,000 people." *Evening Tribune*, February 17, 1903, p.1.

"Love of drink woman's shame." *Evening Tribune*, December 11, 1905, p.1.

"Mexican badly wounded in fight; too much wine cause of trouble." *Long Beach Press*, August 6, 1907, p.1.

"Opposed to the winery; strong petition to be presented to supervisors." *Daily Telegram*, May 27, 1907, p.1.

"She had a large audience, synopsis of Mrs. Nation's address at the Tabernacle last night." *Evening Tribune*, March 13, 1903, p.1.

"Wants license revoked; strong charges made against Yribarne Winery." *Daily Telegram*, May 28, 1907, p.1.

"Whisky love, woman's fall." *Los Angeles Times*, December 11, 1905, p.II-7.

"Yribarne gets his liquor license; notorious booze joint on edge of city is now legalized." *Evening Tribune*, March 27, 1905, p.1.

Rum Raids

"Arrest made by federal sleuths in Naples liquor ring." *Press Telegram*, September 2, 1925, p.13.

"Deadly rum war hinted: asserted bootlegger king tells of conflict to gain supremacy in liquor circles." *Los Angeles Times*, August 6, 1925, p.II-1.

Dodge, Clark. "Government's grip closing on dry-law violators." *Los Angeles Times*, August 29, 1926, p.II-7.

"Federal dry agent charged with taking liquor from Naples." *Press Telegram*, September 4, 1925, p.1.

"Imposter deceives police to get liquor." *Press Telegram*, August 28, 1925, p.1.

"Liquor valued at $13,000 seized at Naples: giant rum ring plot revealed." *Press Telegram*, August 26, 1925, p.1.

Nathan, Albert. "Death, sudden and mysterious, is fate of hijacker." *Los Angeles Times*, August 15, 1926, p.B-7.

Nathan, Albert. "How whisky smugglers buy and land cargoes." *Los Angeles Times*, August 8, 1926, p.B-5.

Nathan, Albert. "The rum-runners. Inside details of volume of contraband liquor flooding Southern California." *Los Angeles Times*, August 1, 1926, p.B-5.

"Police officials may be involved in Naples liquor scandal." *Press Telegram*, August 29, 1925, p.9.

"Policeman accused of conspiracy in Naples rum raid." *Press Telegram*, September 24, 1925, p.13.

"Rum seized in Naples raid is saved; use as medicine allowed by edict." *Press Telegram*, September 15, 1925, p.17.

"Suspect in rum war arrested; apprehension of smuggler gang expected soon. Two seriously wounded in gun battle at beach." *Los Angeles Times*, August 5, 1925, p.A-18.

Turney, Raymond I. "Dry act's supreme test must be met by American people." *Los Angeles Times*, September 13, 1925, p. MF-1.

Remington Murder

"A. B. Stewart gets four months in jail; defendant must pay $7500." *Press Telegram*, February 14, 1925, p.1.

"Alexander Stewart is free on $10,000 bond." *Press Telegram*, February 17, 1925, p.17.

"Alleged leader of rum runners taken after long chase." *Long Beach Press*, November 3, 1923, p.13.

"Army will take over Aber case: man who confessed to Remington killing to be sent to Camp Lewis." *Los Angeles Times*, April 19, 1924, p.I-8.

"Arrests crush bootleg gang; Remington murder case is reopened." *Los Angeles Times*, March 24, 1923, p.II-1.

"Booze plot revealed to court; Harold Dolley directly implicates Curtis Company chief." *Press Telegram*, January 23, 1925, p.1.

"Booze raiders uncover gang: murder clews found point to early arrests." *Los Angeles Times*, March 23, 1923, p.II-1.

"Dog restless murder night; neighbor of Remington was aroused by animal." *Los Angeles Times*, February 17, 1923, p.I-2.

"Find revolver wound in Remington's side." *Los Angeles Times*, February 17, 1923, p.I-1.

"Freed by change of word: Stewart, millionaire liquor suspect, wins reversal on altering of indictment." *Los Angeles Times*, May 8, 1926, p.8.

"Jap caught in dry raid escapes." *Long Beach Press*, March 24, 1923, p.1.

"Liquor ring mystery is cleared up: dry chief and asserted rum gang head appear before commissioner." *Los Angeles Times*, March 30, 1923, p.II-4.

"Murder victim prominent: Earle Remington known throughout state as bank designer; once headed aviation company." *Los Angeles Times*, February 17, 1923, p.I-2.

"Relative discusses crime: Remington's brother-in-law says dead man was genial; can't picture him with enemies." *Los Angeles Times*, February 18, 1923, p.I-2.

"Sordid tale is told by widow: Mrs. Remington relates broken home, ties." *Los Angeles Times*, February 22, 1923, p.II-1.

"Widow of slain man returns: Mrs. Earle Remington to nurse ill brother; husband's death unsolved." *Los Angeles Times*, April 14, 1930, p.A-1.

Murder of a Bootlegging Husband

"Goaded to slay, declares wife. Says husband told her to go ahead and kill herself." *Los Angeles Times*, July 9, 1921, p.II-1.

"Julia Johnstone is granted nine year probation." *Daily Telegram*, April 21, 1922, p.9.

"Mrs. Johnstone is found guilty on minor charge; Long Beach woman who shot husband faces term for manslaughter." *Daily Telegram*, February 20, 1922, p.9.

Moonshine

"Bovine toper leads to two hidden stills." *Los Angeles Times*, August 16, 1921, p.1.

"Cows betray liquor still; two, drunk on mash, lead to discovery in North Carolina." *New York Times*, July 17, 1920, p.14.

Dodge, Clark. "Rum smugglers and bootleggers employ amazing ingenuity promoting booze and dope operations." *Los Angeles Times*, February 2, 1926, p.B-11

Dying for a Drink

"Bullet death baffling to police; suicide or murder clues sought as oil worker's body found." *Press Telegram*, November 30, 1928, p.A-1.

"Coroner's jury holds slaying was justifiable." *Los Angeles Times*, July 24, 1926, p.A-6.

"Dairy head held in killing." *Los Angeles Times*, July 21, 1926, p.A-20.

"F.E. McLaren's stabbing is described; Mrs. Adelaide McLaren is accused of causing death of husband." *Press Telegram*, June 1, 1926, p.15.

"Husband brags of killing wife. Slayer flees, then returns wishing to confess." *Los Angeles Times*, January 20, 1932, p.11.

"Inquest on knife death conducted." *Los Angeles Times*, May 15, 1926, p.13.

"Jury fails to fix blame for stabbing of Forest McLaren." *Press Telegram*, May 15, 1926, p.11.

"Long Beach dairyman freed in slaying." *Press Telegram*, July 23, 1926, p.1.

"Mrs. McLaren is held pending arraignment; news of death causes collapse." *Press Telegram*, May 12, 1926, p.17.

"Officers lean to murder theory; supposed suicide note found in home of dead man's sister." *Press Telegram*, December 1, 1928, p.B-1.

"Police demand murder charge. Long Beach officials act in Arthur Park's death." *Los Angeles Times*, December 3, 1928, p.10.

"Ranch manager is held in killing: Los Cerritos dairy boss may face charge of murder." *Press Telegram*, July 21, 1926, p.15.

"Raving killer found insane. Edgar Rucker of Long Beach ordered to asylum." *Los Angeles Times*, March 11, 1932, p.12.

"Salesman stabbed seeks to shield wife; police charge woman with attack." *Press Telegram*, May 10, 1926, p.3.

"Wife makes new plea in knife death." *Los Angeles Times*, August 8, 1926, p.A-3.

"Willis Park held as slayer of brother." *Press Telegram*, December 6, 1928, p.B-1.

"Witness declares death apartment was scene of row." *Press Telegram*, December 14, 1928, p.A-1.

Tijuana Troubles

"Agua Caliente pair in court." *Los Angeles Times*, May 28, 1929, p. 2.

"Ames killer exonerated at inquest; slayer held for inquiry in Mexican border holdup-murder." *Press Telegram*, December 27, 1929, p.A-6.

"Border murder linked to Ames. Agua Caliente crime forms background of killing." *Los Angeles Times*, December 25, 1929, p.A-5.

"Death duelist links trio in border murder; Agua Caliente crime barred by killer." *Press Telegram*, December 23, 1929, p.A-1.

"Father of seven admits killing man he names as Agua Caliente bank-car bandit." *Los Angeles Times*, December 24, 1929, p.A-2.

"Freedom looms for girl in Mexican jail; donations for Porter fund now $972." *Press Telegram*, August 26, 1931, p.B-1.

"Girl in jail at Tijuana tells story; Miss Rose Porter relates incidents of fatal accident on June 7." *Press Telegram*, July 13, 1931, p.B-2.

"Hope now shines in bedlam; jail horrors eased for Rose Porter." *Press Telegram*, August 23, 1931, p.A-1.

"John McClure faces trial for murder." *Press Telegram*, June 19, 1929, p.A-1.

"Kidnap tale by McClure challenged." *Los Angeles Times*, June 18, 1929, p.A-20.

"Long Beach woman murdered near Laguna Beach." *Press Telegram*, June 15, 1929, p. A-1.

"Marcel Dellan in trouble again." *Los Angeles Times*, April 22, 1930, p.8.

"McClure confession brings life term." *Press Telegram*, June 22, 1929, p.A-1.

McGroarty, John Steven. "Agua Caliente, across Mexican border, duplicates Monte Carlo." *Los Angeles Times*, September 8, 1929, p.E-1.

"Mexicans free American girl; home town committee gets bail for her." *Los Angeles Times*, August 28, 1931, p.10.

"Record set by rum offenses in Long Beach." *Press Telegram*, February 2, 1931.

"Rose Porter, freed from jail at Tia Juana, thanks those in Long Beach who aided her." *Press Telegram*, August 28, 1931, p.B-1.

"San Diego officials seek custody of Ames killer; robbery loot seen cause of fight." *Press Telegram*, December 24, 1929, p.A-1.

"Three men and two women now sought in round-up of Agua Caliente bandit killers. Search turns to Long Beach." *Los Angeles Times*, May 24, 1929, p.A-2.

"$2700 fund sought for Long Beach woman in Mexico." *Press Telegram*, July 21, 1931, p.B-1.

GAMBLING SHIPS & GANGSTERS

Offshore Temptation

"Gambling ship towed to port; seized vessel to be held by federal authorities pending action." *Press Telegram*, August 25, 1928, p.A-1.

"Merriam gambling ship bill blocks operators' scheme." *Press Telegram*, April 30, 1929, p.A-8.

"Off-shore gambling ship evil denounced; city attorney asks aid of legislature." *Press Telegram*, March 14, 1929, p.B-1.

"Off shore gambling vessel evades law: authorities of city, county puzzled." *Press Telegram*, July 3, 1928, p.B-1.

"Old vessel rebuilt as gambling ship." *Press Telegram*, October 22, 1928, p.B-1.

"War renewed on gambling ship taxis." *Press Telegram*, August 23, 1928, p.B-1.

Troubles at Sea

"Check on gaming sought: Long Beach passes emergency ordinance to prevent land transportation to gambling-ship taxis." *Los Angeles Times*, November 22, 1930, p.4.

"Council bans line to gambling pier; drastic bill hits ships' business." *Press Telegram*, November 21, 1930, p.B-1.

"Diver to seek sunken riches: gambling barge's treasury on floor of ocean, burned Monfalcone goes down with cash box." *Los Angeles Times*, September 1, 1930, p.6.

"Gambling boat crews seized by police; 20 rounded up in raid at docks." *Press Telegram*, November 30, 1930, A-1.

"Losing patron of gambling ship ends life; Guy L. Bonner aims muzzle at heart." *Press Telegram*, April 28, 1930, p.A-8.

"Old pirate galleon burns off Long Beach; thousands see ship turn to inferno." *Press Telegram*, July 29, 1930, p.A-1.

"Old vessel of war to be casino; former gunboat and troop carrier rebuilt; replaces Monfalcone." *Los Angeles Times*, October 6, 1930, p.A-8.

"Rev. Rourke charges Council aids gambling ships; quiz promised." *Press Telegram*, November 3, 1930, p.A-2.

"Sea gamblers battle with guns for control of floating palace of chance off Seal Beach." *Los Angeles Times*, May 22, 1930, p.A-2.

Kidnapping and Vice

"Are gangsters building another Chicago here?" *Los Angeles Times*, March 29, 1931, p.A-1.

"Bruneman killed by gangsters." *Press Telegram*, October 25, 1937, p.A-1.

"Bruneman surrenders to police." *Press Telegram*, February 26, 1934, p.B-1.

"Caress kidnap gunmen hunted; Long Beach policeman shot in battle may die." *Los Angeles Times*, December 23, 1930, p.A-2.

"Doolen, police play tag with gang; officers keep prisoner ever moving about; authorities fear to subject gunman to perils of gang." *Press Telegram*, January 18, 1932, p.A-1.

"Extortionists keep family in terror. Guard against kidnapers posted on rich family." *Los Angeles Times*, September 18, 1931, p. A-1.

"Four acquitted in gang trial; Long Beach jury returns surprise verdict." *Los Angeles Times*, April 19, 1931, p.A-1.

"Gambling ship test suit is planned; seven arrests made aboard Rose Isle." *Press Telegram*, December 27, 1930, p.B-1.

"Gang battle is described; officer gives version of shooting." *Press Telegram*, March 25, 1931, p.B-1.

"Gangster of Long Beach trial is dead; Ralph Sheldon dies of heart attack at San Quentin." *Press Telegram*, July 5, 1944, p.B-1.

"Graphic story of kidnapping told by "Zeke" Caress." *Press Telegram*, February 8, 1932, p.A-1.

Mandelko, Max. "Sheldon's death recalls crime orgy here." *Independent*, July 9, 1944, p.9.

"Memories are grim; gangster gun victim sees retribution in killing of Bruneman." *Press Telegram*, October 25, 1937, p.B-1.

"Police offered gangster bribe." *Los Angeles Times*, February 12, 1931, p.A-8.

Rasmussen, Cecilia. "Rampart site was noir landmark." *Los Angeles Times*, September 26, 1999, p.3.

"Sheldon, Frank and Orsatti sentenced; gangsters are given limit in penalty; State law provides ten years to life for kidnapping." *Press Telegram*, March 16, 1932, p.B-1.

"Sheldon to testify in gang trial; twelve jurors tentatively chosen to hear case of gun battle with Long Beach police on Dec. 21." *Press Telegram*, March 18, 1931, p.B-8.

"Waggoner, crippled police hero of gang battle, dies." *Press Telegram*, December 18, 1954, p.B-1.

Winston, David. "A notice to gangland: Kidnaping won't pay in Los Angeles." *Los Angeles Times*, June 17, 1934, p.J-4.

Murder on the High Seas

"Barge killing and suicide of cornered bandit declared result of gangland feud." *Los Angeles Times*, July 22, 1932, p. A-2.

"Bounder, bus boy quizzed in slaying; Federals take charge as dealer killed on Rose Isle." *Long Beach Sun*, July 19, 1932, p.A-1.

"Ex-convict confesses killing of friend on gambling ship." *Press Telegram*, September 21, 1933, p.A-1.

"Gambling boat floor man sentenced to five years for killing but probation granted." *Los Angeles Times*, December 17, 1932, p.A-2.

"Gang war seen as fire devours Johanna Smith." *Long Beach Sun*, July 21, 1932, p.A-1.

"Killing linked to river gang: gambling ship principals all from East St. Louis. Prosecutor says witnesses have changed stories." *Los Angeles Times*, December 9, 1932, p.A-3.

"Rose Isle case perjury hinted." *Los Angeles Times*, December 27, 1932, p.A-3.

"Trio describe fight on ship. Dead butcher's companions testify for prosecution." *Los Angeles Times*, December 21, 1933, p.A-8.

End of an Era

"Capone sent to port jail in secret move." *Los Angeles Times*, January 8, 1939, p.A-1.

"Cardenas signs decree permitting games and horse racing in lower California centers." *Los Angeles Times*, June 18, 1936, p1.

"Death on game ship probed." *Press Telegram*, September 5, 1938, p.B-1.

"Death on the Hell Ships." *Independent*, September 8, 1938, p.16.

"Death rolls "7" for Cornero in game at Vegas." *Press Telegram*, August 1, 1955, p.A-1.

"FBI chief visits local prison; condition of Capone investigated." *Press Telegram*, May 26, 1939, p.1.

"Gambling banned at Aqua Caliente." *Los Angeles Times*, July 21, 1935, p.1.

"Gambling ship 'admiral' invades Vegas; Cornero builds plush casino." *Press Telegram*, October 10, 1954, p.A-17.

"Gangsters get $32,000 in holdup aboard gambling ship off coast." *Press Telegram*, July 8, 1935, p.A-1.

"Inglorious end of gaming ship. Rose Isle passes to limbo of forgotten." *Press Telegram*, October 13, 1935, p.A-10.

"Lawmakers act to ban game ships." *Press Telegram*, May 8, 1947, p.B-7.

"Long Beach man stabbed aboard gambling craft." *Press Telegram*, June 13, 1936, p.A-4.

"One gaming ship (Monte Carlo) sold; will quit." *Press Telegram*, March 24, 1936, p.B-1.

"Passenger from gambling craft jumps into sea; suicide note gives no reason for act." *Press Telegram*, August 9, 1937, p.B-1.

"The sinking of the California gambling fleet." *Los Angeles Times*, May 1, 1980, p.X-1.

OIL FEVER

Transformation

Ansell, Martin R. "Oil baron of the Southwest: Edward L. Doheny and the development of the petroleum industry in California." Columbus, Ohio State University Press, 1998.

"City of Signal Hill is created by voters at special election." *Long Beach Press*, April 8, 1924, p.1.

Davis, Margaret L. "Dark side of fortune: triumph and scandal in the life of oil tycoon Edward L. Doheny." Berkeley, University of California Press, 1998.

"Doubles crop of cucumbers. Signal Hill Association buys muslin for covering." *Los Angeles Times,* August 17, 1916. p.I-5.

"Heights tract sales are 400 lots in ten days." *Daily Telegram,* October 19, 1922, p.19.

MacDowell, Syl. "Cucumber patch becomes America's richest town." *Los Angeles Times,* July 6, 1924, p.B-21.

"Modern homes rout oil derricks in Los Cerritos." *Press Telegram,* December 25, 1927, p.C-7.

"Officials sound note of warning; keep idle away from city. Long Beach can take care of own people but influx must stop." *Daily Telegram,* October 7, 1921. p.9.

"Sellers move on summit. Realty event booked for Signal hill today." *Los Angeles Times,* May 25, 1905, p.II-9.

"Signal Hill residents quit handsome homes in wake of gusher." *Long Beach Press,* February 5, 1922, p.M-5.

Sinclair, Upton. "Oil." New York, Albert & Charles Boni, 1927.

"Transform Rancho Los Cerritos into small home tracts." *Long Beach Press,* March 4, 1923, p.E-1.

Fraud

"Admits mail fraud: W.L. Tully to testify against others in oil syndicate." *Los Angeles Times,* February 18, 1926, p.A-10.

"Asa Keyes given pardon restoring all rights." *Los Angeles Times,* August 20, 1933, p.1.

"Berman accuses Keyes in amazing bribe story." *Los Angeles Times,* January 12, 1929, p.1.

Cantorovich, Manya. "Of C.C. Julian the last days." *Los Angeles Times,* September 29, 1935, p.G-16.

Cantorovich, Manya. "The last days of C.C. Julian." *Los Angeles Times,* October 6, 1935, p.G-17.

"Council urges Julian justice; resolution calls on officials for proper punishment." *Los Angeles Times*, June 10, 1927, p.A-1.

"Four seized in beach oil quiz." *Los Angeles Times*, October 15, 1924, p.A-1.

"Friends to buy Julian, penniless at his death." *Los Angeles Times*, March 26, 1934, p.1.

Holohay, James B. "My San Quentin years." *Los Angeles Times*, May 7, 1936, p.10.

"Julian concern buys holding of beach company." *Los Angeles Times*, June 15, 1924, p.3.

"Keyes gets parole; liberty begins in three months." *Los Angeles Times*, July 13, 1931, p.1.

McWilliams, Carey. "Southern California Country." New York, Duell, Sloan & Pearce, 1946.

"More indicted in Julian case. Seven warrants issued on securities act plot." *Los Angeles Times*, April 2, 1930, p.A-1.

"Oil company officer pays fine." *Los Angeles Times*, March 23, 1926, p.A-8.

"Rites said over Keyes." *Los Angeles Times*, October 21, 1934, p.5.

"Six face trial on oil fraud charges today." *Los Angeles Times*, July 6, 1925, p.A-2.

"Two land in oil fraud net; others hunted; huge swindle is charged by officers ex-officials of Bay hills company." *Los Angeles Times*, October 14, 1924, p.A-1.

Tygiel, Jules. "The Great Los Angeles Swindle: oil stocks and scandal during the roaring twenties." N.Y., Oxford, 1994.

Woehlke, Walter V. "Receivers save little from Julian wreckage." *Los Angeles Times*, October 17, 1927, p.A-2.

Woehlke, Walter V. "Spotlight again turned on Julian crash prelude." *Los Angeles Times*, September 18, 1927, p.B-5.

Greed and Murder

"Affidavit in Dorris case is given out. Statement sworn to in Chicago declares Meyer refused to pay note." *Los Angeles Times*, July 20, 1924, p.4.

"Attorney says Meyer decision upset by state." *Los Angeles Times*, July 18, 1928, p.A-8.

"Dorris acts death scene." *Los Angeles Times*, August 9, 1924, p.A-1.

"Dorris visions acquittal; telegram from C.C. Julian asserting Meyer debt to Long Beach man raises defense hopes." *Los Angeles Times*, July 13, 1924, p.A-8.

"Julian fiasco upsets hotel: Long Beach capitalist returns from Toronto only to find contractor he had engaged to put up $500,000 hostelry must go to county jail." *Los Angeles Times*, October 5, 1927, p.23.

"Man, woman dead in double shooting." *Long Beach Press*, June 30, 1924, p.1.

"Sisters get estate of C.W. Dorris." *Los Angeles Times*, September 19, 1925, p.A-5.

"Third ballot frees Dorris." *Los Angeles Times*, August 14, 1924, p.A-1.

"Victims of assassins' bullets." *Los Angeles Times*, May 21, 1931, p.2.

Was God Angry?

"Autoists warned of quarantine guards; bullets stop cars." *Long Beach Press*, April 5, 1924, p.11

"City not liable for payment of hog farm guards." *Long Beach Press*, May 13, 1924, p.27.

"Dairy cows contract plague." *Long Beach Press*, April 8, 1924, p.1.

"Drastic city quarantine proposed." *Long Beach Press*, April 10, 1924, p.13.

"Drastic federal action to end boycott against California." *Long Beach Press*, April 20, 1924, p.1.

"Hog ranch on city lands quarantined." *Long Beach Press*, April 9, 1924, p.13.

"Hogs on city ranch face slaughter." *Long Beach Press*, April 24, 1924, p.9.

"Little Mexico honors its heroine; medal given to teacher . . . who remained in plague area." *Los Angeles Times*, November 14, 1924, p.A-1.

"Nine mourners at wake dead; funeral guests stricken by strange malady eight more are in hospital." *Los Angeles Times*, November 1, 1924, p.A-1.

"No new plague cases show up. Disease in two small local districts halted." *Los Angeles Times*, November 9, 1924, p.5.

Onesti, Silvio J., Jr. "Plague, press and politics," *Stanford Medical Bulletin* 13:1 (February 1955), p.1-10.

"Pasadena herd affected. Hoof and Mouth disease breaks out in new area after epidemic is thought checked." *Los Angeles Times*, April 8, 1924, p.1.

Rasmussen, Cecilia. "L.A. then and now; in 1924, a scourge from the Middle Ages." *Los Angeles Times*, March 5, 2006, p.B-2.

Roark, Anne C. "1924 plague in L.A. traced to S.F., Orient." *Los Angeles Times*, February 23, 1986, p.A-20.

"Seven are dead from pneumonia; nine treated at hospital for malady contracted at funeral." *Los Angeles Times*, November 3, 1924, p.A-1.

"Solons administer knockout to one piece bathing suits." *Daily Telegram*, September 25, 1920, p.9.

"Will repeal Peek bathing ordinance: publicity hurts city." *Long Beach Press*, May 29, 1923, p.13.

Zinser, Ben. "City in Nightmare." *Press Telegram*, May 18, 1958, A-1.

LOVE & MURDER

Bluebeard

"Arch killer tells his life history." *Los Angeles Times*, May 11, 1920, p.II-8.

"Bluebeard is sentenced to life term." *Long Beach Press*, May 10, 1920, p.13.

"Bluebeard murdered one wife near Long Beach; used this city as base." *Long Beach Press*, April 20, 1920, p.11.

"Bluebeard to leave estate to charity." *Los Angeles Times*, March 16, 1931, p.1.

"Convict taken by death; known as Bluebeard because of murders committed here in 1922." *Press Telegram*, October 16, 1939, p.B-1.

"Here's Bluebeard's own defense of himself." *Los Angeles Times*, May 4, 1920, p. II-7.

308

"In modern bluebeard's closet: here are the wives of James P. Watson." *Los Angeles Times*, May 9, 1920, p.II-1.

"Los Angeles Bluebeard, who murdered nine wives, dies in San Quentin prison." *Los Angeles Times*, October 17, 1939, p.5.

"Watson in Sacramento day after murder?" *Los Angeles Times*, May 2, 1920. p.I-1.

"Watson spirited away to escape lynching." *Los Angeles Times*, May 5, 1920. p.II-1.

Whitaker, Alma "Bluebeard's treasure hunt blows up." *Los Angeles Times*, November 30, 1930, p.A-1.

"Will be preserved; Signal Hill monument to be enclosed in a park." *Evening Tribune*, May 3, 1905, p.1.

Killer Moms

"Accuse boy of killing two victims. Long Beach Youth arrested for eight burglaries and double murder." *Los Angeles Times*, November 24, 1927, p.A-8.

"Emotionally dead, physician's verdict on Mrs. Hartman; Long Beach poison case suspect also said to have organic trouble." *Press Telegram*, May 3, 1930, p.B-5.

"Fourth Hartman case death is probed; woman suspect believed to be insane." *Press Telegram*, April 25, 1930, p.B-8.

"Graves opened in poison quiz; bodies of Mrs. Hartman's son and husband removed." *Los Angeles Times*, April 25, 1930, p. A-2.

"Hartman charge dropped. Woman will be put in asylum instead of facing trial on triple murder accusation." *Los Angeles Times*, June 3, 1930, p. A-12.

"Kills husband and self at Terry; just home, to pass Christmas, wealthy Texas banker is shot by his wife as he sleeps in bed." *Daily Telegram*, December 24, 1921, p.1.

"Kills husband, ends own life." *Los Angeles Times*, December 25, 1921, p. I-10.

"Kills husband, then herself: Texas woman who came to coast for health believed deranged." *Ogden Standard Examiner*, December 25, 1921, p.8.

"Long Beach wife kills girl, tries suicide." *Press Telegram*, March 30, 1926. p.1.

"Mother held for quiz in Long Beach poison death investigation; girl's viscera show arsenic." *Los Angeles Times*, April 24, 1930. p.A-2.

"Mother named as girl slayer. Long Beach coroner's jury renders decision." *Los Angeles Times,* April 3, 1926, p. A-10.

"Mrs. Hartman's mind examined." *Los Angeles Times*, April 27, 1930, p.A-7.

"Murder cause denied by wife. Slaying victim not wrecker of home, woman says." *Los Angeles Times,* May 1, 1923, p.I-9.

"Paroled killer suspected of new crimes; Richard Haver again visits Long Beach; slayer of veteran said to have left stolen goods with friend here." *Press Telegram,* October 25, 1929, p.B-8.

"Three deaths here start mystery; arsenic poisoning found in organs of girl by county coroner; brother died in June of last year; bodies of son and father, who was slain, are ordered exhumed." *Press Telegram,* April 23, 1930, p.A-4.

"Wife slays husband, attempts daughter's life and kills self." *Long Beach Press,* December 24, 1921, p.1.

Revenge of the "Wronged" Wife

"Accused woman appeared on local revue stage and as bathing beauty in films." *Los Angeles Times,* July 15, 1922, p.I-5.

"Accuses Peggy as murderess." *Los Angeles Times*, November 14, 1922, p.II-1.

"Clara Phillips pleads to be left to herself." *Los Angeles Times*, June 17, 1935, p.1.

"Clara Phillips trapped in San Quentin romance." *Los Angeles Times*, September 9, 1932, p.1.

"Coroner's jury holds Mrs. Phillips guilty." *Los Angeles Times*, July 18, 1922, p.I-2.

"Grand jurors hear tale; Peggy Caffee, eyewitness to Meadows killing tells of night visit to victim's apartment." *Los Angeles Times*, July 15, 1922, p.I-1

"I don't know whether I killed her, but if . . ." *Los Angeles Times*, November 17, 1922, p.II-1.

"Mrs. Phillips breaks down." *Los Angeles Times,* October 21, 1922, p. II-1.

"Mrs. Phillips used jail phone to plot flight?" *Los Angeles Times,* December 6, 1922, p.I-1.

O'Brien, A.R. "The woman fate was cruel to—and kind." *Ukiah Republican Press,* June 14, 1939, p.2.

"Oil man says jealous wife killed widow with hammer." *Los Angeles Times,* July 14, 1922, p.I1.

"San Quentin for killer." *Los Angeles Times,* June 2, 1923, p.I-1.

"Suspect's only topic is husband." *Los Angeles Times,* July 19, 1922, p.II-2.

"Tiger girl held in New Orleans." *Los Angeles Times,* May 30, 1923, p.I-3.

Whitaker, Alma. "Trial is sordid mess." *Los Angeles Times,* October 28, 1922, p.II-2.

Breaking Up is Hard to Do

"Café scene of triple shooting; jealous husband is being hunted across California." *Press Telegram,* November 5, 1932, p.A-1.

"Casterot is resting easily; bullet removed." *Bakerfield Californian,* January 8, 1920, p.8.

"Casterot slays self rather than yield to police." *Press Telegram,* November 9, 1932, p.B-1.

"Casterot's body will be exhumed for post-mortem; brother requests action to set at rest various rumors." *Press Telegram,* November 17, 1932, p. B-1.

"Child slayer commits suicide: Long Beach Mail carrier hangs two baby daughters by suffocation." *Los Angeles Times,* January 11, 1910, p.10.

"Communist activities among youth of city reported by police." *Press Telegram,* March 31, 1932, p.B-1.

"Coroner's inquest held over bodies of Keller family; joint funeral for slain pair at Utah home of relatives." *Press Telegram,* June 25, 1929, p.A-8.

"Defense closes murder case evidence; arguments in Rodrigues trial to be made to jury today." *Press Telegram,* June 7, 1929, p.B-5.

"Eddie Finck gasps forgiveness for Keller, then dies." *Press Telegram*, June 26, 1929, p.A-1.

"Family quarrel ends in killing; infuriated husband shoots self through brain after he badly wounded his wife." *Daily Telegram*, September 10, 1921, p.9.

"Gunman now en route to Bakersfield." *Centralia Daily Chronicler*, November 5, 1932, p.1.

"Havens opened for Keller children; youngsters orphaned by tragedy find homes with relatives." *Press Telegram*, June 30, 1929, p.A-4.

"Insanity plea for Rodrigues indicated." *Press Telegram*, June 3, 1929, p.B-1.

"Jack Keller dies blaming liquor for tragedy; killer repents just prior to death." *Press Telegram*, June 24, 1929, A1-8.

"Killer's suicide again verified." *Los Angeles Times*, November 24, 1932, p.A-7.

"Kills wife on the street." *Los Angeles Times*, October 17, 1920, p. IV-12.

"Lewis Rodrigues is found guilty." *Press Telegram*, June 12, 1929, p.A-1.

"Long Beach killer dies of wounds." *Los Angeles Times*, June 25, 1929, p.A-8.

"Long Beach man accused of killing wife shot down by police: Keller taken in own home." *Los Angeles Times*, June 24, 1929, p.A-2.

"Sailor faces murder charge after killing of wife's mother." *Press Telegram*, April 19, 1929, p.A-1.

"Search extended for suspected gunman; Joe Casterot believed in hiding with friends in nearby city." *Press Telegram*, November 6, 1932, p.B-1.

"Shoots former wife; ends life. Slayer wears Santa Claus beard as disguise." *Los Angeles Times,* September 10, 1921, p.II-1.

"Shoots wife, then kills himself; aged ex-husband calls her to door and fires; she will live." *Long Beach Press*, September 10, 1921, p.11.

"Slain babies and father buried at double ceremony." *Press Telegram*, January 12, 1929, p.B-1.

"Slayer of two children commits suicide." *Press Telegram*, January 10, 1929, p.B-1.

"Two years under heavy jail guard, Doolen now free." *Press Telegram*, August 23, 1933, p.A-1.

"Wife slain and two wounded." *Los Angeles Times*, June 23, 1929, p.4.

"Wife's voice fails on stand in Rodriguez murder case; attack story related by girl, 17." *Press Telegram*, June 4, 1929, p.B-1.

"Woman fires death shot at party." *Press Telegram*, July 29, 1932, p.B-1.

"Woman killed in thirteen-story drop; Mrs. Ruth L. Boxtall." *Press Telegram*, February 13, 1932, p.B-1.

A Just Verdict?

"Alleged wife-slayer seen at border; police hot on new trail of L.D. Murphy." *Press Telegram*, December 20, 1926, p.3.

"Asserted bride beater charged with murder: Lee D. Murphy is sought as wife killer." *Press Telegram*, December 13, 1926, p.1.

Bowers, William J. "Legal Homicide: death as punishment in America, 1864-1982." Boston, Northeastern University, 1984.

"Bride slayer's doom affirmed: drunkenness held no excuse for Long Beach crime." *Los Angeles Times*, May 18, 1934, p.5.

"Extradition of alleged slayer of wife sought; Lee D. Murphy, wanted for Long Beach crime, to face trial here." *Press Telegram*, July 15, 1933, p.B-1.

"Hunt for wife-slayer suspect centers in imperial Valley." *Los Angeles Times*, December 21, 1926, p.A-2.

"Jury rights waived in Murphy murder case." *Press Telegram*, September 20, 1933, p.B-1.

"Lee D. Murphy indicted for local slaying." *Press Telegram*, July 25, 1933, p.B-6.

"Long Beach murder suspect is caught; woman beaten to death six years ago." *Press Telegram*, July 7, 1933, p.B-1.

"Long Beach slayer of wife will pay penalty tomorrow; Leo Dwight Murphy to hang at San Quentin." *Press Telegram*, August 23, 1934, p.A-5.

"Mother relates details of beating administered to bride that resulted in death." *Los Angeles Times*, December 13, 1926, p.A-2.

"Murphy back in cell on belated reprieve." *Press Telegram*, August 24, 1934, p.A-7.

"Murphy to pay life, last appeal failing." *Press Telegram*, December 6, 1934, p.A-7.

"Penalty paid; slayer dies on gallows." *Los Angeles Times*, December 8, 1934, p.2.

Torso Murder

"Chart of teeth indicates identify of torso murder victim." *Los Angeles Times*, May 22, 1929, p.A-2.

"Doctor friend of absent woman is quizzed in torso murder." *Press Telegram*, May 29, 1929, p.A-1.

"Doctor partially identifies work on teeth in torso mystery." *Press Telegram*, May 22, 1929, p.A-1.

"Doctor's home bloodstained." *Los Angeles Times*, June 1, 1929, p.A-3.

"Dr. Westlake found guilty." *Los Angeles Times*, September 8, 1929, p.A-3.

"Hairdresser tells details of injury to Mrs. Sutton." *Los Angeles Times*, May 23, 1929, p.A-2,

"Headless body taken from river." *Los Angeles Times*, April 5, 1929, p.A-2.

"New clues in torso death spur hunt." *Press Telegram*, April 8, 1929, p.A-1.

"Officers baffled by torso murder mystery." *Press Telegram*, April 5, 1929, p.A-1.

"Physician aids torso inquiry." *Los Angeles Times*, May 26, 1929, p.B-6.

"Physician, fiancé, charged with Torso murder." *Press Telegram*, June 1, 1929, p.A-1.

Reynolds, Ruth. "Too many loves spark that set torso murder." *Port Standard*, August 6, 1950, p.51.

"Torso death suspect found guilty of first degree murder." *Press Telegram*, September 8, 1929, p.A-1.

"Torso murder case near end." *Los Angeles Times*, September 6, 1929, p.A-20.

"Torso murder head found in river bed grave." *Press Telegram*, May 19, 1929, p.A-1.

"Torso murder suspect freed." *Los Angeles Times*, May 8, 1929, p.A-3.

"Westlake case jury selected." *Los Angeles Times*, August 27, 1929, p.A-3.

"Westlake goes to San Quentin." *Los Angeles Times*, July 12, 1930, p.A-3.

MURDER MYSTERIES

The Unsolved Murder on Signal Hill

"Body found at Signal Hill is not that of Joe Stewart, is assertion of acquaintances." *Daily Telegram*, October 21, 1920, p.2.

"Claim Signal hill murder traced; slain man was drug addict killed in revenge by gang for informing on members." *Daily Telegram*, January 14, 1921, p.17.

"Find suit case and bank book; many of Denton's belongings in dressmaker's home." *Los Angeles Times*, September 24, 1920, p.I-6.

Forbes, Claude M. "Mrs. Peete still waits; paroled woman stays in prison as job sought." *Los Angeles Times*, April 12, 1939, p.5.

"Identification of murdered man doubted; disappearance of preacher mystifies police." *Daily Telegram*, September 28, 1920, p.9.

"Joe W. Stewart mystery murder victim, says letter to police." *Daily Telegram*, October 20, 1920, p.9.

"Judson, husband of Mrs. Peete, leaps to death." *Los Angeles Times*, January 13, 1945, p.1.

"Louise Peete meets doom, calm till end." *Los Angeles Times*, April 12, 1947, p.1.

"Man strangled in ditch may be murder." *Long Beach Press*, September 11, 1920, p.1.

"Mrs. Peete held in mystery death echoing 1920 slaying." *Los Angeles Times*, December 22, 1944, p.3.

"Murder probe reopens; Signal Hill murder mystery may be connected with Denton case in new investigation." *Daily Telegram*, January 27, 1921, p.9.

"Mystery goes to the grave." *Los Angeles Times*, September 18, 1920, p.I-6.

"New Peete story held imaginary." *Los Angeles Times*, July 20, 1926, p.A-9.

"Slain on eve of trip east; letters and text of Denton's will show he was in fear of enemies." *Los Angeles Times*, September 24, 1920, p.I-6.

"Spanish woman story Mrs. Peete's defense." *Los Angeles Times*, October 28, 1920, p.II-1.

"State concludes Peete testimony." *Los Angeles Times*, May 15, 1945, p.9.

Did He Know Too Much?

"Administration of Long Beach in new hands." *Los Angeles Times*, July 8, 1930, p.A-15.

"Alexander and Taylor recalled by citizens by three-to-one vote." *Press Telegram*, July 12, 1929, p.1.

"Arraign Arbuckle on murder charge." *Long Beach Press*, September 12, 1921, p.1.

"Asserted false arrest leads to filing of suit." *Los Angeles Times*, September 7, 1929, p.I-1.

"Auditor quits indignantly; Long Beach official thinks he is abused." *Los Angeles Times*, August 8, 1913, p.II-4.

"Auditor resigns, gives up fight with administration." *Daily Telegram*, August 7, 1913, p.1.

"Beach scandal warning given." *Los Angeles Times*, December 12, 1929, p.A-3.

"Boruff killing hunt assisted." *Los Angeles Times*, October 27, 1929, p.C-7.

Case, Walter H. "Did you know that? Bethlehem Inn Long Beach's first maternity hospital." *Long Beach Sun*, September 5, 1933, p.B-8.

"City Auditor discharges Miss Gunsul, Auditor-elect; latter resigns." *Long Beach Press*, June 4, 1919, p.1.

"City Auditor's version of salary dispute." *Long Beach Press*, July 13, 1922, p.13.

"City Manager recall movement fails." *Press Telegram*, February 23, 1931, p.B1.

"Council asks proof of Fitts; official quizzed on asserted Long Beach corruption." *Los Angeles Times*, January 1, 1930, p.16.

"Detective's death here linked with Taylor murder." *Press Telegram*, October 21, 1929, B-1.

"Drug addiction trebled since country is dry." *Los Angeles Times*, August 16, 1921, p.I-3.

Edmonds, Andy. "Frame Up! The untold story of Roscoe "Fatty" Arbuckle." N.Y., Morrow, 1991.

"Fatty Arbuckle Company here permanently; takes five year lease at Balboa." *Long Beach Press,* October 17, 1917, p.3.

Fussell, Betty Harper. "Mabel." New York, Ticknor & Fields, 1982.

Giroux, Robert. "A deed of death: the story behind the unsolved murder of Hollywood director William Desmond Taylor." N.Y., Knopf, 1990.

"Incompetency alleged. Mayor asked aged auditor to quit his post." *Los Angeles Times*, March 7, 1914, p.II-9.

"Inquiry widens on Long Beach; Grand Jury to investigate asserted official graft." *Los Angeles Times,* November 22, 1929, p.A-20.

"Jury hears witnesses in Long Beach quiz." *Los Angeles Times*, November 30, 1929, p.A-2.

Kirkpatrick, Sidney D. "A cast of killers." N.Y., Dutton, 1986.

"Lewis named city manager, his selection surprise, as another agreed upon." *Los Angeles Times*, July 4, 1930, p.7.

"Long Beach inquiry opens; asserted vice protection, bootlegging, gambling and graft investigated by Grand Jury." *Los Angeles Times*, November 21, 1929, p.A-1.

Loos, Anita. "A Girl Like I." New York, Viking Press, 1966.

Marx, Samuel. "Deadly illusions." New York, Dell, 1991.

"Murdered director's life romance told by Long Beach man." *Long Beach Press,* February 17, 1922, p.3.

"North Long Beach threatens recall of four Councilmen." *Press Telegram,* January 26, 1929, p.A-1.

"Noted comedian in role of tragedian at Council session." *Long Beach Press,* July 1, 1924, p.9.

"Old Long Beach council scored. Charges of wasted funds of city are made." *Los Angeles Times,* August 13, 1927, p. 7.

"Plot charged in vice arrest; attorney Barbee accuses Long Beach officials; was found in room with police operative . . ." *Los Angeles Times,* December 2, 1929, p.A-6.

"Plot to snare Fitts reported." *Los Angeles Times,* October 31, 1929, p.A-2.

"Policemen face inquiry: Long Beach officers to be asked about reports they tried to intimidate vice quiz witnesses." *Los Angeles Times,* November 23, 1929, p.A-10.

"Prohibition makes dope fiends, federal report." *Los Angeles Times,* June 2, 1929, p.I-2.

"Sleuth's death mystery." *Los Angeles Times,* October 19, 1929, p.6.

"Taylor murder has echo; officers get new data in slaying of Long Beach detective who worked on film director mystery." *Los Angeles Times,* October 26, 1929, p.A-3.

"Taylor was director at old Balboa studio." *Daily Telegram,* February 12, 1922, p.B-2.

Yallop, David. "The day the laughter stopped." NY., St. Martin, 1976.

Murder on the Scooner *Carma*

"Adventure tale related by Guy." *Los Angeles Times,* December 9, 1932, p.A-6.

"Assassin kills tourist chief; Capt. Walter Wanderwell slain aboard ship at Long Beach dock . . ." *Los Angeles Times,* December 6, 1932, p.A-1.

"Exile of Curly Guy ordered; suspect in Wanderwell slaying, acquitted, to be deported as alien." *Los Angeles Times,* June 26, 1933, p.A-1.

"Foe of Wanderwell seen leaving murder area." *Los Angeles Times*, December 7, 1932, p.A-1.

Henry, Bill. "By the way." *Los Angeles Times*, October 16, 1941, p.A-1.

"Murder suspect's friends subpoenaed to inquest." *Los Angeles Times*, December 9, 1932, p.A-1.

"Ship murder suspect in court; Guy pleads not guilty." *Los Angeles Times*, December 31, 1932, p.A-1.

"Travelers in far places discover Mrs. Wanderwell." *Press Telegram*, July 6, 1936, p.B-1.

"Wanderwell body consigned to sea at simple rites." *Press Telegram*, December 12, 1932, p.A-1.

"Wanderwell's ex-wife tells divorce reason." *Los Angeles Times*, December 9, 1932, p.A-6.

"Widow of Wanderer remarries." *Los Angeles Times*, December 29, 1933, p.3.

Williams, Carlton E. "Aviator friend's story supports alibi offered by Guy in Wanderwell murder trial." *Los Angeles Times*, February 12, 1933, p.15.

Williams, Carlton E. "Guy identified at Wanderwell murder trial on likeness to mystery man at porthole." *Los Angeles Times*, February 7, 1933, p.A-2.

Williams, Carlton E. "Long Beach jury finds Guy not guilty of slaying Capt. Wanderwell on yacht Carma." *Los Angeles Times*, February 17, 1933, p.A-2.

EPILOGUE

"Appeals court upholds ruling deed liquor ban at Long Beach not valid; decision made in long-time title contest." *Los Angeles Times*, January 29, 1937, p.A9.

"California wet by almost 4 to 1; Long Beach goes with state tide on repeal." *Press Telegram*, June 28, 1933, p.A-1.

"Court test looms on Long Beach restrictions." *Los Angeles Times*, December 8, 1933, p.6.

"Deed liquor bans declared void." *Press Telegram*, January 5, 1934, p.B-1.

"Deed rum ban test launched. Long Beach Masons file suit against café man. Injunction asked to stop sale of liquor." *Los Angeles Times*, December 22, 1933, p.6.

"Drink control forces ready." *Los Angeles Times,* December 5, 1933, p.4.

Lippmann, Walter. "Today and Tomorrow: Lawlessness." *Los Angeles Times*, December 5, 1933, p.A-4.

"Liquor clause in city deeds invalidated." *Press Telegram*, January 29, 1937, p.B-1.

"Long Beach vote upon dry repeal proves surprise." *Press Telegram*, March 19, 1932, p.B-1.

"Rum flows in quietly. Repeal hailed in sane style, anticipated rush for legal liquor fails to materialize." *Los Angeles Times*, December 6, 1933, p.1.

"Rum sale clause loses." *Los Angeles Times*, January 5, 1934, p.A-6.

"Rum site titles may go to drys; cancellation of deeds is in doubt." *Press Telegram*, December 13, 1933, p.B-1.

"Trial bearing on deeds is started; injunction suit to restrain liquor sales is before Judge Hight." *Press Telegram*, January 4, 1934, p.B-1.

Index

Bernstein, M.E., 281
Besley, H.R., 240
Betts, Isabel, 64
Bialo, Vittoria, 73
Bibeau, Eva, 223
Bigamists, 183-191, 217-222
Bixby, John, 131
Bixby, Jotham, 131, 135
Bixby Company, 135, 136
Bixby Knolls (area of Long Beach), 37
Bixby Park, 18, 33
Black Death. *See* Plague
Blackmail, 247, 250, 256
Blacks. *See* African Americans
Blackwell, Catherine, 48-49
Blackwell, John, 49
Blake, Helen, 92-93
Bogges, Henry, 14
Boies, Horace, 18
Bonner, James H., vi, 43
Bonner,Guy, 104-105
Bonzer, Alexander F., vii
Bootlegging, xi, 5, 8, 14, 20, 26, 27, 28,
 29, 30-31, 32, 33, 36, 44, 55-60, 65,
 66, 68-70, 73-81, 89, 91, 93, 94,
 103, 107, 125, 134, 138, 156, 157,
 163, 170, 172, 250, 263, 265-266,
 278-279, 282
Borden, Thomas, 2, 12
Borrego, Jose Perez, 90, 94
Boruff, Earl C., 243-245, 247, 248,
 250, 259, 260, 264-268, 272
Boruff, Esther, 268
Bosley, George, 9-10
Boynton, Charles O., 261-262
Bozeman, Charles M., 119-122
Brehm, Marie, 16
Bribery, 34, 63, 110, 141, 143, 145,
 156, 209, 269
Bridgeman, Arta, 10
Bridgeman, Orlando, 2, 10-11
Briggs, A.M., 17
Bronson, J.H., 31, 33
Brooks, Clarence H., 42

Brooks, Walter R., 42
Brown, George T., 29
Brown, H.L., 68
Brown, Thad, 239
Brown, William, 150
Browne, Georgia, 114
Brualla, M., 159
Bruneman, George "Les", 109-117
Buchler, Paul, 213
Buck, George L., vi, 157
Buck, William R., 139-140
Buffum, Charles A., vi, vii, 27, 134,
 248
Bullard, James M., 211
Burbridge, O.H., xi
Burgess, Norman, 124
Burglars & burglaries, 2, 30-31, 63, 64,
 65, 120, 122, 195-198, 208
Burnell, Charles S., 117
Burns, Ken, xii, 279
Busch, Mae, 247
Butterfield, James, vi, 21, 23-24, 27
Buttram, Ernest A., 42

Caffee, M.D., 200
Caffee, Peggy, 199-207
Cahill, Bill, 259
California - Constitutiion. *See*
 Constitution - California
California - Governor, 18, 20, 23, 32,
 40, 126, 127, 144, 221, 259-260,
 267, 280
California Heights (area of Long
 Beach), 135-137
California Supreme Court, 101, 152,
 221, 232, 264
Callahan, Henry S., vi, vii, 35
Campbell, Willard C., 139
Campbell, Melvin L., viii
Camping, 182-183, 185
Canada, 56, 57, 58, 62, 67, 76, 140,
 143, 187, 190, 245
Capone, Al, 109, 110, 118, 127-128

Long Beach Law Enforcement League, 265

Long Beach Ministerial Union, 19, 270

Long Beach Press (Newspaper), 22, 146, 254, 262. 270

Loos, Anita, 246

Lord, Victor C., 64, 68, 70

LoRentz, Ralph E., vii

Los Alamitos, CA., 213-214

Los Angeles, CA., 2, 4, 18, 21, 31, 34, 59, 64, 68, 70, 82, 88, 91, 92, 111, 112, 113, 116, 117, 120, 123, 130-131, 132, 134, 140, 141, 142, 145, 150, 157, 159-162, 187, 189, 196, 199, 202, 205, 207, 208, 210, 225-226, 228, 230, 235, 240, 241, 251, 258, 259, 272, 274-275

Los Angeles - City Council, 161

Los Angeles - Mayor, 144

Los Angeles - Police, 63, 64, 65, 67, 70, 74, 116, 117, 160, 161, 183, 185, 189, 200, 202, 205, 223, 224, 226, 236-242

Los Angeles Co., 17, 32, 34, 49-51, 55, 62, 68, 100, 102, 107, 115, 138, 154, 155-157, 158, 160, 186, 248, 250, 265, 266, 268

Los Angeles Co. - Board of Supervisors, 32, 49, 50-51

Los Angeles Co. - Booze squad, 33-34, 40

Los Angeles Co. - District Attorney, 32, 33, 34, 69, 109, 110, 142, 143, 207, 232, 241, 244, 253, 257-260, 265, 266, 268-269

Los Angeles Co. - Jail, 42, 70, 71, 74, 92, 110, 113, 202-203, 205-206, 207, 209, 220, 240

Los Angeles Co. - Sheriffs, 73, 74, 223, 224, 225, 226, 227, 228, 229, 230

Los Angeles Examiner (Newspaper), 206

Los Angeles Herald Express (Newspaper) 227

Los Angeles River, 223, 224-225, 226, 231

Los Angeles Times (Newspaper), xiii, 17, 30, 33, 38, 55, 56, 76, 89, 107, 115, 132, 140, 141, 185, 186, 190, 204, 224, 245, 262, 265, 266

Los Cerritos (area of Long Beach), 2, 73, 83, 136-137

Los Cerritos Rancho. *See* Ranchos - Los Cerritos

Loujon, Francisca, 159

Lowell, Ina, 97

Ludvigsen, Alice, 184

Lund, Oscar, 67, 68, 71

Lybarger, Jay G., 48, 49

Lynwood, CA., 223, 224

MacDowell, Syl, 132

MacLean, Faith, 253

Madoff, Bernie, 141

Mandez, Jose, 50

Maner, George, 160

Manhunts, 210, 211

Manriquez, Ramon, 223

Marcy, Jessie, 241

Martin, Ray L., 224

Marx, Samuel, 261

Matteson, J.B., 6

Matthews, Blayney, 111-112

McAdams, Ralph, 6-8

McAllister, Wayne, 89

McClelland, Joseph H., vi, 43

McClure, J.H., 98

McClure, John Alexander, 95-98

McComas, Frank, 149-150

McCoy, William H., vii

McCrary, Will, 48-49

McDuffie, John, 139-140

McElroy, Julia, 203

McGann, Anna, 6-8

McGann, Frank, 6-8

McGroarty, John Steven, 89

McKinley, William, 48

McLaren, Adelaide, 82-83

McLaren, Forrest, 82-83

McLendon, Ben, vi, xiii, 22-23, 24, 27-28, 74, 167, 263

McPhail, Addie, 271-272

About the Author

Claudine Burnett has written several other books and articles on Southern California history for which she has received numerous awards. Her credentials include a B.A. in history from the University of California, Irvine; a Master's in Information Science from the University of California, Los Angeles; and a Master's in Public Administration from California State University, Long Beach. Named one of the City of Long Beach's most influential people in the cultural arts by the Long Beach Business Journal, and described by the Long Beach Press Telegram as "one of this town's finest historians," Ms. Burnett's latest book is sure to live up to her reputation as the expert on things Long Beach.